D0461543

Artists
of the
American
West

Volume
II

Artists of the A

merican West

Volume II

A BIOGRAPHICAL DICTIONARY

Doris Ostrander Dawdy

SAGE BOOKS

THE **SWALLOW PRESS** INC.
CHICAGO

First Edition

Sage/Swallow Press Books are published by
The Ohio University Press
Athens, Ohio

Library of Congress Cataloging in Publication Data (Revised)

Dawdy, Doris Ostrander.
 Artists of the American West.

 Bibliography: v. 1, p.
 Vol. 2, without ed. statement, published by Ohio
University Press, Athens, Ohio.
 1. Artists—United States—Biography. 2. Artists
—Biography. 3. The West in art. I. Title.
N6536.D38 709'.2'2 [B] 72-91919
ISBN 0-8040-0607-5 (v. 1)
ISBN 0-8040-0352-1 (v. 2)

Contents

Preface

This sequel to *Artists of the American West* may come as a surprise to those who have wondered why so many Western artists were missing from its predecessor. However, every book must come to an end. When the first volume went to press in 1974, the author and the publisher were not aware that there were hundreds of other artists, born before 1900, yet to be identified as having worked in the West.

The artists in this volume also worked in the 17 states lying roughly west of the 95th meridian. Theirs, too, is the West of mountains and deserts, forests and sagebrush, cowboys and cattle, trappers and Indians, miners and pioneers.

Many of these artists are in the *American Art Annual*, that early and excellent source of information which began publication in 1898, ceased in the 1930s, and now can be found only in large or specialized libraries. The origin of the *Annual* is of interest. There was a need for a "full, authentic and carefully compiled annual record of the progress of Art," wrote Florence Levy, editor, in the first compilation. It was not a simple matter to compile a list of these thousands of artists. Levy related in her preface that it sometimes took as many as six letters to obtain the information she sought in the questionnaires she sent to artists, museums, dealers, art schools, and art societies. Moreover, many of her questionnaires were not returned. Yet Levy was able to present more than 3,000 artists in 1898.

Only about 30 of those artists were then living in the 17 Western states. San Francisco and Denver claimed most of them. As the *Art Annual*[1] moved into the 20th century, a significant number from Salt Lake City were added. The impetus was the state-sponsored Utah Art Institute, established in 1899. But weather as conducive to painting as that of Southern California brought artists to Los Angeles and Pasadena, and displaced Utah in the number of entries in subsequent volumes.

Meanwhile, San Francisco moved into a comfortable lead, helped substantially by being the first Western city to have an art school. Now called the San Francisco Art Institute, it was opened to students in 1871. They came from near and far, even Canada, to study. And artists came to teach.

vii

Denver was the second most important art center. There Henry Read[2] headed the extremely active Artists' Club, taught at the Students' School of Art, and served on the advisory board of the *Art Annual.*

Another impetus to the development of art in the West was the Society of Western Artists, organized in 1896 to publicize and exhibit the work of artists living west of the Alleghenies. Art associations on state and local levels began to mushroom and to aggressively publicize and exhibit the work of their members, helping them achieve the recognition that merited their inclusion in the *Art Annual* and other art directories. As each volume of the *Annual* materialized, artists were systematically added as they appeared in important exhibitions, and dropped when they failed to exhibit or otherwise prove their commitment to art. Often an artist who was dropped, subsequently reappeared in the *Annual* or its successor, *Who's Who in American Art* which began compiling artists in 1936.

About that time other American art directories and dictionaries began making their appearance. Mallett's *Index of Artists,* first published in 1935, followed by a supplement in 1940, is international in scope. Editions for 1948 have since been published.

Fielding's Dictionary of *American Painters, Sculptors and Engravers* began publication in 1945. Editions have since appeared for 1965 and 1974.

The *New York Historical Society's Dictionary of Artists in America 1564–1860,* compiled by George C. Groce and David H. Wallace, appeared in 1957 and was reprinted in 1964.

Patricia Havlice's *Index to Artistic Biography,* published in 1974, lists almost every artist in the first ten volumes of *Who's Who in American Art,* as well as artists appearing in a great variety of other publications.

Quite a number of American artists appear in Bénézit, that comprehensive dictionary of internationally-known artists, published in French.

Not all artists in *Who's Who in America* find their way into *Who Was Who in America,* nor does it contain names of many women artists. Nevertheless, *Who Was Who in America* is a useful reference for the relatively few artists whose names it does contain.

viii

Full citations for these dictionaries and directories are in the bibliography, together with many other references used in compiling this second volume of *Artists of the American West.*

Often an artist's year of birth and/or death is absent from these references. Rather than indicate this with question marks, we have left the spaces blank. For example: (1880-), or (-1942), or (-). Even more often the day of death is missing, depriving the researcher of a lead to newspaper and magazine obituaries. It is included here when known. The day of birth serves no particularly useful purpose and is omitted.

Perhaps the most reliable lead to details of an artist's career is knowledge of his whereabouts at a given time. The *American Art Annual* and *Who's Who in American Art* supply this information for specific years. In this volume the format has been redesigned to reflect this information at a glance. For example:

Abbot, Hazel Newham/Newnham (1894-)

 B. Montreal, Canada. Havlice; Mallett; WWAA 1938-1941 (Colorado Springs, Colorado).

The slash, as used above, shows two spellings of what probably was Abbot's maiden name. Throughout this second volume the more common or more likely spelling precedes the other.

Spellings, dates and places of birth, and other pertinent data vary from reference to reference. Often the artist wished to appear younger. Often the place of birth was *near* the town or city cited. Occasionally a town lost its identity through annexation or underwent a change of name.

Museums and art associations, too, undergo name changes or otherwise lose their identity. Where an artist's work is at one time may not be where it is at a later date. Such variations as these are less confusing to users of this and other art directories and dictionaries if it is known that they exist.

In order to show which artists actually worked in the West, it was necessary to scan a great many art periodicals as well as art directories. Among the former the most useful and productive were *Art and Archaeology, Arts and Decoration, Touchstone, International Studio, The Art Digest,* and the *American Magazine of Art.* Currently, a great many periodicals have featured early and contemporary artists who have worked in the West. Among these are *American Artist, Art in America, Art*

News, American Art Review, and *Antiques.* Since the 1960s, *Kennedy Quarterly, Montana Magazine of Western History, The American West, Arizona Highways,* and others have featured early Western artists with full-page illustrations of their work, often in color.

An absorbing interest in abstract art during the last fifty or sixty years virtually eclipsed the merit of representational painting during the 1940s and 1950s. In the 1960s a very real appreciation of the art of the old West began to emerge and may have hastened the return to favor of all representational art, sculpture as well as painting. Whatever the reason, the art of our West is now more popular than ever, and representational art is again in vogue.

Yet, the artist of the abstract can, as Georgia O'Keefe has done, tell us just as much about our West as the artist of the representational—perhaps more. So, too, can the impressionists—the Ernest Lawsons and the lesser known Nellie Knopfs.

It is not widely known which prominent women artists worked in the Western states, but lived elsewhere, for they have been less publicized than the men. Mary Butler, Harriet Blackstone, Grace Ravlin, Nellie Knopf, Bertha Menzler-Peyton, and the Englishwoman Nora Cundell come to mind. Nor is it widely known that women artists who worked and/or lived in these states number in the many hundreds: one-fifth of the more than 1300 in the first volume of *Artists of the American West*; two-fifths of the more than 1400[3] in this volume.

Guidelines for inclusion in both volumes are these: the artists were born before 1900; they worked in the West and have been identified as painters or illustrators or printmakers; or they traveled in the West and had sufficient talent and skill to make pictorial records of what they saw.

Entries for these artists have been designed to enable users of this book to gauge at a glance their professional standing, the span of their careers, the cities and towns in which they lived, and the years they lived in them. Additional data are supplied in comments about their work, sketching trips, and ex·hibitions.

As for those artists who were dropped from the *American Art Annual* or *Who's Who in American Art* after one or two entries, it can be assumed that they were in other fields or are no

longer living and active. Even meager information, such as name and address, is useful should their work emerge in the future. For many of them, names of their teachers, art schools, and art affiliations have been supplied in both AAA and WWAA. When this information is in the former, it has been included in the artist's entry; when it is in the latter, it has not been included. The reason is that AAA covers an earlier period, is seldom available, and is out of print.

Like its predecessor, this volume of *Artists of the American West* is for collectors, curators, librarians, laymen, and art dealers whose interest in the preservation of early works of art helps to preserve our American heritage. Its publication brings the number of artists presented by this writer and researcher to 1800. There are many others who belong in a book of this kind—perhaps enough to fill a third volume.

DORIS OSTRANDER DAWDY
San Francisco, California
and
Bethesda, Maryland

1. *American Art Annual* volumes with art directories are: 1898, 1900, 1903, 1905–1906, 1907–1908, 1909–1910, 1913, 1915, 1917, 1919, 1921, 1923–1924, 1925, 1927, 1929, 1931, 1932, and 1933.
2. Dawdy, *Artists of the American West*, Vol. I, Swallow Press, 1974.
3. This figure does not include artists from the first volume of *Artists of the American West* who are given fuller treatment here.

Notes on Usage

Books, articles, and other information of general coverage are cited in artists' listings by last name of author, editor or compiler, or by initials. Full citations appear in the bibliography. If references apply only to a specific artist, they are fully cited in the listing rather than in the bibliography. References cited by initials are as follows:

AAA American Art Annual
WWAA Who's Who in American Art
WWWA Who Was Who in America

Asterisks used herein designate:

* An obituary in AAA or WWAA
** A biographical sketch covering an artist previously listed in the first volume of *Artists of the American West.*

The category "Work" is not meant to be a current and complete listing of artists' works in public and private institutions. Rather it is to provide useful leads to what specific institutions may have. Because museum storage, exchange, and exhibition practices often make collections inaccessible for months at a time, it is good policy to make arrangements to see them well in advance.

Two collections cited within the category "Work" need clarification. By Act of Congress on March 24, 1937, the National Gallery of Art became the National Collection of Fine Arts, and the former title was given to the art collection and building presented to the nation by Andrew W. Mellon. These titles still are used synonymously by artists and art directories. Because most of the information in the category "Work" comes from these sources, the practice has been continued in this volume.

"Santa Fe Collection" is the title used here for works whose owner is listed variously as Atchison, Topeka, and Santa Fe Railroad Company; Santa Fe Railway; Santa Fe Industries, Inc. An exception exists when a reference refers to the catalog of Santa Fe Industries, Inc., prepared in 1973 for the National Archives exhibition, "Indians and the American West." Santa Fe Industries, Inc., has in its collection 543 paintings which the Railroad began acquiring in 1903.

Artists

A

Abbot, Hazel Newham/Newnham (1894–)
B. Montreal, Canada. Havlice; Mallett; WWAA 1938–1941 (Colorado Springs, Colorado).

Abbot, who specialized in landscape painting, was a graduate of Child-Walker School of Design in Boston.

Abbott, Edward Roydon (1897–)
B. Joplin, Missouri. Havlice; WWAA 1947–1962 (Oklahoma City, Oklahoma).

Abbott exhibited in Colorado, Oklahoma, Mississippi, and Missouri from 1936 to 1958.

Abbott, Marguerite Elizabeth (1870–)
B. San Francisco, California. California State Library.

Abbott, who lived in Los Angeles, studied with Warren E. Rollins and Chris Jorgenson, probably in San Francisco, where both taught at one time. She worked primarily in water color.

Abrams, Lucien (1870–1941)
B. Lawrence, Kansas. D. Old Lyme, Connecticut, April 14. Work: Dallas Museum of Fine Arts. AAA 1915 (Dallas, Texas); AAA 1917–1933 (Lyme, Connecticut); Bénézit; Fielding; Havlice; WWAA 1936–1941 (Old Lyme); "French Influence in Abrams," *The Art Digest*, May 1, 1934, 14; O'Brien.

Acker, Herbert Van Blarcom (1895–)
B. Pasadena, California. Work: Portraits in private collections in the United States; London, England; Buenos Aires, Argentina. AAA 1925–1933 (South Pasadena and San Marino, California); Bénézit; Havlice; Mallett; WWAA 1936–1962 (San Gabriel, Altadena, and Los Angeles, California).

1

Ackerman, Olga M. (-)
　　B. San Francisco, California. AAA 1909–1915 (San Francisco).

Ackerman, Virginia (1893–)
　　B. Lawrence, Kansas. Fisher.
　　Ackerman, who painted in the realistic style, moved to New Mexico in 1944. By 1947 she was living in Santa Fe.

Adams, Grace Arvilla Rice (1887–1972)
　　B. Olivet, South Dakota. D. Huron, South Dakota, December 14. Work: Brookings Hospital collection.
　　Adams, though primarily self-taught, studied briefly in Minot, North Dakota.

Adlon, Emma (1868–)
　　B. Albia, Iowa. Fisher.
　　Adlon moved to New Mexico in 1882. By 1947 she was living in the town of Las Vegas.

Albinson, E. Dewey (1898–)
　　B. Minneapolis, Minnesota. Work: National Collection of Fine Arts; Minneapolis Institute of Art; California Museum, San Diego. AAA 1923–1925, 1933 (Minneapolis); Havlice; Mallett; WWAA 1936–1941 (Minneapolis); "Albinson and Fresco," *The Art Digest*, October 1, 1931, 7.
　　During the 1920s Albinson spent two years studying fresco painting in Italy. The article in the *Digest* provides a glimpse of his interests then and in 1931 when he was exhibiting paintings of Indians, lumberjacks, and mining camps of the Black Hills where he had gone for fresh material. The critic of the *Digest* described them as "strong and colorful."

Albright, Lloyd Lhron (1897–)
　　B. Cleburne, Texas. Work: "Cimarron Canyon," "Old Church," "Ranchos de Taos," and others in Dalhart (Texas) banks; "Aspens" and "Taos Pueblo" in Dallas County Court House, Dalhart. AAA 1931–1933 (Dalhart, Texas); Havlice; Mallett; WWAA 1936–1941 (Dalhart); O'Brien.
　　Albright's work was done primarily in Texas and New

Mexico. There, according to O'Brien, he "succeeded in putting some of his emotional reactions and some of the inspiring grandeur and power of nature into his work."

An architect and a craftsman as well as a painter, Albright has had a continuing interest in adobe houses and their period furnishings. He reproduced many replicas of the latter for homes and public buildings in the Dalhart area.

Aldrich, Clarence Nelson (1893–1954?)
B. Milford, Maine. Work: Society of California Pioneers; Los Angeles Museum of Art. AAA 1931–1933 (Long Beach, California); Havlice; Mallett; WWAA 1936–1953 (Long Beach).

Aldrin, Anders/Andrew Gustave (1889–1970)
B. Stjernsfors, Sweden. D. Los Angeles, California, February 24. Havlice; Mallett Supplement; WWAA 1938–1941, 1956–1962 (Los Angeles); California State Library.

Aldrin, who worked in Los Angeles, Santa Barbara, and San Francisco, exhibited nationally from 1936 to 1961. Among his works are landscapes, portraits, still life subjects, and woodblock prints.

Alexander, (Sara) Dora Block (1888–)
B. Suwalki, Poland. Work: Federated Women's Club Collection. Havlice; Mallett; WWAA 1936–1962 (Mission Beach, Los Angeles, and Woodland Hills, California).

Alexander exhibited frequently in California from 1936 to 1961, and at the Denver Art Museum in 1936.

Allen, Gregory Seymour (1884–1934)
B. Orange, New Jersey. D. Los Angeles, California, April 8. Work: "Cabrillo Landing in Bay of Smokes," Los Angeles Museum of Art. AAA 1913–1924 (New York City; Morsemere, New Jersey); AAA 1925–1933 (Los Angeles and Glendale, California); Bénézit; Fielding; Havlice; Mallett; WWAA 1936–1937 (Glendale).

Allen, Marion Boyd (1862–1941)**
B. Boston, Massachusetts. D. Boston, December 28.

Work: Libraries at Barre and Arlington, Massachusetts; College Library, Brunswick, Maine; Illinois College, Jacksonville; Lynchburg (Virginia) College; Christian Science Publishing House, Boston. AAA 1913-1933 (Boston); Bénézit; Fielding; Havlice; Mallett; WWAA 1936-1941 (Boston); WWWA; "At 67, Mrs. Allen Braves Wilds to Paint," *The Art Digest*, February 1, 1934, 16. (Actually, Allen was 71, not 67.)

Marion Boyd Allen "does not hesitate to ride miles over rough trails and to live in isolated cabins to get material for painting," wrote *The Art Digest* in 1934. At that time Allen had been specializing in landscapes for little more than a decade. Despite her age, rugged terrain did not deter her from getting to the vantage points from which she wished to paint. Mountain areas of Washington and Oregon and the Grand Canyon figure significantly in her landscapes.

Allen's lifelong specialty, however, was portraiture. During the latter part of her career she spent about ten summers in Arizona where she specialized in Indian portraits.

Allen, Mary Coleman (1888-)
B. Troy, Ohio. Work: Brooklyn Museum; Dayton Art Institute. AAA 1923-1933 (Pasadena, California; Troy); Fielding; Havlice; Mallett; WWAA 1936-1962 (Troy).

Prior to settling in Pasadena, Allen lived in New York City where she specialized in the study of miniature painting. She lived in Pasadena until about 1929 when she returned to Troy.

Allen, Mary Gertrude Stockbridge (1869-1949)
B. Mendota, Illinois. D. Everett, Washington, January 22. Work: Whitman College, Walla Walla, Washington; Lake Stevens High School Library. AAA 1929-1933 (Lake Stevens, Washington); Havlice; Mallett; WWAA 1936-1941 (Lake Stevens); WWAA 1947-1953* (Everett); *Who's Who in Northwest Art; Who's Who on the Pacific Coast,* 1947.

Allen was a landscape painter who taught many years in Washington. Her recreation was painting the desert in Southern California where she was a member of the Laguna Beach Art Association. She also painted portraits.

Allen, Pearl Wright (1880–)

B. Kossuth, Mississippi. Work: "Laguna Beach" and "Sunlit Rocks," Muskogee (Oklahoma) Public Library. AAA 1925–1933 (Muskogee); Havlice; Mallett; WWAA 1936–1941 (Muskogee).

Allen studied with John F. Carlson, and with Anna Hills in California.

Allis, C. Harry (1876–1938)

B. Dayton, Ohio. D. June 8. Work: University of Oregon, Eugene; Detroit Institute of Art. AAA 1898–1900 (Detroit, Michigan); AAA 1907–1910 (France); AAA 1915 (Plattsburgh, New York); AAA 1921–1933 (New York City); Bénézit; Fielding; Havlice; Mallett; WWAA 1936–1939 (New York City); California State Library.

Sometime after Allis's return from France, he lived in Southern California for about 11 months.

Anderson, Alice Sloan (1888–)

B. South Orange, New Jersey. Havlice; Mallett; WWAA 1940–1941 (Bedford Hills, New York); Fisher.

Little is known about this artist who became a part-time resident of New Mexico in 1939.

Anderson, Dorothy Visjn (1874–1960)

B. Oslo, Norway. D. Los Angeles, California, September 4. Work: Vanderpoel Memorial Collection (Chicago); Elks Club (Los Angeles); Women's Club (Hollywood). AAA 1915–1924 (Chicago, Illinois); AAA 1925–1933 (Hollywood, California); Bénézit; Fielding; Havlice; WWAA 1936–1962 (Hollywood); *Art News,* May 19, 1923, 7.

Anderson, Louise Catherine Vallet (–1944)

B. Heidelberg, Germany. D. Sacramento, California, June 28. Work: California State Library.

According to information at the California State Library, Anderson had received some art training in San Francisco and Santa Cruz, California, before settling in French Creek, California. An oil in the primitive style has hung for years in the state library in Sacramento.

Andrews, Willard H. (c.1899–)

B. Louisville, Colorado. Denver Public Library; Albuquerque Public Library; Ina Sizer Cassidy, "Art and Artists of New Mexico," *New Mexico* Magazine, March 1952, 22, 36.

Andrews was 16 when he began working for the Denver *Post* as a cartoonist, a job he soon left to serve in the First World War. After the war he studied at University of California in Berkeley, and Mark Hopkins Institute in San Francisco.

About 1933 Andrews left California for New Mexico to hunt for gold. He lived at the old Laguna Hotel on the edge of Laguna Pueblo, made friends among the local Indians, and in their company explored the back trails on the nearby mesas. Although no gold materialized, his experiences and observations determined the content of many paintings during his years as an illustrator in Albuquerque. "Navajo Woman," reproduced to illustrate Cassidy's article about Andrews, is the sort of thing he did for magazines such as *Sunset.*

Angelo, Valenti (1897–)

B. Massarosa, Italy. Work: Library of Congress; New York Public Library; Daniel Estate, Bristol, Virginia. Havlice; Mallett; WWAA 1938–1939, 1953–1962 (Bronxville, New York); San Francisco *Chronicle,* February 15, 1977, 18.

The production of beautiful books has been a motivating force in the life of Angelo from the time of his boyhood in the San Francisco Bay area. It led him to become an accomplished painter, illustrator, and printer who illustrated some 30 books for Grabhorn Press in San Francisco between 1926 and 1933. Several years later Angelo moved to New York to continue his work, remaining there until 1975 when he returned to San Francisco.

Ankeney, John Sites (1870–1946)

B. Xenia, Ohio. D. May 16. Work: University of Missouri; Bethany College, Lindsborg, Kansas; Lindenwood College, St. Charles, Missouri; Carl Milles Collection, Cranbrook, Michigan. AAA 1909–1929 (Columbia, Missouri); AAA 1931–1933 (Dallas, Texas; summer: Estes Park, Colorado); Bénézit; Fielding; Havlice; Mallett; WWAA 1936–1941 (Columbia; Estes Park); WWWA; O'Brien; Bromwell, page 30.

Ankeney painted many Southwestern scenes which he began exhibiting at least as early as November 1897 when he showed several at the first exhibition of the Kansas City print Club.

During the years Ankeney directed the art school at the University of Missouri, he exhibited widely. For several years he lived in Dallas where he was curator for the Dallas Museum of Fine Arts, supervisor of the art department of Texas state fairs, and director of the Public Works of Art Project for Texas and Oklahoma.

Antlers, Max H. (1873–)
B. Berlin, Germany. AAA 1907-1919 (New York City); Bénézit; Mallett; San Francisco *Examiner*, April 27, 1947.

According to the *Examiner*, Antler's Yosemite and Crater Lake paintings were to be exhibited in San Francisco in May in honor of his 75th anniversary.

Applegate, Frank G. (1882-1931)**
B. Atlanta, Illinois. D. February 13. Work: Museum of New Mexico, Santa Fe. AAA 1909 1913 (Trenton, New Jersey); AAA 1915-1921 (Morristown, Pennsylvania); AAA 1923-1931* (Santa Fe, New Mexico); Bénézit; Fielding; Mallett; WWWA; Ina Sizer Cassidy, "Art and Artists of New Mexico," *New Mexico*, June 1934.

In 1921 Applegate took his family to see the famous Santa Fe Fiesta, expecting to go on to the West Coast before returning to Trenton School of Industrial Arts where he headed the department of sculpture and ceramics. Instead, the Santa Fe mystique caught hold and changed the course of his career.

In Santa Fe, Applegate assumed the role of adviser in matters related to Indian culture, and ultimately turned to painting in order to record Indian life. He saw the aesthetic qualities of Pueblo architecture and urged that they be used in designing the homes then being built by artists along Camino del Monte Sol. He visited the curio shops and urged that Indian crafts and Penitente carvings and paintings (Santos and Bultos) be treated as collectors' items.

Among the Hopis of Arizona, Applegate developed a new formula for making pottery from the few remaining clay deposits.

7

The old deposits having long ago been exhausted, the Hopis had been unable to develop a formula suitable for the remaining clay.

Appleton, Norman R. (1899–)
B. Philadelphia, Pennsylvania. Fisher.
According to Fisher's compilation of New Mexico artists, published in 1947, Appleton had been working in Santa Fe since 1924.

Armer, Laura Adams (1874–)
B. Sacramento, California. Work: Oakland Museum. Mallett (Berkeley, California); California State Library; *The Art Digest,* October 1, 1929, 8.
During the late 1920s, Armer lived for awhile on the Navajo Reservation. From her experiences there came *Southwest,* published in 1935 by Longmans, Green and Co., which she also illustrated.

Armer, Ruth (1896–)
B. San Francisco, California. Work: Oakland Museum. AAA 1933 (San Francisco); Havlice; Mallett; WWAA 1940–1941; San Francisco Art Association *Bulletin,* December 1947, March 1948, October 1950; Arthur Bloomfield, "New Style for Veteran Artist," San Francisco *Examiner,* October 21, 1971, 34.

Armer, Sidney (1871–)
B. San Francisco, California. Mallett (Berkeley, California); California State Library; San Francisco Public Library.
Although Armer and his wife, Laura Adams Armer, worked primarily in the San Francisco Bay area, by 1956 they were living in Fortuna, California. Armer specialized in California plant life. His work is highly regarded by botanists and horticulturists.

Arms, John Taylor (1887–1953)
B. Washington, D.C. D. New York City, October 13. Work: British Museum and Victoria and Albert Museum, London, England; Toronto Art Gallery; Metropolitan Museum of Art; Pennsylvania Academy of Fine Arts; Detroit In-

stitute of Art; Boston Museum of Fine Arts; Seattle Art Museum; Library of Congress; M.H. De Young Memorial Museum, San Francisco. AAA 1917-1919 (New York City); AAA 1921-1932 (Fairfield, Connecticut); Bénézit; Fielding; Havlice; Mallett; WWAA 1936-1953 (Fairfield); WWWA; M. Barr.

Armstrong, Samuel John (1893-)
B. Denver, Colorado. Work: Ferry Museum, Tacoma, Washington; Doheny Memorial Library, University of Southern California; Temple of Justice, Olympia, Washington; Arlington Theatre, Santa Barbara, California. AAA 1921-1933 (Steilacoom Lake, Washington; Santa Barbara, California); Bénézit; Fielding; Havlice; Mallett; WWAA 1936-1941 (Stcilacoom Lake; Santa Barbara); *Who's Who in Northwest Art.*

As founder of Armstrong School of Art in Tacoma in 1923, and as art editor for the Tacoma *News Tribune* from 1918 to 1928, Armstrong played a significant role in the development of art in the Northwest. He also became known for his illustrations and cover designs for *Sunset Magazine.*

Armstrong, Voyle Neville (1891-)
B. Dobbin, West Virginia. Work: Cincinnati Art Club. AAA 1915 (Cincinnati, Ohio); AAA 1917-1924 (Bedford, Indiana); AAA 1925-1933 (Wichita Falls, Texas); Bénézit; Fielding; Havlice; Mallett; WWAA 1936-1941 (Wichita Falls).

Arnautoff, Victor Michail (1896-)
B. Mariupol, Ukraine, Russia. Work: San Francisco Museum of Art; Albert Bender Memorial Collection, Stanford University rare books library. Havlice; Mallett Supplement; WWAA 1936-1962 (San Francisco and Colma, California); San Francisco Public Library.

Arnautoff is best known in the San Francisco Bay area where he has taught at Stanford University and has lived since 1925. His frescoes and murals are in various public buildings, including George Washington High School in San Francisco, and United States Post Offices in Linden and College Station, Texas.

Arnstein, Helen (-)
AAA 1913 (San Francisco, California).

Arpa, Jose (c1862–1952)**
B. Carmona, Spain. Work: San Antonio (Texas) Art League; Art Academy, Seville, Spain; Mural paintings, Texas Theatre, San Antonio. AAA 1903, 1925–1933 (San Antonio, Texas); Bénézit; Fielding; Mallett; WWAA 1936 (San Antonio); O'Brien.

Arpa was an internationally known painter when he settled briefly in San Antonio early this century, and made it his home in the 1920s. Although his work is in major museums in various countries, in the 1930s the two largest collections, according to O'Brien, were in San Antonio. Sixty-six canvases were in the studio of a Mr. Raba, and 75 were owned by Mrs. Erhard Guenther.

Arpa's handling of sunshine brought him the title "Sunshine Man" in Texas. He is also known there for the excellence of his teaching.

Ashford, Frank Clifford (1880–1960)
B. Perry, Iowa. D. Aberdeen, South Dakota, November 21. Work: South Dakota State Capitol; Yankton (South Dakota) College; Alexander Mitchell Library, Aberdeen. Bénézit; Mallett; Stuart (Brown County, South Dakota; Paris, France 1909–1911; Seattle, Washington 1915; Aberdeen, Black Hills, and Sioux Falls, South Dakota 1920s; Salem, Oregon 1948; South Dakota 1956).

Ashford studied at Art Institute of Chicago, Pennsylvania Academy of Fine Arts, with William Merritt Chase at the New York School of Art, and in Paris.

Atkins, Florence Elizabeth (-)
B. Pleasant Hill, Louisiana. Work: Portfolio, American Birds in color lithography for library, school, and museum use. AAA 1919–1933 (San Francisco, California); Fielding; Havlice; Mallett; WWAA 1936–1953 (San Francisco).

Atkinson, Leo Franklin (1896–)
B. Sunnyside, Washington. Work: Seattle Fine Arts

Gallery; Columbian Theatre, Baton Rouge, Louisiana; Murals, American Theatre, Bellingham, Washington. AAA 1923-1931 (Seattle, Washington); Fielding.

Atkinson, William Sackston (1864-)
B. Cazenovia, New York. Work: Illustrations for scientific publications. WWWA (Stanford, California); California State Library.

Atkinson specialized in zoological and botanical drawing while at Stanford University where he began working in 1896. His work can be seen in LeRoy Abrams's *Illustrated Flora of the Pacific States, Washington, Oregon, and California*, published in four volumes by Stanford University Press, 1923-1960.

Atwater, G. Barry (1892-1956)
Work: McKee Collection. Fisher; El Paso (Texas) Museum, McKee Collection catalog, 1968; Rocky Mountain *News*, October 19, 1952; *Desert* Magazine, October 1947, 24-25; *New Mexico* Magazine, September 1946, 26.

Although Atwater does not appear in standard art directories, he was an exhibiting artist in the Southwest for many years. His particular interest was desert landscapes which he began painting in the mid-1930s.

Much of Atwater's work was done in New Mexico where he became a part-time resident in 1944. Three years later he moved permanently to Santa Fe.

Atwater grew up in Colorado, attended high school and college in Denver, and studied at Henry Read's Art School. Before becoming a painter, Atwater was an interior decorator in Los Angeles, California. He has had solo exhibitions in Los Angeles; Phoenix and Tucson, Arizona; and El Paso and Houston, Texas.

Atwood, Mary Hall (1894-)
B. Chicago, Illinois. Work: Rotary Club, Phoenix, Arizona. AAA 1929-1933 (Los Angeles, California); Havlice; Mallett; WWAA 1936-1941 (Los Angeles).

Atwood specialized in murals and map-making. Her maps of Southern California, including Death Valley, are in various public buildings, banks, and clubs.

11

Aunspaugh, Vivian Louise (-)
B. Bedford, Virginia. AAA 1925-1933 (Dallas, Texas): Mallett; O'Brien.

Aunspaugh is a legerdary figure in Southwest art history, for it was she who, in 1902, ⸱ ⸱ened the first school in Texas offering courses in fine and commercial art, using nude as well as draped models.

Before moving to Dallas to become art department head at St. Mary's Episcopal College, she taught in McKinney, Bonham, and Greenville, Texas. Previously she had taught art and French in an Alabama college.

Aunspaugh studied with Twachtman and B.R. Fitz in New York, and in France and Italy. It was following study in Rome that she opened Aunspaugh Art School of Dallas, the realization of an ambition she had harbored for many years. Management and teaching responsibilities must have interfered greatly with painting; yet she continued to exhibit regularly in Dallas where she received a number of awards.

Austen, Edward J. (1850-1930)
B. St. John's Wood, London. Work: Joslyn Art Museum. Baird, 1965; John Howell, San Francisco.

Austen studied art in Paris, and spent some years in South Africa before moving to New York in 1900. In 1915, when Austen was in California, he did a series of Western landscapes. "View of Panama-Pacific International Exposition" and "View of the Fine Arts Pavilion," done in San Francisco, are in a private collection.

Austin, Ella M. (1864-)
B. Dawson, Pennsylvania. California State Library.

Austin studied with Mr. and Mrs. Arthur W. Best in San Francisco. Her specialty was California poppies. She also painted landscapes, including scenes along the Merced River. She lived in Nevada City, California.

Avery, Kenneth Newell (1883-)
B. Bay City, Michigan. AAA 1931-1933 (Pasadena, California); Bénézit; Havlice; Mallett; WWAA 1936-1941 (Hemet, California).

12

Avey, Martha (-1943)

B. Arcola, Illinois. D. Oklahoma City, Oklahoma, August 28. Work: John H. Vanderpoel Art Association, Chicago. AAA 1919-1933 (Oklahoma City); Havlice; Mallett; WWAA 1936-1941 (Oklahoma City); Jacobson and d'Ucel, 272.

Avey, whose influence on the development of art in Oklahoma was considerable, was Oklahoma City's first art supervisor of schools, a position she undertook in 1906. In 1925 she organized the art department at Oklahoma City University where she served as department head until her retirement in 1938.

Avey's most productive painting years in Oklahoma were from about 1915 to 1925, during which she also taught privately. Besides many landscapes, she did a series of Oklahoma wild flower paintings.

B

Babcock, Dean (1888-1969)

B. Canton, Illinois. Work: Denver Art Museum; Denver University Library. AAA 1915-1931 (Estes Park, Denver, and Long's Peak, Colorado); Bénézit; Fielding; Havlice; Mallett; WWAA 1936-1939 (Long's Peak); Theo Merrill Fisher, "Dean Babcock," *American Magazine of Art,* November 1921.

The Long's Peak region of Colorado has been for more than a century a favorite sketching place for artists, but few have braved the high-altitude winters as long as Dean Babcock. About 1911, following study at the Chicago Art Institute, Babcock made his home and studio in a remote log cabin on the mountainside where snowshoes were the main form of travel from October to April. There he set out to realize his highest ambition which, he told Fisher, was "to do with tints and lines what Thoreau did with words. . . ."

The medium Babcock chose was not that with which he was familiar—oil and water color—but the woodblock. With a predisposition toward Japanese art because it fit in with his own

concept of design, he felt that woodblock printing best suited his requirements for expressing his subject. The distinctive technique Babcock developed brought him early recognition as an illustrator and a printmaker. It was particularly suited to the making of bookplates, an art in which he also achieved recognition.

Babcock, Roscoe Lloyd (1897–)
B. Thayer, Kansas. California State Library.
Babcock lived for some time in Laguna Beach, California, where he specialized in seascapes and desert scenes.

Bacharach, Herman Ilfeld (1899–)
B. Las Vegas, New Mexico. AAA 1929–1932 (Philadelphia, Pennsylvania); Havlice; Mallett; WWAA 1936–1953 (Philadelphia; Phoenix, Arizona).
Bacharach worked primarily as an illustrator and engraver.

Bacon, Henry (1839–1912)
B. Haverhill, Massachusetts. D. Cairo, Egypt, March 13. Work: National Collection of Fine Arts. Bénézit; Fielding; Groce and Wallace; Havlice; California State Library; Garnier; Temple Emanu-El, San Francisco.
Bacon was in San Francisco during the 1860s or 1870s. According to information at Temple Emanu-El, he taught Toby Rosenthal in San Francisco for virtually nothing because he did not want to see Rosenthal's talent wasted. Bacon, who specialized in Egyptian subjects, lived many years in Paris.

Bailey, Walter Alexander (1894–)
B. Wallula, Kansas. Work: Murals, William Rockhill Nelson Gallery of Art; Kansas City Public Library; Springfield (Massachusetts) Public Library. AAA 1923–1933 (Kansas City, Missouri); Bénézit; Havlice; Mallett; WWAA 1936–1941 (Kansas City); *The Art Digest*, February 1, 1929, 11. Bailey's "Sunset on the Rio Grande" was reproduced in *The Art Digest* to illustrate its comments about the artist and his work.

Bailhache, Anne Dodge (–)
B. Lancaster, Pennsylvania. Havlice; Mallett Supplement;

WWAA 1936–1947 (San Francisco and Saratoga, California); WWAA 1953–1956 (Coronado, California); California State Library.

Bailhache, who married in 1906, was active primarily in California. She founded, and directed from 1939 to 1948, the Montalvo Foundation in Saratoga. Thereafter she moved to Southern California where she directed the Coronado Art Association until 1952.

Bain, Lilian Pherne (1873–)
B. Salem, Oregon. AAA 1923–1933 (New York City and Long Island City, New York); Havlice; Mallett; WWAA 1936–1953* (Portland, Oregon); *Who's Who in Northwest Art; Western Artist,* July-August 1936, 14, 16.

Bain was Frank DuMond's assistant for over ten years. Besides teaching, she exhibited her oil paintings and etchings in group and solo shows in major American cities. She often spent summers in Oregon, Maine or Rhode Island.

Bainbridge, Henry (–)
Work: Two lithographs in Peters's *California on Stone.* Groce and Wallace; Evans.

Bainbridge was a lithographer and landscape draftsman who collaborated with George Casilear on views of San Francisco and Sacramento, California, about 1851. It seems likely that he is the same Henry Bainbridge, employed as clerk, who appears in the 1852 San Francisco City Directory.

Baker, Grace M. (1876–)
B. Annawan, Illinois. AAA 1925–1933 (Greeley, Colorado); Havlice; Mallett; *The Art Digest,* January 1, 1937, 26.

Baker studied at the Art Institute of Chicago. For a number of years she headed the art department of Colorado State Teachers College in Greeley.

Baker, William Henry (1899–)
B. Dallas, Texas. Work: Murals, Central High School and U.S. Post Office, Fort Worth. Havlice; Mallett Supplement; WWAA 1936–1941 (Fort Worth, Texas; summer: Dallas); O'Brien.

15

Although Baker was a commercial artist by profession, he took annual sketching trips to obtain material for his easel paintings, and he also did a number of murals.

Baldaugh, Anni (1886–)

B. Holland. Work: San Diego Fine Arts Gallery. AAA 1915 (San Francisco, California); AAA 1921 (New York City); AAA 1925–1933 (Los Angeles and San Diego, California); Havlice; Mallett; WWAA 1936–1941 (North San Diego).

Baldaugh painted under the names Westrum and Von Westrum in the early years of her career and is so listed in 1915 and 1921.

Baldridge, Cyrus Leroy (1889–1975)**

B. Alton, New York. Work: Fiske University, Nashville; Boston Museum of Fine Arts; New York Public Library; National Gallery of Art. AAA 1921–1932 (Harmon-on-Hudson and New York, New York); Bénézit; Fielding; Havlice; Mallett; WWAA 1936–1947 (New York City); WWAA 1953–1962 (Santa Fe, New Mexico); "Baldridge, Roamer," *The Art Digest,* March 1, 1939, 24; "Cyrus Leroy Baldridge Cured of Wanderlust," *The Santa Fe Scene,* January 23, 1960, 4–7.

After graduating from the University of Chicago in 1911, Baldridge worked at odd jobs, including that of cow puncher. His training in art came primarily from trial, error, and experience; yet he moved from odd jobs into illustration at an early age.

Baldridge was first in New Mexico in 1926 when a friend arranged for him to stay near San Juan Pueblo. Thereafter he made regular trips to Santa Fe and to other New Mexican towns. In 1952 he moved to Santa Fe to devote full time to easel painting. Equipped with an army canteen and watercolor paints, Baldridge was a familiar sight on the nearby desert and mountain landscape.

During the years Baldridge was an illustrator, he traveled extensively and lived an unusually exciting life—good material for an autobiography. *Time and Chance* was published by John Day Company in 1947.

Balfour, Helen Johnson (1857-)

B. London, England. D. Los Angeles, California. Work: Smithsonian Institution; Society of California Pioneers. AAA 1909-1913 (Riverside, Illinois); AAA 1915-1929 (Los Angeles); Bénézit; Fielding; California State Library.

Balfour was a landscape painter and illustrator who worked in Oakland, Piedmont, and Elsinor, California, as well as Los Angeles. Some of her work appeared in *Sunset Highways.*

Balfour, Roberta (1871-)

B. Yarmouth, Nova Scotia, Canada. Work: Vancouver (British Columbia) Armory. Havlice; Mallett Supplement; WWAA 1940-1941 (Carmel, California).

Ballinger, Harry Russell (1892-)

B. Port Townsend, Washington. Work: Wadsworth Atheneum; New Britain Museum of American Art; Springfield Museum of Art; Murals, Plant High School, Hartford, Connecticut. AAA 1923-1933 (New York City); Bénézit; Fielding; Havlice; Mallett; WWAA 1936-1976 (New York City; Hartford, Connecticut); *American Artist,* June 1965, 4.

Ballinger studied art in San Francisco before moving to the East. From 1945 to 1959 he was instructor of art at Connecticut Central College.

Ballou, Addie Lucia (1837-1916)**

B. Ohio. Work: Society of California Pioneers. Oakland Art Museum; Evans; San Francisco *Chronicle,* August 15, 1916, 11/8; Reda Davis, *California Women/A Guide to Their Politics, 1885-1911,* n.d. Privately published.

Ballou, who arrived in California in 1870, became prominent in San Francisco art circles about 1879. For many years she had a studio on lower Market Street. Painting was but one of her pursuits, for she was a poet, notary public, suffragist, and a correspondent for Spiritualist publications.

From the time of the Civil War when Ballou served as nurse and regimental matron, public affairs occupied her life. Social reforms, politics, and writing appear to have been as important to her as painting, or perhaps more so.

Bankson, Glen Peyton (1890–)

B. Mount Hope, Washington. Work: Murals, First National Bank, Spokane. AAA 1921–1933 (Spokane, Washington); Havlice; Mallett; WWAA 1936–1941 (Spokane).

During the early years of Bankson's career he lived in the small town of Valley, but maintained a studio in nearby Spokane. In the late 1930s he joined the Spokane Art Association.

Barber, Mary D. (–)

B. San Francisco, California. AAA 1909–1910 (Ross, California); AAA 1913 (Bolinas, California); Bénézit; California State Library.

Barber was a landscape painter who had studied with William Keith.

Barchus, Eliza Rosanna (1857–1959)

B. Salt Lake City, Utah. Work: Bancroft Library, University of California; Crater Lake National Park; Sunnyside (Washington) Congregational Church. *Who's Who in Northwest Art;* Kovinick.

Barchus settled in Portland, Oregon, in 1880. She studied with the popular Washington and Oregon artist, William Samuel Parrott. In 1887 she won a gold medal at the Portland Mechanics Fair, and in 1905 she won another gold medal. The latter was a turning point in her career.

A widow with a family to support, Barchus found the way by marketing her romantic scenes, painted from memory, imagination, and occasionally from photographs and written descriptions. Scenes of such remarkable sights as Yellowstone, Yosemite, and Mount Hood were much in vogue. Many of them came from Barchus's Portland studio, and some were purchased by such prominent persons as Woodrow Wilson, William Jennings Bryan, and Theodore Roosevelt.

Barfoot, Dorothy (1896–)

B. Decorah, Iowa. Havlice; Mallett Supplement; WWAA 1938–1966 (Manhattan, Kansas; summer: Decorah).

This painter and printmaker was for many years head of the art department of Kansas State University.

Barnett, Jay W. (1897-1959)

B. Rockville, Missouri. D. Hot Springs, South Dakota, October 27. Work: Adams Memorial Hall Museum, Deadwood, South Dakota; Friends of Middle Border Museum, Mitchell, South Dakota. Stuart.

Barnett received his training at the Veterans Administration Center in Hot Springs and by correspondence with Famous Artists' School of Westport, Connecticut.

Barney, Alice Pike (1857-1931)

B. Cincinnati, Ohio. D. Los Angeles, California, October 12. Work: National Collection of Fine Arts. AAA 1898-1927 (Washington, D.C.); AAA 1931;* Bénézit; Fielding; Mallett; WWWA (Hollywood, California, and Washington, D.C.).

Barney, Esther Stevens (See: Stevens, Esther)

Barnouw, Adriaan Jacob (1877-1968)

B. Amsterdam, Holland. D. September 27. Havlice; WWAA 1947-1956 (New York City); WWWA; Luhan.

Barnouw was a historian who also was active as a painter. According to Mable Dodge Luhan he had several solo exhibitions in Amsterdam and New York City and was represented in the Metropolitan Museum of Art. He was briefly in Taos, New Mexico, where he did some paintings of Indian life and Taos Valley.

Barns, Cornelia (1888-)

B. New York City. AAA 1917-1931 (Morgan Hill, California); AAA 1933 (Berkeley, California); Fielding; Mallett.

Barns studied with Twachtman and Chase in New York City. During the early years of her career she was listed as an illustrator for the *Liberator,* working under the name Cornelia Barns Garbett.

Barrows, Albert (1893-)

B. San Francisco, California. AAA 1925 (Monterey, California); California State Library.

Barrows, who studied with Armin Hansen, was known for

his atmospheric landscape paintings. Besides Monterey, he worked in San Francisco, Berkeley, and Los Angeles.

Bartnett, Frances Griffiths (1861–)
B. Des Moines, Iowa. California State Library.
Bartnett studied with William Keith, and in Paris and Rome. In California she lived in San Francisco and Mill Valley where she was better known for her sculpture.

Basinet, Victor Hugh (1899–)
B. Providence, Rhode Island. Work: National Collection of Fine Arts; University of Southern California. Havlice; Mallett Supplement; WWAA 1938–1941 (Los Angeles, California; summer: Monterey, California).

Bateman, Talbot (–)
AAA 1915 (Dallas, Texas). At that time Bateman worked for the Dallas *News*.

Baumgartner, John Jay (1865–1946)
B. Milwaukee, Wisconsin. D. San Francisco, California, October 18. Work: Oakland Museum, California State Library.
Baumgartner was a self-taught artist who lived in San Francisco and Menlo Park, California. In 1892 he received a gold medal for work exhibited in the Milwaukee Exposition.

Baxley, Ellen Cooper (1860–)
B. Lancaster County, Pennsylvania. Work: "Gaviota Pass," Court House, Santa Barbara. AAA 1931–1933 (Santa Barbara, California); Mallett; California State Library.
Baxley studied art in San Francisco, New York City, and in Paris, France.

Baze, Willi (1896–1947)
B. Mason, Texas. Work: Murals, First Christian Church and First Baptist Church, Chickasha. AAA 1933 (Oklahoma City, Oklahoma); Havlice; Mallett; WWAA 1936–1941 (Chickasha, Oklahoma); WWAA 1953.*

This artist, who taught Kiowa Indian students from 1922 to 1927, was known also as Mrs. Lane and later as Mrs. Pond.

Beach, D. Antoinette (–)
 AAA 1909-1910 (Redfield, South Dakota).

Beall, Cecil Calvert [Ted])1892–)
 B. Saratoga, Wyoming. Work: Air Force Academy, Colorado Springs, Colorado; Marine Museum, Quantico, Virginia. Havlice; Mallett; WWAA 1936-1947 (Valhalla and Larchmont, New York; Wilton, Connecticut); WWAA 1956-1962 (New Rochelle, New York); "C.C. Beall Creates a New Technique," *American Artist*, January 1968, 30-31, 37.

Beecher, Harriet Foster (1854–1915)
 B. Indiana. Work: Henry Gallery, University of Washington; Bancroft Library, University of California. Panama-Pacific I.E. Catalog; Kovinick.
 Beecher, who opened a studio in Seattle in 1881, was a far better-known artist than her absence from standard art directories indicates. And she was among the few women artists selected to serve on the Panama-Pacific International Exposition's Advisory Committee for the West. Of particular interest now are her paintings of Challam and Makah Indian life at Port Townsend and her portraits of Washington pioneers.

Beggs, Thomas Montague (1899–)
 B. Brooklyn, New York. Work: Redlands (California) University; Pacific Building, Miami, Florida. AAA 1933 (Claremont, California); Havlice; Mallett; WWAA 1936-1947 (Claremont); WWAA 1953-1976 (McLean, Virginia).
 Beggs headed the art department at Pomona College from 1926 to 1947. Since then he has been with the Smithsonian Institution in Washington, D.C.

Behman, Frederick (–)
 Work: National Archives, Washington, D.C. Stuart; John C. Ewers, "Folk Art in the Fur Trade of the Upper Missouri," *Prologue/The Journal of the National Archives,*

Summer 1972, 99–108; reproduction in color, page 103.

Beiler, (Ida) Zoe (1884–1969)
B. Lima, Ohio. Work: Fine Arts Club, Fargo, North Dakota; North Dakota State Teachers College, Mayville; North Dakota State University; North Dakota State Teachers College, Dickinson; Capitol Building, Bismarck; IBM. Havlice; WWAA 1947–1962 (Dickinson, North Dakota).

Beiler, who taught art at the State College in Dickinson for over 20 years, retired in 1953 to teach privately. She exhibited widely for more than three decades, becoming one of the best-known artists of the Dakota region. A number of her landscapes are of the North Dakota Badlands.

Bell, Blanche Browne (1881–)
B. Helena, Texas. Work: Murals, Robert E. Green Hospital, San Antonio. AAA 1931–1933 (San Antonio, Texas); Havlice; Mallett; WWAA 1936–1941 (San Antonio).

Bell, Thomas Sloan (–)
AAA 1898–1900 (Arvada, Colorado); Bénézit; Bromwell.

According to a clipping in Bromwell's Scrapbook, page 6, Bell had returned from California in November 1895, and was exhibiting a marine scene at the Denver Artists' Club annual fall exhibition. Another clipping, page 12, refers to a painting of his in the fifth annual exhibition of the club in April 1898.

Belmont, Steven (1899–)
B. Budapest, Hungary. California State Library.

Belmont, who lived in Fontana and Los Angeles, California, was a landscape painter. He was active until 1968 when a serious accident forced him to curtail his painting.

Bemus, Mary B. (1849–1944)
B. Leicester, New York. AAA 1907–1913 (Wyoming County and Perry, New York); AAA 1915–1929 (Laguna Beach, Los Angeles and Santa Barbara, California; summer: Owensmouth, California); Bénézit; Fielding; Mallett.

Bemus, who was a member of the Laguna Beach Art Asso-

ciation, lived in Laguna Beach for several years during the early 1920s.

Bendle, Robert (1867–)
B. Carlisle, England. California State Library. Bendle, who studied art in England, was a resident of Oakland, California.

Benedict, Frank M. (1840–1930)
AAA 1909–1910 (Lawrence, Kansas); Mallett.

Benedict, J. B. (–)
AAA 1913–1915 (Denver, Colorado); Fielding.
Benedict was a member of the Denver Artist's Club. In 1922 he exhibited a watercolor landscape at Pennsylvania Academy of Fine Arts.

Benjamin, Charles Henry (1856–1937)
B. Patten, Maine. AAA 1923–1931 (Altadena, California); Havlice; Mallett Supplement; WWAA 1936–1937 (Washington, D.C.); WWWA (Lafayette, Indiana); California State Library.
This self-taught artist was a professor of mechanical engineering at Purdue University. He painted in New England, Virginia, the Rocky Mountains, New Mexico, California, Canada, and England.

Bennett, Joseph Hastings (1889–)
B. San Diego, California. Work: California State Library. Havlice; Mallett Supplement; WWAA 1936–1941 (Piedmont, California).

Bennett, Ruth Manerva (1899–1960)
B. Momence, Illinois. D. Los Angeles, California, July 21. Work: Twelve woodcuts published by the University of Washington in 1927. AAA 1929–1933 (Hollywood, California); Havlice; Mallett; WWAA 1936–1959 (Hollywood).

Benolken, Leonore Ethel (1896–)
B. Saskatchewan, Canada. Work: Blanden Memorial

23

Gallery, Fort Dodge, Iowa; Auditorium, Fremont, Nebraska; Belleview (Nebraska) High School. Havlice; Mallett; WWAA 1940-1941 (Omaha, Nebraska).

Benrimo, Thomas Duncan (1887-1958)
B. San Francisco, California. Work: Cincinnati Art Museum. Mallett Supplement (Larchmont, New York); Fisher; Luhan; Museum of New Mexico, Santa Fe.

Benrimo, who lived in Taos, New Mexico, from 1939 to 1958, is known primarily for his surrealist and imaginative paintings.

Bensco, Charles J. (1894-1960)
B. Turchok, Hungary. D. Phoenix, Arizona. Work: Gardena (California) High School; Fine Arts and Crafts Museum, Budapest; First Federal Savings and Loan Association, Phoeniz; Westward Ho Hotel, Phoenix. Havlice; Mallett Supplement; WWAA 1936-1941 (Hollywood and Los Angeles, California); WWAA 1953-1959 (Phoenix, Arizona).

Bentley, Rachel (1894-)
B. Stoughton, Wisconsin. Work: Menlo Park (California) City collection.

Bentley did not begin painting until the early 1950s. With a particular interest in old buildings, she set out to paint them before they disappeared from the scene. About a hundred Northern California country schools have come under her brush as well as many other picturesque buildings.

As Bentley's reputation grew, she found she was doing paintings by special request. Menlo Park's charming railway station proved to be especially popular.

Benton, Thomas Hart (1889-1975)**
B. Neosho, Missouri. D. January 19. Work: Metropolitan Museum of Art; Museum of Modern Art; Whitney Museum of American Art; Brooklyn Museum; Murals, State Capitol, Jefferson, Missouri; Indiana State University; Harry Truman Library. AAA 1921-1933 (New York City); Bénézit; Fielding; Havlice; Mallett; WWAA

1936-1973 (Kansas City, Missouri); WWWA; Thomas
Hart Benton, *An Artist in America*, New York: Robert M.
McBride & Company, 1937; George Michael Cohan,
"Thomas Hart Benton/A discussion of his lithographs,"
American Artist, September 1962, 22-25, 74-77; M. Barr.

From 1924 to 1937, alone or with a student, Benton trav-
eled through the rural area of this country. By foot, river boat, or
automobile he sought first-hand contact with miners, farmers,
cowboys, and ranchers.

In 1930 Benton was in Wyoming, living a month or more
with cowboys. He watched them perform at rodeos, and he
watched them while they worked.

Much of life as it was lived in the West at that time came
under Benton's scrutiny during his travels. His experiences are
related and illustrated in *An Artist in America*.

Bergquist, F. O. (1890-1968)
B. Ashland, Wisconsin. D. Albuquerque, New Mexico,
April 2. Work: Brown-Bigelow. Albuquerque Public Li-
brary.

Bergquist was a commercial artist and teacher who moved
to Albuquerque in 1928. He painted a number of calendar sub-
jects for Brown-Bigelow.

Berlin, Harry (1886-)
B. New York City. Work: Santa Fe Collection. AAA 1913-
1915 (New York City); Bénézit; Mallett.

Berlin painted and exhibited in the Santa Fe-Taos area in
1915.

Berman, Eugene (1899-1972)
B. St. Petersburg, Russia. D. December 14. Work: Muse-
um of Modern Art; Metropolitan Museum of Art; Art In-
stitute of Chicago; Denver Museum of Art; Boston Muse-
um of Fine Arts; University of Nebraska; Santa Barbara
Museum of Art; Los Angeles Museum of Art. Bénézit;
Havlice; Mallett; WWAA 1940-1970 (New York City);
WWWA. Berman also lived briefly in Hollywood.

Berson, Adolph (1880-1970)
B. San Francisco, California. AAA 1913 (Paris, France);

AAA 1919-1925 (San Francisco); Bénézit; Fielding; Kerwin Galleries; San Francisco Public Library; Alexander Fried, "Berson Wields Brush to Express Feeling," San Francisco *Chronicle*, August 23, 1931; Harry Hammond, Jr., "Revolution in Art Seen by S. F. Painter," San Francisco *Call & Post*, April 21, 1927.

Berson's initial success was in Paris where he spent the early years of his career. An invitation to exhibit at Carnegie Institute brought recognition in this country. In San Francisco, art critics were particularly enthusiastic about Berson's old Missions and other landmarks. Hammond described his canvases as "luminous, sun bathed and done after the Oriental manner."

Some years later Berson's work fell from favor, for he was not of the futuristic school, nor was he a conservative. Not until the 1970s, largely through the efforts of Mr. and Mrs. Richard Kerwin, did his work re-emerge in the San Francisco area.

Bessel, Evelyn Byers (–)
B. Houston, Texas. AAA 1923-1924 (Houston); Fielding; Havlice; WWAA 1940-1941 (Houston); O'Brien.

Bessel, who exhibited as Evelyn Byers during the early years of her career, was instructor in drawing and painting at the Houston Museum School of Art.

Bessinger, Frederic Herbert (1886–)
B. Kansas City, Missouri. Havlice; Mallett Supplement; WWAA 1938-1941 (Santa Monica, California).

Best, Mrs. A. W. (–)
AAA 1909-1917 (San Francicso, California).

Mrs. Best was associated with Best Art School of San Francisco, founded by her husband Arthur.

Best, Arthur William (1859-1935)**
B. Canada. Work: Oakland Museum; Phoenix Art Museum; Museum of Art, University of Oregon; Charles M. Russell Gallery, Great Falls, Montana; Santa Fe Industries, Inc. AAA 1909-1917 (San Francisco, California); Bénézit; California State Library; San Francisco *Chronicle*, September 19, 1904, 10/1.

Arthur and his brother Harry were fond of painting the brilliant desert landscapes of Arizona, as well as the mountains of the High Sierras. A series of Arthur's Grand Canyon scenes was exhibited in 1904, and reviewed by the San Francisco *Chronicle*. He also did many Southwestern Indian paintings. Some of Best's work was destroyed in the San Francisco earthquake and fire of April 1906.

Best, Harry Cassie (1863–1936)**
B. Peterborough, Canada. D. San Francisco, California, October 14. Work: St. Mary's College; Yosemite National Park. AAA 1909–1910 (San Francisco); AAA 1933 (Yosemite National Park, California); Havlice; Mallett; WWAA 1936–1937 (Yosemite); Elizabeth H. Godfrey in *Yosemite Nature Notes,* March 1945, 42–44; George Wharton James in *Out West,* January 1914, 3–16.

The tale has been told of how Best's first glimpse of Mt. Hood changed him from a largely self-taught musician to a largely self-taught painter. It is said that he went directly to Portland after viewing the splendor of Mt. Hood and there purchased art supplies.

During Best's first years in San Francisco he worked as a cartoonist. Following a sketching trip to Yosemite Valley with the artist Thaddeus Welch, he determined to be married there and if possible to live there. The marriage took place at the foot of Bridalveil Falls on July 28, 1901.

Best obtained a concession to build a studio in the Valley, and there produced hundreds of paintings of the Park. In winter months he was likely to be found in warmer climates such as Arizona and Southern California, Hawaii where he went in 1916 and 1920, or Italy where he went in 1908. His work came to the attention of Teddy Roosevelt who acquired "Evening at Mt. Shasta," and Franklin K. Lane (later Secretary of the Interior) who acquired "Afterglow on Half Dome."

Best, Margaret Callahan (1895–)
B. Arima, Japan. Havlice; Mallett Supplement; WWAA 1940–1941 (Houston, Texas).

Betts, Grace May (1883–)
B. New York City. AAA 1905–1915 (Chicago, Illinois);

Bénézit; Mallett.

Betts specialized in Arizona, New Mexico, and California landscapes and Indian subjects during the early years of her career.

Bewley, Murray Percival (1884-)

B. Fort Worth, Texas. Work: Pennsylvania Academy of Fine Arts; Dayton Art Institute; Fort Worth Art Center; Industrial Archives, New York. AAA 1909-1915 (Paris, France); AAA 1917 (Fort Worth); AAA 1919-1933 (New York City); Bénézit; Fielding; Havlice; Mallett; WWAA 1936-1941 (New York City); WWAA 1947-1953 (Hollywood, California); O'Brien.

Bewley, who is best known for his portraits of children, specialized in portrait and figure painting in oil. He probably did some landscape work in Denver when he studied with Henry Read.

Among Bewley's teachers was William Merritt Chase who advised him to open a studio in Paris. It was not a successful venture, but his studio in New York was. Within a few years he established a summer home in Mystic, Connecticut.

Bierach, S. E. (1872-)

B. Jersey City, New Jersey. AAA 1905-1906 (South Pasadena, California); AAA 1907-1910 (Brooklyn, New York); Bénézit.

Billing, Frederick William (1835-1914)

B. Germany. D. Santa Cruz, California. Work: Smithsonian Institution. California State Library; Oakland Art Museum; Sacramento *Bee,* September 11, 1966, A8/3.

Billing's Western paintings were discovered and exhibited in 1966. He had begun working in California in 1895. Among his paintings are some of the Ben Lomond area near Santa Cruz. A painting entitled "Grand Canyon of the Yellowstone," at National Collection of Fine Arts, indicates he collaborated with Thomas and Peter Moran in its completion.

Bintliff, Martha Bradshaw (1869-)

B. Superior, Wisconsin. AAA 1905-1906 (Norfolk,

Virginia); AAA 1917-1919 (San Diego and La Jolla, California); AAA 1921-1933 (La Jolla); Bénézit; Havlice; Mallett; WWAA 1936-1941 (La Jolla).

Bishop, Katherine Bell (1883-)
B. Los Angeles, California. AAA 1913 (San Francisco, California); California State Library.
Bishop studied with Will Sparks, Arthur F. Mathews, and others.

Black, Mary C. Winslow (1873-1943)
B. Poughkeepsie, New York. D. Monterey, California, December 4. Work: Seattle Art Museum; Santa Cruz Art Club; Officers' Club, Presidio of Monterey. AAA 1919-1921 (Santa Barbara, California); AAA 1923-1933 (Monterey, California; summer: Hammil's Point, Muskoka, Canada); Bénézit; Fielding; Havlice; Mallett; WWAA 1936-1941 (Monterey).

Black, Oswald Ragan [Oz] (1898-)
B. Neoga, Illinois. Havlice; Mallett; WWAA 1936-1941 (Lincoln, Nebraska); WWAA 1947-1956 (Minneapolis and Excelsior, Minnesota); WWAA 1959-1962 (Denver, Colorado).

Blackburn, Josephine Eckler (1873-)
B. San Francisco, California. AAA 1909-1913 (San Francisco); California State Library.
Blackburn also lived in Soulsbyville, California. She exhibited in Sacramento where she received several prizes.

Blackshear, Kathleen (1897-)
B. Navasota, Texas. Work: Houston Museum of Fine Arts. AAA 1931-1933 (Chicago, Illinois); Havlice; Mallett; WWAA 1936-1959 (Chicago); 1962-1966 (Navasota); O'Brien.
During the years Blackshear taught history of art, composition, and lettering at the Chicago Art Institute from 1926 to 1961, she spent summers with her family in Navasota. From there she made sketching trips to Arizona, New Mexico, Mexico, and other parts of Texas.

Blackstone, Harriet (1864–1939)

B. New Hartford, New York. D. New York, March 16. Work: M. H. De Young Memorial Museum; Brooklyn Museum; Layton Art Gallery, Milwaukee; Vincennes Art Association; National Gallery of Art. AAA 1907–1919 (Glencoe, Illinois); AAA 1921–1933 (New York City); Bénézit; Fielding; Havlice; Mallett; WWAA 1936–1939 (New York City); *The Art Digest,* April 1, 1939, 21.

Blackstone was active in the Santa Fe–Taos art movement in 1918.

Blaine, Mahlon (–)

AAA 1917 (San Francisco, California); Mallett Supplement (New York).

Blakeman, Thomas Greenleaf (1887–)

B. Orange, New Jersey. Work: Minneapolis Institute of Art; New York Public Library; New York Bar Association; Harvard University; Duke University; Boston Public Library; Wood Gallery, Montpelier, Vermont. AAA 1929 (Gloucester County, Virginia); AAA 1931–1932 (Provincetown, Massachusetts); Havlice; Mallett; WWAA 1936–1941 (North Truro, Massachusetts; summer: Melville, Sweetgrass County, Montana); "Artist-Rancher Shows Prints," *The Art Digest,* December 1, 1932, 21.

Blakeman roamed the West from the time he was 20, and eventually acquired a cattle ranch in Montana. After the First World War he gave it up and settled in Virginia. During the 1930s and early 1940s he spent summers in Montana. The etchings he exhibited at Grand Central Galleries in 1932 were inspired by his Western experience.

Blakiston, Duncan George (1869–)

B. London, England. California State Library.

This self-taught artist worked on the San Francisco *Examiner,* and did illustrations for *The Overland Monthly.* He lived in San Francisco and also in San Diego.

Blashfield, Edwin Howland (1848–1936)

B. New York City. D. South Dennis, Massachusetts, Oc-

tober 12. Work: Metropolitan Museum of Art; State Capitol, Madison, Wisconsin; State Capitol, St. Paul, Minnesota; Library of Congress; Detroit (Michigan) Public Library. AAA 1898-1933 (New York City); Bénézit; Fielding; Mallett; WWWA; Garnier; Stuart.

Blashfield's murals are in many public buildings. He was in South Dakota probably about 1910 when he painted "The Spirit of the People." In 1912, his *Mural Painting in America* was published.

Bleil, Charles George (1893-)
B. San Francisco, California. AAA 1919-1933 (San Mateo and San Francisco, California; summer: Monterey, California); Bénézit; Fielding; Havlice; Mallett; WWAA 1936-1953 (San Francisco). Bleil's specialty was landscapes.

Blesch, Rudolph (-)
AAA 1917 (Oklahoma City, Oklahoma).

Bloser, Florence Parker (1889-1935)
B. Los Angeles, California. D. Los Angeles, September 20. AAA 1925-1933 (Los Angeles); Havlice; Mallett; WWAA 1936-1941 (Los Angeles). Bloser specialized in Southern California landscapes.

Blumenstiel, Helen Alpiner (1899-)
B. Rochester, New York. Havlice; Mallett Supplement; WWAA 1938-1941 (New York); WWAA 1947-1953 (Salem, Oregon).

Boak, Milvia W. (1897-)
B. Oakland, California. Havlice; Mallett Supplement; WWAA 1940-1941 (San Francisco, California).

Bock, Charles Peter (1872-)
B. Germany. Work: "Where Sand and Water Meet," Dallas Public Library. AAA 1915-1921 (Manuel, Texas); Bénézit; Fielding; Mallett.

The Bulletin of the Chicago Art Institute, where Bock was a student, commented in its January 1910 issue that Bock's

sketches showed the "color effects of the plains country."

Boething, Marjory Adele (1896–)
B. Glendale, California. Havlice; Mallett Supplement; WWAA 1936–1941 (Glendale).

Bohlman/Bohleman, Herman T. (1872–)
B. Portland, Oregon. Work: Portland City Hall. AAA 1931–1933 (Portland); Havlice; Mallett; WWAA 1936–1941 (Portland; summer: Manzanita, Oregon); *Who's Who in Northwest Art.*

Bolmar, Carl/Charles Pierce (1874–1950)
B. Topeka, Kansas. D. Topeka, August 14. AAA 1925–1933 (Topeka); Havlice; Mallett; WWAA 1936–1953 (Topeka); Topeka Public Library.

As an early painter of Kansas scenes, an illustrator of Western books, an art critic, and a cartoonist, Bolmar made a particularly significant contribution to his native state. Among the books he illustrated were several by Margaret Hill McCarter and one by Frank Albert Root. The latter, entitled *Overland Stage to California,* is the account of George Root, a Western pioneer who recorded his experiences and observations during his travels. Steeped as Bolmar was in Western lore, he was well qualified to illustrate this book.

Bolmar was staff artist for the *State Journal* in Topeka, a position he held for forty years. During part of that time he conducted a column called "Gleanings from the Field of Art."

A man of various interests, Bolmar strove for perfection in whatever he undertook. A typical remark when complimented on a painting was, "I wish I could have done it better."

Bolton, Hale William (1885–1920)**
B. Honey Grove, Texas. D. Dallas, Texas. AAA 1915–1920* (Dallas); Bénézit; Mallett; *American Art News,* October 30, 1920, 4; O'Brien.

References differ as to the year and place of birth for Bolton. Whether it was Honey Grove in 1885 or Fredericksburg, Iowa, in 1879, as given by *American Art News,* is not so important as his contribution to art in so short a lifetime.

Bolton is best known for Western landscapes, the subject of his choice. He also painted in Europe.

Bolton had begun spending summers in Los Angeles about 1917 and had done excellent work along the Coastal range. Following his death, the California Society of Art awarded him its grand prize.

According to O'Brien, Bolton's best work was in oil. His training had been extensive, and he had exhibited successfully in the South, East, and West.

Bonestell, Chesley (1888–)

B. San Francisco, California. *Who's Who in California;* Paul Johnson, *The Golden Era of the Missions 1769–1834/ Paintings by Chesley Bonestell,* San Francisco: Chronicle Books, 1974.

Bonestell worked as a designer and artist in Hollywood before moving to Carmel, California.

Bonner, Mary (1885–1935)**

B. Bastrop, Louisiana. D. San Antonio, Texas, June 26. Work: New York Public Library; Luxembourg Museum, Paris; British Museum, London. AAA 1931–1933 (San Antonio, Texas; summer: Paris, France); Bénézit; Havlice; Mallett; WWAA 1936–1937;* O'Brien.

Bonner, who achieved fame on two continents with her etchings, is considered one of the most original interpreters of the cowboy-and-cattle West. Her friezes depicting this life were enthusiastically received from the time they were first exhibited in Europe in 1925. Several were purchased by the British Museum and the French government, the latter awarding her the much coveted *Palmes Academique.*

Even the borders of Bonner's friezes were unusual. One French critic characterized her display of "rattlesnakes and bats, game roosters and horned frogs" as "the only absolutely new motif in design since the Italian Renaissance."

Bonner did not become interested in printmaking until 1922. Upon consulting a lithographer about that technique, she was advised to try etching, for he felt the physical endurance required for lithography might be too strenuous. Heeding his advice, Bonner returned to Paris where she studied with Edouard

Leon. The excellence of her etchings brought instant recognition and soon placed her among the internationally known artists of this century.

Bonnet, Leon Durand (1868–1936)
B. Philadelphia, Pennsylvania. D. San Diego, California, June 22. AAA 1921–1925 (New York City); AAA 1931–1933 (Bonita, California; summer: Ogunquit, Maine); Havlice; Mallett; WWAA 1936–1937; *The Art Digest,* June 1929, 12.

Bontecou, Helen (1892–)
B. Kansas City, Missouri. California State Library; Sacramento *Bee,* May 5, 1958, D-1/1.
Bontecou lived in San Francisco, where she studied art, and also in Palo Alto, Nevada City, and Grass Valley, California.

Boone, Cora M. (1871–)
B. St. Louis, Missouri. AAA 1919–1924 (Oakland, California); Fielding; Mallett Supplement; California State Library.
Boone, who studied in London, Paris, and San Francisco, was known locally for her paintings of flowers and elm trees in water color. In 1922 she exhibited a water color at the Pennsylvania Academy of Fine Arts. Besides Oakland and San Francisco, she lived in Danville and Benecia, California.

Booth, Eunice Ellenetta (–1942)
B. Goshen, New Hampshire. D. Massachusetts, November 12. AAA 1925–1933 (Stockton, California; summer: Norton, Massachusetts); Havlice; Mallett; WWAA 1936–1941 (Stockton); California State Library.
Booth, who specialized in landscapes, was professor of drawing and painting at the College of the Pacific. She was also an art critic and a writer. During the early years of her career she lived for short periods in Napa, San Francisco, and San Jose, California.

Borghi, Lillian Lewis (1899–)
B. Pueblo, Colorado. Havlice; WWAA 1947–1953 (Sparks, Nevada).

Borghi was also a writer and critic who worked on the
Reno *Evening Gazette* from 1938 to 1945.

Born, Ernest Alexander (1898–)
B. San Francisco, California. AAA 1933 (New York City;
San Francisco); Bénézit; Havlice; Mallett; WWAA 1936–
1941 (New York City).

Borzo, Karel (1888–)
B. Hertogenbosch, Holland. AAA 1921–1933 (Seattle,
Washington); Havlice; Mallett; WWAA 1940–1953 (Seat-
tle); *Who's Who in Northwest Art.*

Boswell, Leslie Alfred (1894–)
B. Providence, Rhode Island. Fisher.
Boswell lived in Taos, New Mexico, where he was active
until at least 1947.

Boswell, Norman Gould (1882–)
B. Halifax, Nova Scotia, Canada. AAA 1933 (San Jose,
California); Havlice; Mallett; WWAA 1936–1962 (San
Jose, Los Angeles, and Vallejo, California).

Bosworth, Hobart Van Zandt (1867–1943)
B. Marietta, Ohio. D. La Canada, California, December 20.
WWWA; California State Library; *Who's Who in Cali-
fornia.*
Bosworth was an actor who painted landscapes for recrea-
tion. He was self-taught, except for one month of instruction with
Charles Partridge Adams in Denver. From 1882 to 1885 and 1905
to 1910 Bosworth lived in San Francisco, Los Angeles, and Alta-
dena, California. He probably began his landscape painting dur-
ing the nine years he spent in Colorado and the Southwest at the
turn of the century when Adams was living in Denver. During
Bosworth's last years he lived in La Canada, California.

Bouzek, Cathryn (1898–)
B. Highmore, South Dakota. Stuart.
Bouzek was living in Highmore when *Index of South
Dakota Artists* was compiled in the early 1970s. There she had

taught art in junior high school, high school, and college for 25 years. During that time she exhibited at the Chicago Art Institute where she had studied, and also at Knox College in Galesburg, Illinois.

Bower, Frances (1877–)

B. near Topeka, Kansas. Albuquerque Public Library; Albuquerque *Tribune,* August 14, 1965; Denver *Post,* September 26, 1960.

Bower grew up in central Kansas where she began teaching school at age 17. She taught herself to paint, but later studied with Ted Schuyler. She exhibited primarily in New Mexico and Nebraska. In 1947 she moved to Albuquerque where she is sometimes referred to as the city's Grandma Moses, an appellation she does not enjoy. Her specialty is landscapes and flower studies.

Bowers, Beulah Sprague (1892–)

B. Everett, Massachusetts. Havlice; Mallett Supplement; WWAA 1936-1962 (Wichita Kansas; Meriden, Connecticut).

Bowles, Caroline Hutchinson (–)

AAA 1917-1924 (Pasadena, California). Bowles was a member of the California Art Club.

Bowling, Charles Taylor (1891–)

B. Quitman, Texas. Work: Southern Methodist University, Dallas. Havlice; Mallett Supplement; WWAA 1938-1941 (Dallas, Texas); O'Brien.

A professional engineer by training, Bowling taught himself to paint with some help from artists Alexander Hogue, Frank Klepper, and Olin Travis. By the late 1930s he had won prizes in water color, oil, and lithography. The subjects of his work often were old buildings, especially old houses that seemed to have shut their secrets in with their shutters. Bowling described them as showing life "on the side where the seams are."

Boyd, Byron Bennett (1887–)

B. Wichita, Kansas. AAA 1929-1933 (Des Moines, Iowa); Havlice; Mallett; WWAA 1936-1941 (Des Moines);

Denver *Post,* February 9, 1930, A10.

Boyd spent some time in Paris in 1929, and he was active at one time in Denver, for the *Post* refers to him as a Denver artist.

Boyd, W. J. (-)
AAA 1917, 1923-1924 (Oklahoma City, Oklahoma). Boyd was a member of the Oklahoma Art Association.

Boynton, Anna E. (-)
San Francisco Public Library. Boynton was active in San Francisco in 1880.

Braddock, Katherine (1870-)
B. Mt. Vernon, Ohio. Havlice; Mallett Supplement; WWAA 1936-1956 (Stockton, California).

Brady, Mary C. (-)
AAA 1909-1913 (San Francisco, California); California State Library; San Francisco Public Library.

Brasher, Rex (1869-1960)
B. Brooklyn, New York. D. February 29. Havlice; Mallett; WWAA 1940-1941 (Phoenix, Arizona), WWWA (Kent, Connecticut); "Brasher, Audubon," *The Art Digest,* December 1, 1932, 31; Denver *Post Empire Magazine,* May 10, 1964, 8-9; *Western Artist,* January 1935, 6.

Brasher was an ornithologist who turned to painting. He began exhibiting in 1933.

Breckenridge, Dorothy (1896-)
B. Tampa, Florida. Havlice; Mallett Supplement; WWAA 1938-1941 (Houston, Texas); WWAA 1962 (Dallas, Texas).

Breeze, Louisa (-)
AAA 1913 (San Francisco, California).

Brewster, Ada Augusta (-)
B. Kingston, Massachusetts. AAA 1898-1900 (New York

37

City); California State Library.

Brewster studied in San Francisco with Virgil Williams and Raymond Dabb Yelland, probably in the late 1880s. She also studied with Samuel Rouse at Lowell Institute in Boston. By 1900 she had two gold medals and a diploma and was working as a china decorator and illustrator as well as a painter and teacher. She specialized in portraits.

Breyman, Edna Cranston (-)
AAA 1913 (Portland, Oregon).

Breyman, William (-)
Groce and Wallace; Federal Writers' Project, American Guide Series: *Kansas*, 137–138.
Breyman worked in Kansas prior to the Civil War.

Brigante, Nicholas P. (1895-)
B. Padulla, Naples, Italy. Havlice; Mallett Supplement; WWAA 1936–1962 (Hollywood and Los Angeles, California).

Briggs, Annie F./Anne Frances (-)
Work: Oakland Museum. AAA 1909–1910 (Oakland, California).

Brisac, Edith Mae (1894-)
B. Walton, New York. Havlice; Mallett; WWAA 1936–1962 (Brooklyn, New York; Denton, Texas).

Brochaud, Joseph F. (-)
AAA 1909–1910 (San Francisco, California).

Brooks, Mabel H. (-1929)
B. Greenfield, Alabama. AAA 1915–1924 (Austin, Texas); O'Brien.
Brooks, who obtained her bachelor's and master's degrees at the University of Texas, remained in Austin a number of years. She exhibited locally and in New York City. According to O'Brien, Brooks's best work was her landscapes. Additional information about her can be obtained at the Carnegie Library in San Antonio.

Broughton, Charles (1861–1912)

B. Montreal, Canada. Havlice; California State Library.

Broughton studied at the Art Students' League and the National Academy of Design. In Canada he worked as a painter and an illustrator. He lived for awhile in Pasadena, California, where he painted wild flowers and landscapes.

Brougier, Rudolphe W. (c.1870–1926)

B. Switzerland. D. Santa Barbara, California, March 11. AAA 1926* (Santa Barbara); Bénézit?; Mallett. Bénézit lists Adolph Brougier, born in 1870.

Brown, Bess L. (1891–)

B. Washington, Kansas. Havlice; Mallett; WWAA 1938–1941 (Tulsa, Oklahoma).

Brown, Bolton Colt (1865–1936)

B. Dresden, New York. D. September 15. Work: Indianapolis Museum of Art; Brooklyn Institute Museum; British Museum; New York Public Library. AAA 1903–1933 (New York City and Woodstock, New York); Bénézit; Fielding; Havlice; Mallett; WWAA 1936–1937; WWWA; J. M. Bowles, "The Color Harmonies of Bolton Brown," *Arts and Decoration,* September 1911, 439–441.

By the time Brown was 21 he had done so many drawings that he felt compelled to destroy some 10,000 studies of nature just to get them out of his way. So strong was Brown's conviction that the practice of drawing was absolutely essential to the development of art that it took considerable urging by his friends to turn him to the practice of using color. Beginning in the late 1890s, Brown applied the same perseverance to that medium, and in 1915 published *The Painter's Pallette.*

In 1924 Brown published *Lithography,* another scholarly work based on intensive study and experimentation.

Brown was early in California where he organized the art department at Stanford University in 1894 and remained as professor of art until 1902. Many of his paintings and lithographs are of California scenes.

Brown, Dayton Reginald Eugene (1895–)

B. Chicago, Illinois. California State Library.

Brown was a painter, sculptor, etcher, and teacher who lived in Van Nuys and other cities in the Los Angeles area. He specialized in portraits.

Brown, Frances Sager Norton (1875–)
B. Chicago, Illinois. California State Library.
Brown was a landscape and portrait painter who lived in Palo Alto, California.

Brown, Grafton Tyler (1841–1918)**
B. Harrisburg, Pennsylvania. D. St. Peter, Minnesota. Work: Evansville (Indiana) Museum of Arts and Science; Oakland Art Museum. Groce & Wallace; Havlice; Mallett Supplement; Harper, 1970; Cederholm; T. W. Patterson, "Grafton Tyler Brown/Black Artist of the West," *Canadian Illustrated News,* June 1976; "History Revived in Book," *The Country Almanac,* December 18, 1974, 1–2, published in Woodside, California; *Art in America,* September-October, 1969, 109.

California's first Black artist of note settled in San Francisco about 1861, worked for lithographers Kuchel & Dresel, and in 1872 established his own lithographic business. It was G. T. Brown & Company who first printed *The Illustrated History of San Mateo County,* and it was Brown who drew most of the pictures it contains.

In 1882 Brown undertook an assignment with the Canadian geological survey, stopping en route at Victoria, British Columbia. Upon completion of the season's work, Brown returned to Victoria where he painted landscapes. Newspaper accounts were most enthusiastic, commenting upon their being "correct portraits, as well as good paintings."

From Victoria, Brown moved on down to Tacoma and then to Portland, painting Mount Tacoma, Mount Ranier, and other scenic sights. Apparently eastward bound, Brown painted Grand Canyon of the Yellowstone from Hayden Point.

Brown's last 25 years were spent in St. Peter, Minnesota, where he was a draughtsman in the city's civil engineering department.

Brown, John Wallace (1850–)
B. Dundee, Scotland. California State Library.

Brown, who had studied in England and Holland, lived for awhile in Alameda and other California cities.

Brown, Thomas Austen [Tom] (1859–1924)
B. Edinburgh, Scotland. D. San Antonio, Texas, June 9. Work: Witte Memorial Museum. AAA 1913–1915 (San Antonio); Bénézit; Mallett; Waters.

Brown, who was a landscape and genre painter, exhibited at the Royal Academy from 1885. He exhibited widely in this country and in Europe, and his work is in many public collections, according to Waters.

Browne, Carl Albert/Charles (–)
California State Library; Evans; Society of California Pioneers, San Francisco.

According to Evans's compilation of early artists in California, Browne was an artist and illustrator who lived in Los Angeles from 1888 to 1906.

Browne, Lewis (1897–1949)
B. London, England. D. January 3. AAA 1927–1932 (New York City; summer: Westport, Connecticut); Havlice; Mallett Supplement; WWAA 1936–1941 (New York City and Santa Monica, California); WWWA.

Browning, Amzie Dee (Mr.) (1892–)
B. Kent, Washington. AAA 1923–1933 (Tacoma, Washington); Havlice; Mallett; WWAA 1938–1941 (Tacoma).

Bruce, Edward (1879–1943)
B. Dover Plains, New York. D. Hollywood, Florida, January 26. Work: National Collection of Fine Arts; Luxembourg Gallery, Paris; Phillips Memorial Gallery, Washington, D.C. AAA 1929–1933 (New York City); Bénézit; Fielding; Havlice; Mallett; WWAA 1936–1941 (Washington, D.C.); WWWA; William Ayreshire, "The Diversity of Edward Bruce's Art," *International Studio,* December 1927, 57–62; *Art News,* December 1, 1934, 8; Garnier.

In the early 1920s Bruce abandoned his career as lawyer and promoter of big business in China to realize a life-long ambi-

tion to paint professionally. Following study in Italy he exhibited in this country, achieving considerable recognition by 1927.

Thoroughly familiar with the art of China where his job had kept him for extended periods, Bruce reflects in his paintings that influence, combined with his own fresh approach. His landscapes of West Coast scenes in the Carmel and Santa Barbara vicinities were said by Ayreshire to demonstrate his ability to convey atmospheric conditions and to show the geologic structure of the terrain—a "geotectonic sense," Ayreshire called it.

Brumback, Louise Upton (1872–1929)
B. Rochester, New York. D. Gloucester, Massachusetts, February 22. Work: Joslyn Art Museum; Memorial Gallery, Rochester, New York; Brooklyn Museum; Newark Museum. AAA 1913–1927 (Kansas City, Missouri; New York City; Gloucester); Fielding; Mallett; Effie Seachrest, "Louise Upton Brumback," *American Magazine of Art*, July 1919, 336–337.

Prior to Seachrest's article, Brumback had been painting in California.

Brunet, Adele Laure (1879–)
B. Austin, Texas. Work: Murals, Newman Club Hall, Austin; Dallas Women's Forum; Parkland Hospital, Dallas. AAA 1931–1933 (Dallas, Texas); Bénézit; Havlice; Mallett; WWAA 1936–1962; O'Brien, *The Art Digest,* July 1928, 17.

Although Brunet had the distinction of receiving her first award at the age of seven when she won a silver medal for drawing, her career got off to a late start. Stranded in New York when the ship that was to take her to Paris for further study was turned back because the First World War was on, Brunet had to meet the high cost of living with regular employment. For the next 13 years she worked in the field of costume design. During spare time she designed bookcovers and prepared advertising material. With her savings she enrolled at the Art Students' League.

Brunet returned to Texas in the late 1920s. In Dallas she was active many years in painting, illustrating, and teaching. During the summer of 1928 she taught at the Texas Artists'

Camp at Christoval, and in the 1930s at the Texas Artists' Colony in San Angelo. She exhibited in this country and abroad.

Bryan, William Edward (1876-)
B. Iredell, Texas. AAA 1903-1927 (Dublin, Texas); Mallett; O'Brien.

Bryan studied at Baylor University and Cincinnati Art Academy. Three of his four years at the Academy were with Frank Duveneck, and it was there that he won the Longworth Traveling Scholarship worth $1500 at that time, and a home scholarship worth $350. In Paris, where Bryan was from 1905 to 1907, he studied at Julien and Colorossi academies, won several prizes, and exhibited at the Louvre.

From 1907 to 1909 Bryan was professor of art at Cincinnati Art Academy which he had to leave because of ill health. He returned to Dublin to rest and to salvage what he could of an exceptionally promising career. That he accomplished as much as he did deserves attention, for he earned recognition in the Southwest with the landscape and figure paintings he continued to do during the next 20 years or more.

Bryant, Everett Lloyd (1864-1945)
B. Galion, Ohio. D. Los Angeles, California, September 7. Work: Pennsylvania Academy of Fine Arts; Baltimore Museum of Art; St. Paul Institute. AAA 1907-1929 (Hendricks, Pennsylvania; Baltimore, Maryland); AAA 1931-1933 (Los Angeles); Bénézit; Fielding; Havlice; Mallett; WWAA 1936-1941 (Los Angeles).

Bryson, Hope Mercereau (1877-1944)
B. St. Louis, Missouri. D. New York City, March 23. AAA 1931-1933 (San Diego, California); Havlice; Mallett; WWAA 1936-1941 (San Diego; New York City); California State Library. Bryson specialized in portraits and landscapes.

Buchanan, Ella (See: Vysekal, Luvena Buchanan)

Buck, Margaret Warriner (1857-)
B. New York. California State Library.

Buck was an illustrator who lived in San Rafael, San Francisco, Berkeley, and Redlands, California. She studied at the Mark Hopkins Art School in San Francisco and at Yale Art School.

Bufano, Beniamino Benvinuto [Benny] (1898-1970)
B. San-Fele, Italy. D. San Francisco, California, August 18. AAA 1913 (New York City); Bénézit; Havlice; Mallett; WWAA 1938-1962 (San Francisco).

Bull, W. H. (-)
AAA 1921 (San Mateo, California); California State Library; *Sunset* Magazine, November 1915, 843-844.
Bull, who specialized in Kings River Canyon scenes, did illustrations for *Sunset*. Featured in the November 1915 issue are "In the Footsteps of the Padres," "Under the Highest Peaks in the U.S.," and "Blazing the Trail to Whitney."

Burdett, Dorothy May (1893-)
B. Arkansas City, Kansas. Havlice; Mallett Supplement (Independence, Kansas); WWAA 1947-1962 (Independence).

Burks, Garnett (1878-)
B. Kentucky. Fisher.
Burks, who moved to New Mexico in 1894, was living in Albuquerque in 1947.

Burrell, Louise H. (-)
B. London, England. AAA 1917, 1921 (Los Angeles, California); Fielding; Johnson.
Burrell, who was a painter of miniature portraits, exhibited in London in 1904 under the name Louise H. Luker.

Burt, Marie Bruner Haines. See: Marie Bruner Haines.

Butler, Andrew R. (1896-)
B. Yonkers, New York. Work: Bibliothèque Nationale, Paris; National Collection of Fine Arts; Whitney Museum of American Art. AAA 1923-1925 (Yonkers); AAA 1929-

1932 (New York City; summer: Walpole, New Hampshire); Havlice; Mallett; WWAA 1936-1941 (New York City; Walpole); "Butler Depicts Western Desert," *The Art Digest*, May 15, 1934, 15, in which Butler's Arizona and New Mexico paintings are discussed.

Butler, Bessie Sandes/Sanders (1868-)
B. Galesburg, Michigan. Work: Scotts Bluff National Monument. AAA 1903-1906 (Kalispell, Montana); AAA 1907-1910 (Los Angeles, California); Bénézit. Butler studied at the Art Institute of Chicago.

Butler, Courtland (1871-)
B. Columbus, Ohio. AAA 1917-1924 (Tulsa, Oklahoma); AAA 1925 (Pittsburgh, Pennsylvania); Mallett Supplement (Hartford, Connecticut).

Butler, Edward Burgess (1853-1928)
B. Lewiston, Maine. D. Pasadena, California, February 20. Work: Art Institute of Chicago; Cleveland Museum of Art; Dallas Museum of Fine Arts. AAA 1913-1925 (Chicago and Hubbard Woods, Illinois); Bénézit; Fielding; Mallett; WWWA.
 Butler was a merchant who retired in 1914 to devote himself to painting. He had a winter home in Pasadena.

Butler, Howard Russell (1856-1934)
B. New York. D. Princeton, New Jersey, May 22. Work: National Collection of Fine Arts; Metropolitan Museum of Art; Historical Society of Princeton; Bowdoin College Museum of Art. AAA 1898-1910 (New York City); AAA 1913-1919 (Princeton); AAA 1921 (Pasadena, California); AAA 1923-1924 (Santa Barbara, California); AAA 1925-1933 (Princeton); Bénézit; Fielding; Havlice; Mallett; WWAA 1936-1937*; WWWA; Garnier; *American Magazine of Art*, July 1923, 400, reviewing Butler's book *Painter and Space*, published by Charles Scribner's Sons.

Butler, Mary (1865-1946)
B. Chester County, Pennsylvania. D. Philadelphia, Penn-

sylvania, March 16. Work: Pennsylvania Academy of Fine Arts; Butler Institute of American Art; Dayton Art Institute; West Chester (Pennsylvania) State College; Williamsport High School; Pennsylvania State Teachers College; Lebanon (Missouri) High School; Springfield (Missouri) Art Museum. AAA 1905–1933 (Philadelphia); Bénézit; Fielding; Havlice; Mallett; WWAA 1936–1941 (Philadelphia; summer: Uwchland, Pennsylvania); WWWA; "Critics Like Mary Butler's Mountains," *The Art Digest,* February 1, 1930, 15.

Specializing in mountains and the sea throughout a long and productive career, Mary Butler was no stranger to the West where she painted in California and the Northwestern states. About her mountain scenes Dorothy Grafly of the Philadelphia *Public Ledger* wrote in 1930, "There is . . . no petty fussing with details. As she prefers nature in its sterner moods, so also she enjoys directness of expression and depth of color interpretation."

Working in both oil and water color, Butler depicted many of the world's most rugged mountains, returning at different times of the year to catch the nuances of seasonal change.

Butler, Rozel Oertle (–)
B. Nebraska. AAA 1917 (New York City); "Pictures of the Southwest," *Arts and Decoration,* January 1915, 103.

Known also as Mrs. Royal Oertle, Butler, during her brief career as an exhibiting artist, specialized in Arizona, New Mexico, and Mexico scenes. For three years she traveled many miles on horseback to obtain subjects for her canvases. Her only companion was her guide.

With the exception of Butler's Mexico and city paintings, her exhibition of January 1915 at Ehrich Gallery in New York was not favorably reviewed in *Arts and Decoration.* Her reviewer noted that while she had "produced a great many desert pictures with a strong, heavily loaded, masculine brush, the majority of her work, and probably the better part, was painted in the cities where life is expressed more obviously with a great deal more action."

Butterfield, M. (–)
AAA 1898–1900 (Omaha, Nebraska).

C

Cahill, Katharine Kavanaugh (1890-)

B. Four Oaks, Kentucky. AAA 1917–1919 (Laguna Beach, California); AAA 1921 (San Francisco, California); AAA 1923–1925 (Chicago, Illinois); AAA 1927–1933 (Los Angeles, California; summer: Phoenix, Arizona); Fielding; Mallett.

Katharine Cahill is listed in the Art Annual under Kavanaugh during the early years of her career.

Caldwell, Ada Bertha (1869–1937)

B. Ohio. D. Brookings, South Dakota, November 8. Stuart (Nebraska; Yankton and Brookings, South Dakota); Lincoln Memorial Library, Brookings; Gertrude Stickney Young, *South Dakota/An Appreciation*, privately published in Brookings in 1944.

Current interest in the work of little-known artists working in the American West has brought attention to such deserving persons as Ada Caldwell who taught art from 1899 to 1936 at South Dakota State University where she also headed the art department. A number of her pupils went on to successful careers. Among them was the famous illustrator Harvey Dunn who recalled that she "seemed to dig out talent where none had been. . . ."

Caldwell was among the first well-trained artists to paint landscapes in South Dakota. She did some painting in other states, particularly Colorado.

Striving always to perfect her technique, Caldwell spent summers and sabbaticals studying at Pratt Institute, Columbia University, and Chase School of Art. Her early training was at the University of Nebraska and at the Chicago Institute of Art.

Calkins, Bertis H. (1882–1968)

B. Kansas. D. Albuquerque, New Mexico, January 27. Albuquerque Public Library.

Prior to moving to Albuquerque in 1907, Calkins was a resident of Herrington, Kansas. He was a self-taught artist who worked as a surveyor, surveying much of New Mexico during the

years he lived there. He did still life and landscape painting in oil and pen and ink.

Callahan, Caroline (-)
B. San Francisco, California. AAA 1909–1910, 1913 (Mountain View, California); Bénézit.

Cameron, Edgar Spier (1862–1944)
B. Ottawa, Illinois. D. Chicago, Illinois, November 5. Work: Chicago Historical Society; Chicago Union League Club; Santa Fe Collection; Supreme Court Library, Springfield, Illinois; Art Institute of Chicago. AAA 1898–1933 (Chicago); Bénézit; Fielding; Havlice; Mallett; WWAA 1936–1941 (Chicago); WWWA; Robertson and Nestor.

Cameron, William Ross (1893–1971)
B. New York City. D. Berkeley, California, December 9. Work: M. H. De Young Memorial Museum; Art Institute of Chicago; Pennsylvania Academy of Fine Arts. AAA 1917–1933 (Berkeley, San Francisco, and Alameda, California); Fielding; Havlice; Mallett; WWAA 1936–1941 (Alameda); "W. R. Cameron Stresses Line, Light and Form," *American Artist*, March 1963, 34–35, 66; correspondence with Elma C. Cameron.

Cameron, during his long career in San Francisco, was staff artist for the San Francisco *Call-Bulletin* and the San Francisco *Chronicle*, and a free-lance illustrator. He illustrated a number of books, including two he wrote: *David Copperfield in Copper Plate* and *Glimpses of Old World Cities and Towns*.

Cameron made frequent trips to distant places such as London and Paris and Edinburgh. By the 1930s he was exhibiting nationally in group shows and locally in solo shows. In 1945 Alfred Frankenstein wrote that Cameron's "small almost miniaturistic watercolors were among the most exquisite things being produced in San Francisco."

Campbell, Fannie/Frances Soulé (-)
AAA 1909–1910 (Berkeley, California); California State Library.

Little is known about this artist who studied at the Penn-

sylvania Academy of Fine Arts, except that she painted prominent persons in Washington, D.C., and San Francisco, and was for a time staff artist for *Overland* magazine.

Campbell, Isabella Frowe (1874-)
B. Rockford, Illinois. Work: Hollywood Congregational Church. AAA 1931-1933 (Hollywood, California); Havlice; Mallett; WWAA 1936-1962 (Los Angeles, California).

Campbell, Myrtle Hoffman (1886-)
B. Columbus, Nebraska. Havlice; Mallett Supplement; WWAA 1936-1953 (Boulder, Colorado).

Cannon, Jennie Vennerstrom (1869-)
B. Albert Lea, Minnesota. AAA 1917 (New York City; summer: Palo Alto, California); AAA 1919-1931 (Berkeley, California; summer: Carmel, California); Havlice; Mallett; WWAA 1936-1947 (Berkeley); WWAA 1953 (Tucson, Arizona); "West vs. East," *The Art Digest*, Mid-December 1929, 8.

Capwell, Josephine Edwards (-)
B. New Albany, Indiana. AAA 1898-1900 (San Francisco, California); Bénézit; Mallett Supplement.
Capwell was a member of the San Francisco Art Association who continued to be interested in art for many years after her brief experience in the field. She studied in San Francisco and in Paris, and received a prize when she exhibited at the Mechanics Institute Fair in San Francisco.

Carew, Berta/Bertha (1878-1956)
B. Springfield, Massachusetts. D. Los Angeles, California, April 27. Work: Los Angeles Museum of Art; Philadelphia Museum of Art. AAA 1907-1915 (New York City); AAA 1917-1925 (Berks County, Pennsylvania); AAA 1927-1933 (Rome, Italy); Fielding; Havlice; Mallett; WWAA 1936-1947 (Los Angeles, California).

Carey, Rockwell W. (1882-)
B. Waldo Hills, Oregon. Work: Public buildings in Port-

land, Oregon; Treasury Department, Washington, D.C.; Post office, Newburg, Oregon. Havlice; Mallett Supplement; WWAA 1940-1953 (Portland, Oregon); *Who's Who in Northwest Art; The Art Digest,* November 15, 1930, 9.

Carlson, Charles Joseph (1860-　)
B. Gothenburg, Sweden. California Historical Society. AAA 1900-1908 (San Francisco, California); Bénézit.

Carlson studied with Virgil Williams at the California School of Design. Between 1876 and 1890, he won a number of awards. He was a member of the San Francisco Art Association and the Bohemian Club, and his work is in the collection of the club.

Carlson, Zena Paulson (1894-　)
B. near Lily, South Dakota. Stuart (Webster, South Dakota).

Carlson attended college in Jewell, Iowa, and Madison, South Dakota. She taught in the public schools of Day County, South Dakota.

Carpenter, (Miss) A. M. (1887-　)
B. Prairie Home, Missouri. Work: First Baptist Church, Abilene, Texas; high schools in Abilene, Travis, and Lamar, Texas; Mansfield (Louisiana) College. AAA 1925-1933 (Abilene); Havlice; Mallett; WWAA 1936-1941 (Abilene).

Carpenter, Dudley Saltonstall (1870-　)
B. Nashville, Tennessee. Work: Denver Public Library. AAA 1900-1903 (New York City); AAA 1905-1913 (Montclair, New Jersey); AAA 1915-1917 (Denver, Colorado); AAA 1921 (LaJolla, California); Bénézit; Fielding; Mallett; Denver *Times,* April 12, 1916, 2; Denver Public Library Western History Department.

Carpenter, Louise (1865-1963)
Work: Oakland Museum; Santa Cruz City Museum. AAA 1917 (Berkeley, California); Mallett Supplement (Montclair, New Jersey).

Carr, Emily (1871–1945)

B. Victoria, British Columbia, Canada. D. Victoria. Work: Art Gallery of Greater Victoria; Vancouver Art Gallery; National Gallery of Canada. Bénézit; Harper, 1966; Havlice; Hubbard & Ostiguy; Mallett Supplement; *Who's Who in Northwest Art;* Emily Carr, *Growing Pains,* Toronto and Vancouver: Clarke, Irwin & Company Limited, 1946, 1966.

Carr has written in *Growing Pains* that she was 16 when she began several years of study at the San Francisco School of Art. She recalled the squalid quarters of the school on top of the old Pine Street Public Market, its removal to the Mark Hopkins mansion—a move she did not condone—, and the professors and their students.

Lorenzo Latimer, whose Wednesday morning outdoor sketch class she attended with 30 to 40 other students, was a favorite teacher. Meeting Latimer at the ferry, she crossed San Francisco Bay to sketch all manner of subjects, "the little Professor hopping from student to student advising and encouraging," Carr wrote in *Growing Pains* [p. 26].

Always an outdoor painter by preference, Carr specialized first in Canada's Northwest Coast Indian life, and later in interpreting Canada's majestic forests and open spaces.

Ill health when she was nearly 70 forced Carr to forego the strenuous life of a landscape painter. It was then that she turned to writing books, including *Growing Pains,* an autobiography. Not only has she become one of Canada's great painters, but she has achieved distinction as a writer as well.

Carrothers, Grace Neville (1882–)

B. Abington, Indiana. Work: New York Public Library; Gibbes Art Gallery, Charleston, South Carolina; National Gallery of Art; British Museum; Library of Congress; Royal Ontario Museum, Toronto; Bibliothèque Nationale, Paris; Philbrook Art Center, Tulsa. AAA 1933 (Tulsa, Oklahoma); Havlice; Mallett; WWAA 1936–1962 (Tulsa; summer: Bellaire, Michigan).

Carrothers taught landscape painting at Philbrook Art Center from 1940 to 1952 and headed her own school of landscape painting from 1932 to 1952.

Casey, John Joseph Clifford (1878–1930)
B. San Francisco, California. D. New York City. AAA
1915–1917 (Paris, France); AAA 1923–1925 (New York
City); Fielding; Mallett; *The Art Digest,* March 15, 1931,
page 7, regarding an exhibition of paintings in San Fran-
cisco.

Cashin, Nora (–)
AAA 1913 (San Francisco, California).

Chadwick, Grace Willard (1893–)
AAA 1919 (Oklahoma City, Oklahoma); Havlice; Mallett
Supplement; WWAA 1938–1941 (Oklahoma City).

Chaffee, Olive Holbert (1881–1944)
B. Paducah, Kentucky. AAA 1925 (New York City); AAA
1931–1933 (St. Louis, Missouri); Havlice; Mallett; WWAA
1936–1941 (St. Louis; Glendale, California).

Chain, Helen [Mrs. James A.] (1852–1892)**
B. Indianapolis, Indiana. D. at sea, October 10, when the
S.S. *Bokhara* sank. Work: Denver Public Library Western
History Collection; Colorado State Museum, Denver.
Denver Public Library; University of Colorado (Boulder)
Western History Archives; Hafen 1927; Kovinick.
 An undated manuscript in the Western History Archives
of the University of Colorado states that Chain was in Colorado
before John Harrison Mills arrived in 1872. Previously she had
lived in San Francisco.
 According to Mrs. Joe Mills, the author of the manuscript,
Chain met the artist Hamilton Hamilton in 1873 when he was on
a sketching trip with John Mills in the upper Arkansas River re-
gion where the firm of Chain and Hardy, Denver bookstore
owners, had a summer camp. Under "Hamilton's encouragement
Chain developed rapidly" as a painter. Several years later she
spent a winter in New York studying with George Inness. Follow-
ing her return she "painted many fine landscapes from native
subjects which remain a monument to her memory."
 Chain also painted in California, New Mexico, and Mexico.
She worked in oil and water color, occasionally painting on ivory.

She began teaching art in Denver in 1877. Among her pupils was the far better known Charles Partridge Adams.

Chamberlain, Samuel V. (1895-1975)
B. Cresco, Iowa. D. January 10. Work: Library of Congress; New York Public Library; Metropolitan Museum of Art; Boston Museum of Fine Arts; Art Institute of Chicago. AAA 1927-1931 (Paris, France); Bénézit; Havlice; Mallett; WWAA 1936-1941 (Chestnut Hill, Massachusetts); WWAA 1947-1973 (Marblehead, Massachusetts); WWWA; Fridolf Johnson, "Samuel Chamberlain: Artist & Photographer," *American Artist,* February 1965, 28 ff.
Chamberlain spent his early years in Washington where he grew up in the lumbering town of Aberdeen. For two years he studied architecture at the University of Washington.

Champlin, Ada Belle (1875-1950?)
B. St. Louis, Missouri. D. Pasadena, California. Work: Vanderpoel Art Association, Chicago; Montclair (New Jersey) Art Museum. AAA 1909-1910 (Chicago); AAA 1917-1919 (Pasadena); AAA 1921-1933 (Pasadena and Carmel, California); Fielding; Havlice; Mallett; WWAA 1936-1953 (Pasadena and Carmel).

Chandler, Helen Clark (1881-)
B. Wellington, Kansas. Work: National Academy of Design. AAA 1915-1933 (Los Angeles, California); Fielding; Mallett.

Chaplin, Prescott (1897-)
B. Boston, Massachusetts. Work: Los Angeles Public Library; Scripps College; Lehigh University. Havlice; Mallett Supplement; WWAA 1936-1941 (Los Angeles); *The Art Digest,* January 15, 1931, 21.

Chapman, John Gadsby (1808-1889)
B. Alexandria, Virginia. D. Brooklyn, New York, November 28. Work: Princeton University Art Museum; Boston Museum of Fine Arts; Cleveland Museum of Art; Metro-

politan Museum of Art. Bénézit; Fielding; Groce and Wallace; Mallett; WWWA (Brooklyn).

According to Groce and Wallace, Chapman died in 1890. During his lifetime he painted landscapes, portraits, and historical subjects. He also did etchings and illustrations, and some writing. He is the author of *The American Drawing Book,* published in 1847.

Chapman, Josephine E. (-)
AAA 1909-1910 (Alameda, California).

Chapman, Minerva Josephine (1858-1947)
B. Altmar, New York. Work: National Collection of Fine Arts; Smithsonian Institution; George Washington University. AAA 1898-1903 (Chicago, Illinois); AAA 1905-1915 (Paris, France); AAA 1917 (Arlington Heights, Illinois); AAA 1919-1921 (Paris); AAA 1923-1933 (Palo Alto, California); Bénézit; Fielding; Havlice; Mallett; WWAA 1936-1941 (Palo Alto).

Cheever, Walter L. (1880-1951)
B. Malden, Massachusetts. D. Santa Paula, California. AAA 1917-1924 (Glendale, California); Havlice; Mallett Supplement; WWAA 1936-1953 (Santa Barbara, California).

Chenoweth, J. A. (-)
AAA 1913 (Salem, Oregon).

Chepourkoff, Michael G. (1899-)
B. Russia. Work: San Francisco Museum of Art. Havlice; Mallett Supplement; WWAA 1940-1953 (San Francisco).

Cherry, Emma Richardson (1859-)
B. Aurora, Illinois. Work: Elizabet Ney Museum, Austin; Society of Civil Engineers' Club, New York City; San Antonio Art League; Houston Museum of Fine Arts; Denver Art Museum; Denver Public Library; John Vanderpoel Collection, Chicago; Harris County (Texas) Heritage Society. AAA 1898-1933 (Houston); Bénézit; Fielding; Mallett;

WWAA 1936-1941 (Houston); O'Brien; Denver Public Library.

Richardson was a well-known Denver artist when she moved to Houston in 1898. A prolific and popular painter, she exhibited widely in this country and in London and Paris.

Chesney, Letitia (1875–)
B. Louisville, Kentucky. Work: Kentucky State House, Louisville; Queen Anne Hill Branch Library, Seattle. AAA 1903 (Frankfort, Kentucky); AAA 1929–1933 (Winslow, Bainbridge Island, Washington); Havlice; Mallett; WWAA 1936-1941 (Winslow).

Chesney, Mary (1872–)
B. Louisville, Kentucky. AAA 1929–1933 (Winslow, Bainbridge Island, Washington); Mallett.

Chiapella, Edouard Emile (1889-1951)
B. New Orleans, Louisiana. Havlice; Mallett Supplement; WWAA 1940-1947 (Hollywood, California; summer: Manhattan Beach, California).

Chillman, James, Jr. (1891-1972)
B. Philadelphia, Pennsylvania. D. probably Houston, Texas, May 13. AAA 1927-1933 (Houston); Bénézit; Havlice; Mallett; WWAA 1936-1962 (Houston); WWWA; O'Brien.

Chillman obtained his BA and MA degrees at the University of Pennsylvania where he had won a scholarship. He also taught freehand drawing and water color there for two years.

From 1916 to 1919 Chillman taught architecture at Rice Institute in Houston, followed by three years of further study in Rome at the American Academy where he had a fellowship.

A year after Chillman's return to Rice Institute in 1923, he became director of Houston's Museum of Fine Arts. He retired from the Museum in 1953, but continued to be active as director emeritus.

Early in his career, Chillman was a water color painter of considerable ability who received numerous awards for his work.

Chouinard, Nelbert Murphy (1879-1969)**

B. Montevideo, Minnesota. D. Pasadena, California, July 9. AAA 1921 (Los Angeles, California); AAA 1923-1929 (South Pasadena, California); Bénézit; Fielding; Havlice; Mallett; WWAA 1936-1941, 1970* (South Pasadena); WWWA; Marie Angelino, "Nelbert Chouinard," *American Artist*, May 1968, 28-32.

As famous as Chouinard Art School of Los Angeles had been for four decades before it became part of the California Institute of Arts, relatively few know that its founder was a talented painter. Marie Angelino in an article for *American Artist* has remarked on Chouinard's ability as a landscape painter as well as the founding in 1921 of her school. The struggle to build the school left little time for painting or recreation, but Chouinard combined the two on occasional horseback trips to then rural Newhall. Some of Chouinard's landscapes are of this beautiful area before smog settled heavily upon it.

When Chouinard opened the school in 1921, her only financial assets were a small pension from her husband's death in the first World War, and her salary as a teacher at Otis Art Institute. The salary she offered to Frank Tolles Chamberlin who joined the staff, remaining until 1929. Chouinard, who wanted only the best teachers, obtained many such prominent artists for the school in subsequent years.

Christensen, Ethel Lenora (1896-)

B. Santa Barbara, California. Havlice; Mallett Supplement; WWAA 1940-1941 (Santa Barbara and Wilmington, California).

Christensen, Florence (-)

B. Salt Lake City, Utah. AAA 1915 (Salt Lake City); Bénézit.

Christensen exhibited in France in 1910 and 1911.

Christie, Mae Allyn (1895-)

B. Moberly, Missouri. Havlice; Mallett Supplement (Toledo, Ohio); WWAA 1936-1941 (Tulsa, Oklahoma). Christie is also known as Mae Allyn Schupbach.

Church, Grace (See: Jones, Grace Church)

Ciprico, Marguerite Freytag (1891–1973)

B. Germany. D. Burlingame, California, November 8. H. J. Dengler, Palo Alto, California.

Although Ciprico is little known outside the San Francisco Bay area, she associated with well-known Northern California artists, and she studied with several of them. Among the latter were Wores, Neuhaus, and Putnam, her teachers at San Francisco's California School of Design which she attended from 1908 to 1912. Then she studied for two years in Munich, Milan, and Paris. Her teacher when World War I broke out was Anders Zorn.

From 1915 to 1923 Ciprico did commercial work, including portraits for the *Chronicle's* society section. Marriage in 1923 brought to a close her years in San Francisco where she had lived since 1906. The rest of her life was spent in the San Mateo-Burlingame area of the San Francisco Peninsula where she specialized in landscapes and still lifes. A considerable influence in her still-life work was William Hubacek, long-time friend and colleague.

Clack, Clyde Clifton (1896–1955)

B. Bonham, Texas. D. December 24. Havlice; WWAA 1947–1953, 1956* (Dallas, Texas); O'Brien.

Clapp, William Henry (1879–1954)

B. Montreal, Canada. D. Oakland, California. Work: Canadian National Gallery; Montreal Museum of Fine Arts; Oakland Museum. AAA 1919–1933 (Oakland); Bénézit; Fielding; Harper, 1966; Havlice; Mallett; WWAA 1936–1956 (Piedmont, California); Oakland Museum, *Society of Six*, October 3–November 12, 1972 exhibition catalog.

Clapp grew up in Oakland and settled there permanently in 1917 after many years of study in Montreal and in Europe. From 1918 to 1949 he was with the Oakland Museum Art Gallery, first as assistant curator, then director, and finally as part-time curator.

Aside from furthering the development of art in East San Francisco Bay cities, Clapp did a great deal of painting there, including many landscapes of the area. He exhibited widely, is as well known in Canada as he is in the United States, and for six years in Oakland he directed the Clapp School of Art. His delicate

style of painting has been compared with that of Signac and Seurat.

Clark, Arthur Bridgman (1866–1948)
B. Syracuse, New York. D. May 15. Havlice; WWAA 1936–1941 (Stanford, California); WWWA. Clark was professor of art at Stanford University from 1892 to 1931.

Clark, Helen Bard Merrill (1858–1951)
B. Decorah, Iowa. D. Belle Fourche, South Dakota, October 9. Stuart.

Clark, who studied at the Art Institute of Chicago, did some china painting in the 1890s when she lived in Lead, South Dakota.

Clarke, Frank (1885–1973)
B. Big Pine, California. D. Mountain Home, Idaho, October 20. Boise Public Library; The Idaho *Statesman,* October 22, 1973.

Clark was four when his family moved to Idaho. Years later he established a gift shop business at Glenns Ferry, where he taught art classes for awhile. He had once studied three years at the Art Institute of Chicago.

Claxton, Virgie (1883–)
B. Gatesville, Texas. AAA 1933 (Houston, Texas); Havlice; Mallett; WWAA 1936–1941 (Houston).

Cleaver, Alice (1878–)
B. Racine, Wisconsin. Work: Santa Fe Collection. AAA 1917–1933 (Falls City, Nebraska); Mallett.

Cleaver had studied with John Vanderpoel, William Merritt Chase, and others. She was a member of Lincoln (Nebraska) Art Gallery and Omaha (Nebraska) Society of Fine Arts, and she was the recipient of several awards.

Cleaves, Muriel Mattocks (–1947)
B. Hastings, Nebraska. AAA 1921 (San Diego, California); AAA 1923–1924 (Kansas City, Missouri); AAA 1925 (Honolulu, Hawaii); AAA 1927 (Coral Gables, Florida);

AAA 1929-1933 (New York City and Staten Island, New York); Fielding; Havlice; Mallett; WWAA 1936-1947 (Staten Island).

Until 1929, the *Art Annual* lists the artist as Muriel Mattocks. She was primarily an illustrator. During the early 1920s she exhibited for a few years and won several awards for her watercolors.

Cleenewerck, Henry (–)

B. Waton, Belgium, of French parents. Work: Santa Cruz (California) City Museum; Monterey (California) Custom House; Society of California Pioneers. Bénézit; *Kennedy Quarterly,* May 1965, 160-161; Society of California Pioneers, San Francisco.

Cleenewerck, who was active in this country from about 1860 to 1890, was in San Francisco during the late 1870s and early 1880s. His "Yosemite Trail" was shown in 1882.

Clement, Catherine (1881–)

B. Rochester, New York. AAA 1915 (Portland, Oregon).

Clopath, Henriette (1862-1936)

B. Aigle, Switzerland. D. Tulsa, Oklahoma. Work: University of Minnesota Art Gallery. AAA 1903-1910 (Minneapolis, Minnesota); AAA 1919-1927 (Tulsa); Bénézit; Fielding; Jacobson and d'Ucel, page 270.

Recently, art historians have been giving more attention to this country's lesser-known first impressionists. Such an artist is Clopath who came here in 1895 following seven years as head of the art department of American College in Constantinople, Turkey. She taught French at Northrup Academy and headed the then newly established art department of the University of Minnesota.

Clopath had studied art in Dresden, Munich, Paris, and Switzerland. Much influenced by the French impressionists, she wrote and lectured extensively on impressionism before it was widely accepted here.

In 1913 Clopath settled in Tulsa where she gave private lessons and did a considerable amount of landscape painting that followed closely the French impressionist movement.

Clover-Bew, May/Mattie (1865-)
B. Indianapolis, Indiana. AAA 1933 (San Francisco, California); Havlice; Mallett; WWAA 1938-1953 (San Francisco).

Clute, Beulah Mitchell (1873-)
B. Rushville, Illinois. AAA 1913 (Parkridge, Illinois); AAA 1915-1933 (Berkeley, California); Bénézit; Fielding; Mallett.
Clute specialized in bookplates and illuminated parchments.

Coan, Helen E. (1859-1938)
B. Byron, New York. D. Los Angeles, California, October 14. AAA 1898-1933 (Los Angeles, California); Bénézit; Fielding; Havlice; Mallett; WWAA 1936-1941 (Los Angeles).
When the first volume of the *American Art Annual* appeared in 1898, Coan was teaching at the Art League of Los Angeles and specializing in painting Chinese and Mexican subjects. Among her other works is "Capistrano Mission" owned by the California Chapter of the Daughters of the American Revolution.

Coburn, Frank (-)
Bowers Library, Santa Ana, California.
Coburn, who lived in Los Angeles and Laguna Beach, California, was a self-taught artist. He began painting landscapes in Southern California about 1910.

Cocking, Mar Gretta (1894-)
B. Mineral Point, Wisconsin. Work: Murals, Little Gallery, School of Architecture and Allied Arts, University of Oregon, Eugene; Black Hills Art Center and Black Hills State College, Spearfish, South Dakota. Havlice; Mallett Supplement; WWAA 1947-1962 (Spearfish); *Who's Who in Northwest Art;* Stuart.

Cockrell, Dura Brokaw (1877-)
B. Liscomb, Iowa. AAA 1917-1925 (Fort Worth, Texas);

AAA 1927–1933 (Fulton, Missouri); Fielding; Havlice; Mallett; WWAA 1936–1937 (Fulton); WWAA 1938–1962 (Winslow, Arkansas); O'Brien.

Cockrell was active in Texas for 34 years, primarily in Waco where she was art instructor at Add Ran College, and in Fort Worth when Add Ran became Texas Christian University.

Colburn, Laura Rohm (1886–1972)

B. Seymour, Wisconsin. D. Madison, South Dakota, December 19. Stuart.

This long-time resident of Madison was a self-taught artist who exhibited and won awards at Lake County fairs.

Colby, George Ernest (1859–)

B. Minneapolis, Minnesota. Work: University of Kansas Museum of Art; Chicago Historical Society. AAA 1898–1913 (Chicago, Illinois); Bénézit; Young; Denver *Times,* July 1, 1902, 3/3; Denver Public Library.

Colby was a life member of the Art Institute of Chicago. He painted in Europe and in this country, where he did a number of landscapes of scenes in the Rocky Mountains.

Colby, Madolin (1887–)

B. Norwalk, Ohio. Fisher.

Colby, who lived in Albuquerque, New Mexico, had been a resident of the state since 1931.

Colby, Vincent V. (1879–)

B. Poland. Work: Museum of New Mexico; Santa Fe Collection. Fisher; Museum of New Mexico.

Colby, who lived in Albuquerque, New Mexico, was an inventor and craftsman who had worked in the state since 1931. He had studied with Jean Mannheim at one time and continued to do some painting and printing. For the latter he used etching and engraving processes.

Cole, Blanche Dougan/Dugan (1869–)

B. Richmond, Indiana. Work: Santa Fe Collection. AAA 1898 (Chicago, Illinois); AAA 1900–1906 (Denver, Colorado); AAA 1907–1925 (Los Angeles, California); Brom-

well, pages 5, 14, and 22; Denver Public Library.

In 1898 Cole exhibited several oil paintings of life-size Indian heads at the Denver Artists' Club. Eight of her Indian subjects and Southwestern landscapes are in the Santa Fe Collection.

Collier, Estelle Elizabeth (1880-)

B. Chicago, Illinois. Work: Stadium High School and the Yacht Club, Seattle, Washington. AAA 1925-1933 (South Tacoma, Washington); Havlice; Mallett; WWAA 1936-1941 (South Tacoma); *Who's Who in Northwest Art.*

Colton, Mary-Russell Ferrell (1889-1971)**

B. Louisville, Kentucky. D. Phoenix Arizona, July 26. Work: Museum of Northern Arizona, Flagstaff. AAA 1915 -1929 (Germantown and Ardmore, Pennsylvania); AAA 1931 (Ardmore; summer: "Coyote Range," Flagstaff); Fielding; Havlice; Mallett; WWAA 1936-1959 (Flagstaff); Museum of Northern Arizona manuscript by Katharine Bartlett, Curator of History.

Mary-Russell Colton was one of the first women painters to work in Arizona and New Mexico. Beginning in 1912 she made regular trips to the Southwest, and in 1926 she and her husband, Dr. Harold S. Colton, made Flagstaff their permanent home.

Mrs. Colton helped her husband establish the Museum of Northern Arizona in 1928, and subsequently became its curator of art. By 1930 she had under way the now famous Hopi Craftsman exhibit, an annual event to display the arts and crafts of the Hopis. The Navajo Craftsman annual followed. Other outstanding achievements include her assistance to the Hopi silvercraft industry, and her own regular exhibitions in Philadelphia which span the years 1909 to 1941.

Conant, Homer B. (1880/1887-1927)

B. Courtland, Nebraska. D. New York City, November 11. AAA 1907-1910 (Chicago, Illinois); Mallett Supplement (Omaha, Nebraska).

According to the obituary in the *Art Annual* of 1928, Conant spent most of his life in Omaha.

Condit, C. L./Mrs. Charles L. (1863-)
B. Perrysburg, Ohio. AAA 1929 (San Antonio, Texas); AAA 1931-1933 (Austin, Texas); Havlice; Mallett Supplement; WWAA 1936-1941 (Austin).

Connell, Mary K. (c.1885-1971)
B. New York. D. Santa Fe, New Mexico, February 17. Mallett Supplement (New York); Albuquerque Public Library; Albuquerque *Tribune,* February 19, 1971. Connell lived in Santa Fe for many years.

Connelly, Lillian B. (-)
AAA 1915 (Salt Lake City, Utah). Connelly was an illustrator.

Conner, Albert Clinton (1848-1929)
B. Fountain City, Indiana. D. Manhattan Beach, California, April 13. Work: "The Grand Canyon," Santa Fe Collection. AAA 1929* (Manhattan Beach); Mallett.

Conner, Paul (1881-1968)
B. Richmond, Indiana. D. Long Beach, California, March 11. Work: Athletic Club, Los Angeles; Deauville Club, Santa Monica; Ebell Club, Long Beach; Rockefeller Foundation. AAA 1925-1933 (Long Beach, California); Havlice; Mallett; WWAA 1936-1941 (Long Beach).

Conway, John Severinus (1852-1925)
B. Dayton, Ohio. D. Tenafly, New Jersey, December 24. Work: Milwaukee Art Center; Minnesota Historical Society. AAA 1903-1925 (Tenafly); Bénézit; Fielding; Mallett, WWWA.

Cook, E. F. (-)
Work: Society of California Pioneers, San Francisco. Evans.
Cook was active in San Francisco from about 1885 to 1890, except for 1888 when he was in Los Angeles. He was an artist for Britton & Rey, lithographers.

Cook, Paul Rodda (1897–)

B. Salina, Kansas. Work: John H. Vanderpoel Memorial Collection, Chicago; Witte Memorial Museum, San Antonio. AAA 1929–1933 (San Antonio, Texas); Havlice; Mallett; WWAA 1936–1941 (San Antonio); O'Brien; "San Antonio's First Mural," *The Art Digest,* Mid-March 1930, 19.

Cook began painting seriously about 1925, and by 1929 was winning prizes for his work. His landscape subjects are primarily of the region around San Antonio. His murals are in San Antonio's public buildings.

Cooney, Fanny Y. Cory (See: Cory, Fanny Y.)

Coover, Nell/Nella B. (–)

B. Wooster, Ohio. Work: California State Building, Los Angeles; The Guignol, Paris, France. AAA 1898–1903 (Harvey, Illinois); AAA 1913 (Paris); AAA 1915–1919 (Chicago, Illinois); AAA 1931–1933 (Laguna Beach, California); Havlice; Mallett; WWAA 1938–1941 (Laguna Beach).

Cope, George (1855–1929)

Work: Butler Institute of American Art; Wadsworth Atheneum. *Kennedy Quarterly,* October 1962, 58.

Although Cope specialized in still life, he painted landscapes of the Plains and the Pacific Coast region in the late 1870s.

Corder, Elene Moffett (1887–)

B. Minden, Nebraska. Fisher.

Corder moved to Las Cruces, New Mexico, in 1940, and was active there at least until 1947.

Cordero/Cardero, José/Josef (1768–)**

B. Spain? Work: Robert B. Honeyman, Jr. Collection, Bancroft Library, University of California, Berkeley; Museo Naval, Madrid, Spain. Groce and Wallace; Baird, 1968; Donald Cutter, *Malaspina in California,* San Francisco: John Howell-Books, 1960; John F. Henry, "The Truthful

Eye of Jose Cardero," *Pacific Search* magazine, June 1977, 17; Van Nostrand and Coulter.

Although Cordero was not the official artist on the Malaspina voyage to the Northwest Coast in 1791, during that and subsequent explorations he made drawings that are invaluable. Serving first as cabin boy and then as cartographer, Cordero sketched Monterey Presidio and San Carlos Mission in California en route to Vancouver Island.

Sources differ as to whether the first voyage was in 1791 or 1792. A second voyage to Vancouver Island followed during which Cordero did at least 25 black and white drawings of natives living on the Island, showing their customs. Included are maps of the region.

Among Cordero's drawings are some of Monterey, California, dated September 10, 1797, indicating either another visit or copies of drawings of an early visit. Although Cordero continued to work for the Spanish Navy, he apparently pursued no further a career as ship's artist. In 1808 he was promoted to Second Official, but dropped from the official list by 1811.

Cordero's drawings are especially valued for their accuracy, a quality often lacking in the work of professional artists concerned more with making a picture than a record. Baird described "Vista del Presidio de Monte Ray" as showing the "Presidio complex in center, middleground; stockade and carts at R; people working at tilling fields or conversing, foreground; three European ships in harbor, center background."

Corson, Stanley (1895–)
B. Las Vegas, New Mexico. Fisher.
Corson was living in Albuquerque, New Mexico, when Fisher was preparing *Art Directory of New Mexico*.

Cory, Fanny Y. (1877–1972)
B. Waukegan, Illinois. D. Stanwood, Washington, January 28. AAA 1903 (c/o Century Company, New York City); AAA 1905–1910, 1921 (Canyon Ferry, Montana); Bénézit; Havlice; Mallett Supplement; *Who's Who in Northwest Art; Who's Who of American Women;* correspondence with her daughter Mrs. Sayre (Thos. B.) Dodgson.
Known as "little sister of the Century Company" in the

1890s because she was very small and very young, Fanny Cory was one of the few well-known early women illustrators. She "crashed into the field in desperation," wrote her daughter Sayre, to make money to support her invalid sister. When her sister died, Cory went to Montana. In 1904 she married a rancher, settled in Canyon Ferry, and continued to fill illustrating assignments until family obligations required all her time and energy.

Later Cory returned to illustration work with a view to helping with family expenses, but was unable to obtain sufficient assignments. So she tried her hand at children's cartoons. Her daughter Sayre recalled that her mother's syndicated cartoons saw the three Cooney children through high school, and that "Little Miss Muffet" helped them through college, art school, medical school, and nurse's training.

When a dam caused the Canyon Ferry ranch home to be flooded, Cory bought a cottage on Camano Island near Stanwood, Washington, which she called "Montana Beach." Sayre recalled that her mother was about 85 when she gave up her "Sonny Sayings" and "Little Miss Muffet" strips, but that she continued with her watercolor sketches of the beautiful scenes and sunsets at Montana Beach.

Cosgrove, Earle M. (–1915)
B. Santa Catalina Island, California. D. Los Angeles, California, December 21. AAA 1917*; Bénézit; Mallett. Cosgrove studied at the New York School of Art.

Costello, Val (1875–1937)
B. Marion, Kansas. D. Los Angeles, California, May 8. AAA 1917–1933 (Los Angeles); Fielding; Mallett.

Coughlin, Mildred Marion (1895–)
B. Pennsylvania. Work: National Gallery of Art; Library of Congress; University of Nebraska; Bibliothèque Nationale, Paris, France. AAA 1925–1933 (New York City and Long Island, New York); Havlice; Mallett; WWAA 1936–1953 (Long Island; Beverly Hills, California; New York City).

Courtney, Leo (1890–)
B. Hutchinson, Kansas. Work: Smoky Hill Print Club,

Lindsborg, Kansas; Kansas Federation of Women's Clubs; public schools, Wichita, Kansas; Tulsa (Oklahoma) University; Artists' Guild of Topeka, Kansas. AAA 1925-1931 (Wichita, Kansas); Havlice; Mallett Supplement; WWAA 1936-1941 (Wichita).

Cox, Charles Hudson (1829-1901)
B. Liverpool, England. D. Waco, Texas, August 7. Work: Waco Art League; Waco High School. AAA 1898-1903* (Waco); Bénézit; Groce and Wallace; Mallett; University of Colorado Western History Archives, Boulder; O'Brien; Denver Public Library.

In London, Cox was a member of the Royal Watercolor Society, and a well-known illustrator. In Waco he was a cotton broker, an artist, and an art teacher. In 1900 he organized the Waco Art League.

Before moving to Waco in 1891, Cox lived in Norfolk, Virginia, where he had settled after leaving London. Despite relatively few years in Texas, he was capable of "interpreting Texas life and landscape with as much feeling as though he had roamed the plains during childhood," wrote O'Brien in her biography of Texas artists.

Cox did much to further the appreciation of art in Texas and in Colorado where he taught for several summers at the Texas-Colorado Chautauqua in Boulder. It was he who organized the elite Chautauqua Drawing Society—it was limited to 25 members—and financed prizes for the award-winning work of Texas and Colorado artists.

Crabb, Robert James (1888-)
B. Livermore, Kentucky. Havlice; Mallett Supplement; WWAA 1938-1941 (Houston, Texas).

Crapuchettes, E.J./Emile Jean (1889-1972)
AAA 1917 (San Francisco, California).

Crawford, Esther Mabel (1872-1958)
B. Atlanta, Georgia. Work: British Museum, London. AAA 1903 (New York City); AAA 1905-1910 (Jacksonville, Illinois); AAA 1913 (Chicago, Illinois); AAA 1919-

1933 (Los Angeles, California); Fielding; Havlice; Mallett; WWAA 1936-1941 (Los Angeles).

Cressy, Birl/Bert (1883-1944)
AAA 1917-1925 (Compton, California).
Cressy was a member of the California Art Club and the Los Angeles Modern Art Society.

Cressy, Josiah Perkins (1814-)
Work: Corcoran Gallery Archives. Groce and Wallace (Marblehead, Massachusetts); Van Nostrand and Coulter.

Cressy, Meta (1882-1964)
B. Ohio. AAA 1917-1925 (Compton, California).
Cressy was a member of the California Art Club and the Los Angeles Modern Art Society.

Crew, Katherin (-)
AAA 1909-1910 (Lawrence, Kansas).

Criley, Theodore (1880-)
B. Lawrence, Kansas. Work: Mills College Art Gallery. AAA 1915 (Paris, France); AAA 1917-1924 (Carmel, California). Bénézit. Criley exhibited at the Paris Salon in 1913.

Crittenden, Ethel Stuart (1894-)
B. Cincinnati, Ohio. Havlice; Mallett Supplement; WWAA 1940-1941 (Houston, Texas).

Cronau, Rudolf Daniel Ludwig (1855-1939)
B. Solingen, Germany. D. October 27. Work: Gilcrease Institute, Tulsa, Oklahoma. Bénézit; Mallett Supplement; WWWA (Philipse Manor, New York); *American Art Review,* January-February 1976, 39; *True West,* July-August 1960, 20-21.
Prior to publication in 1886 of *From Wonderland to Wonderland* and *Travels in the Lands of the Sioux,* and publication of *In the Wild West—Trips of an Artist* in 1890, Cronau, who then lived in Leipzig, made two trips to this country. These books are

illustrated with views of the American West, and 16 of his oils are in Gilcrease Institute.

Cronin, Marie (-)

 B. Palestine, Texas. Work: Mural, San Antonio Club; mural, Bartlett Baptist Church; six Texas statesmen, Texas State Capitol, Austin. AAA 1915 (Palestine); Havlice; Mallett Supplement; WWAA 1938–1941 (Bartlett, Texas); O'Brien.

 Cronin began the study of art in Texas, continued it in Chicago, and later studied in New York City and in Europe. She also studied for the stage.

 Cronin's years in Europe were spent copying the paintings of Velasquez, Titian, and Goya. While she was in Paris, four of her own paintings were exhibited at the Paris Salon. Although her preference was portrait work, she did some landscapes.

 With an aptitude for business as well as art, Cronin was for some time president of Bartlett Western Railway.

Cross, Ernest (-)

 B. California. Work: Oakland Museum. *The Overland Monthly,* January 1908, 29; *News Notes* (California State Library), vol. 3, 1908, 29. San Francisco Public Library.

 Cross, whose studio was in Belmont, California, was active in the Monterey and San Francisco Bay areas.

Crow, Louise (1891–)

 B. Seattle, Washington. Work: Museum of New Mexico; AAA 1917 (San Francisco, California; summer: Carmel, California); Bénézit; Mallett (Seattle, Washington); Museum of New Mexico, Santa Fe.

 Crow studied with Paul Gustin and William Merritt Chase. Her Santa Fe work caught the attention of Marsden Hartley, who wrote enthusiastically about her ability to paint Southwestern subjects after he had seen her San Ildefonso paintings at the Museum of New Mexico in May 1919.

 In Paris, where Crow lived in 1921, and Rome, where she lived in 1922, she also showed her Southwestern Indian paintings. "The Italians were not interested in my Indians, whereas the French were intensely so," Crow wrote her Santa Fe friends.

After living abroad and in Washington, D.C., Crow returned to Seattle in 1928 to teach art. A decade later she was back in Santa Fe where she purchased a studio on Canyon Road.

Crowder, William (1882-)
B. Dyerville, Iowa. Mallett Supplement (New York); Fisher.
Crowder moved to Santa Fe, New Mexico about 1946.

Crowell, Margaret (-)
B. Philadelphia, Pennsylvania. AAA 1904 (Avondale, Pennsylvania); AAA 1915-1919 (San Francisco, California; Avondale); Fielding.

Cruess, Marie Gleason (1894-)
B. San Francisco, California. Havlice; Mallett Supplement; WWAA 1938-1941 (Berkeley, California).

Culbertson, Josephine M. (1852-)
B. Shanghai, China. AAA 1898 (Boston, Massachusetts); AAA 1929-1933 (Carmel, California); Havlice; Mallett; WWAA 1936-1941 (Carmel).

Cundell, N. L. M./Nora Lucy Mowbray (1889-1948)
B. London, England. D. London, August 3. Work: Museum of Northern Arizona. Bénézit; Mallett Supplement (Downey, England); Johnson & Greutzner; Waters; C. Klohr, "The Ashes of Nora Cundell," *True West*, May-June 1974, 20-22.
Cundell was a figure, flower, and landscape painter who visited this country on several occasions.

Cunningham, Theodore Saint-Amant (1899-)
B. Ennis, Texas. Work: Swiss Legation, Washington, D.C.; Tennessee State Capitol, Nashville; American Embassy, Canberra; ceiling mural, St. Eugenia Covenant, Asheville, North Carolina. Havlice; Mallett Supplement; WWAA 1938-1962 (Ennis; Clarksboro, New Jersey; West Asheville, North Carolina; Speicher and St. Gallen, Switzerland); O'Brien.

Cunningham began the study of art in Dallas, Texas, at Aunspaugh Art School. He taught briefly at Fredericksburg and Waco, Texas, but soon pursued his career in Eastern cities and in Switzerland.

This internationally known artist who specialized in landscapes exhibited regularly at prominent art galleries and taught at various art colonies as well as privately.

Curjel, E. (-)
AAA 1917 (San Francisco, California).

Curry, John Steuart (1897-1946)**
B. Dunavant, Kansas. D. Madison, Wisconsin, August 29. Work: Whitney Museum of American Art; Metropolitan Museum of Art; Addison Gallery of American Art, Andover, Massachusetts; University of Nebraska; Kansas State College, Manhattan. AAA 1925-1933 (Westport, Connecticut); Bénézit; Mallett; WWAA 1936-1941 (Madison); WWWA; Nancy Heller and Julia Williams, "John Steuart Curry, the American Farmlands," *American Artist,* January 1976, 46; *The Art Digest,* October 1, 1936, 18; "Curry, a Pioneer in Art," *The Art Digest,* February 15, 1935, 16.

"Kansas has found its Homer," announced the New York *Times* in a review of Curry's New York exhibition in 1930. What Winslow Homer had done for the coast of Maine, Curry had done for Kansas farming country.

Farm animals and cowboys were Curry's models during boyhood. From 1920 to 1925, when he illustrated pulp magazines, his knowledge of their roles in Western plains development was put to good use. Later, after further study, that knowledge was the essence of many murals and easel paintings. With it Curry made Kansas landscapes, tornadoes, country baptisms, and farm life a respected regional art form.

Curtis, Elizabeth (-)
B. San Francisco, California. California State Library; *The Argonaut,* August 9, 1946, 11, and March 14, 1947, 11; San Francisco *Call,* October 1, 1893, 15/1.

During her San Francisco years, Curtis maintained a

studio in her parents' home, and, for a short while, a studio in Bolinas, California. Following marriage to Denis O'Sullivan, she lived in London and Oxfordshire, England.

Curtis, Ida Maynard (1860–1959)
B. Lewisburg, Pennsylvania. D. Carmel, California, January 28. Work: Cornell University; Harrison Memorial Library, Carmel; City of Monterey (California) municipal collection; Girls' High School and Brighton High School, Boston, Massachusetts. AAA 1919–1921 (Boston; summer: Carmel); AAA 1923–1933 (Carmel); Fielding; Havlice; Mallett; WWAA 1936–1956 (Carmel).

Curtis, Rosa M. (1894–)
B. Auckland, New Zealand. Fisher. Curtis lived in Santa Fe, New Mexico, from 1906.

Cutler, Frank E. (–)
California State Library files indicate that Cutler was once a successful California scenic artist. He also is mentioned in an article for *Overland Monthly,* February 1905, 171.

D

Dailey, Anne/Annie Emily (1872–1935)
B. Denver, Colorado. Work: Denver Public Library Western History Collection. AAA 1903–1908, 1915 (Denver); Denver Public Library.
Dailey was a painter and illustrator who taught art in the Denver public schools. She studied at the Art Institute of Chicago. During the early years of this century she exhibited regularly with the Denver Artists' Club.

Daingerfield, Elliott (1859-1932)

B. Harpers Ferry, Virginia. D. New York City, October 22. Work: Metropolitan Museum; Toledo Museum; National Gallery; Brooklyn Institute Museum; City Art Museum, St. Louis; Art Institute of Chicago; Butler Institute; Los Angeles Museum. AAA 1898-1932* (New York City); Bénézit; Fielding; Havlice; Mallett; WWWA; "An Expensive Canvas," *Touchstone*, July 1920, 331.

Daingerfield's "The Genius of the Canyon" brought $15,000 in 1920, probably the highest price theretofore paid for the work of a living American painter, according to an article in *Touchstone*. Completed in 1913, the painting was inspired by a visit to the Grand Canyon when Daingerfield and other artists were there as guests of the Santa Fe Railroad.

Adept at writing as well as painting, Daingerfield wrote verse for "Genius" to accompany the *Touchstone* article:

Strip from the earth her crest, and see revealed
the carven glory of the inner world,
Templed, domed, silent,—the while the Genius
of the Canyon broods,
Nor counts the ages of mankind a thought, amid
the everlasting calm.

Daingerfield has done a number of fine paintings of the Grand Canyon in the romantic vein of that time.

Dana, Gladys Elizabeth (1896-)

Bénézit; Havlice; Mallett Supplement; WWAA 1940-1941 (Lincoln, Nebraska).

Dando, Susie May (1873-)

B. Odell, Illinois. AAA 1917-1933 (Venice, California); Bénézit; Fielding; Havlice; Mallett; WWAA 1936-1941 (Venice).

Daniell, William Swift (1865-1933)

B. San Francisco, California. D. Los Angeles, California, June 28. Work: Laguna Beach Museum of Art. AAA 1917-1933 (Laguna Beach and Los Angeles, California); Fielding; Mallett.

Daniell was a member of the California Art Club, Laguna

Beach Art Club, and the Beach Combers of Provincetown, Massachusetts.

Daroux, Leonora (1886–)
B. Sacramento, California. AAA 1931–1933 (Sacramento and Monterey, California); Bénézit; Havlice; Mallett; WWAA 1936–1941 (Sacramento).

Dasburg, Andrew Michel (1887–)**
B. Paris, France. Work: Whitney Museum of American Art; Denver Art Museum; Los Angeles Museum of Art; California Palace of the Legion of Honor; Dallas Museum of Fine Arts; Museum of New Mexico. AAA 1915 (Yonkers, New York); AAA 1917–1919 (Woodstock, New York); AAA 1921 (New York City; summer: Taos, New Mexico); AAA 1923–1933 (Taos); Bénézit; Fielding; Havlice; Mallett; WWAA 1936–1976 (Taos and Talpa, New Mexico); Van Deren Coke, "Why Artists Came to New Mexico/'Nature presents a new face each moment,' " *Art News*, January 1974, 51; Asha Briesen, "Dasburg's 90th Birthday Heralds Show," *The Taos News*, April 28, 1977, B-1.

When Dasburg celebrated his 90th birthday in Taos in May 1977, he had been painting there for 60 years. The *News* published a review of those eventful years, quoting his first reactions to the region in letters he wrote his wife, artist Grace Mott Johnson. "In the hard transparency of sky were fractured stretches of clouds, their shape vanishing into the blue, while over the distant ranges was a turbulence of clouds in storm tearing against the peaks," wrote Dasburg.

Dasburg's cubical handling of clusters of adobe homes in his work evolved from his first sight of them. To his wife he wrote: "The effect of a number of the adobe houses seen together is one of a simple massiveness that is only broken by the windows and the chimneys breaking up the skyline."

So much has been written about this internationally known artist that little else needs to be said here, except that in 1977 he was still working and exhibiting.

Davenport, McHarg/MacHarg (1891–1941)
B. New York City. D. Santa Fe, New Mexico, September

12. Bénézit; Havlice; Mallett Supplement; WWAA 1938–1941 (Santa Fe, New Mexico); *New Mexico* Magazine, October 1935, 24.

Davey, Randall (1887–1964)**

B. East Orange, New Jersey. D. Santa Fe, New Mexico, November 4. Work: Art Institute of Chicago; Corcoran Gallery; Whitney Museum of American Art; Montclair Art Museum; Kansas City Art Institute; Cleveland Museum of Art; Detroit Institute of Art. AAA 1915–1919 (New York City); AAA 1921–1924 (Santa Fe); AAA 1925–1929 (New York City and Santa Fe); AAA 1931–1933 (Santa Fe); Bénézit; Fielding; Havlice; Mallett; WWAA 1936–1962 (Santa Fe); WWWA; William B. McCormick, "The New Randall Davey," *International Studio*, March 1922, 57–60; Brooks.

During the summer of 1919, when Davey and John Sloan were growing tired of Gloucester, Massachusetts, Davey suggested an excursion to Santa Fe. With their wives they set out in Davey's racing car, loaded down with camping gear. (Sloan remembered that when the old Simplex was cruising at 70 miles per hour it sounded like a "soul on its way to hell.")

Arriving at Santa Fe, both families succumbed to her charm. Davey promptly purchased a ranch three miles out Canyon Road for his permanent home. The change in surroundings and pace did not materially change the subject matter of much of Davey's work; horse racing and polo scenes and portraits continued to predominate.

From 1925 to 1930 Davey taught at the Broadmoor Art Academy in Colorado Springs, Colorado, and he was often in other parts of the country teaching and executing commissions.

Davidson, John (1890–)

B. New York City. Bénézit; Havlice; Mallett Supplement; WWAA 1938–1941 (Hollywood, California).

Davis/Cassady-Davis, Cornelia Cassady (1870–1920)**

B. Cleves, Ohio. D. Cincinnati, Ohio, December 23. Work: Butler Institute of American Art; Santa Fe Collection; Westminster Central Hall, London; El Tovar Gallery,

Grand Canyon; Hubbell Trading Post National Historic Site, Ganado, Arizona; Cincinnati Court House. AAA 1898 (Chicago, Illinois); AAA 1900-1903 (Cleves); AAA 1905-1910 (Cincinnati); AAA 1913 (Cleves); AAA 1915-1919 (Cincinnati); Bénézit; Fielding; Mallett; Hubbell Trading Post National Historic Site.

Following marriage in 1897, Davis and her husband stayed at various places on Southwestern Indian reservations. For awhile they were guests of Lorenzo Hubbell, famous for his hospitality to travelers, especially artists, passing through Northern Arizona.

Being a friend of Hubbell gave artists entrée to Navajo and Hopi homes, enabling them to do paintings of ethnographic as well as artistic importance. Davis, who was a portrait painter of acknowledged talent, now seems better known for her work among these Indians than for her portraits of important persons, among whom is President McKinley.

Davis, Willis E. (–)
AAA 1909-1910 (San Francisco, California); California State Library.

Dawes, Pansy (1885–)
B. Clay Center, Kansas. AAA 1933 (Colorado Springs, Colorado); Bénézit; Havlice; Mallett; WWAA 1936-1939 (Woodland Park, Colorado); WWAA 1940-1941 (Colorado Springs; summer: Woodland Park).

Day, Richard W. (1896-1972)
B. Canada. D. Los Angeles, California, May 23. Mallett (Hollywood, California); *London Studio,* February 1934, 67.

Dean, Eva Ellen (1871-1954)
B. Storm Lake, Iowa. D. Los Angeles, California, May 1. AAA 1931 (Los Angeles; Sioux City, Iowa); AAA 1933 (Los Angeles); Bénézit; Havlice; Mallett; WWAA 1936-1941 (Los Angeles; Sioux City); WWAA 1947-1953 (Los Angeles).

Deane, Keith R. (-)
 AAA 1913 (San Francisco, California).

Deane, Lillian Reubena (1881-)
 B. Chicago, Illinois. AAA 1903-1915 (Chicago); AAA 1917
 -1933 (West Hollywood and Los Angeles, California);
 Fielding; Mallett.

Dearborn, Annie F. (-)
 AAA 1909-1910 (San Francisco, California).

de Boronda, Tulita (1894-)
 B. Monterey, California. Work: Monterey Public Library;
 Oak Grove Grammar School, Monterey. Havlice; Mallett
 Supplement; WWAA 1940-1941 (Monterey).

Debouzek, J. A. (-)
 AAA 1915-1917 (Salt Lake City, Utah).

De Conte, Fortune (-1897)
 B. France. D. San Francisco, June 24. San Francisco *Call,*
 June 25, 27, 30, 1897; Hartley.

 The "sad struggle against want" ended for De Conte in
San Francisco where he had brought his wife and two children six
months previously. A competent and well-trained painter, De
Conte had hoped to make a living there. He was unsuccessful, as
were most artists of that city at that time, only more so. His
deprivations contributed to his early death.

 De Conte was born Carlos Santa Cour de Conte of royal
family. Prior to working as a draughtsman in the United States
Navy, he lived in Brazil. He was far from being an unknown art-
ist, for he had done work for William Astor and Russell Sage, and
for *Appleton's* and *Leslie's* publications. Three years before his
death he was dean of the art department and professor of art at
the University of Southern California. According to his wife, a
faction seeking control of the University caused the president to
resign and her husband to lose his position.

 De Conte's paintings were on display in San Francisco at
an exhibition following his death. Some were sold, the purpose of
the exhibition being to raise money for De Conte's destitute fami-

ly. Artists William Keith and Amadee Joullin were among the principal promoters of the affair.

DeFrasse, Louise (-)
AAA 1909–1910 (San Francisco, California)

De Joiner, Luther Evans (1886–1955)
B. Switzer, Kentucky. D. Santa Cruz, California, December 25. Bénézit; Havlice; Mallett Supplement; WWAA 1936–1941 (Ben Lomond, California); WWAA 1947–1953 (Santa Cruz, California). De Joiner specialized in California landscapes.

De La Harpe, Joseph (c.1850–1901)
B. Switzerland. D. Brooklyn, New York, February 11. AAA 1903*; Mallett; Denver Public Library.
According to the 1903 obituary, De La Harpe had lived in Salt Lake City and New York.

Delano, Annita (1894–)
B. Hueneme, California. Work: Los Angeles Museum. AAA 1929–1933 (Los Angeles, California); Bénézit; Havlice; Mallett; WWAA 1936–1953 (Los Angeles); *Archives of American Art Journal*, Smithsonian Institution, vol. 15, #3, 1975, 19–20; *New Mexico* Magazine, September 1938, 23, 42.
Delano is a founder of the art department of UCLA where she taught many years. Of particular importance here are her Southwest desert and Indian paintings, made primarily in the 1930s when she was a frequent visitor to New Mexico.
Recently Delano donated her personal papers and records to the Archives of American Art to be made available to researchers. Such material is microfilmed for use at selected art centers in cities throughout the United States.

Deming, Mabel Reed (1874–)
B. San Francisco, California. AAA 1903 (San Francisco).

De Saisett, Ernest Pierre (–1899)
B. San Jose, California. D. San Jose. AAA 1900*; Mallett;

San Francisco Public Library, San Francisco Art & Artists Scrapbook, vol. II, 61.

De Saisett, who studied art in Paris, was a patron of the arts for whom De Saisett Gallery at the University of Santa Clara is named. He is also known for the portraits he painted of his San Jose contemporaries.

Dethloff, Peter Hans (1869-)
B. Barnsdorf, Germany. Work: St. Mary's Academy Chapel, Salt Lake City, Utah. AAA 1915-1919 (Salt Lake City); AAA 1921-1933 (Hollywood and Los Angeles, California); Fielding; Havlice; Mallett; WWAA 1936-1941 (Los Angeles).

Deutsch, Boris (1892-)
B. Krasnogorka, Lithuania, Russia. Work: Palace of the Legion of Honor; Mills College; Portland (Oregon) Museum of Art; Carnegie Institute; Denver Art Museum; San Diego Fine Arts Museum. AAA 1931-1933 (Los Angeles, California); Fielding; Havlice; Mallett; WWAA 1936-1962 (Los Angeles).

De Ville, E. George (1890-1960)
B. Appleton, Wisconsin. D. St. Johns, Arizona, April 29. Albuquerque Public Library; Evalyn Hickman, Colorado State University.

De Ville is best remembered for his sand paintings for which he used much the same method as that used by Southwest Indian artists. A painting entitled "Rainbow Bridge" is inscribed as follows: "Hand made: Employing sand, ground rock and minerals as the color medium." He specialized in Western New Mexico and Grand Canyon subjects, including among his portraits some of the old time Indians and pioneers of that region. He was a resident of St. Johns when he died, but had probably lived in Flagstaff, Arizona, and Gallup, New Mexico, during much of his career.

Dewey, Alfred James (1874-)
B. Tioga, Pennsylvania. AAA 1915 (Pleasantville, New York); AAA 1921-1924 (New York City); AAA 1925

(Pleasantville); *Who's Who in California* (Sierra Madre). This illustrator for *Life, Harpers, Century, Judge,* and various novels founded the Old Adobe Art School in Sierra Madre where he began teaching in 1936.

De Wolfe, Sarah Bender (-)
Work: Oakland Museum. AAA 1909-1910 (San Francisco, California); California State Library. During early years, this artist was known as Sarah E. Bender.

De Young, Harry Anthony (1893-1956)**
B. Chicago, Illinois. D. January 15. Work: Chicago Public Schools; Hammond (Indiana) High School; Witte Memorial Museum and Museum of the Alamo, both in San Antonio, Texas. AAA 1917-1927 (Chicago); AAA 1929-1933 (San Antonio); Fielding; Havlice; Mallett; WWAA 1936-1953 (Boerne, Texas); WWWA; O'Brien.

Before moving to San Antonio in 1928, De Young taught in Wisconsin at Bailey's Harbor School of Art and directed Midwest Summer School of Art in Paw Paw, Michigan. In San Antonio he established his own school. He also started outdoor painting classes at Eagle Pass, Abilene, and Boerne, Texas; in Mexico and New Mexico; and he established De Young Painting Camp in the Davis Mountains.

De Young was an honor student at the Art Institute of Chicago, and a winner of prizes for landscapes and other paintings. Among his Texas paintings are a mural of the Basket-maker Indians of West Texas, several large oils, and a water color—all located at Witte Memorial Museum in San Antonio.

Dixon, Ethel (-1916)
B. North Dakota. D. East India, September 14. Work: Art Institute of Chicago; New York Institute of Art. O'Brien.

Little has been written about this artist who lived in Waco, Texas, at the turn of the century, and whose bluebonnet paintings were used on the first bluebonnet postcards. In addition to her training under Eleanor Wragg, who was on the staff at Baylor University, and Charles Hudson Cox, Dixon studied in New York where she earned two scholarships.

Following marriage, Dixon moved to Canada, and later to India where she was a missionary.

Dodge, Arthur Burnside (1865–1952)

AAA 1917–1925 (Los Angeles, California).

Dodge, who worked on the *Times,* was a member of the California Art Club and the Print Makers of Los Angeles.

Dodge, William L./W. De Leftwich (1867–1935)

B. Liberty, Virginia. D. New York City, March 25. Work: National Collection of Fine Arts; Teachers College, Cedar Falls, Iowa; Metropolitan Museum of Art; National Academy of Design; Kenosha (Wisconsin) Court House. AAA 1898 (Paris, France); AAA 1900–1933 (New York City); Bénézit; Fielding; Havlice; Mallett; WWAA 1936–1937*; WWWA (Setauket, Long Island, New York); *Kennedy Quarterly,* June 1975, 82, 119.

Dodge, whose work is in many hotels and theatres, is best known for his murals.

Doke, Sallie George Fullilove (–)

B. Keachie, Louisiana. AAA 1917 (Alma, Texas); AAA 1919–1921 (Lometa, Texas); Fielding.

Doke, who was a member of the Society of Independent Artists, studied at Cincinnati Art Academy and Chicago Academy of Fine Arts. In 1916 she won a gold medal at an exhibition in Dallas.

Dolan, Nellie Henrich (1890–)

B. Hurley, South Dakota. Stuart.

Dolan, who lived mostly in Beresford, South Dakota, studied in Iowa and Minnesota. She has exhibited at the Sioux Empire Fair in Sioux Falls, South Dakota.

Dolecheck, Christine A. (1894–)

B. Dubuque, Iowa. AAA 1933 (Ellsworth, Kansas); Havlice; Mallett; WWAA 1936–1937 (Ellsworth).

Doran, Robert C. (1889–)

B. Dallas, Texas. AAA 1915 (Dallas, Texas); AAA 1917–1921 (New York City); Fielding.

Dorgeloh/Dorgelon, Marguerite Redman (1890–)

B. Watsonville, California. Work: San Francisco Museum

of Art. Havlice; Mallett Supplement; WWAA 1940-1941 (San Francisco, California).

Dorney, Genevieve (1898-1965)
B. Gilman City, Missouri. D. Madison, South Dakota. Work: Mundt Library, Dakota State College. Stuart.

Dorney, who lived at Madison, was professor of art and head of the art department at Dakota State College from 1923 to 1965. In 1935 she published *Teaching of Art.* She had studied art in Chicago, Kansas City, and Denver; and in 1931 she received her MFA at Columbia University.

Dosch, Roswell (-)
AAA 1913 (Hillsdale, Oregon).

Douglas, Aaron (1899-)
B. Topeka, Kansas. Work: Fisk University Library, Nashville; Sherman Hotel, Chicago; New York Public Library; YMCA, New York City. Havlice; Mallett; WWAA 1936-1941 (New York City).

Douglas, Haldane (1893-)
B. Pittsburgh, Pennsylvania. Work: National Collection of Fine Arts. AAA 1925-1931 (Los Angeles, California; summer: Monterey, California); AAA 1933 (Address unknown); Bénézit; Mallett; *The Art Digest*, Mid October 1928, 7.

Douglas studied with Armin Hansen in California and with Andre L'Hote in Paris, France. He was a member of the California Art Club, California Painters and Sculptors, and Laguna Beach Art Association. In a review of his work for *The Art Digest*, critic Arthur Millier stated that he had "gone modern."

Douglass, Ralph Waddell (1895-1971)
B. St. Louis, Missouri. D. Albuquerque, New Mexico, May 29. Work: Coronado Library, University of New Mexico; American University, Cairo, Egypt; Highland High School, Albuquerque. Havlice; WWAA 1947-1962 (Albuquerque); Ina Sizer Cassidy, "Art and Artists of New Mexico," *New Mexico* Magazine, May 1946, 24, 49; Albuquerque Public Library.

Ranch life and mountain scenes near Albuquerque were Douglass's specialties, partly because of their proximity to his work. For Douglass had a demanding schedule at the University of New Mexico from 1929 to 1961, including ten years as department head. During summers, he painted many Eastern landscapes.

Douglass is also known for the calligraphic designs he did for sacred and secular books and for his own book, *Calligraphic Lettering,* published by Watson-Guptill.

Downes, John Ireland Howe (1861-1933)

B. Derby, Connecticut. D. New Haven, Connecticut, October 16. Work: National Gallery. AAA 1909-1931 (New Haven); Fielding; Mallett; *The Art Digest,* March 1, 1931, 17, and November 1, 1933, 18.

This landscape painter traveled to many places for his subjects, including California, France, Spain, and Italy.

Drake, Will Henry (1856-1926)

B. New York City. D. Los Angeles, California, January 23. AAA 1898-1919 (New York City); AAA 1921-1926* (Los Angeles); Bénézit; Fielding; Mallett; WWWA.

Drake specialized in the painting of animals.

Dudley, Katherine (1884-)

Work: Municipal Art Commission of Chicago; Art Institute of Chicago. AAA 1913-1917 (Chicago, Illinois); Mallett; Robertson and Nestor.

Dudley probably was living in Santa Fe by 1917, for she is referred to as a Santa Fe painter who exhibited in the opening show at the Museum of New Mexico in November of that year.

DuMond, Frank Vincent (1865-1951)

B. Rochester, New York. D. New York City, February 6. Work: National Academy of Design; Portland (Oregon) Art Museum; Denver Art Museum; Lotos Club; Public Gallery, Richmond, Indiana; San Francisco Public Library. AAA 1898 (Paris, France); AAA 1900 (New York City and Paris); AAA 1903-1933 (New York City; Briarcliff Manor, New York; Lyme, Connecticut); Bénézit; Field-

ing; Havlice; Mallett; WWAA 1936–1941 (Chicago, Illinois; summer: Chesterton, Indiana); WWAA 1947 (Lyme); WWWA; Herbert E. Abrams, "The Teachings of Frank Vincent DuMond," *American Artist,* March 1974, 64–66.

Dunlap, (Adele) Helena (1876–1955)**
B. Los Angeles, California. D. Whittier, California, May 1. Work: Santa Fe Collection; San Diego Fine Arts Gallery; Los Angeles Museum. AAA 1905–1910 (Philadelphia, Pennsylvania); AAA 1913–1921 (Whittier; Paris, France); AAA 1923–1933 (Los Angeles and Paris); Bénézit; Fielding; WWAA 1936–1941 (Fullerton, California); *El Palacio,* November 16, 1918, 236.

An inveterate traveler, Dunlap painted for months at a time in many places throughout the world. In this country she painted mainly in the Southwest, principally Southern California. From 1916 to 1918 she spent summers in Taos, New Mexico, in order to portray the Spanish Americans living there. During those years she exhibited in Santa Fe.

Considered a modernist at a time when realism was more fashionable in the West, Dunlap exhibited regularly in Los Angeles, but not elsewhere. She also exhibited regularly in Paris.

Dunlap, Mary Stewart (1846–)**
B. Ohio. AAA 1909–1910 (Los Angeles, California); Fielding; Havlice; Mallett; Martin T. Shepard, "The Landscape Painting of Mary Stewart Dunlap," *Arts and Decoration,* July 1912, 327–328.

The work of this artist was sufficiently important at the turn of the century to attract favorable comment in widely-read art periodicals.

Much of Dunlap's training was in Paris where she studied for a time with Whistler. Prior to moving to Southern California to paint the atmospheric effects for which the Coastal Southwest is known, she specialized in landscapes of Brittany and Normandy. Dunlap's move to California in 1906 was occasioned by her belief that an even wider diversity of material awaited her there.

Dustin, Silas S. (1855–1940)
B. Richfield, Ohio. D. Los Angeles, California, September

24. Work: Seattle Museum of Art; Berkshire Athenaeum and Museum, Pittsfield, Massachusetts. AAA 1898-1913 (New York City); AAA 1915-1921 (Westport, Connecticut); AAA 1923-1933 (Los Angeles, California); Fielding; Mallett; WWAA 1936-1941 (Los Angeles).

E

East, Pattie Richardson (1894-)**

B. Hardesty, Oklahoma. Work: National Collection of Fine Arts; mural, Shady Oaks Country Club, Fort Worth. AAA 1933 (Fort Worth, Texas); Havlice; Mallett; WWAA 1936-1962 (Fort Worth); O'Brien.

East studied with well-known artists in New Mexico, Colorado, California, and Texas, and at the Art Institute of Chicago. After moving from New Mexico to Texas she did considerable sketching in the Big Bend Country, one of the state's most scenic areas.

Easterday, Sybil Unis (1876-1961)

B. San Jose, California. D. California, October 9. Work: San Mateo County Historical Museum. Betty Lochrie Hoag's article in San Mateo County Historical Association publication *La Peninsula,* October 1971, 8-15.

Easterday was 16 when she studied painting for a year with Juan B. Wandesforde, a San Francisco artist. Then she attended Mark Hopkins Institute of Art where she studied sculpture and painting.

Except for the years 1903 to 1905 when Easterday lived in Mexico, her home was the San Francisco Bay area, in towns then known as Haywards and Mayfield (later Hayward and Palo Alto), the present city of San Jose, and a small community known as Tunitas Glen in San Mateo County.

Easton, Frank Lorence (1884-1952?)

B. Elmira, New York. Havlice; Mallett; WWAA 1940-1941 (Denver, Colorado; summer: Foxton, Colorado); WWAA 1947 (Denver); Denver Public Library.

Eastwood, Raymond James (1898-)

B. Bridgeport, Connecticut. Work: Wichita Art Association; Tulsa University; Philbrook Art Center; University of Kansas; Baker University; Cornell University; Elisabet Ney Museum, Austin, Texas; Witte Memorial Museum, San Antonio. AAA 1923-1933 (Lawrence, Kansas; summer: Bridgeport; Provincetown, Massachusetts); Bénézit; Havlice; Mallett; WWAA 1936-1962 (Lawrence).

Eckford, Jessiejo (1895-)

B. Dallas, Texas. Work: Elisabet Ney Museum, Austin; Witte Memorial Museum, San Antonio; North Texas Agricultural College, Arlington. AAA 1921-1933 (Dallas); Bénézit; Fielding; Havlice; Mallett; WWAA 1936-1941 (Dallas); O'Brien.

Eckford painted mainly in Texas, New Mexico, and Mexico. Until the early 1930s she worked in oils; thereafter she turned to water colors and woodblocks. Thirty woodblock prints, including some in full color, were exhibited in January 1934 at Joseph Sartor Galleries in Dallas, each edition running from 10 to 20 prints.

Eckford exhibited primarily in Texas and with Northwest Printmakers of which she was a member.

Edens, Annette (1889-)

B. Bellingham, Washington. AAA 1921-1929 (Seattle, Washington; summer: Bellingham, from 1923); Havlice; Mallett Supplement; WWAA 1940-1941 (Cincinnati, Ohio; summer: Bellingham); WWAA 1947-1953 (Bellingham).

Edgerly, Beatrice (-1973)

B. Washington, D.C. D. June 13. Work: Pennsylvania Academy of Fine Arts. AAA 1917-1925 (Philadelphia, Pennsylvania); Havlice; Mallett; WWAA 1936-1941

(Trenton, New Jersey); WWAA 1947-1973 (Tucson, Arizona); WWWA.

Edie, Fern Elizabeth (See: Knecht, Fern Edie)

Edmiston/Edminston, Alice R. (–)
B. Monroe, Wisconsin. Work: Vanderpoel Art Association; Lincoln (Nebraska) Public Schools. AAA 1915-1933 (Lincoln); Bénézit; Havlice; Mallett; WWAA 1936-1941 (Lincoln).

Eisele, Christian/Carl/Charles (–1919)
B. Germany. Work: Denver Public Library Western History Collection. AAA 1900 (Salt Lake City, Utah). Eisele was a member of the Society of Utah Artists.

Eisenlohr, Edward G. (1872-1961)**
B. Cincinnati, Ohio. D. Dallas, Texas, June 6. Work: Dallas Museum of Fine Arts; Elisabet Ney Museum, Austin; Delgado Museum of Art, New Orleans; Witte Memorial Museum, San Antonio; Museum of Fine Arts, Abilene; Houston Museum of Fine Arts. AAA 1907-1933 (Dallas); Fielding; Havlice; Mallett; WWAA 1936-1959 (Dallas); O'Drien.
In October 1933, Eisenlohr exhibited 10 lithographs at Joseph Sartor Galleries in Dallas, the subjects of which were found within 10 minutes of his home. It was typical of Eisenlohr to depict familiar scenes, whether in Texas, New Mexico, or elsewhere. The distinctive touch he gave them brought national recognition when he was one of six Texas artists whose works were shown at a Museum of Modern Art exhibition entitled "Painting and Sculpture from Sixteen American Cities."
A writer as well as a painter, Eisenlohr has written "Study and Enjoyment of Pictures," "Tendencies in Art and Their Significance," and "Landscape Painters."

Elder, Inez Staub (1894-)
B. Kosuth, Ohio. Work: Texas Woman's University; Peabody School, Dallas. AAA 1933 (Dallas, Texas); Havlice; Mallett; WWAA 1936-1962 (Dallas); O'Brien.
Elder, who moved to Dallas about 1920 following her mar-

87

riage, has won a number of prizes for portraits and still life subjects.

Ellis, Clyde Garfield (1879-1970)
B. Humboldt, Kansas. D. Los Angeles, California, September 6. Work: Park Central Hotel, New York City; St. James Protestant Episcopal Church, Fordham, New York. AAA 1925, 1931-1933 (Los Angeles); Bénézit; Havlice; Mallett; WWAA 1936-1941 (Los Angeles).

Elms, Willard F. (-)
Work: Santa Fe Collection. AAA 1925 (Chicago, Illinois).
Little is known about this artist who became attracted to the Southwest and established a studio at Tucson, Arizona.

Elshin, Jacob Alexander/Alexandrovitch (1892-)
B. Petrograd, Russia. Work: Seattle Art Museum; Seattle Public Schools; Smithsonian Institution; Denver Art Museum; National Collection of Fine Arts; Washington State College; Cornish School of Art and Music, Seattle. AAA 1929-1933 (Seattle); Bénézit; Havlice; Mallett; WWAA 1936-1962 (Seattle); *Who's Who in Northwest Art.*

Enser, John F. (1898-)
B. Ennis, Texas. Work: City Hall, Brockton; Cary Library, Lexington, Massachusetts; Boston Post Office. AAA 1931 -1933 (San Antonio, Texas; summer: Lexington); Bénézit; Havlice; Mallett; WWAA 1936-1937 (same as AAA); WWAA 1938-1941 (Lexington); O'Brien.

Eresch, Josie (1894-)
B. Beloit, Kansas. Work: Chanute Public Library, Kansas. AAA 1932-1933 (Beloit); Havlice; Mallett; WWAA 1936-1962 (Beloit); Denver Public Library; The Kansas *Magazine News,* vol. 1, #1, 1, in which Eresch is referred to as the artist-banker from Beloit who designed the Kansas Magazine Publishing Association's hallmark. The subject was buffalo grazing on the Kansas prairie. Eresch is the author of *Come Up and See My Etchings,* published in 1938.

Ernst, Max (1891–1976)

B. Bruhl, Germany. D. Paris, France, April 1. Bénézit; Havlice; Mallett; WWAA 1953 (Sedona, Arizona).

Ernst lived in Sedona during the late 1940s and early 1950s.

Escherich, Elsa F. (1888–)

B. Davenport, Iowa. AAA 1917–1933 (Los Angeles and Pasadena, California); Bénézit; Mallett.

Escherich studied with Vanderpoel, Hawthorne, and Wolcott. She was a member of the California Art Club, West Coast Arts, Inc., and the Los Angeles Art League.

Euler, (Edwin) Reeves (1896–)

B. De Lamar, Nevada. AAA 1923–1924 (Brooklyn, New York; summer. Provincetown, Massachusetts); Havlice; Mallett; WWAA 1936–1941 (Washington, D.C.; summer: Provincetown); WWAA 1947–1962 (Provincetown); *Who's Who in Northwest Art:* Boise Public Library.

Evans, Anne (–)

AAA 1915–1929 (Denver, Colorado); Denver Public Library; Bromwell, pages 6, 7, 22.

Anne Evans was the daughter of a Colorado governor. She began exhibiting with the Denver Artists' Club in 1893. She was also a member of the American Federation of Arts.

Evans, Jessie Benton (1866–1954)**

B. Akron, Ohio. D. Phoenix, Arizona. Work: Santa Fe Collection; Phoenix Art Museum; Phoenix Public Schools, Country Club, and Municipal Collection; Public School Art Societies, Chicago; College Club, Chicago; Vanderpoel Art Association. AAA 1905–1910 (Chicago); AAA 1913 (Paris, France); AAA 1915–1919 (Chicago); AAA 1921–1933 (winter: Scottsdale, Arizona); Bénézit; Fielding; Havlice; Mallett; WWAA 1936–1941 (Scottsdale, Arizona); WWWA; Florence Seville Berryman, "An Artist of the Salt River Valley," *American Magazine of Art,* August 1929.

About 1911 the Salt River region of Arizona became Evans's specialty as a result of a doctor's suggestion that she

spend time in a warm, dry climate to ward off serious illness. Evans found Arizona's desert climate so beneficial she urged her family to make Scottsdale their winter home. Ultimately it became their year-round home, and Evans became one of the state's best known painters.

What is it about the Arizona desert that attracts so many artists? Evans told Berryman that for her it was the desert's illusiveness: "It never allows one to work in an imitative way, which would certainly rob it of its charm."

Everett, Elizabeth Rinehart (–)
> B. Toledo, Ohio. AAA 1929-1933 (Seattle, Washington); Bénézit; Havlice; Mallett; WWAA 1938-1962 (Seattle); *Who's Who in Northwest Art.*

Everett, Raymond (1885–)**
> B. Englishtown, New Jersey. Work: Detroit Public Library; Elisabet Ney Museum, Austin, Texas; University of Colorado Museum. AAA 1923-1933 (Austin); Bénézit; Fielding; Havlice; Mallett; WWAA 1936-1941 (Austin); O'Brien.

Everett's versatility as an artist is well known in Texas where, according to O'Brien, he began teaching drawing and painting at the University in Austin in 1915. He worked in water color, oil, tempera, and pastel; he etched, designed bookplates, carved wood, and sculpted; he was also one of the architects who had been awarded the Appelton Teaching Fellowship at Harvard.

Everett exhibited widely, and his work—especially his bookplates—brought him recognition here and abroad.

F

Fabian, Lydia Dunham (1857–)
> B. Charlotte, Michigan. Work: Santa Fe Collection. AAA

1919-1933 (Chicago, Illinois); Bénézit; Fielding; Mallett; Hewett, 1918.

Fabian, who was a member of Santa Fe Society of Artists, was represented in the opening exhibition of the Museum of New Mexico with a painting entitled "The Inner Court." Oil paintings entitled "Hopi Girl with Plaque" and "Laguna Girl Shelling Corn" are in the Santa Fe Collection.

Failing, Ida C. (-)
AAA 1898, 1915-1925 (Denver, Colorado). Denver Public Library; Bromwell, 5, 6, 21, 23, and 46.

Failing began exhibiting with the Denver Artists' Club in 1894.

Faille, Carl Arthur (1883-1952?)
B. Detroit, Michigan. Work: Joslyn Memorial Museum; Detroit Institute of Art; Albany Institute of History and Art. AAA 1925 (Brooklyn, New York; summer: Bonney Doon, Santa Cruz County, California); AAA 1929 (San Diego, California; Columbus, Ohio); AAA 1931 (San Diego; Michigan City, Indiana); AAA 1933 (San Diego; Ligonier, Pennsylvania; Parksdale, Oregon); Bénézit; Havlice; Mallett; WWAA 1936-1939 (Parksdale); WWAA 1940-1941 (Hartford, Connecticut); WWAA 1947 (Clarksdale, New York); WWAA 1953 (Gloucester, Massachusetts); "Faille, the Dante of an Animal Kingdom," *The Art Digest*, October 1, 1937, 16.

Faille was a self-taught artist whose imaginative works brought him considerable recognition. His life as a "mountain hermit-painter" took him to many a mountain top. The imaginative works exhibited in New York City during October 1937 were inspired by a dream Faille experienced following a frightening thunderstorm in Grand Valley, Idaho, near the Teton Mountains.

Fallis, Belle S. (-)
AAA 1898-1900 (Denver, Colorado); Bromwell, page 6; Denver Public Library.

Fallis, who was a member of the Artists' Club of Denver, exhibited there in 1894, and perhaps later.

Farrington, Walter/Walter Farrington Moses (1874–)
B. Sterling, Illinois. Havlice; Mallett Supplement; WWAA
1940-1953 (Los Angeles, California).

Fay, Nellie (1870–)
B. Eureka, California. AAA 1913 (Sacramento, California);
AAA 1915-1921 (San Francisco, California); Fielding;
Mallett.
Fay, a pupil of Arthur F. Mathews and Emil Carlsen, was a
member of the San Francisco Sketch Club and Kingsley Art Club.

Fazel, John Winfield (1882–)
B. Pleasant Hill, Wisconsin. AAA 1925 (Topeka, Kansas);
Havlice; Mallett Supplement; WWAA 1936-1941
(Topeka).

Feitelson, I. Lorser (1898–)
B. Savannah, Georgia. Bénézit; Havlice; Mallett; WWAA
1940-1941 (Los Angeles, California).

Fenyes, Eva Scott (1846-1930)
B. New York. Work: Southwest Museum, Los Angeles.
Kovinick; Isabel Lopez de Fages, *Thirty-two Adobe
Houses of Old California*. Los Angeles: Southwest
Museum, 1950.
In 1898 publisher-writer Charles Lummis suggested to
Fenyes that the old missions and adobe houses of early Spanish-
speaking Californians should be painted by an artist. Fenyes
agreed, and during the three decades that followed she painted
virtually all these buildings between San Diego and Sonoma,
often reaching them by wagon over rough and sometimes non-
existent roads.
Following Fenyes's death, 301 of her historic watercolor
paintings were given to the Southwest Museum. In 1950 the
Museum published 32 of them, each with an account of the build-
ing's origin and subsequent use.

Ferguson, Elizabeth Foote (1884–)
B. Omaha, Nebraska. AAA 1917 (Omaha); AAA 1919-
1921 (Chicago, Illinois; summer: Bay View, Michigan);

AAA 1923-1925 (Milwaukee, Wisconsin; Chicago; Bay View); Fielding.

Ferguson, who studied at the Art Institute of Chicago and the Pennsylvania Academy of Fine Arts, was an alumna of the Art Institute and a member of the Omaha Art Guild.

Ferguson, Lillian Prest (1869–1955)
B. Windsor, Ontario, Canada. D. Los Angeles, California, February 2. Work: Vanderpoel Collection, Chicago; Palace of the Legion of Honor, San Francisco; San Diego Fine Arts Society; Pasadena Art Institute. AAA 1919–1927 (Laguna Beach, California); AAA 1929–1933 (Hollywood, California); Bénézit; Fielding; Havlice; Mallett; WWAA 1938–1941 (Burbank, California); WWAA 1947–1953 (Los Angeles).

Finta, Alexander S. (1881–1958)
B. Turkeve, Hungary. D. August 3. AAA 1929–1933 (New York City; summer: Hellertown, Pennsylvania); Bénézit; Havlice; Mallett; WWAA 1936–1939 (New York City; summer: Hellertown); WWAA 1940–1956 (Los Angeles, California); WWWA.

Finta, who illustrated for various book publishers and wrote several books, was primarily a sculptor.

Firebaugh, Nettie King (–)
B. Oakland, California. AAA 1915–1917 (San Francisco, California).

Firks, Henry (–)
Work: Bancroft Library; Newport (Rhode Island) Historical Society. Groce and Wallace; *Kennedy Quarterly,* June 1967, 102–103.

This little-known painter did a view of San Francisco when he was there in 1849.

Fisher, Howard (1889–)
B. Santa Fe, New Mexico. Work: Huntington Library. Havlice; Mallett Supplement; WWAA 1938–1953 (Portland, Oregon). Fisher was active primarily as a cartoonist.

Fisher, H. Melville/Hugo Melville (1878-1946)

B. Brooklyn, New York. D. Alameda, California. Work: Butler Institute of American Art; Oakland Museum; Reading (Pennsylvania) Public Museum and Art Gallery. AAA 1921-1931 (New York City); Bénézit; Fielding; Edward K. Rogers; Richard Kerwin; Paul Faberman.

Fisher's American landscapes usually were of coastal and autumn scenes and sand dunes. His sand dune subjects, exhibited in New York City in the early 1920s, were described by Peyton Boswell as "so soft and subtle that they appeal immediately to all who are fond of Whistler and Cazin. . . ."

Fisher grew up in Alameda, California. After many years in Paris and New York he returned to Alameda in 1938 to spend the remaining years of his life.

Fisken, Jessie (1860-)

B. Row, Scotland. AAA 1898-1900 (Seattle, Washington); AAA 1921-1925 (Seattle; summer: Winslow, Washington); Fielding.

Fisken, who studied at Glasgow School of Art in Scotland, was a member of the Seattle Fine Arts Society.

Fitzgerald, James (1899-)

B. Boston, Massachusetts. AAA 1931-1933 (Monterey, California); Bénézit; Havlice; Mallett; WWAA 1936-1941 (Monterey; summer 1940-1941: Monhegan, Maine).

Fjellboe, Paul (-)

AAA 1915 (Salt Lake City, Utah).

Folawn, Thomas Jefferson (1876-)

B. Youngstown, Ohio. AAA 1921-1933 (Boulder, Colorado; summer: Santa Fe, New Mexico); Bénézit; Fielding; Havlice; Mallett; WWAA 1936-1937.

Foltz, Lloyd Chester (1897-)

B. Potawattomie County, Kansas. Work: Bethany College; Thayer Museum, University of Kansas, Lawrence; East High School, Wichita; Art Guild, Topeka. AAA 1929-1931 (Wichita, Kansas); Bénézit; Havlice; Mallett; WWAA 1936-1941 (Wichita).

Force, Clara G. (1852-1939)
B. Erie, Pennsylvania. D. April 8. AAA 1907-1927 (Erie); AAA 1929-1933 (Pasadena, California); Bénézit; Havlice; Mallett; WWAA 1936-1939 (Pasadena).

Foresman, Alice Carter (1868-)
B. Darien, Wisconsin. Work: California State Building, Exposition Park. AAA 1915-1921 (Seattle, Washington); AAA 1925 (Hollywood, California; summer: Portland, Oregon); AAA 1929 (Los Angeles); AAA 1931-1933 (Hollywood; summer 1931: Portland); Bénézit; Fielding; Havlice; Mallett; WWAA 1936-1941 (Hollywood; summer; Portland); WWAA 1947-1953 (Portland); *Who's Who in Northwest Art.*

Forkner, Edgar (1867-1945)
B. Richmond, Indiana. D. July 7. Work: Art Institute of Chicago; Indianapolis Museum of Art. AAA 1903-1915 (Chicago); AAA 1919-1933 (Seattle, Washington); Bénézit; Fielding; Havlice; Mallett; WWAA 1936-1941 (Seattle); *Who's Who in Northwest Art;* "Seattle Venture," *The Art Digest,* July 1, 1931, 7. *American Magazine of Art,* June 1927, 330-331.

Forman, Kerr Smith (1889-)
B. Jacksonville, Illinois. Work: Des Moines Women's Club. AAA 1929-1933 (Des Moines, Iowa); Havlice; Mallett; WWAA 1936-1937 (Des Moines); WWAA 1938-1941 (El Paso, Texas).

Forster, Washburne (1884-)
B. Versailles, Missouri. Fisher.
In 1936 Forster moved to Hatch, New Mexico, where he was still painting in 1947, and perhaps later.

Foster, Bertha Knox (1896-)
B. Hymer, Kansas. AAA 1931-1933 (Glendale, California); Bénézit; Havlice; Mallett; WWAA 1936-1941 (Glendale).

Foster, Grace (1879-1931?)
B. Wolfe City, Texas. D. November 19. AAA 1929-1933

(Greenville, Texas; summer 1929: Abilene, Texas); Bénézit; Mallett; O'Brien.

Foster specialized in painting wild flowers, ultimately resigning from her teaching position at Burleson College to paint full time. She exhibited regularly at Hunt County Fair in Fort Worth and in Dallas.

Foster's early training was with Frank Reaugh, Kate Maddroy, and Zella Webb of Dallas. Later she studied with Ella J. Hobbs at Simmons College in Abilene. She was a member of Southern States Art League.

Foster, Willet S. (1885–)
B. Gouverneur, New York. AAA 1931–1933 (Riverside, California); Bénézit; Mallett; WWAA 1940–1941*.

Fowler, Eva/Evangeline (–1935)
B. Kingsville, Ohio. Work: Hillsdale College; Public Library, Sherman, Texas. AAA 1913–1931 (Sherman); AAA 1933 (Birmingham, Michigan); Bénézit; Havlice; Mallett; WWAA 1936–1937 (Birmingham); O'Brien.

Fowler was active in Texas until she resigned in 1931 as head of the Fine Arts Department of North Texas College (formerly Kyd Kee) in Sherman. O'Brien states that Fowler was the first to plan courses in art history for education systems of the Southwest. In recognition of that contribution the Bureau of University Travel of Boston awarded her a scholarship in 1924 for further study in Europe.

Fowler's career spanned many years. Among other awards she received was the St. Gaudens Medal in 1893 at the Chicago World's Fair. She was active in the Related Arts Club at the College in Sherman and in the Eva Fowler Art League. The Denison (Texas) Art Club awarded her a complimentary life membership.

Fowler was a member of the Southern States Art League from its second year, the College Art Association of America, and the Detroit Society of Women Painters and Sculptors. Her best-known landscapes are of Texas, California, France, and Italy, according to O'Brien.

Francis, Muriel Wilkins (1893–)
B. Longview, Texas. Havlice; Mallett Supplement; WWAA 1940–1962 (Fort Worth, Texas).

Frank, Eugene C. (-1914)

B. Stuttgart, Germany. D. Glendale, California, January 11. AAA 1914* (Glendale); Mallett.

Frank, who specialized in landscapes and marines, began his career as an engraver. He came to the United States in 1861, and began studying painting in New York City in 1874.

Frantz, Alice Maurine (1892-)

B. Wellington, Kansas. Havlice; Mallett; WWAA 1936-1941 (Enid, Oklahoma).

Frazee, Isaac Jenkinson (1858-1942)

D. Laguna Beach, California. Work: Laguna Beach Museum of Art; Festival of Arts of Laguna Beach. Bowers Library, Santa Ana, California.

Frazee made a sketch of Laguna Beach on August 16, 1878, probably the first man to do so. He also did some writing, for he was the author of a pageant play, "Kitshi-Manido," based on an American Indian theme. The play was presented at Laguna Beach in 1921.

Frazier, John Robinson (1889-1966)

B. Stonington, Connecticut. D. Truro, Massachusetts, July 23. Work: Art Institute of Chicago, Rhode Island School of Design; Brooklyn Museum; Kansas City Art Institute; Brown University; Bradley University. AAA 1915-1917 (Peoria, Illinois); AAA 1919-1924 (Lawrence, Kansas); AAA 1925-1933 (Providence, Rhode Island); Bénézit; Fielding; Havlice; Mallett; WWAA 1936-1941 (Providence; summer: Provincetown, Massachusetts); WWAA 1959-1962 (Providence); WWWA.

Free, Mary Arnold (1895-)

B. Pleasant Hill, Missouri. Havlice; Mallett Supplement; WWAA 1936-1937 (Kansas City, Missouri); WWAA 1938-1962 (San Antonio, Texas).

French, Grace Ann (1858-1942)

B. Hopkinton, New Hampshire. D. Rapid City, South Dakota, July 31. Work: Black Hills State College; Massa-

chusetts Institute of Technology; Minnilusa Pioneer Museum, Rapid City; South Dakota Memorial Art Center, Brookings. Mallett Supplement (Rapid City); Stuart.

This well-trained painter and educator taught at Black Hills College in Hot Springs, South Dakota, from 1888 to 1893, and maintained a studio and taught privately in Rapid City from 1900 to 1942.

Frey, Charles Daniel (1881-1959)
B. Denver, Colorado. D. November. AAA 1907-1910 (Chicago, Illinois); WWWA.

Frey, who studied art in Denver and in Paris, was a member of the Bohemian Club in San Francisco. Following employment with the Chicago *Examiner* and the Chicago *Evening Post*, he became an advertising executive.

Friend, Washington F. (1820-1886)
B. England. Work: Boston Museum of Fine Arts; Denver Public Library Western History Collection. Havlice; *Kennedy Quarterly*, June 1968, 63; Smithsonian Institution; Garnier.

Friend did water color paintings of scenes in Utah, Colorado, California, and Montana, probably in the 1870s. "King Solomon Mountain" is the title of the painting in the Western History Collection of the Denver Public Library.

Fritz, Eleanor Virginia (1885-)
B. St. Cloud, Minnesota. Work: Polytechnic High School, Fort Worth, Texas. AAA 1933 (Fort Worth; summer: Los Angeles, California); Havlice; Mallett; WWAA 1936-1941 (Santa Monica, California; Fort Worth); O'Brien.

Launched on her career by winning a box of oil paints as a prize for obtaining subscriptions to a magazine, Fritz later established herself as an artist in Texas and Southern California. Her specialty was landscapes.

Frost, Francis S. (1825-1902)
Kennedy Quarterly, November 1963; Gordon Hendricks, "The First Three Western Journeys of Albert Bierstadt," *The Art Bulletin*, September 1964.

Frost, who lived in Boston, was with Bierstadt in the Lander (Wyoming) Expedition of 1859.

Fuertes, Louis Agassiz (1874–1927)
B. Ithaca, New York. D. near Unadilla, New York, August 22. Work: Cornell University; American Museum of Natural History; U.S. Department of Fish and Wild Life Service. AAA 1905–1925 (Ithaca); Bénézit; Fielding; Mallett; WWWA; Mary Fuertes Boynton, *Louis Agassiz Fuertes*, New York: Oxford University Press, 1956.

From May to late July or early August 1901, Fuertes sketched birds in Texas and New Mexico. His letters indicate that he camped at Usleta, Tornillo Creek, in the Chisos Mountains of Texas, and in the Sacramento Mountains of New Mexico.

Fuller, Adella Ryan (c.1861–　　)
Albuquerque Public Library; Albuquerque *Tribune*, March 15, 1952.

Fuller had lived and studied art in Detroit and Denver before moving to Albuquerque where she was still painting in 1952 at age 91.

Fuller, Alfred (1899–　　)
B. Deerfield, Massachusetts. Havlice; Mallett Supplement; WWAA 1936–1941 (La Jolla, California); WWAA 1947–1962 (Monhegan Island and Port Clyde, Maine).

Fulop, Karoly/Koroly (1898–　　)
B. Hungary. AAA 1921–1924, 1933 (New York City); Havlice; Mallett; WWAA 1940–1941 (Los Angeles, California).

Fulton, Cyrus James (1873–1949)
B. Pueblo, Colorado. D. July 30. Work: Eugene (Oregon) Chamber of Commerce; Eugene YMCA; Salem (Oregon) YMCA. AAA 1923–1933 (Eugene); Fielding; Havlice; Mallett; WWAA 1936–1947 (Eugene); *Who's Who in Northwest Art*.

Furlong, Charles Wellington (1874–1967)
B. Cambridge, Massachusetts. D. October 9. Work: Cor-

nell University; Smithsonian Institution; Baker Library, Dartmouth College. AAA 1903–1906 (Ithaca, New York; New York City); AAA 1907–1933 (Watertown, Newton, Boston, and Cohasset, Massachusetts; summers: 1921–1931 (Pendleton, Oregon); Bénézit; Fielding; Havlice; Mallett; WWAA 1936–1962 (Cohasset and Scituate, Massachusetts); WWWA (Dartmouth College, Hanover, New Hampshire); Umatilla County Library, Pendleton.

Years before Furlong listed his summer address as Pendleton, he had been soaking up the lore of Northwest cattle country and experiencing the life. He had ridden the range of Oregon and Montana, and he had lived with the Blackfeet and the Crow. In 1914 he topped off his pioneering prowess by winning the world's bullriding championship at the Pendleton Round-Up.

In 1921 G. P. Putnam's Sons published Furlong's *Let 'Er Buck/A Story of the Passing of the Old West.* Illustrated by Furlong with pictures of bucking horses, cowboys and cowgirls, Indians, and old-time scouts, the Pendleton Round-Up as it was celebrated in the second decade of this century was made real to many a reader.

As painter, illustrator, writer, and lecturer, Furlong has long been a familiar figure in Western art. But most of his work has been done in other parts of the world where, as explorer and ethnologist, he went to study and write about less publicized inhabitants.

G

Gale, Goddard (–1938)
B. Canada. D. Oakland, California, August 19. Work: Oakland Museum. AAA 1909–1910 (Oakland); Havlice; Mallett Supplement; California State Library; *The Argonaut,* September 2, 1938, 20–2; *The Overland Monthly,* December 1924, 546.

Gale, Jane Green (1898-)
B. Leipzig, Germany. Work: San Diego Fine Arts Gallery; Newport Harbor High School. Havlice; WWAA 1956-1962 (Fresno, California).

Garbett, Cornelia Barns (See: Barns, Cornelia)

Garden-Macleod, Louise E. (See: Macleod, Louise E. Garden)

Garland, Marie T. (1870-)
B. Massachusetts. Fisher; *The Art Digest*, Mid-October 1929, 18.
Garland, who exhibited in Santa Fe at least as early as 1929, settled in Espanola, New Mexico, in 1931.

Garnsey, Julian Ellsworth (1887-)
B. New York City. Work: Decorations, University of California and Public Library in Los Angeles; Union Depot, Ogden, Utah; Stock Exchange, Los Angeles. AAA 1929 1933 (Los Angeles; summer: Hermosa Beach, California); Bénézit; Havlice; Mallett; WWAA 1936-1939 (Los Angeles); WWAA 1940-1941 (Scarsdale, New York); WWAA 1947-1953 (Princeton, New Jersey).

Garrison, Martha [Minta] Hicks (1874-)
B. Center, Shelby County, Texas. AAA 1933 (Houston, Texas); Havlice; Mallett; WWAA 1936-1941 (Houston); O'Brien.

Garth, John (1894-1971)
B. Chicago, Illinois. D. San Francisco, California. Work: Murals, University of California; California State Industrial Commission; Fairmont and Sir Francis Drake Hotels, San Francisco; Miami University. Havlice; Mallett; WWAA 1936-1970 (San Francisco); California State Library.

Gaskin, William (1892-)
B. San Francisco, California. Mallett Supplement; San Francisco Art Commission.

Gaskin's oil painting, "San Francisco Scene," is in the collection of the San Francisco Art Commission on which he served as a Commissioner.

Gaw, Hugh (-)
AAA 1919 (Berkeley, California).

Gay, Mary (-)
B. Oscoda, Michigan. AAA 1907-1908 (Cambridge, Massachusetts; Los Angeles, California).
Gay was a pupil of Benson and Tarbell in Boston, and Lasar, Menard, and Cottet in Paris.

Gearhart, Frances Hammel (-1958)
B. Illinois. Work: Toronto Museum; Rhode Island School of Design; Los Angeles Museum; Delgado Museum; California State Library. AAA 1919-1931 (Pasadena, California); Fielding; Havlice; Mallett; WWAA 1936-1941 (Pasadena).
Gearhart's woodblock prints of Southern California date from 1910.

Geise, Rose M. (1895-)
B. Holmes, Iowa. Stuart.
Geise, who settled in Clark, South Dakota, exhibited at local art festivals and at state fairs.

Geiser, Bernard (1887-)
B. Geuda Springs, Kansas. Work: Seattle Art Museum; Portland (Oregon) Art Museum; churches in Portland, and Gunnison, Colorado. Havlice; Mallett Supplement; WWAA 1940-1962 (Portland); *Who's Who in Northwest Art.*

Gellenbeck, Anna/Ann P. (-)
B. Shakopee, Minnesota. Work: Bellarmine College. AAA 1923-1933 (Tacoma, Washington); Bénézit; Havlice; Mallett; WWAA 1938-1941 (Tacoma); *Who's Who in Northwest Art.*

Gelwicks, Frances Slater (-1915)
D. Oakland, California, February 19. Work: Oakland Museum. AAA 1909-1910 (Oakland); California State Library; San Francisco *Examiner*, February 21, 1915, 29-3.

Gelwicks was a California pioneer who lived many years in Alameda.

Genter/Gentler, Paul Huntington (1888-)
B. Rawlings, Wyoming. Havlice; Mallett Supplement; WWAA 1936-1937 (Colorado Springs, Colorado); WWAA 1938-1941 (Denver).

George, (Helen-) Margaret (-)
B. Blandford, Dorset, England. AAA 1917-1919 (Denver, Colorado); AAA 1921 (Newton Center, Massachusetts); Bénézit; Mallett Supplement; Waters; *El Palacio*, August 15, 1921, 58; *Touchstone*, January 1920, 241-243; Denver Public Library.

George was active in England from about 1925. Her American period started about 1916 when she began exhibiting in Denver with the Artists' Club. Also, during that year, her paintings and sculptures were featured in a joint exhibition with Denver artist Albert Byron Olson.

Subsequently George spent a season in Santa Fe. *Touchstone* commented upon her long stay in the Southwest and reproduced some of her drawings of Navajo, Santo Domingo, and Taos Indians. In August 1921, *El Palacio* referred to her Indian drawings as a "remarkable series."

Gere, Nelle/Nellie Huntington (1859-1949)
B. Norwich, Connecticut. D. Los Angeles, California. Work: University of California, Los Angeles. AAA 1905-1906 (Chicago, Illinois); AAA 1907-1933 (Los Angeles); Bénézit; Fielding; Havlice; Mallett; WWAA 1940-1941 (Los Angeles).

Gerlach, Albert Anthony (1884-)
B. Chicago, Illinois. AAA 1931-1933 (Portland, Oregon); Bénézit; Havlice; Mallett; WWAA 1936-1962 (Portland); *Who's Who in Northwest Art*.

Gerrer, Robert Gregory (1867–1946)

B. Lauterbach, Alsace, France. D. Oklahoma City, Oklahoma, August 24. Work: Oklahoma Historical Building, Oklahoma City; Wightman Memorial Gallery, Notre Dame, Indiana; St. Gregory's Art Gallery and Museum, Shawnee. AAA 1917–1933 (Shawnee, Oklahoma); Bénézit; Fielding; Havlice; Mallett; WWAA 1936–1941 (Shawnee); WWWA; Jacobson and d'Ucel, 273.

Gerrer began sketching landscapes in San Francisco when he was 19. He signed on a small steamer that plied the coastal waters between that city and Victoria, British Columbia. When he had free time from his duties as cook, he sketched scenes along the coast.

Gerrer settled in Oklahoma in 1892, subsequently serving as assistant pastor at St. Benedict in Shawnee. His commitment to art has been expressed in the decoration of churches as well as in the painting of portraits and landscapes. In 1916, he was selected first president of the Association of Oklahoma Artists.

Gerrity/Gerritty, John Emmett (1895–)

B. Mountain View, California. Havlice; Mallett Supplement; WWAA 1940–1941 (San Francisco); California State Library.

Gerstle, Miriam Alice (1898–)

B. San Francisco, California. Work: Murals, Royal Links Hotel and Royal Bath Hotel, England. AAA 1917–1921 (San Francisco; New York City); AAA 1923–1933 (London); Fielding; Mallett; San Francisco Public Library; San Francisco *Chronicle,* April 21, 1946, 1-S.

The artist, who left San Francisco when she was 22, is also known as Miriam Gerstle Warnum.

Ghirardelli, Alida (–)

Work: M. H. De Young Memorial Museum; Oakland Museum; Society of California Pioneers. AAA 1907–1908 (San Francisco, California).

Gibson, Mestre Lydia (1891–)

B. New York City. AAA 1919 (San Francisco, California);

AAA 1923–1924 (New York City); AAA 1929–1933 (Croton-on-Hudson, New York); Mallett.

Gibson was a member of Society of Independent Artists.

Gideon, Samuel Edward (1875–)

B. Louisville, Kentucky. AAA 1900 (Louisville); AAA 1923–1933 (Austin, Texas; summers 1923–1927: Paris, France); Fielding; Havlice; Mallett; WWAA 1936–1941 (Austin); *American Magazine of Art,* December 1925, 680. Gideon wrote *Historic and Picturesque Austin.*

Gilbert, R./Robert (–)

Work: Oakland Museum; National Park Service, Fort Point, San Francisco. California State Library. Gilbert was active in California from about 1880 to 1895.

Gilchrist, Meda (–)

AAA 1919–1925 (Los Angeles, California).

Gildersleeve, Beatrice (1899–)

B. San Francisco, California. AAA 1929–1933 (Felton, California); Mallett.

Gildersleeve was a member of San Francisco Society of Women Artists and Santa Cruz (California) Art League.

Gill, De Lancey (1859–1940)

B. Camden, South Carolina. D. Alexandria, Virginia, August 31. Work: National Collection of Fine Arts; Smithsonian Institution; Cosmos Club. AAA 1900, 1909–1910, 1923–1929 (Washington, D.C.); Mallett; Paul H. Oehser, "De Lancey Gill," Cosmos Club *Bulletin,* July-August, 1977, 4–8.

With little formal education, Gill passed a government examination in 1887 for a position as assistant draftsman in the Supervising Architect's office. Subsequently the artist-scientist William Henry Holmes noticed Gill's artistic ability and helped him obtain illustration work with United States Geological Survey and the Bureau of Ethnology.

During the course of his duties, Gill traveled extensively in Indian Territory, the Arizona desert, and the region of the Upper

Yellowstone River. Three Southwestern watercolor paintings, dated 1888, are in the Smithsonian Collection. They are "Street in the Pueblo of Zuni," "Street in the Pueblo of Oraibi," and "Pueblo Bonito Ruin."

Gill exhibited in various cities and taught art at Corcoran Gallery during its early years. Of his work Holmes said: "As an illustrator in pen, pencil, and watercolor, and as a photographer he has few equals, and his paintings in watercolor and oil take a high rank."

Gillam, William Charles Frederick (1867–)
B. Brighton, England. Work: Hambrook House, Sussex, England; Provincial Normal School, Vancouver, B.C.; Queen Mary High School, Vancouver, B.C.; California State Library. AAA 1925-1933 (Burlingame, California); Havlice; Mallett; WWAA 1936-1941 (Burlingame); California State Library.

Gillette, Frances W. (1880–)
B. Humboldt, Iowa. Work: Mural panels, California Pacific International Exposition, San Diego. Havlice; Mallett Supplement; WWAA 1936-1941 (La Verne, California, summer 1936, Balboa Island).

Gilliam, Marguerite (See: Hubbard, Marguerite Gilliam)

Gimeno, Harold (1897–)
B. New York City. AAA 1923-1924 (Cambridge, Massachusetts; Havlice; Mallett Supplement; WWAA 1940-1941 (Oklahoma City, Oklahoma). Gimeno specialized in landscape painting.

Gimeno, Patricio (1865–)
B. Arequipa, Peru. Work: Governor's Palace, Lima, Peru; Oklahoma State Historical Building; University of Oklahoma Library. AAA 1919-1933 (Norman, Oklahoma); Fielding; Havlice; Mallett; WWAA 1936-1941 (Norman; summers 1940-1941 (Laguna Beach, California); Jacobson and d'Ucel, 270-271.

Girardin, Frank J. (1856-1945)

B. Louisville, Kentucky. Work: Public Gallery, Richmond, Indiana; Marion Art League; Connersville Art League; Queen City Club of Cincinnati; Cincinnati Art Club. AAA 1903-1919 (Richmond); AAA 1921-1925 (Redondo Beach, California); AAA 1931-1933 (Los Angeles); Bénézit; Fielding; Havlice; Mallett; WWAA 1936-1941 (Redondo Beach).

Girardin specialized in painting landscapes throughout his career.

Gjonovich, Miles (1892-)

B. Montenegro, Yugoslavia. Fisher.

Gjonovich settled in Clayton, New Mexico, in 1935.

Goddard, Florence M. ()

AAA 1919 (Fullerton, California); AAA 1921-1925 (Los Angeles).

Goddard was a member of the Print Makers of Los Angeles.

Goeller/Goeller-wood, [Miss] E. Shotwell (1887-)

B. San Francisco, California. Work: Mural, San Mateo Park School. AAA 1917 (San Francisco); AAA 1919 (New York City); Havlice; Mallett Supplement; WWAA 1936-1941 (Sausalito, California); WWAA 1953-1959 (Nevada City, California), in which the artist's name appears as E. Shotwell Wood.

Goldberg, Reuben Lucius (1883-1970)

B. San Francisco, California. Work: Huntington Library, San Marino, California. AAA 1913-1933 (New York City); Fielding; Havlice; Mallett; WWAA 1938-1962 (New York City); WWWA; California State Library.

Goldberg was with the San Francisco *Chronicle* during 1904-1905. Thereafter he was with New York papers as a cartoonist. During the last few years of his life he achieved recognition as a sculptor.

Goldstein, Louise Marks (1899-)

B. Corsicana, Texas. Work: Austin (Texas) College.

Havlice; Mallett Supplement; WWAA 1940-1953 (Sherman, Texas); O'Brien.

Golton, Glenn (1897-)
B. Milton, Kansas. Havlice; Mallett; WWAA 1940-1941 (Wichita, Kansas).

Gonzales/Gonzalez, Boyer (1878-1934)
B. Houston, Texas. D. Galveston, Texas, February 14. Work: Rosenberg Library, Galveston; Galveston Art League and municipal schools of Galveston; Delgado Museum; Witte Memorial Museum; John H. Vanderpoel Art Association, Chicago. AAA 1913-1933 (Galveston); Bénézit; Havlice; Mallett; WWAA 1936-1937*; O'Brien.
Although Gonzales listed his address in art directories as Galveston, most of his career was spent in Woodstock, New York. In 1913 he spent the summer in Pasadena, California. Thereafter he was frequently in the Southwest during winter months, most often in San Antonio. Galveston, he considered his permanent home.
Known primarily as a marine painter, Gonzales used the Gulf of Mexico, the Mediterranean, and the coast of Maine prominently in his work. During four summers in Maine, early in his career, his painting companion was Winslow Homer.

Gonzales/Gonzalez, Xavier (1898-)
B. Almeria, Spain. Work: National Collection of Fine Arts; Dallas Museum of Fine Arts; State Teachers College, Alpine, Texas; murals, Hammond (Louisiana) Post Office; Huntsville (Alabama) Court House; War and Peace Auditorium, San Antonio, Texas. Havlice; Mallett; WWAA 1936-1941 (San Antonio; New Orleans; summer: Alpine); WWAA 1953-1954 (Cleveland); WWAA 1956-1976 (New York City); O'Brien.
Gonzales began his training in San Antonio with his uncle and first teacher, Jose Arpa. In the 1930s he joined the staff of Newcomb College, returning each summer to teach at San Angelo, where he helped found an artist's colony, and at Alpine.
Several important awards brought Gonzales to the attention of Eastern schools and museums. He was artist-in-residence

at Western Reserve University in 1953 and 1954. Thereafter he lived in New York City where he lectured at the Metropolitan Museum of Art. During summer months he directed the Summer School of Art in Wellfleet, Massachusetts.

Goodan, Tillman P. (1896–1958)
B. Colorado. D. Tulare, California, May 24. California State Library; "The Cover Artist," *Corral Dust*, Potomac Corral of the Westerners, Fall 1964.
Goodan was an avid horseman and outdoor man who worked principally in Los Angeles and Whittier, California, as an illustrator of Western subjects.

Goodwin, Philip Russell (1882–1935)
B. Norwich, Connecticut. D. Mamaroneck, New York, December 14. Work: Minneapolis Institute of Arts; Glenbow-Alberta Institute, Calgary, Canada. AAA 1905–1913 (New York City); AAA 1915–1921 (Mamaroneck); Fielding; Mallett Supplement; Dykes.
Goodwin, who was a pupil of Howard Pyle, also studied at the Art Students' League and the Rhode Island School of Design. He was at Lake McDonald with Charles Russell during the summer of 1910, illustrating a book about the famous cowboy artist.

Goss, Louise H. (–)
AAA 1915 (Salt Lake City, Utah).

Graf, Gladys H. (1898–)
Work: Piedmont High School, Oakland, California. Havlice; Mallett Supplement; WWAA 1940–1941 (Berkeley, California).

Grain, Frederick (–)
Work: Arnot Art Museum, Elmira, New York. Fielding Supplement, 1974; California State Library.
Grain who painted landscapes and panoramas was active from 1833 to 1857.

Grandstaff, Harriet Phillips (1895–)
B. Longview, Texas. Havlice; Mallett Supplement;

WWAA 1940-1941 (Dallas, Texas); O'Brien.

Although Grandstaff's preference was portraits, and her specialty was commercial design, she did some landscape work. Among her teachers were Vivian Aunspaugh, Frank Reaugh, and L. O. Griffith.

Grandstaff has the distinction of having her Dallas studio decorated by several prominent artists. It began when Reaugh did a pastel drawing of a Texas longhorn that reached entirely across one wall.

Gray, Kathryn (1881-1931)
B. Jefferson County, Kansas. D. Kansas City, Missouri. AAA 1915-1925 (New York City); AAA 1927 (Pasadena, California); AAA 1929-1931* (New York City); Fielding; Mallett.

Gray, who studied in New York and Paris, was a member of the Art Students' League, American Artists' Professional League, and American Federation of Artists. She specialized in miniatures and landscapes.

Gray, Mary/Marie Chilton (1888-)
B. Philadelphia, Pennsylvania. Work: Murals, Denver Art Museum; Hall of Man. AAA 1915-1917, 1923-1925 (Indianapolis, Indiana); Havlice; Mallett; WWAA 1947-1962 (Denver, Colorado); Denver Public Library; Bertha Welch, "For Those Who Seek Sanity in Painting/The Paintings of Mary Chilton Gray," *Western Sport Set*, May 1942, 13.

Gray spent several months in Taos in 1930 doing landscapes and portraits. She returned with 40 canvases, 35 of which were sold at solo exhibitions in Indianapolis and Columbus. A landscape, "Old Mill at Taos," was accepted by American Watercolor Society for its March 1942 exhibition.

Gray, Percy (1869-1952)**
B. San Francisco, California. D. San Francisco, October 10. Work: Oakland Museum; E. B. Crocker Art Gallery; Bancroft Library; M. H. De Young Memorial Museum; California Historical Society; Bohemian Club. AAA 1909-1910 (Alameda, California); AAA 1915-1921 (Burlingame, California); AAA 1923-1933 (Monterey, California); Field-

ing; Havlice; Mallett; WWAA 1936-1941 (Monterey); Donald C. Whitton and Robert E. Johnson, *Percy Gray,* printed by East Wind Printers, San Francisco, 1970.

Before the era of news photographers, it was the newspaper artist's lot to sketch newsworthy incidents. Gray began his career with the San Francisco *Call,* rushing to the scene of action to draw a hasty sketch—then rushing back to the office to complete it in ink for printing. In later years Gray acknowledged that this demanding job was excellent training for an artist.

In 1895 Gray went to New York for further study, and again worked as a newspaper artist. When he returned to California in 1906, he settled down to a lifetime of depicting the natural beauty of the San Francisco and Monterey Bay regions, and occasionally that of Washington, Oregon, Arizona, and Southern California.

Unlike many other artists of his time, Gray did not go to the Reservations to paint Indians. The Indian portaits he did were the product of his New York and California studios. Presumably they were done with the aid of photographs.

Gray seldom dated his paintings. It is not possible to determine when they were painted from mere knowledge of his residences, for he made repeated trips to his favorite sites. Nevertheless it is helpful to know that he did much of his painting in Marin County when he lived in San Anselmo from 1938 to 1952.

A chronological account of Gray's life, with bibliography, is in Whitton's beautifully illustrated book *Percy Gray,* for which Joseph A. Baird, Jr., wrote the preface; Thomas Albright, the introduction; and Lewis Ferbrache, the concluding essay. Gray's particular contribution is to Northern California, where, as Professor Baird says, he was a "tireless interpreter of certain special qualities in the California landscape which have become increasingly precious in the hectic changes of the past two decades."

Gray, Una (-1930)
Work: Reading (Pennsylvania) Public Museum and Art Gallery. AAA 1919 (Boston, Massachusetts); Mallett.

Green, Emma Edwards (-1942)
B. Stockton, California. D. Boise, Idaho, January 6. *Who's Who in Northwest Art; The Idaho Statesman,* July 2,

1972, 2-C; Boise Public Library; *American Magazine of Art,* May 1927, 270.

This early artist of the sparsely settled West arrived in Boise for a visit in 1890 and stayed to become one of Idaho's best-known residents. Her first project in Boise was to open classes in art. Her second, at the behest of her new friends, was to enter the state competition to provide a design for Idaho's state seal. Green's remarks regarding her winning design are of interest:

"Now, if I'm going to embody the State seal, I must embody the resources, principally mining, so I put a miner on the seal; woman's suffrage was coming in so I put a woman on the seal opposite him to signify the equality between the sexes."

After marriage to James G. Green whose business was mining, Emma Green accompanied him on his exploratory trips and did many a painting from log cabin and tent. She also did many paintings in the vicinity of their vacation home in the mountains five miles above Lowman, as well as in the vicinity around Boise.

Among Green's other interests was woman's suffrage, a goal she helped greatly to achieve.

Green, Hiram Harold (1865–1930)

B. Paris, New York. D. Canada, August 4. Work: Santa Fe Collection; Southern Pacific Railroad. AAA 1919–1931* (Fort Erie, Ontario, Canada); Fielding; Mallett.

Green, who studied with Mowbray, Cox, and Bridgman, listed "Grand Canyon" and "Apache Trail" as being in the collections of the Santa Fe and the Southern Pacific.

Greener, Charles Theodore (1870–1935)

B. Lancaster, Wisconsin. D. Faulkton, South Dakota, July 4. Work: Robinson Museum and State Portrait Collection, Pierre, South Dakota; South Dakota State University; South Dakota Memorial Art Center; mural, Faulk County Court House. AAA 1915–1917 (Faulkton; summer: Rapid City, South Dakota); Stuart.

Greener was a landscape and portrait painter who had considerable training in art. He settled in Faulkton in 1890.

Gregg, Paul (1876–1949)**

B. Baxter Springs, Kansas. D. Denver, Colorado, July 9.

Work: University of Wyoming Library. Gene Lindberg, "The Paul Gregg I Knew," Denver *Post Empire* Magazine, 1954; Denver Public Library.

From boyhood, when Gregg lived just north of Indian territory, he retained his interest in Western history. His paintings of Indians in tribal regalia and pioneers in covered wagons are the product of his considerable knowledge of the era, as well as his photographic memory of how they looked when they passed by his boyhood home.

In 1954 such landscapes as "Hay on the Stem" (Buffalo grass) and "When the Desert Blooms" were reproduced in color and featured in an article by Gregg's friend and colleague Gene Lindberg. Lindberg wrote that during Gregg's 47 years with the Denver *Post* he did thousands of paintings for publication. Yet, despite the persistent deadlines of his profession, Gregg managed to finish many of them far beyond the requirements of a newspaper artist.

Grell, Louis Frederick (1887–1960)
B. Council Bluffs, Iowa. D. Chicago, Illinois, November 21. Work: Murals, Mayflower Hotel, Washington, D.C.; Union Station, St. Louis; Detroit Water Board Building. AAA 1917, 1925–1927, 1933 (Chicago and Downers Grove, Illinois); Havlice; Mallett; WWAA 1936–1962 (Chicago and Downers Grove); WWWA.

Griffin, Worth Dickman (1892–)
B. Sheridan, Indiana. Work: Washington State College. AAA 1933 (Pullman, Washington); Havlice; Mallett; WWAA 1947–1962 (Pullman).

Griffith, Conway (1863–1924)
B. Springfield, Ohio. D. Laguna Beach, California, April 28. Work: Laguna Beach Museum of Art. AAA 1923–1924 (Laguna Beach); Fielding; Mallett.
Griffith was a member of Laguna Beach Art Association.

Griffith, Lillian (1889–)
B. Philadelphia, Pennsylvania. AAA 1929 (Azusa, California; summer: Balboa, California); AAA 1933 (Azusa); Havlice; Mallett; WWAA 1936–1941 (Azusa).

Griffith, Louis Oscar (1875-1956)

B. Greencastle, Indiana. D. November 13. Work: National Gallery of Art; Witte Memorial Museum; Indiana University; Lafayette (Indiana) Art Association; Vanderpoel Memorial Collection; Oakland Museum; Delgado Museum. AAA 1905-1921 (Chicago, Illinois); AAA 1923-1933 (Nashville, Indiana); Bénézit; Fielding; Havlice; Mallett; WWAA 1936-1956 (Nashville); O'Brien.

Grigg, Joanna S. (-)

AAA 1905-1906 (Butte, Montana).

Groesbeck/Grosbeck, Dan Sayre (1878-1950)

D. Los Angeles, California, August 29. AAA 1921 (San Francisco, California); Fielding; California State Library.

Grosse, Garnet Davy (1895-)

B. Kansas City, Kansas. Work: Tiffany's, New York City; Arizona Museum of Art; Whittier House, Lowell, Massachusetts; College of Fine Arts, Tempe, Arizona. Havlice; Mallett Supplement; WWAA 1938-1962 (Scottsdale, Arizona).

Grosser, Eleanor M. (-)

AAA 1903 (Los Angeles, California), listed under "Art Supervisors and Teachers."

Grothjean, Francesca C. R./Fanny C. (1871-)

B. near Hamburg, Germany. AAA 1900-1906 (New York City; summer 1905-1906: Portland, Oregon); Bénézit; WWWA.

Grubb, Ethel McAllister (1890-)

B. San Francisco, California. AAA 1919-1925 (San Francisco); Mallett Supplement.

Grubb, a member of the San Francisco Art Association, studied at the Art Students' League in New York and at the San Francisco Art Institute.

Gruenfeld, (John) Caspar (Laehne) (1872-1954)

B. Holzminden, Germany. D. Los Angeles, California,

December 10. AAA 1905-1906 (Chicago, Illinois); AAA 1917-1925 (Los Angeles); Havlice; Mallett Supplement; WWAA 1936-1941 (Los Angeles).

During the later years of his career, Gruenfeld specialized in sculpture.

Guillot, Ann (1875-)
B. Kentucky. Work: Dallas Woman's Forum. AAA 1933 (Dallas, Texas); Havlice; Mallett; WWAA 1936-1941 (Dallas).

Guillot traveled extensively over the sage-covered prairies of Texas in search of her wild-flower subjects. She also painted in the vicinity of Winslow, Arkansas, where she had her other studio.

Gundlach, Max E. H. (1863-)
B. Breslau, Germany. Work: Santa Fe Collection. AAA 1903-1910 (Chicago, Illinois); Bénézit; Denver Public Library; Santa Fe Industries, Inc.

Many of Gundlach's paintings are of historic points along the early Western trails, for his interest in painting Western scenery soon led to the study of their history.

Gunn, Florence (c.1899-1969)
B. Laguna, New Mexico. D. Albuquerque, New Mexico, November 12. Albuquerque Public Library; Albuquerque *Tribune*, November 14, 1969.

Gunn left New Mexico for Los Angeles when she was 12, and later returned to live at Cubero. She was also a wood carver.

H

Habeger, Ruth (1895-)
B. Alvord, Iowa. Stuart.

Habeger, who had some private lessons in painting, exhibited primarily with the Community College Art Association in Madison, South Dakota, where she lived.

Haddock, Arthus E. (1895–)
B. San Joaquin County, California. Mallett Supplement (Stockton, California); Personal interview with the artist in Santa Fe, in 1976.
Without formal training, except a 30-day stint at San Francisco Art Institute many years ago, Haddock has learned to paint through persistence and observation. The person who helped him most was Maynard Dixon, for Haddock often joined Dixon on sketching trips in California, Arizona, Nevada, and Utah.
Haddock's interest in art began very early—at least as early as 1910, for he has a small dated drawing to prove it. Not to be deterred by the need to make a living, he chose night shifts, working on the railroad, so that he could paint by day. Now retired, Haddock is still painting. He has had several solo exhibitions, three in California and a recent one in Santa Fe, New Mexico, where he lives.

Hader, Berta Hoerner (–1976)
B. San Pedro, Coahuila, Mexico. D. February 6. AAA 1919, as Hoerner (San Francisco, California); Havlice; Mallett; WWAA 1936–1941 (Grandview-on-Hudson, Nyack, New York); WWWA.

Hader, Elmer Stanley (1889–)
B. Pajaro, California. Work: San Francisco Institute of Art; Bohemian Club. AAA 1915 (Paris, France); AAA 1919 (San Francisco, California); Mallett; WWAA 1936–1970 (Grandview-on-Hudson).

Haffner, F. J. (–)
AAA 1915–1925 (Denver, Colorado).
Haffner, an illustrator, was a member of the Denver Artists' Club.

Hagendorn, Max (1870–)
B. Stuttgart, Germany. Work: Boston Museum of Fine

Arts. AAA 1913 (Topeka, Kansas); AAA 1915 (Peterborough, New Hampshire); AAA 1917–1919 (Boston); AAA 1921–1933 (Sharon, Massachusetts); Havlice; Mallett; WWAA 1936–1941 (Sharon).

Haines, Marie Bruner (1884–)

B. Cincinnati, Ohio. Work: Museum of New Mexico. AAA 1919–1921 (Atlanta, Georgia); AAA 1923–1924 (St. Augustine, Florida); AAA 1925–1933 (College Station, Texas); Bénézit; Fielding; Havlice; Mallett; WWAA 1936–1953 (College Station); WWAA 1956–1962 (Bennington, Vermont); O'Brien.

Haines spent her summers studying at Taos, Provincetown, Ogunquit, and Woodstock. Taos Indian life is the theme of some Gesso lunettes (panels) that brought her early recognition. The title of one, "Pueblo Family in Black, Gold and Ivory," is particularly descriptive. In another series of lunettes Haines chose to depict life along the Brazos River. "Nights in the Brazos Bottom" brought her an award in the 1932 Southern States Art League exhibition in New Orleans.

Better known during the latter years of her career as Marie Haines Burt, this artist moved to Bennington, Vermont, where she continued to be active until the 1960s.

Hall, Florence Slocum (–)

B. Grand Rapids, Michigan. AAA 1919–1924 (Chicago, Illinois; summer: Denver, Colorado); Fielding.

Hall, Leola (–)

AAA 1909–1910 (Berkeley, California).

Hall, Parker L. (1898–)

B. Denver, Colorado. Work: Coit Tower, San Francisco; Library of Congress. AAA 1931–1933 (Berkeley, California); Havlice; Mallett; WWAA 1936–1941 (Berkeley and San Francisco).

Halseth, Edna Scofield (See: Scofield, Edna)

Haltom/Halton, Minnie Hollis (1889–)

B. Belton, Texas. Work: Colorado and Main Avenue high

schools, San Antonio, Texas. AAA 1923-1931 (San Antonio); AAA 1933 (Austin, Texas); Bénézit; Havlice; Mallett; WWAA 1936-1939 (Austin); WWAA 1940-1941 (San Antonio); O'Brien.

Hamilton, Edgar Scudder (1869-1903)
B. San Antonio, Texas. D. Sullivan County, New York, June 3. Work: Detroit Institute of Arts; Flint (Michigan) Institute of Arts. AAA 1898-1903* (New York City; Stamford, Connecticut); Bénézit; Mallett.

Hamilton studied at the Art Students' League under Brush and Metcalf, and in Paris. He settled in New York in 1888. In 1901 he began traveling for his health.

Hannon, Olga Ross (1890-)
Havlice; WWAA 1936-1941 (Bozeman, Montana); *Who's Who in Northwest Art.*

Hannon's work was a part of that selected by the New York City Municipal Art Committee for its Second Annual Exhibition, held in 1937.

Harding, Neva Whealey (1872-)
B. Rock Island County, Illinois. Work: South Dakota Memorial Art Center, Brookings. Stuart.

Harding, who lived in Brookings, studied with Ada Caldwell from about 1893 to 1897.

Hardwick, Lily Norling (1890-)
B. Ellensburg, Washington. Havlice; Mallett Supplement; WWAA 1936-1941 (Seattle, Washington); *Who's Who on the Pacific Coast,* 1947; *Who's Who in Northwest Art.*

An extremely active person who liked to fish and explore and visit Indian villages, Hardwick thereby gained access to unusual subject matter. So interested in Indian culture did she become that she painted what may be the only complete record of the Washington chiefs and their families. Not content merely to paint them, she studied, lectured, and wrote about them. Though specializing in portraiture, she also painted landscapes.

118

Harland, Mary (1863-)
 B. Yorkshire, England. AAA 1915-1933 (Santa Monica, California); Bénézit; Fielding; Mallett.

Harmer, Thomas C. (1865-1930)
 B. Hastings, England. D. Tacoma, Washington, August 10. AAA 1923-1931 (Tacoma); *Who's Who in Northwest Art; American Magazine of Art,* June 1927, 331.
 Harmer was a landscape painter. He studied with Duveneck and Meakin, and he was a member of Tacoma Art Society and Seattle Fine Arts Society.

Harper, William A. (1873-1910)
 B. Cayuga, Ontario, Canada. D. Mexico City, Mexico, March 27. AAA 1903 (Houston, Texas); AAA 1905-1910* (Chicago, Illinois); Cederholm; Havlice; Mallett.
 Following graduation from the Art Institute of Chicago in 1901, Harper taught drawing for several years in Houston public schools.

Harris, Georgia Maverick (1889-)
 B. San Antonio, Texas. Havlice; Mallett Supplement; WWAA 1940-1941 (San Antonio).

Harris, Greta (-)
 AAA 1915 (New York City); AAA 1917-1919 (Pasadena, California).

Harris, Samuel Hyde (1889-)
 B. Brentford, England. AAA 1925 (Los Angeles, California); Havlice; WWAA 1956-1962 (Alhambra, California); California State Library.

Harshe, Robert Bartholow (1879-1938)
 B. Salisbury, Missouri. D. January 11. Work: Luxembourg Museum, Paris; Brooklyn Museum; Toledo Museum of Art; Society of California Pioneers; Harrison Gallery, Los Angeles Museum. AAA 1909-1913 (Stanford University); AAA 1915 (Berkeley, California); AAA 1917-1919 (Pittsburgh, Pennsylvania); AAA 1921-1933 (Chicago, Illinois);

Bénézit; Havlice; Mallett; WWAA 1936-1939 (Chicago);
WWWA.

Hartmann, Sadakichi (1869-1944)
B. Nagasaki, Japan. D. St. Petersburg, Florida, November
21. Havlice; Mallett; WWAA 1936-1937 (Los Angeles,
California; winter: Banning, California); WWAA 1938-
1939 (Andover, New Hampshire; summer: Banning);
WWWA.

Hartwell, Nina Rosabel (-)
B. Salt Lake City, Utah. AAA 1903 (Salt Lake City); AAA
1913-1915 (Paris, France).

Harvey, Paul (1878-1948)
B. Chicago, Illinois. D. Queens, New York, January 8.
Work: Boston Art Club. AAA 1915-1924 (Santa Barbara,
California); AAA 1925-1933 (New York City); Fielding;
Mallett; WWWA (Bayside, Long Island, New York);
American Magazine of Art, December 1921, 414.

Hastings, Marion Keith (1894-)
B. Geneva, New York. AAA 1929-1933 (Seattle, Washing-
ton; summer 1933: Southbridge, Massachusetts); Havlice;
Mallett; WWAA 1936-1937 (Seattle); WWAA 1938-1941
(Los Angeles, California).

Hatfield, Dalzell (1893-1963)
B. Pittsburgh, Pennsylvania. D. Los Angeles, California,
July 13. AAA 1933 (Los Angeles); Havlice; Mallett;
WWAA 1936-1937 (Temple City, California); WWAA
1938-1941 (Los Angeles).

Hatfield, Karl Leroy (1886-)
B. Jacksonville, Illinois. AAA 1929-1933 (El Paso, Texas;
summer: Santa Fe, New Mexico); Mallett.
 Hatfield studied with Cyril Kay-Scott and John Mont-
gomery. He was a member of the El Paso Art Guild and Southern
States Art League.

Hawkins, Grace Milner (1869–)

B. Bloomington, Wisconsin. Work: Ney Gallery, Hartford, Connecticut; State Museum, Springfield, Illinois; Montana State Collection. AAA 1929–1933 (Madison, Wisconsin; summer: Leafy Lodge, Absarokee, Montana); Bénézit; Havlice; Mallett; WWAA 1936–1941 (Palos Verdes Estates, California).

Hayden, Harriet Clark Winslow (1840–1906)

B. Franklin, Massachusetts. D. Denver, Colorado, March 29. AAA 1900–1908* (Denver); Bénézit; Groce and Wallace; Denver Public Library.

Hayes, Lee (1854–)

B. Plattesville, Wisconsin. AAA 1915–1925 (Butte, Montana); Mallett; "Art in Butte, Montana," *American Magazine of Art*, May 1921, 181.

Hayes, a successful etcher, was chief engineer of the engineering department of Anaconda Copper Mining Company.

Haynes, Elsie Haddon (1881–1963)

B. Isle of Wight, England. D. Denver, Colorado, May 10. Work: Denver Public Library; International House, Denver; East Denver High School. Havlice; Mallett Supplement; WWAA 1938–1941 (Denver); Anne Arneil, "Guild Founder Remains True to Favorite Peaks," *Denver Post* Roundup, January 17, 1960, 14; Denver Public Library.

The daughter of a Cambridge professor, Haynes studied in London, Brussels, and Paris. In France she met her future husband and returned with him to Denver. There she became a charter member of the Denver Artists' Guild, founded in 1928, and a regular exhibitor.

Haynes had the distinction of having a painting of South Boulder Canyon (near Eldora, Colorado) purchased as a gift to President Eisenhower when he was recovering from a heart attack. It received a particularly warm reception, for Eisenhower recognized the site of a favorite fishing spot.

Haynes's specialty was landscapes. Many a high altitude lake and towering mountain peak can be seen in her pastels, the

medium of her choice. The Engleman spruce also was a favorite subject with Haynes. "They are like bass notes booming out in music," she told art critic Arneill.

Hazard, Arthur Merton (1872-1930)

B. North Bridgewater, Massachusetts. D. near Paris, France, December 26. Work: California Historical Society; Temple Israel, Boston; Amon Carter Museum of Western Art; Houses of Parliament, Toronto; National Museum, Washington, D.C. AAA 1900-1910 (Boston); AAA 1913 (Cambridge, Massachusetts); AAA 1915-1924 (Brookline, Massachusetts); AAA 1925 (Santa Barbara and Los Angeles, California); AAA 1927 (Brookline); AAA 1929-1931* (New York City; Hollywood, California); Bénézit; Fielding; Mallett.

Hazen, Bessie Ella (1862-1946)

B. Waterford, New Brunswick, Canada. D. March 11. Work: Springfield (Massachusetts) City Library; Sacramento (California) Public Library; Los Angeles Public Library; Dixie College, St. George, Utah. AAA 1915-1933 (Los Angeles, California); Fielding; Havlice; Mallett; WWAA 1936-1941 (Los Angeles); *American Magazine of Art,* January 1922, 26.

Hazen, Fannie Wilhelmina (1877-)

B. Murphy's Gulch, California. AAA 1915-1925 (San Francisco, California; summer: Santa Cruz, California); AAA 1927-1933 (Los Angeles, California; summer 1933: Los Gatos, California); Havlice; Mallett; WWAA 1936-1941 (Los Angeles; summer: Los Gatos).

Heath, Edda Maxwell (1875-1972)

B. Brooklyn, New York. D. November 6. Work: Monterey Peninsula Museum of Art; Idaho State College, Caldwell. AAA 1927-1929 (Yonkers, New York); AAA 1931-1933 (Carmel, California); Bénézit; Havlice; Mallett; WWAA 1936-1941 (Carmel); *The Art Digest,* May 1, 1929, 9; Carmel Public Library.

Heath was a painter of landscapes and seascapes who

worked in Carmel from 1928. She was also known as Edda Pappel.

Heath, Lillian Josephine Drake (1864–1961)

B. Milwaukee, Wisconsin. Work: Santa Cruz Art League. AAA 1925 (Santa Cruz, California); Binheim; California State Library.

Heath studied with Yard, Latimer, Bier, and her husband, Frank L. Heath. At age 94 she was still painting, according to *News Notes of California Libraries,* June 1973.

Hebert/Herbert, Marian (1899–1960)

B. Spencer, Iowa. D. Santa Barbara, California, July 15. Work: University of Nebraska. Havlice; Mallett; WWAA 1936–1941 (Santa Barbara); WWAA 1947–1959 (Santa Barbara; Belton, Texas).

Heil, Elizabeth (1877–)

B. Columbus, Ohio. AAA 1909–1910 (Akron, Ohio); AAA 1913–1915 (Seattle, Washington); Mallett.

Heil studied at the Cincinnati Art Academy under Thomas Noble and Caroline Lord.

Heinze, Adolph (1887–1958)

B. Chicago, Illinois. Work: John Marshall High School, Chicago; Downers High School, Downers Grove, Illinois; Santa Fe Collection; American Forks High School, American Forks, Utah. AAA 1925–1929 (Chicago); AAA 1931–1933 (Downers Grove); Bénézit; Mallett; WWAA 1936–1941 (Downers Grove); Denver Public Library; Santa Fe Industries, Inc.

Hekking, William Mathews (1885–1970)

B. Chelsea, Wisconsin. Work: Franklin School and Nichols School, Buffalo, New York. AAA 1917–1921 (Lawrence, Kansas); AAA 1923–1924 (Columbus, Ohio); AAA 1925–1933 (Buffalo; summer: Monhegan, Maine); Bénézit; Fielding; Havlice; Mallett; WWAA 1936–1941 (Buffalo; Hollywood, California; summer: Monhegan Island); WWWA (Woolwich, Maine).

Heller, Bessie Peirce (1896–)

B. St. Paul, Minnesota. Work: Virgil Junior High School, Los Angeles, California. AAA 1933 (New Hope, Pennsylvania); Havlice; Mallett; WWAA 1936–1937 (New Hope); WWAA 1938–1953 (Los Angeles; Culver City, California).

Henderson, Evelyn (–)

B. Cape Anne, Massachusetts. AAA 1921–1933 (Mill Valley, California); Havlice; Mallett; WWAA 1936–1941 (Mill Valley).

Hendricks, Emma Stockmon (1869–)

B. Solano County, California. Work: Canyon (Texas) Historical Society; Amarillo Library. AAA 1929–1931 (Amarillo, Texas); AAA 1933 (Tucumcari, New Mexico); Havlice; Mallett; WWAA 1936–1937 (Amarillo); WWAA 1938–1941 (San Antonio, Texas); O'Brien.

In 1894 Hendricks moved from California to West Texas where she became one of Amarillo's most energetic promoters of the arts. A pupil of Arpa, Lawson, and Cassidy, she studied in San Antonio, Colorado Springs, and Santa Fe. Among her paintings in Texas collections are "Taos Pueblo" and "Palo Duro Canyon."

Henning, Virginia (c.1881–1962)

B. Jacksonville, Illinois. D. Albuquerque, New Mexico, January 15. Albuquerque Public Library. Henning moved to Albuquerque in 1909.

Henri, Robert (1865–1929)**

B. Cincinnati, Ohio. D. New York City, July 12. Work: Art Institute of Chicago; Carnegie Institute; Gallery of Fine Arts, Columbus; Brooklyn Institute Museum; Pennsylvania Academy of Fine Arts; Kansas City Art Institute; San Francisco Institute of Art; Minneapolis Institute of Art; Museum of New Mexico; Los Angeles Museum. AAA 1898–1900 (Philadelphia, Pennsylvania; Paris, France); AAA 1903–1927 (New York City); Bénézit; Fielding; Havlice; Mallett; WWWA; Van Wyck Brooks, "Henri and His Circle" from *John Sloan/A Painter's Life*.

Henri was the son of a professional gambler and land speculator for whom Cozad, Nebraska, was named. Born Robert Henry Cozad, the artist changed his name to one more to his liking.

Henri first showed up in Santa Fe in 1916 to paint Indians, for he specialized in portraits of racial and national types. He called them "my people," and traveled extensively here and abroad to paint them. Among his favorite subjects were American Indians, New England Yankees, Spanish gypsies, and Irish peasants.

A landscape painter as well as a portrait painter, Henri was also famous as a teacher. For many years he was a leading influence on the artists of this country.

Heron, Edith Harvey (1895–)
B. San Jose, California. Havlice; Mallett Supplement; WWAA 1940–1941 (San Francisco, California); WWAA 1947–1953 (San Jose); California State Library.

Herrick, Hugh M. (1890–1946)
B. Rocky Ford, Colorado. AAA 1917 (Indianapolis, Indiana); AAA 1923–1933 (Los Angeles, California); Mallett.
Herrick, who was active in the California Art Club, studied with E. Roscoe Shrader, William Forsyth, and Clifton Wheeler.

Herrington, Florence F.
AAA 1909–1910 (Lawrence, Kansas).

Herrmann, Fernande Luise (–)
B. San Francisco, California. AAA 1931–1933 (San Francisco); Havlice; Mallett; WWAA 1936–1941 (San Francisco).
Herrmann, who taught art at Lowell High School in San Francisco, was a member of the San Francisco Society of Women Artists.

Herter, Albert (1871–1950)
B. New York City. D. February 15. Work: Brooklyn Institute Museum; Metropolitan Museum of Art. AAA 1898–1919 (New York City); AAA 1921–1933 (New York City

and Long Island, New York; studio: Santa Barbara, California); Bénézit; Fielding; Havlice; Mallett; WWAA 1936–1947 (Long Island); WWWA.

Hessova, Bess/Boza (–)
B. Czechoslovakia. *Who's Who in Los Angeles.*

Hiatt, Maurine (1898–)
B. Kansas City, Missouri. AAA 1921–1925 (Seattle, Washington). Hiatt is also known as Maurine Hiatt Roberts.

Hiler, Hilaire (1898–1966)
B. St. Paul, Minnesota. D. Paris, France, January 19. Work: Santa Barbara Museum of Art; Museum of New Mexico; National Collection of Fine Arts; Museum of Modern Art; Los Angeles Museum of Art. Bénézit; Havlice; Mallett Supplement; WWAA 1936–1941 (New York City); WWAA 1953 (Santa Fe, New Mexico); WWAA 1956 (Mexico); WWAA 1959 (New York City); WWAA 1962–1966 (Paris); Santa Fe *New Mexican,* December 28, 1943.

Hiler also lived briefly in Hollywood, probably just prior to moving to Santa Fe.

Hill, Alice Stewart (–)
B. Wisconsin. Work: Pioneer Museum, Colorado Springs; Denver Public Library Western History Collection. McClurg; Ormes and Ormes: Shalkop; Denver Public Library.

According to Ormes and Ormes, Hill painted "with great care and skill the wild flowers of Colorado." She illustrated Helen Hunt's *Procession of the Flowers of Colorado* and various of Mrs. Gilbert McClurg's poems. McClurg wrote that Hill studied at Cooper Union and the Academy of Design and studied flower painting in Chicago. She was active from 1875 to the early 1880s. The two water colors in the Western History Collection were painted in 1884.

Hill, John Henry (1839–1922)
B. West Nyack, New York. Bénézit; Fielding; Groce and Wallace; Havlice; Young; Weston J. Naef, "Artists and Photographers of the Western Expeditions," *Art News,* December 1975, 62, 64.

The art directories are vague about Hill's residence. It is presumed that he lived in West Nyack most of his life. Hill was in the West with Clarence King during King's western survey of 1868-1869. Among Hill's work from that trip are "Yosemite Falls" and "Shoshone Falls, Idaho," the latter reproduced with Naef's article.

Hill, Robert Jerome (1878-)
B. Austin, Texas. Work: State Teachers College, Nacogdoches, Texas; Oak Cliff High School. AAA 1917-1933 (Dallas, Texas); Fielding; Havlice; Mallett; WWAA 1936-1941 (Dallas); O'Brien.

Hill, Stephen G. (c.1819-)
Groce and Wallace (Cincinnati, Ohio); *Kennedy Quarterly*, June 1968, 122.

Hill was an amateur artist who joined the Infantry in June 1846, and was discharged the following October in Monterey, California. His view of Monterey was lithographed by a Cincinnati firm. "Platte River, Colorado," an oil, may have been painted about 1846 from sketches made on the trip west.

Hilliard/Hillard, William Henry (1836-1905)
B. Auburn, New York. D. Washington, D.C., April. Work: Philadelphia Museum of Art; Indianapolis Museum of Art; Princeton University; Reading (Pennsylvania) Public Museum and Art Gallery. AAA 1905-1906*; Bénézit; Fielding; Groce and Wallace; Havlice; Mallett; California State Library.

Hilliard studied in New York City and in Britain and France. Upon his return from Europe he opened a studio in New York City. Later he moved to Boston. An item in the San Francisco *Call* in July 1892 noted that he was in California to sketch and paint Yosemite. According to Groce and Wallace his first Western painting trip preceded his European study.

Hilton, William Hayes (1829-1909)
B. New York City. D. Oakland, California, November 23. Work: California Historical Society; Denver Public Library; Huntington Library, San Marino, California; Carey

S. Bliss, *Sketches in the Southwest and Mexico, 1858-1877.* Los Angeles: Dawson's Book Shop, 1963.

Hilton, an amateur artist, was at various times in his life a rancher, stockbroker, cattle drover, miner, and soldier. From 1858 to 1877, and perhaps later, he sketched the life he saw in California, Arizona, Texas, and Mexico.

Hilton was first in Texas sometime between 1846 and 1848. In 1849 he was in San Francisco. For awhile he mined on the Feather River in Northern California. In 1873 he settled in San Francisco where he was listed in the directories as a mining engineer. In 1881 he was living near Glen Ellen, California.

Among Hilton's sketches are such subjects as the Overland Stage, the Maricopa Indians of Arizona, Lake County (California) resort scenes, and California mining camps. Hilton also did some work in oils, and at least one of these paintings was destroyed in the fire following the San Francisco earthquake of 1906.

Hinchman, John Herbert (1884-1948)
B. Detroit, Michigan. AAA 1921 (Woodmont, Connecticut); AAA 1931-1933 (Laguna Beach, California); Bénézit; Havlice; Mallett; WWAA 1936-1937 (Grosse Ile, Michigan); WWAA 1938-1941 (New Hope, Pennsylvania).

Hinkle, Elizabeth H. (c.1876-1972)
D. Albuquerque, New Mexico, April 23. Albuquerque Public Library; Albuquerque *Tribune,* April 24, 1972.

Prior to moving to Albuquerque in 1940, Hinkle lived in Dallas, Texas. She did landscape and still life paintings.

Hinkle, Lucile Bernice (1895-)
B. Kansas City, Missouri. AAA 1931-1933 (Fullerton, California); Havlice; Mallett; WWAA 1936-1941 (Fullerton).

Hitchings, Henry (-1902)
Groce and Wallace; *Kennedy Quarterly,* June 1967, 117, 122-124; Rocky Mountain *News,* May 4, 1865, 3-1; M. Barr; Denver Public Library.

According to the *News,* Hitchings had on that day left for

Virginia City, Montana. He had previously been in the West, having joined the Lander Expedition of 1859. The water color and sepia wash drawings reproduced in the *Kennedy Quarterly* are from the 1859 expedition and include views along the route from Nebraska Territory to northeastern Oregon. Maurice Barr, in an exhibition catalog for the University of Wyoming Art Museum, said that seven Hitchings paintings had been recently discovered. Among them are scenes in the Wind River Mountains and along the Sweetwater River in Wyoming.

Hoar, Frances (1898–)
B. Philadelphia, Pennsylvania. Havlice; Mallett Supplement; WWAA 1936–1941 (Boulder, Colorado); University of Colorado Western History Archives; Denver Public Library; *Western Artist*, November 1934, 6; December 1934, 7; June 1935, 4.

Hoar, also known as Frances Hoar Trucksess, taught art at the University of Colorado in Boulder, and exhibited frequently in Colorado and Kansas. Articles in *Western Artist* refer to solo and joint exhibitions at Bethany College and in major Kansas cities. She also exhibited with Boulder's five-member club called The Prospectors.

It was at a 1936 exhibition of The Prospectors that Hoar's water colors of "Twin Lakes Ranch," "New Mexico," "The Corral," and "Black Diamond Coal Mine" were singled out for comment. The titles are indicative of the areas in which Hoar painted at that time.

Although teaching left little time for painting and exhibiting, Hoar reappeared in the news in 1965 when Dorothy Bridaham featured her and her artist husband and daughter in the May 27 Denver *Post Roundup,* at which time all three were active.

Hobart, Gladys Marie (1892–)
B. Santa Cruz, California. AAA 1917–1933 (San Francisco, California); Mallett.

Hobart was for many years a member of the San Francisco Art Association.

Hobby, Charles/Carl Frederick (1886–)
B. Iowa City, Iowa. Work: California Historical Society.

129

Havlice; Mallett Supplement; WWAA 1940–1941 (San Francisco, California).

Hochderffer, George (1863–1955)
B. Bethlehem, Illinois. Work: Northern Arizona Pioneer Historical Society. University of Northern Arizona, Flagstaff; Hochderffer, *Flagstaff Whoa! The Autobiography of a Western Pioneer.* Flagstaff: Museum of Northern Arizona, 1965.

Hochderffer studied art at Woodstock Art School and Columbia University. While at school he painted some of his Jamaica Bay neighbors' children. He moved to Flagstaff about 1886, later becoming one of the town's leading citizens.

Hodge, Helen I. Francis (–)
B. Topeka, Kansas. Work: Mulvane Art Museum, Topeka; Kansas State Historical Society; Woman's Club of Wichita. AAA 1917, as Francis (Topeka); AAA 1919–1933 (Topeka); Fielding; Havlice; Mallett; WWAA 1936–1941 (Topeka); Margaret E. Whittmore, "Some Topeka Artists," *Community Arts & Crafts,* December 1927, 19.

Whittmore said that some of Hodge's finest paintings resulted from a trip to Taos. Hodge also worked in Laguna Beach, California, where she spent several summers.

Hodges, Marjorie (–)
AAA 1919 (Los Angeles, California).

Hoen, Elizabeth (–)
AAA 1917–1919 (Santa Rosa, California).

Hoerman, Carl (1885–1955)
B. Babenhausen, Bavaria, Germany. D. Douglas, Michigan, November 8. Work: Springfield (Illinois) State Museum; Paw Paw (Michigan) High School. AAA 1929–1933 (Highland Park, Illinois; studio: Saugatuck, Michigan); Havlice; Mallett; WWAA 1936–1937 (Highland Park and Saugatuck); WWAA 1938–1939 (Saugatuck; winter: Palm Springs, California); WWAA 1940–1941 (Saugatuck; winter: Riverside, California); The National Cyclopaedia; *Western Artist,* May 1935, 5.

Savings from the sale of some of Hoerman's charcoal drawings and from his employment in a Hamburg shipyard financed his move to the United States in 1904. Evening classes in architecture and apprenticeships in Chicago architectural firms enabled Hoerman to open his own office in 1909. A decade later he built a studio and art gallery at Saugatuck, Michigan.

Painting trips to the West and Southwest brought customers for his mountain, Grand Canyon, and desert scenes. "Mount Shasta, California," painted in 1927, was acquired by the State Museum in Springfield.

Later in his career as an artist, Hoerman became known as a "dunes painter" for his work in Western Michigan in the vicinity of Saugatuck, Douglas, and Castle Park. He also painted in Mexico, Europe, and North Africa.

Hoerner, Berta (See: Hader, Berta Hoerner)

Hoffman, Polly (1890–)
B. Bryan, Texas. AAA 1929-1933 (Wichita Falls, Texas); Havlice; Mallett; WWAA 1936-1953 (Wichita Falls); O'Brien.

Hoffman, Victor (1834–)
B. Prussia. Work: Oakland Museum. Groce and Wallace; Oakland Art Museum.

Hoffman was in California about 1856 when he did a lithographic view of Sacramento and an oil painting, the latter entitled "Indian Family on San Francisco Bay."

Hogner, Nils (1893-1970)**
B. Whiteville, Massachusetts. D. July 31. Work: Oklahoma Art Center; Oklahoma City Public Schools; Museum of New Mexico; Hickory Museum, North Carolina; Whistler House, Lowell, Massachusetts; St. Louis Public Library. Havlice; Mallett (Taos, New Mexico, in 1934); WWAA 1936-1941 (Litchfield, Connecticut); WWAA 1947-1962 (New York City); *El Palacio,* November 2, 1932, 165; "Southwestern Artists: Nils Hogner Exhibit at Norwalk, Connecticut," *El Palacio,* October 1934, 145; Frank Waters, *Leon Gaspard,* Flagstaff, Arizona: Northland Press, 1964.

Hogner's years in the West, where he had gone to regain his health, were most unusual. Not only did he undertake the duties of a trader at Klagetoh, but he married a Navajo. Gaspard, who had become lost near Klagetoh, recalled Hogner's wife as a woman of charm and considerable business ability. Although the marriage appeared to be a happy one, it did not last.

Hogner also lived briefly in Taos, and in Albuquerque where he taught at the University of New Mexico. In the mid 1930s he returned to the East.

Holden, James Albert (-)
B. England. Work: Oakland Museum; St. Mary's College, Moraga, California; St. Francis Hotel, San Francisco. Havlice; Mallett Supplement; WWAA 1936-1959 (Oakland).

Holden was active in the San Francisco area from about 1905. He painted several murals there and a number of Bay area landscapes.

Holliday, Robert (-)
B. England. Work: Montana Historical Society. *Kennedy Quarterly,* June 1967, 109.

Holliday, who was active in Montana in the 1860s, was with the Fisk party of pioneers in 1862. His sketch of Bannock is in the Montana Historical Society collection.

Holman, Abigail (-)
AAA 1915-1927 (Denver, Colorado); Denver Public Library.

Holman was director of the Fine Arts Academy of Denver, and a member of the Denver Artists' Club.

Holme, John Francis/Frank (1868-1904)
B. Corinth, West Virginia. D. Denver, Colorado, July 27. AAA 1903-1906* (Chicago, Illinois; Phoenix, Arizona; Denver); Bénézit; Mallett; WWWA; Denver Public Library; Denver *Times,* July 27, 1904, 5.

Within his short lifetime, Holme, who began as a reporter and newspaper artist, became a well-known artist, author, and printer. His last important accomplishment was Bandar Log Press which he established in Phoenix while there for his health.

Among the newspapers he worked for was the San Francisco *Chronicle*, 1893 and 1894.

Holmes, Harriet Morton (–)
B. Portland, Maine. AAA 1919–1931 (Phoenix, Arizona); Mallett; *Western Artist*, June 1935, 3.
Holmes was a member of Print Makers of Los Angeles and California Society of Etchers. At the Fiesta in Santa Fe in 1924, she exhibited "Taos Pueblo" and "Back Yards."

Holmlund, Marvin N. (1896–)
B. Jamestown, New York. Stuart.
This largely self-taught artist who lived in Spearfish, South Dakota, exhibited at Black Hills State College and with the Black Hills Art Association.

Holslag, Edward J. (1870–1925)
B. Buffalo, New York. D. DeKalb, Illinois. Work: murals, Library of Congress. AAA 1900 (New York City); AAA 1915 (Los Angeles, California); AAA 1917–1921 (Chicago, Illinois); AAA 1923–1924 (Aurora, Illinois); Bénézit; Fielding; Mallett; *The Art Digest*, February 1, 1933, 16; *American Magazine of Art*, December 1920, 516.
Holslag's murals depicting Southwestern historical scenes were later seen by artist Oscar Strobel in the First National Bank of El Paso, Texas, and his discovery publicized in *The Art Digest*. Holslag also painted landscapes and portraits. A Western landscape, painted in 1903, hung for years in the Savoy Grill in Kansas City, Missouri.

Holt, Percy William (–)
B. Mobile, Alabama. AAA 1923–1931 (Galveston, Texas; summer: Woodstock, New York); Havlice; Mallett; WWAA 1936–1941 (Galveston); O'Brien.

Holzlhuber/Holzhuber, Franz (1826–1898)
B. Austria. Work: Boston Museum of Fine Arts; Glenbow-Alberta Institute, Calgary; Amon Carter Museum of Western Art. *Kennedy Quarterly*, May 1965, 167; *American Heritage*, June 1965, 49–64.

Holzlhuber, who came here in 1856, traveled in Nebraska, Kansas, Texas, and in Canada. He settled in Milwaukee for several years before returning to Austria in 1860. The *American Heritage* article deals primarily with his travels in the Middle West and the South.

Hong, Anna Helga (See: Rutt, Anna Hong)

Hooper, Annie Blakeslee (-)
B. California. AAA 1905-1908 (New York City); AAA 1909-1910 (San Francisco, California); AAA 1913-1931 (New York City; Long Island and Sputen Duyvil, New York); Bénézit; Fielding; Mallett.

Hooper, Rosa/Rose (1876-)
B. San Francisco, California. Work: Corcoran Gallery of Art; California Historical Society. AAA 1909-1910 (San Francisco); AAA 1915 (Palo Alto, California); AAA 1925-1933 (New York City); Bénézit; Havlice; Mallett; WWAA 1936-1941 (New York City).

Hope, Thelma Paddock (1898-)
B. LaPort, Indiana. AAA 1931 (Hollywood, California); AAA 1933 (Beverly Hills, California); Bénézit; Havlice; Mallett; WWAA 1936-1941 (Beverly Hills; summer: Corona del Mar, California).

Horton, Charles Orson (1896-)
B. Hayward, California. Work: St. John's Church, Oakland, California. Havlice; Mallett; WWAA 1936-1941 (Oakland).

Horvath, Ferdinand Huszti (1891-)
B. Budapest, Hungary. AAA 1931-1933 (New York City); Havlice; Mallett; WWAA 1936-1947 (Hollywood, California); WWAA 1953-1956 (Putney and Westminster West, Vermont); WWAA 1959-1962 (Temecula, California).

Hoskins, Gayle Porter (1887-1962)
B. Brazil, Indiana. Work: Delaware Chamber of Com-

merce; Delaware Art Museum; Salesianium and Warner high schools, Wilmington, Delaware; University of Delaware; Eleutherian-Hagley Mills Foundation Museum, Wilmington. AAA 1919-1933 (Wilmington); Havlice; Mallett; WWAA 1936-1962 (Wilmington); "Santa Fe in New York," *The Art Digest,* March 15, 1934, 10.

Hosmer, Laurence F. (1895-)
B. Lamberton, Minnesota. Mallett Supplement; California State Library.
In the mid 1930s Hosmer was living in Lodi, California.

Houlahan, Kathleen (1887-1964)
B. Winnipeg, Manitoba, Canada. Work: Smithsonian Institution. AAA 1915-1933 (Seattle, Washington); Havlice; Mallett; WWAA 1938-1941 (Seattle); *American Magazine of Art,* June 1927, 331.

House, Howard Elmer (1877-)
B. Manhattan, Kansas. Havlice; Mallett Supplement; WWAA 1938-1941 (Portland, Oregon).

Howard, Florence (-1914)
D. Colorado Springs, Colorado, January 10. AAA 1914* (Colorado Springs); Mallett.
Howard was a New York artist whose last six years were spent in Colorado for her health.

Howard, Mary R. Bradbury (1864-)
B. Cambridge, Massachusetts. AAA 1900-1903 (Montclair, New Jersey); AAA 1905-1913 (Berkeley, California); Bénézit.
Howard studied at the Art Students' League and in Paris.

Howard, Nellie Hopps (-)
B. San Francisco, California. Work: Society of California Pioneers. California State Library; *The Argonaut,* June 5, 1942, 10.
Howard, who lived in the Orient during most of her married life, was active in San Francisco from 1880 to 1885. In 1942

she exhibited in San Francisco, including some of the landscapes painted 60 years previously when she lived there.

Howland, Alfred Cornelius (1838–1909)
B. Walpole, New Hampshire. D. Pasadena, California, March 17. Work: Smithsonian Institution; Milwaukee Art Center; High Museum of Atlanta; Princeton Historical Society; Yale University. AAA 1898–1909* (New York City); Bénézit; Fielding; Groce and Wallace; Mallett; WWWA.

Howland spent winters in Pasadena and summers in Williamstown, Massachusetts, during his later years.

Hubacek, William (1864–1958)
B. Chicago, Illinois. D. mid-June. Work: San Bruno (California) Public Library; Oakland Museum; California Historical Society. AAA 1917 (San Francisco, California); San Francisco Public Library; Richard and Mercedes Kerwin, Burlingame, California; San Francisco *Chronicle,* June 16, 1958; San Francisco *Examiner,* February 16, 1958.

Although Hubacek is listed in only one art directory, and there for just one year, he was very much a part of San Francisco's art world during his long lifetime. He grew up there, studied at the original San Francisco School of Art, painted there professionally from the age of 18, and later taught there. He also painted and studied in France and Italy.

When the earthquake and fire of 1906 destroyed his studio and the many paintings it contained, Hubacek moved a short distance down the Peninsula to San Bruno. The San Bruno Library is the beneficiary of what is probably the largest collection of his paintings.

Hubacek is known principally for landscapes and still lifes in the realistic style. Newspaper accounts describe Hubacek's aversion to abstract art which he maintained he could not stand, and restate his conviction that it would be a better world if "man spent more time in art than on those instruments of science he perfects for the destruction of man." Hubacek's commitment to art began when he was 12.

Hubbard, Bess Bingham (1896–)
B. Fort Worth, Texas. Work: Colorado Springs Fine Arts

Center; Dallas Museum of Fine Arts; Texas Fine Arts Association; Elizabet Ney Museum, Austin. Havlice; WWAA 1947-1962 (Lubbock, Texas).

Hubbard, Marguerite [Gilliam] (1894-)
B. Boulder, Colorado. AAA 1917 (Philadelphia, Pennsylvania); AAA 1923-1931 (Boulder); Fielding; Havlice; Mallett Supplement; WWAA 1936-1941 (Boulder).

This artist was known in art circles by the name Gilliam as well as Hubbard, especially during the 1920s.

Huddle, Nannie Z. Carber (-)
B. Virginia. O'Brien.

Nannie Huddle, who married William Henry Huddle, lived in Texas from the time she was a young girl. She studied at the Art Students' League in New York, and later she studied in Chicago. Among her teachers were William Merritt Chase and Wayman Adams. She is best known in Texas for her wild flower paintings.

Huddle, William Henry (1847-1892)**
B. Wytheville, Virginia. Work: Texas State Capitol; Texas State Library; Dallas Museum of Fine Arts. Mallett Supplement; O'Brien; Pinckney.

Huddle moved with his family to Paris, Texas, in the late 1860s. In 1876, following two years at the National Academy of Design and at the Art Students' League in New York City, he moved to Austin, Texas. In New York he had been one of the student organizers of ASL when the National Academy temporarily closed its doors.

Huddle left Austin to study portraiture in Europe, but returned in 1885. He established himself quickly as a portrait painter, but his landscape work was not considered impressive. What work he did in that field included scenes of Pedernales River which he sketched in 1887, Marble Falls, and Austin. He made a trip to Leadville to sketch and "to see the old Colorado sparkle . . . ," but no work from there has materialized.

Hughes, Daisy Marguerite (1883-1968)
B. Los Angeles, California. D. Los Angeles. Work: Chrysler

of Southern California; Provincetown Art Association. AAA 1921-1925 (Los Angeles; summer: Carmel, California); AAA 1927-1933 (Los Angeles; studio: Paris, France); Fielding; Havlice; Mallett; WWAA 1936-1962 (Los Angeles; summer: Provincetown, Massachusetts).

Hulbert, Katherine Allmond (-)
B. Sacramento County, California. Work: Girls' High School Library, Brooklyn. AAA 1898-1933 (South Egremont, Massachusetts); Bénézit; Fielding; Havlice; Mallett; WWAA 1936-1941 (South Egremont).

Hull, Mary L. (1877-)
B. Brooklyn, New York. Fisher.
Hull moved to Santa Fe, New Mexico, in 1932.

Hullenkremer, Odon (1888-)
B. Budapest, Hungary. Work: Museum of New Mexico. Havlice; WWAA 1962 (Santa Fe, New Mexico); School of American Research, 1940; Ina Sizer Cassidy, "Art and Artists of New Mexico," *New Mexico* Magazine, April 1936, 21, 46; *New Mexico* Magazine, March 1951, 16, showing Hullenkremer's "Spring at Chimayo" in color.

Hullenkremer's background is that of an artist whose talent was recognized early and whose reputation apparently was well established in Europe by the time he was 30. Although he further enhanced his reputation in New Mexico with easel paintings and a much publicized mural of Conchas Dam, his interest in painting declined. He turned to horticulture and civic affairs. In Santa Fe he was a popular speaker in the Great Decisions program, an active member of the Council of International Relations, and a 20-year participant in Red Cross work during which he taught life-saving techniques.

Hullenkremer came to this country in 1912 and settled in Santa Fe in 1933. One of his early paintings there was inspired by his concern for the unemployed. He called it "The Depression." His specialty, however, was landscapes.

Hunley, Katharine Jones (1883-1964)
B. Beacon, Iowa. D. Lynwood, California. Work: Redlands

University; Redlands High School; Contemporary Club, Redlands. AAA 1931-1933 (Redlands, California; summer: Laguna Beach, California); Havlice; Mallett; WWAA 1936-1953 (Redlands; summer: Laguna Beach).

Hunt, Esther Anna (1885-)
B. Grand Island, Nebraska. Work: Oakland Museum. AAA 1909-1913 (Paris, France); AAA 1915-1917 (Los Angeles, California); AAA 1919-1925 (San Francisco, California); AAA 1927-1933 (New York City); Mallett; California State Library.

Huntington, Daniel Riggs (1871-)
B. Newark, New Jersey. AAA 1923-1933 (Seattle, Washington); Havlice; Mallett; WWAA 1936-1941 (Seattle); *Who's Who in Northwest Art.*

Huntoon, Mary [Hull] (1896-)
B. Topeka, Kansas. Work: Salina (Kansas) Art Association; Art Guild, Topeka; Topeka Public Library; Fifty Prints of the Year, 1928-1929; PWAP, U.S. Government. AAA 1929 (Paris, France; summer: Topeka); AAA 1933 (Topeka); Havlice; Mallett; WWAA 1936-1962 (Topeka).

Hurst, Clara Scott (1889-)
B. Kirwin, Kansas. AAA 1929-1931 (Kirwin); Havlice; Mallett; WWAA 1936-1941 (Kirwin).

Hurtt, Arthur R. (1861-1938)
B. Wisconsin. Work: State Building, Exposition Park, Los Angeles. AAA 1915-1933 (Los Angeles, California); Fielding; Havlice; Mallett; WWAA 1936-1937 (Los Angeles).

Husted, Elvera C. (-)
B. Omaha, Nebraska. Havlice; Mallett; WWAA 1936-1941 (San Francisco, California).

Hutchens, Frank Townsend (1869-1937)
B. Canandaigua, New York. D. February 6. Work: Pasadena Art Museum; Butler Institute of American Art; Erie

(Pennsylvania) Art Club; Herron Art Institute; Toledo Museum; New Orleans Museum of Art; Sioux Falls (South Dakota) Art Association. AAA 1900–1910 (Canandaigua; New York City); AAA 1915–1933 (Norwalk, Connecticut; summer 1931–1933: Taos, New Mexico); Bénézit; Fielding; Havlice; Mallett; WWAA 1936–1937 (Norwalk); WWWA.

Hutchins, Charles Bowman (1889–)
B. Seattle, Washington. Work: Denver, Detroit, Milwaukee, and Chicago public schools; author, *Whiff o' the West.* AAA 1931–1933 (Boulder, Colorado); Havlice; Mallett; WWAA 1936–1941 (Boulder; studio: Grand Lake Lodge).

Hyde, Marie A. H. (1882–)
B. Sidney, Ohio. Work: Metropolitan Museum of Art; Southwest Museum; Museum of New Mexico. Havlice; Mallett Supplement; WWAA 1940–1941 (Hollywood, California); WWAA 1947–1953 (New York City).

I

Iannelli, Alfonso (1888–1965)
B. Andretta, Italy. D. Chicago, Illinois. AAA 1927–1933 (Park Ridge, Illinois; summer: Palatin, Illinois); Bénézit; Havlice; Mallett; WWAA 1936–1956 (Park Ridge).
Iannelli was an instructor at the Los Angeles Art Club from 1911 to 1913.

Immel, Paul J. (1896–)
B. Helena, Montana. Work: Seattle Art Museum. Havlice; Mallett Supplement; WWAA 1947–1962 (Seattle, Washington); *Who's Who in Northwest Art.*

Ingels, Frank Lee (1886-1957)

B. Tamora, Nebraska. D. Los Angeles, California. Work: Agricultural School, Goodwell, Oklahoma; N.S.N. School, Alva, Oklahoma. AAA 1917-1919 (Chicago, Illinois); AAA 1923-1933 (Los Angeles); Bénézit; Havlice; Mallett; WWAA 1936-1941 (Los Angeles).

Inman, John O'Brien (1828-1896)

B. New York City. D. Fordham, New York, May 28. Work: National Academy of Design; Smithsonian Institution; University of Georgia; National Collection of Fine Arts. Bénézit; Fielding (New York City; Rome, Italy); Groce and Wallace; Havlice; Mallett; *Kennedy Miscellany*, #1, August 1965.

Inman painted in the West sometime after 1853, but before 1866 when he opened a studio in Rome.

Iredell, Russell (1889-1959)

Havlice; Mallett Supplement; WWAA 1938-1941 (Pasadena, California; summer: Coronado Beach, California); WWAA 1947-1959 (Laguna Beach, California).

Irvin, Rea (1881-1972)

B. San Francisco, California. D. May 28. AAA 1915-1917 (Forest Hills and Brookhaven, Long Island); AAA 1919-1933 (Spuyten Duyvil, New York); Havlice; Mallett; WWAA 1938-1959 (Newtown, Connecticut); WWAA 1962-1970 (Frederiksted, Virgin Islands); WWWA.

Irwin, Benoni (1840-1896)

B. Newmarket, Ontario, Canada. D. South Coventry, Connecticut. Work: National Academy of Design; E. B. Crocker Art Gallery; California Historical Society. Bénézit; Fielding; Havlice; Mallett; California State Library.

Irwin was in New York City from 1861 to 1863; in Paris from 1867 to 1869; in California in 1870, and from 1872 to 1877; and thereafter in New York City. During Irwin's years in California he lived in San Francisco and Oakland. He specialized in portraits and genre subjects.

Isaacs, Walter F. (1886-)

B. Gillespie, Illinois. Work: Seattle Art Museum. AAA 1925-1931 (Seattle, Washington); Bénézit; Havlice; Mallett Supplement; WWAA 1936-1947 (Seattle); WWAA 1953-1962 (Bellevue, Washington); *Who's Who in Northwest Art; Who's Who on the Pacific Coast,* 1951.

From 1914 to 1918 Isaacs was in Greeley, Colorado, as head of the art department at the college. In Seattle he was art department head at the University of Washington.

Ivey, John (-)

California State Library.

The San Francisco Directory listed Ivey as a landscape artist in 1900. A water color sketch appeared in the Monterey *Cypress* in May of that year.

J

Jackman, Theodore (1878-1940)

B. Bloomington, Illinois. D. La Crescenta, California. Work: Springville Museum of Art, Springville, Utah. AAA 1907-1913 (New York City; Richmond Hill, Long Island [listed Oscar T. Jackman]); AAA 1923-1925 (Laguna Beach, California).

Jackson, Martin Jacob (1871-1955)

B. Newburgh, New York. D. Los Angeles, California. Work: Amherst College; Reading (Pennsylvania) Public Museum and Art Gallery. AAA 1905-1906 (Denver, Colorado); AAA 1915-1933 (Los Angeles); Fielding; Havlice; Mallett; WWAA 1936-1941 (Los Angeles).

Jackson, W. C. (-)

California State Library; Louise Rasmussen, "Artists of

the Explorations Overland, 1840-1860," *Oregon Historical Quarterly*, March 1942, 59.

Jacques, Emil (1874-1937)

B. Moorslede, Flanders, Belgium. D. Bellaire, Michigan, mid-August. Work: Wightman Memorial Art Gallery, University of Notre Dame. AAA 1933 (South Bend, Indiana); Havlice; Mallett; WWAA 1936-1937 (South Bend); "Emil Jacques Drowns," *The Art Digest*, September 1, 1937, 14; "Flanders, Religion and the Pacific Coast," *The Art Digest*, April 15, 1935, 23.

Jacques was known in Europe as a mural painter of religious subjects. Upon coming to this country he turned to painting the American scene.

In Portland, Oregon, Jacques established an art department at the University. Then he moved to South Bend to head the art department at the University of Notre Dame.

Like so many artists from other countries, Jacques found the West a fascinating place to paint. He worked mostly in Southern California, Washington, and Oregon. He became interested in Indian life and used an Indian theme in a series of murals he did for a home in Tacoma. Most of his murals, however, continued to be religious in theme such as those he did for St. Mary's Cathedral in Portland.

James, Rebecca Salsbury Strand (1891-1968)

B. London, England. D. Taos, New Mexico, July 7. Work: Museum of New Mexico. Mallett Supplement, as Rebecca S. Strand; Rocky Mountain *News,* July 9, 1968, 36; Ina Sizer Cassidy, "Art and Artists of New Mexico," *New Mexico* Magazine, July 1952, 33, 45, 47; James, *Allow Me to Present 18 Ladies and Gentlemen and Taos, N. M. 1885-1939,* published in Taos in 1953; Museum of New Mexico.

James was the daughter of Nate Salsbury, vice president and manager of Buffalo Bill's Wild West Show. For awhile she lived in New York City where she married the photographer Paul Strand. Both were active in the life that centered around Alfred Stieglitz's gallery, An American Place. James had two solo shows there in the 1930s.

Also in the 1930s James exhibited at Denver Art Museum

and Colorado Springs Fine Arts Center. In 1951, she exhibited at Santa Barbara Art Museum and the Legion of Honor in San Francisco.

James is best known for her paintings on glass. She exhibited regularly in group shows at the Museum of New Mexico in Santa Fe and at the Harwood Foundation in Taos.

James lived in Taos in the early 1930s, married Mr. James in 1937, and returned permanently in 1964. She visited Taos at other times, including 1928 when she brought Georgia O'Keefe with her.

James, Roy Walter (1897–)
B. Gardena, California. Work: Long Beach (California) Public Library and Long Beach High School; Covina Public Library and Covina High School. AAA 1925-1933 (Covina, California; studios at San Dimas, California in 1925, and Lucia, California in 1927); Havlice; Mallett; WWAA 1936-1941 (Covina); WWAA 1947-1953 (Los Angeles); WWAA 1962 (Berkeley, California).

Jamieson, Agnes D. (–)
AAA 1913-1915 (Portland, Oregon).

Janousek, Louis (1856-1934)
B. Sadaka, Bohemia. D. Yankton, South Dakota, November 19. Work: Robinson Museum, Pierre, South Dakota; Yankton County Historical Society. AAA 1917 (Yankton); Stuart.

From 1869 to 1887 Janousek lived in Niobrara, Nebraska. Thereafter, except for 1908 when he lived in Carmel, California, he worked as a photographer and artist in Yankton. He exhibited primarily at the Minneapolis Art Institute and the St. Paul Art Center in Minnesota.

Jansson, Alfred (1863-1931)
B. Vermland, Sweden. D. Chicago, Illinois, September 5. Work: Chicago Municipal Collection. AAA 1898-1929 (Chicago, Illinois); Bénézit; Fielding; WWAA 1938-1939*.

Jaques/Jacques, Bertha E. Clauson (1863–)
B. Covington, Ohio. Work: Art Institute of Chicago; Na-

tional Collection of Fine Arts; New York Public Library; Library of Congress; St. Paul Institute of Art. AAA 1905–1933 (Chicago, Illinois); Havlice; Mallett Supplement; WWAA 1936–1941 (Chicago); *The Art Digest,* October 1, 1937, 24; *American Magazine of Art,* January 1928, 51.

Jaques's "San Juan Capistrano" is in the Charles Lummis collection in Los Angeles.

Jenkins, Hannah Tempest (–)
B. Philadelphia, Pennsylvania. AAA 1898–1933 (Claremont, California); Bénézit; Fielding; Havlice; Mallett; WWAA 1936–1937 (Claremont).

Jenkins, John Eliot (1868–)
B. Onaga, Kansas. Work: Capitol, Richmond, Virginia; University of Texas; Capitol, Austin, Texas; Waco Public Library, Texas; Tulsa Public Library, Oklahoma; Santa Fe Collection; Carnegie Library, Topeka, Kansas. AAA 1915 (Austin); AAA 1917 (Wichita, Kansas); AAA 1931–1933 (Amarillo, Texas); Bénézit; Havlice; Mallett; WWAA 1936–1941 (Houston, Texas).

Jensen, Dorothy Dolph (1895–)
B. Forest Grove, Oregon. Work: Women's Club, Corvallis, Oregon. AAA 1921 (Seattle, Washington); Havlice; Mallett; WWAA 1938–1941; *Who's Who in Northwest Art.*

Jenssen, Haakon A. (1883–)
B. Kristiana, Norway. AAA 1917–1927 (San Francisco, California).

Jenssen was a member of the San Francisco Art Association.

Jerome, Irene Elizabeth (1858–)
B. New York. Collins; Fielding.

Jerome, a self-taught painter, illustrated many books and other publications. In 1882 she exhibited 18 sketches of Colorado.

Jewell, Foster (1893–)

B. Grand Rapids, Michigan. AAA 1929 (Grand Rapids); Fisher; Museum of New Mexico; Elena Montes, "Art and Artists of New Mexico," *New Mexico* Magazine, August 1962, 33.

Jewell worked primarily in oils when he moved to Santa Fe in 1943, then turned to sculpture. For a time he lived in El Rito, New Mexico, but left there in the late 1960s.

John, Margaret Sawyer (1871–)

B. Patoka, Illinoia. AAA 1933 (Corvallis, Oregon); Havlice; Mallett; WWAA 1936-1941 (Corvallis); *Who's Who in Northwest Art; The Art Digest,* April 15, 1934, 8.

John, Grace Spaulding (1890-1972)**

B. Battle Creek, Michigan. Work: Houston Public Library; Houston Museum of Fine Arts; Huntsville (Texas) Library; Princeton University; murals, City Hall and Sidney Lanier School, Houston; Roanoke (Virginia) Public Library. AAA 1923-1933 (Houston; summer 1933: Alameda, California); Bénézit; Havlice; Mallett; WWAA 1936-1970 (Houston); O'Brien.

John was a writer as well as a painter. She exhibited widely, and wrote and illustrated four books. Of particular importance to historic preservation are her paintings of Houston and Galveston homes.

Johnson, C. Everett (1866–)

B. Gilroy, California. AAA 1909-1913 (Paris, France); AAA 1915-1919 (Chicago, Illinois); AAA 1927 (Evanston, Illinois; summer: Kearsarge, New Hampshire); AAA 1929 -1931 (Altadena, California); Mallett.

Johnson, Carrie Rixford/Caroline R. (–)

Work: M. H. De Young Memorial Museum; Oakland Museum; Pioneer Museum and Haggin Galleries, Stockton, California. AAA 1913, 1917 (San Francisco, California).

Johnson, Marie Runkle (1861–)

B. Flemington, New Jersey. AAA 1898-1900 (Evanston, Illinois); AAA 1919-1929 (Pasdadena, California); Fielding.

Johnson studied in Paris and with William Merritt Chase in New York City.

Johnston, Frederic (1890–)

B. Chicago, Illinois. Havlice; Mallett Supplement; WWAA 1938-1953 (Riverside, California).

Johnston, Mary Virginia Del Castillo (1865–)

B. Puerto Principe, Cuba. Work: State Capitol Library, Jackson, Mississippi. AAA 1913 (Washington, D.C.); AAA 1917-1924 (Riverdale, Maryland; studio 1923-1924: San Francisco, California); AAA 1925-1933 (San Francisco); Fielding; Havlice; Mallett; WWAA 1938-1941 (San Francisco); WWAA 1947 (San Francisco); *Who's Who on the Pacific Coast*, 1947.

Jones, Emma McCune (1873–)

B. Emporia, Kansas. *Who's Who in California.*

Jones, who was educated in Chicago, lived in Berkeley, California, in the early 1940s.

Jones, Esther A. (–)

AAA 1917-1919, 1923-1924 (Dallas, Texas).

Jones, Grace Church [Jonzi] (–)

B. West Falls, New York. Work: Denver Art Museum; Morey Junior High School, Denver. AAA 1913-1933 (Denver; summer 1919-1921: Taos, New Mexico); Bénézit; Fielding; Havlice; Mallett; WWAA 1936-1953 (Denver); Denver Public Library; Bromwell, page 46; Rocky Mountain *News*, September 6, 1931.

The *News* mentioned Jones's murals at Morey Junior High School and her many New Mexico paintings. Jones began exhibiting with the Denver Artists' Club about 1900 and had a solo exhibition in January 1917.

Jones, L. Lova (1874–1951)

B. Postville, Iowa. D. Brandon, South Dakota, June 7. Work: Faulk County Court House, Faulkton, South Dakota; Pettigrew Museum, Sioux Falls; Sioux Falls Public Library; Robinson Museum, Pierre; South Dakota Memorial Art Center, Brookings. AAA 1905–1908 (New York City); AAA 1925 (Brandon); Stuart.

Jones studied at the Art Institute of Chicago, the Art Students' League, and in Long Beach, California, before teaching in Sioux Falls, South Dakota, and Sundance, Wyoming.

Jones, Martha Miles (1870–1945)

B. Denison, Iowa. AAA 1923–1933 (San Diego, California); Havlice; Mallett; WWAA 1936–1941 (La Jolla, California).

Jones, Wendell Cooley (1899–)

B. Galena, Kansas. Work: National Collection of Fine Arts; Murals, U.S.P.O., Granville, Ohio, and Johnson City, Tennessee. Havlice; Mallett Supplement; WWAA 1940–1941 (Woodstock, New York); "A Peaceful Mexico," *The Art Digest,* October 1, 1937, 18.

An exhibition of Arizona, New Mexico, and old Mexico landscapes in New York in October 1937 brought favorable comment.

Judia, B. T. (c.1880–)

B. near Las Cruces, New Mexico. Albuquerque Public Library; Albuquerque *Journal,* May 24, 1965.

Judia, whose hobby was painting landscapes and wild life, was a constable in Ruidosa Downs, New Mexico, at the time the *Journal* article was written.

Judson, Almira Austin (–)

B. Milwaukee, Wisconsin. AAA 1913–1933 (San Francisco, California; summer 1921–1933: Los Gatos, California); Fielding; Mallett.

Judson studied with Robert Henri, and in Munich and Paris. She was a member of the San Francisco Art Association.

K

Kaminski, Edward B. (1895-1964)
B. Milwaukee, Wisconsin. D. Los Angeles, California, November 13. Work: Luxembourg Museum, Paris; San Diego Fine Arts Gallery. Havlice; Mallett Supplement; WWAA 1940-1941 (Los Angeles).

Kangoony, Gregory (1895-)
B. Tokat, Sivas, Armenia. Havlice; Mallett Supplement; WWAA 1940-1941 (San Francisco, California).

Karras, Spiros John (1897-)
B. Kollerion Ellis, Greece. AAA 1933 (Pasadena, California); Mallett.
Karras was a member of the California Art Club. He specialized in landscapes.

Kassler, Charles Moffat, II (1897-)
B. Denver, Colorado. Work: Frescoes, Los Angeles Public Library; Fullerton District Junior College, Fullerton, California; Beverly Hills Post Office. AAA 1925 (Denver); Bénézit; Fielding; Mallett; WWAA 1936-1941 (Los Angeles); Denver Public Library.

Katada, Selsuro (-)
AAA 1919 (San Francisco, California).

Katchamakoff, Atanas (1898-)
B. Leskovetz, Bulgaria. AAA 1931-1933 (Palm Springs, California); Bénézit; Havlice; Mallett; WWAA 1936-1941 (Palm Springs).
Katchamakoff is known primarily for his sculpture.

Kato, Kentaro (1889-1926)
B. Japan. D. New York City, August 18. AAA 1913-1925 (New York City; Japan); Fielding; Mallett.
Kentaro studied with Henry Read in Denver.

Katz, Leo (1887-)
B. Roznau, Austria. Work: Metropolitan Museum of Art; Brooklyn Museum; New York Public Library; Library of Congress. Bénézit; Havlice; Mallett; WWAA 1936-1941 (Los Angeles, California); WWAA 1947-1953 (Hampton, Virginia); WWAA 1956-1959 (Atlanta, Georgia); WWAA 1962-1970 (New York City).

Kaufman, Ferdinand (1864-)
B. Oberhausen, Germany. Work: Municipal Art Gallery, Davenport, Iowa. AAA 1915-1929 (Pittsburgh, Pennsylvania); AAA 1931 (Denver, Colorado; Long Beach, California); AAA 1933 (South Pasadena, California); Fielding; Havlice; Mallett; WWAA 1936-1941 (South Pasadena).

Kavanaugh, Katharine (See: Cahill, Katharine Kavanaugh)

Kay-Scott, Cyril (1879-)
B. near Richmond, Virginia. Work: Denver Art Museum; University of North Carolina. AAA 1929 (El Paso, Texas; summer: Santa Fe, New Mexico); AAA 1931-1933 (Denver, Colorado; summer: Santa Fe); Bénézit; Havlice; Mallett; WWAA 1936-1937 (Denver); WWAA 1938-1941 (New York City); WWWA; "Kay-Scott's Art," *The Art Digest,* June 1, 1933, 10; Denver Art Museum exhibition brochure.

Although better known for his portraits of eminent Americans and Europeans, Kay-Scott created a stir with his water color landscapes of places he had been, when they were exhibited in Denver in 1933. From over a thousand water colors, 100 were selected for the 1923-1933 retrospective held at Denver Art Museum's Chappell House.

Art critic Donald J. Bear found in Kay-Scott's work a "simple and ardent love of nature and particular places." Art critic Turner B. Messick described Kay-Scott's "fine organic arrangement of material, and a logical bringing together, or perhaps better, a careful elimination of all but those elements needed. . . ." "Real places—beautifully seen," said Messick.

In 1929 when Kay-Scott painted "In the Panhandle, Texas," he was living in El Paso where he had founded and was

directing the El Paso Art School. He spent summers in Santa Fe where he directed summer sessions of the Santa Fe Art School which he had also founded. By 1931 Kay-Scott was dividing his time between Santa Fe and Denver where he had become director of the Denver Art Museum. That was the year of such paintings as "From My Window, Santa Fe," and "Hills Near Santa Fe."

The year of Kay-Scott's South Dakota Bad Lands work was 1932. He also painted in the Southwestern coastal region. "The Bay of Baja California" which appeared in the retrospective at the Denver Art Museum may have been painted late that year or early in 1933.

Keating, Mary Aubrey (1898–1953)

B. San Antonio, Texas. Work: Murals, Gunter Hotel, Public Library, Aviation Cadet Center Hospital, and USO—all in San Antonio. Havlice; Mallett; WWAA 1936–1953 (San Antonio); O'Brien; Witte Museum, San Antonio.

This self-taught artist, who was also a musician, exhibited widely, according to O'Brien.

Keefer, Elizabeth E. (1899–)

B. Houston, Texas. Work: National Collection of Fine Arts; Southwest Museum, Los Angeles; Museum of New Mexico. AAA 1929–1931 (Alpine, Texas); Havlice; Mallett Supplement; WWAA 1936–1937 (El Paso, Texas); WWAA 1938–1941 (Austin, Texas); O'Brien; Museum of New Mexico.

Keefer's interest in the living art of the Indians began in 1921 when she visited Billings, Montana. But not until 1927 did she make her first etching on an Indian theme. Since then the Indians of Arizona and the Indians and Penitentes of New Mexico have been featured in her work. From a solo exhibition at the National Museum in 1935, three etchings were acquired for its permanent collection: "Penitentes, New Mexico," "Taos—Singing in the Moonlight," and "The Sandpainter—Navajo." The first two are aquatints; the last is a drypoint etching.

Although best known as an etcher, Keefer has done many water color landscapes, especially in Texas. Fifty water colors of the Big Bend Country were exhibited in 1966.

Keefer, who married folklorist Mody Boatright in 1931

and sometimes uses his name professionally, signs her paintings as Keefer, often without Christian name or initial.

Keeler, Julia Annette (1895-)
B. Garden City, Kansas. Havlice; Mallett Supplement; WWAA 1936-1941 (Deerfield, Kansas; Des Moines, Iowa).

Keeler, Louise Mapes Bunnell (-)
California State Library.
Little is known about this artist who lived in California, was on the staff of *Out West* in the early 1900s, and illustrated Charles Augustus Keeler's *Idyls of El Dorado.* She was active in California at least as early as 1894, for her drawings were used as illustrations in *A Light Through the Storm,* published that year by C. A. Murdock & Co.

Kegg, George W. (1884-1943)
B. Wilmot, South Dakota. AAA 1917 (San Francisco, California); Havlice; Mallett Supplement; WWAA 1936-1941; Richard and Mercedes Kerwin, Burlingame, California.
Kegg, who studied art in San Francisco, returned to South Dakota when he was in his early twenties to live among and paint the Sioux. In 1909 he won a bronze medal at the Alaska Yukon Exposition in Seattle, Washington. He settled in San Francisco after leaving the Sioux Reservation.

Keller, Clyde Leon (1872-)
B. Salem, Oregon. Work: Liberty Theatre, Portland, Oregon; Portland Press Club; B.P.O.E. Club, Portland; Public Gallery, Norway. AAA 1919-1933 (Portland); Bénézit; Fielding; Havlice; Mallett; WWAA 1936-1941 (Portland); *Who's Who in Northwest Art.*
Keller is best known for his Oregon and California landscapes. Among his patrons were Herbert Hoover and Franklin Roosevelt. "Site of Bonneville Dam" was in the latter's collection.

Keller, Edgar Martin (1868-1932)
B. Crescent City, California. D. Los Angeles, California, January 10. Work: Santa Fe Collection. AAA 1913 (New

York); AAA 1915-1917 (Los Angeles); AAA 1919, 1923-1925, 1931-1932* (New York City and Los Angeles); Mallett; "Artists of the Santa Fe," *American Heritage*, February 1976, 62.

The Hopi girl Koyts-Y-See, pictured in *American Heritage*, is in the Santa Fe Collection along with two other portraits of her painted by Keller before 1907. Also in the collection and painted about that time are "Pueblo of Laguna," "Santa Clara Indian Head," "Taos Indian Head," and "Sunset at Laguna."

By 1912, Keller was living in Southern California. His "San Juan Capistrano Mission" was acquired by the Atchison, Topeka, and Santa Fe Railway before 1913.

Keller exhibited regularly in Los Angeles and New York City, especially during the early years of his career. He is also known for his illustrations of children's books.

Keller, George Frederick (-)
Work: Bancroft Library, University of California. California State Library; Baird, 1968.

Keller, who fought in the Civil War, settled in California about 1870. He first worked as an artist for lithographer George Baker. About 1875 Keller turned to lithography. The San Francisco Directory listed him in 1870 as a draftsman, and in 1883 as a lithographer and artist. Until well into the 1880s, he illustrated books and magazines in California.

Kellogg, Joseph Mitchell (1885-)
B. Emporia, Kansas. Havlice; WWAA 1936-1941 (Lawrence, Kansas; summer: Laguna Beach, California).

Kelly, John Melville (1877-)
B. Oakland, California. Work: Fogg Museum, Cambridge, Massachusetts; New York Public Library; National Gallery of Art. Havlice; Mallett; WWAA 1936-1941, 1959-1962 (Honolulu, Hawaii); California State Library.

Kemp, Oliver (1887-1934)
B. Trenton, New Jersey. D. East Lansing, Michigan. Work: Murals, Mayan Theatre, Bay City, Michigan. AAA 1907-1915 (Wilmington, Delaware; summer: Bowerbank,

Maine); AAA 1917 (Trenton, New Jersey); AAA 1921-
1924 (New York City; summer: Bowerbank); AAA 1925
(Birmingham, Michigan; summer: Bowerbank); AAA 1927
-1933 (Detroit, Michigan; summer: Bowerbank); Bénézit;
Fielding; Havlice; Mallett; WWAA 1936-1937*; *Kennedy
Quarterly*, October 1961, 174.

Kemp, who made yearly trips to the Rocky Mountains, has
been referred to as a nature lover who spent much time in wilder-
ness and jungle regions throughout the world. He probably painted
more cover designs for the *Saturday Evening Post* than any other
artist. He also did illustrations for *Collier's, Scribner's, Century,*
and others.

Kendall, Marie Boening (1885-1953)
B. Mount Morris, New York. Work: Virginia Hotel, Long
Beach, California; Polytechnic High School, Long Beach;
Teachers College, Mt. Pleasant, Michigan; Hollywood
Riviera Club House. AAA 1917-1919 (Redlands, Califor-
nia; summer: Laguna Beach, California); AAA 1921-1929
(Long Beach; summer: Laguna Beach); AAA 1931-1933
(Hollywood Riviera, via Redondo, California); Fielding;
Havlice; Mallett; WWAA 1936-1941 (Long Beach).

Kennedy, Leta M. (1895-)
B. Pendleton, Oregon. Work: Portland Art Museum. AAA
1923-1924 (Portland, Oregon); Havlice; WWAA 1936-
1962, 1970 (Portland); *Who's Who in Northwest Art.*

Kennedy, Martha (1883-)
B. Roswell, New Mexico. Work: Roswell Chamber of Com-
merce. Havlice; Mallett Supplement; WWAA 1940-1941
(Roswell).

Kennicott, R. H. (1892-)
B. Luverne, Minnesota. Havlice; Mallett; WWAA 1938-
1941 (Los Angeles, California).

Kerns, Fannie M. (1878-1968)
B. Los Angeles, California. D. Los Angeles. AAA 1919-
1929 (Los Angeles); Fielding; Havlice; Mallett Supple-

ment; WWAA 1936-1941 (San Marino, California); *Who's Who in California.*

Kerns also lived in Pasadena during the early years of her career.

Kerr, James Wilfrid (1897-)
B. New York City. Work: Florida Southern College; Grand Central Gallery; Midland Park (New Jersey) Municipal Building. AAA 1925-1933 (New York City); Havlice; Mallett; WWAA 1936-1937 (New York City); WWAA 1940-1959 (Waldwick, New Jersey); WWAA 1962-1970 (Albuquerque, New Mexico); Albuquerque Public Library.

During the early years of Kerr's residency in Albuquerque, he painted "Acoma Twilight," "Sandia Glow," and "Jemez Country."

Kervily, George Le Serrec de (1883-)
B. Karkow, Russia. Mallett; *Who's Who in California* [as Le Serrec de Kervily].

Kervily exhibited in San Francisco in 1935, but probably was living in Los Angeles by that time.

Keszthelyi, Alexander Samuel (1874-1953)
B. Sambor, Poland. Work: Los Angeles Court House; State Capitol, Winnipeg, Manitoba; Carnegie Institute. AAA 1907-1913 (Pittsburgh, Pennsylvania); AAA 1915-1917 (Los Angeles, California); Bénézit; Havlice; Mallett; WWAA 1936-1953 (Los Angeles).

Ketcham, Rosemary (-1940)
B. Springfield, Ohio. D. July 19. Havlice; WWAA 1936-1941 (Lawrence, Kansas); WWWA.

Ketchel, H. M. (1865-1934)
B. Cincinnati, Ohio. D. Hollywood, California. Springville (Utah) Museum of Art.

Kidd, Hari/Harry Matthew (1899-)
B. Detroit, Michigan. Work: Philadelphia Museum of Art; Allentown (Pennsylvania) Museum; La France Art Mu-

seum, Philadelphia. Havlice; Mallett; WWAA 1940–1941 (El Paso, Texas).

King, Sara (1892–)
B. Pauls Valley, New Mexico. Fisher.
King moved to Hondo, New Mexico, in 1929.

Kingan, Samuel Latta (1869–1943)**
B. Pittsburgh, Pennsylvania. Havlice; Mallett Supplement; WWAA 1940–1941 (Tucson, Arizona; summer: Oracle, Arizona); "The Southwest the Tourist Seldom Sees," *The Art Digest*, March 1, 1937, 15; *The Art Digest*, November 1, 1937, 14.

After settling in Tucson in 1894, Kingan practiced law on weekdays and painted on weekends, for he had not given up the idea of being the artist he had studied to be in his youth. It was not until 1937 that he was able to devote full time to painting.

With a particular fondness for the old ranches, convents, missions, and other remnants of the past situated in and about Tucson, Kingan produced many scenes seldom seen by tourists. He was adept at conveying the feeling of the desert under moonlight, at the close of day, and under the searing mid-day sun, wrote *The Art Digest* regarding Kingan's New York exhibitions.

Kingsley, Elbridge/Eldridge (1842–1918)
B. Carthage, Ohio. D. Brooklyn, New York, August 28. Work: Dwight Art Building, Mt. Holyoke College; National Collection of Fine Arts; New York Public Library. AAA 1898 (New York City, c/o Scribner's); AAA 1903–1917 (Hadley, Massachusetts); AAA 1918*; Bénézit; Fielding; Mallett; WWWA; California State Library.

Kingsley was a member of Ruskin Art Club and Kingsley Art Club in California.

Kinzinger, Alice Fish (1899–1968)
B. Grand Rapids, Michigan. D. Los Alamos, New Mexico, February 21. Work: Francis Parker School, Chicago; Mural, Grand Rapids (Michigan) public school. Havlice; WWAA 1947–1953 (Waco, Texas); Albuquerque Public Library.

Kinzinger married Edmund Daniel Kinzinger. She was active in Texas and in New Mexico where she headed the art department of Taos Art School. She had also lived in Santa Fe and in Bombay, India.

Kinzinger, Edmund Daniel (1888-)
B. Pforzheim, Germany. Work: Dallas Museum of Fine Arts; Houston Museum of Fine Arts. Havlice; Mallett Supplement; WWAA 1940-1953 (Waco, Texas); WWAA 1956-1962 (Delavan, Wisconsin).

Kirkland, Forrest (1892-1942)
B. Mist, Arkansas. AAA 1933 (Dallas, Texas); Havlice; Mallett; WWAA 1936-1941 (Dallas); O'Brien.

Kissel, Eleanora M. (1891-1966)**
B. Morristown, New Jersey. Work: Harwood Foundation, Taos, New Mexico. AAA 1923-1931 (New York City; summer: Morristown); Havlice; Mallett; WWAA 1936-1947 (New York City; studio: Taos, New Mexico); "Eleanora Kissel In Taos," *The Western Woman*, vol. 15, #4, n.d.

Kissel entered the Art Students' League at age 19, following three years of private lessons. Later she studied in France and in Italy. By 1926 she had done considerable painting in and around Morristown; in Provincetown, Massachusetts, where she frequently spent summers; and in Europe and North Africa.

In search of new subjects Kissel set out in 1926 for the Grand Canyon, but got only as far as Taos. Each summer she returned to paint landscapes of the surrounding area and portraits of the Taos Indians. After her studio was built in 1929, she spent less and less time in New York City, usually just the winter months. In the mid-thirties she spent some time at the Grand Canyon.

Although Kissel specialized in etchings during the early years of her career, the compelling colors of the Southwest influenced her to do the greater part of her work in oil and water color.

Kitt, Katherine Florence (1876-)
B. Chico, California. AAA 1919-1933 (Tucson, Arizona); Havlice; Mallett; WWAA 1936-1941 (Tucson).

Kittinger, Peg Phillips (1896–)

B. Erie, Pennsylvania. Fisher.

Kittinger settled in Albuquerque, New Mexico, where she was active until at least 1947.

Kitts, Jasmine/Jessie de Lancey (1869–)

B. Knoxville, Tennessee. AAA 1929–1933 (San Francisco, California); Havlice; Mallett; WWAA 1936–1941 (San Francisco).

Klein, Lillie V. O'Ryan (–)

B. Quebec, Canada. Work: Oakland Museum. AAA 1915 (Portland, Oregon); California State Library; Joseph A. Baird, Jr.

Klein was a painter of miniatures who studied with George De Forrest Brush, William Merritt Chase, Willard Metcalf, and others. Known as O'Ryan in San Francisco, where she settled in 1900, Klein rented a studio from artist William Keith. She painted a portrait of him and of various other San Franciscoans.

Although little is known about Klein today, she was a popular artist in her time. About 1897, for four consecutive years, she won first prize at the University of New York for best "Type of Ideal Beauty." Later she won a gold medal at the Alaska-Yukon Exhibition in Seattle.

Soon after Klein exhibited at the 1915 Panama-Pacific International Exposition, she left San Francisco to work in the Northwest and in Canada. She returned in 1924.

Kleiser, Lorentz (1879–1963)

B. Elgin, Illinois. D. May 28. Work: State House, Lincoln, Nebraska; Cranbrook Museum. Havlice; Mallett Supplement; WWAA 1938–1941 (Palos Verdes Estates, California); WWAA 1947–1953 (New York City); WWWA.

Knecht, Fern Elizabeth/Edie (–)

B. Du Bois, Nebraska. Work: Little Rock (Arkansas) Gallery; Little Rock Public Library. AAA 1921–1925 (St. Louis, Missouri); AAA 1929–1933 (Little Rock; summer 1931–1933: Taos, New Mexico); Havlice; Mallett; WWAA 1936–1941 (Little Rock; Jefferson City, Missouri; summer: Taxco, Mexico).

Knecht, Karl Kae (1883-1972)

B. Iroquois, South Dakota. D. July 28. Work: Evansville (Indiana) Museum of Art; Hoosier Salon. AAA 1913-1931 (Evansville); Havlice; Mallett Supplement; WWAA 1936-1970 (Evansville); WWWA; Stuart.

Knight, Augusta (-)

B. Augusta, Illinois. AAA 1919-1933 (Omaha, Nebraska); Mallett.

Knight, who studied at St. Louis School of Fine Arts and the Art Students' League, was director of art at the University of Omaha and a member of the Omaha Art Guild.

Knochenmuss, Fanny Chase (1883-1962)

B. Deadwood, South Dakota. D. Rapid City, South Dakota, July 11. Work: Adams Memorial Hall Museum, Deadwood; South Dakota Memorial Art Center, Brookings.

Knochenmuss, a South Dakota resident throughout her life, studied in Boston.

Knopf, Nellie Augusta (1875-1962)

B. Chicago, Illinois. Work: John H. Vanderpoel Memorial Collection; Lafayette (Indiana) Art Association. AAA 1905-1908 (Jacksonville, Illinois; summer: Lansing, Michigan); AAA 1909-1933 (Jacksonville; summer 1909-1915: Ogunquit, Maine); Fielding; Havlice; Mallett; WWAA 1936-1937 (Jacksonville); WWAA 1938-1953 (Lansing, Michigan); WWAA 1956-1962 (Eaton Rapids, Michigan); Nicholas Fox Weber, "Rediscovered American Impressionists," *American Art Review,* January-February 1976; *Kennedy Quarterly,* October 1975, 141-146, 166.

Knopf was 80 when she announced that she had done miles of paintings, "some of them very good." Critics confirm that they are, and she is now becoming more widely known as one of this country's impressionists.

For several decades Knopf, despite the handicap of being deaf, directed the School of Fine Arts at Illinois Woman's College (now MacMurray College) where she began teaching at the turn of the century. From 1923 to 1925 she took a leave of absence to

paint in Colorado, New Mexico, Arizona, Texas, and California. From that trip came paintings of the Rio Grande Pueblos and Santa Fe. A few are reproduced in the *Kennedy Quarterly*.

When Knopf later returned to the West, she included Montana in her itinerary. She also painted in the New England states, Eastern Canada, and Mexico, besides the states in which she lived, including Indiana where she had a home at West Lafayette during her later years at the college.

Knott, Arthur Harold (1883-)
B. Toronto, Ontario, Canada. AAA 1923-1927 (Carmel, California); AAA 1929 (Morro Bay, California); *Who's Who in California*.

Knowles, Joseph (c.1869-1942)
D. October 22. Mallett Supplement; California State Library; WWAA 1947*; Santa Barbara Historical Society Quarterly vol. 16, #1, Winter 1970, 10-20.

Knowles, an illustrator of wild life, lived in Santa Barbara during the 1930s and perhaps later.

Knox, Katherine (1878-1965)
Mallett Supplement. Work: Laguna Beach Museum of Art.

Knox was active in Santa Ana, California, during the mid 1930s.

Koch, Berthe Couch (1899-1975)
B. Columbus, Ohio. Work: IBM Collection; Passedoit Gallery; Ohio State University; Syracuse Museum of Fine Arts. Havlice; Mallett Supplement; WWAA 1936-1939 (Columbus; summer: Rockport, Massachusetts); WWAA 1940-1941 (Omaha, Nebraska; summer: Rockport); WWAA 1947-1956 (Omaha; summer: East Gloucester, Massachusetts); WWAA 1959 (Mankato, Minnesota; summer: East Gloucester); WWAA 1962-1970 (Orlando Beach and Daytona Beach, Florida).

Kohlmeier, Helen Louise (1888-)
B. Wilmington, California. AAA 1917-1925 (Los Angeles, California); Havlice; Mallett Supplement; WWAA 1936-1941 (Los Angeles).

Korybut, Kasimir (1878-)
Havlice; Mallett Supplement; WWAA 1940-1941 (Los Angeles, California).

Kosa, Emil (-)
B. Czechoslovakia. Frederic Whitaker, "Watercolor in California," *American Artist*, May 1968.
Kosa was an amateur artist of considerable talent. He should not be confused with Emil Kosa, Jr., his son.

Krasnow, Peter (1886-)
B. Ukraine, Russia. AAA 1925 (Los Angeles, California). Mallett.

Krauth, Charles Philip (1893-)
B. Pittsburgh, Pennsylvania. AAA 1931 (Laguna Beach, California); AAA 1933 (29 Palms or Pine Knot, California); Mallett; WWAA 1936-1941 (Pine Knot).

Kromer, Carol Adelaide (1892-)
B. Elgin, Illinois. AAA 1931-1933 (Los Angeles, California); Havlice; Mallett; WWAA 1936-1941 (Los Angeles).

Kuck, Martha D. (-)
AAA 1913 (Menlo Park and San Francisco, California).

Kurtzworth, Harry Muir (1887-)
B. Detroit, Michigan. Work: Lincoln School and Nichols School Gallery, Evanston, Illinois. AAA 1915-1924 (Muskegon, Michigan); AAA 1925 (Kansas City, Missouri, and Detroit); AAA 1927-1931 (Detroit; Studio 1931: Los Angeles, California); AAA 1933 (Los Angeles); Fielding; Havlice; Mallett; WWAA 1936-1962 (Los Angeles).

Kusianovich, Daniel (1899-1965)
B. Dubrovnik, Yugoslavia. D. Albuquerque, New Mexico, February 17. Work: Museum of New Mexico. Fisher; Albuquerque Public Library; Museum of New Mexico; *New Mexico* Magazine, December 1956, 16.

In 1929, when Kusianovich was regaining his health at the United States Marine Hospital at Fort Stanton, New Mexico, he spent many hours drawing Indians. He liked their strong features and rich coloring, their positive character and ornamental attire. Among his subjects were Mescalero Apaches, Navajos, and Taos Indians. He did some work in oil as well as in pencil and charcoal and exhibited in several major American cities as well as in Paris and his native land.

New Mexico became home to this seaman who had roamed the world with his sketchbook from the time he was very young. While living in Lincoln County, Kusianovich was befriended by the artist Peter Hurd. Later he settled in Albuquerque. Although Indians predominate in his work, he also depicted prospectors, cowboys, and old *pastores.*

Kutcher, Ben (1895–1967)
B. Kiev, Russia. D. Los Angeles, California. Havlice; Mallett Supplement; WWAA 1936–1941 (Hollywood).

L

Lamade, Erich (1894–)
B. Braunschweig, Germany. Work: Portland Art Museum. Havlice; Mallett Supplement; WWAA 1940–1941 (Portland, Oregon); *Who's Who in Northwest Art.*

Two major works of Lamade's that are of particular historic interest are "Early History" and "Present Industry," located in post offices in St. Johns and Grants Pass, Oregon.

Lambert, Fred (c.1886–)
Albuquerque Public Library.
Once a deputy sheriff, Lambert later became curator of the

Old Mill Museum in Cimarron, New Mexico, where he is known as an artist and a writer. His *Bygone Days of the Old West* was published in 1948 by Burton Publishing Company, Kansas City, Missouri.

La Mond, Stella Lodge (1893-)
B. Morganfield, Kentucky. Work: Evansville (Indiana) Art Museum; Dallas Museum of Fine Arts; Southern Methodist University; Texas Technical College; Corpus Christi Museum; Museum of Art, Greensboro, North Carolina; Nebraska Wesleyan University; Sam Houston College. Havlice; Mallett Supplement; WWAA 1938-1962 (Dallas, Texas).

Lanfair, Harold Edward (1898-)
B. Portland, Oregon. Work: Cleveland Museum of Art. Havlice; Mallett Supplement; WWAA 1936-1959 (Los Angeles and Hollywood, California).

Langston, Lucy E. (c.1894-1966)
D. Albuquerque, New Mexico, September 29. Albuquerque Public Library.
Langston lived in Taos, New Mexico, before moving to Albuquerque in 1948.

Lanham/Langham, Emily (1895-)
B. Shepherd, Texas. AAA 1933 (Houston, Texas); Havlice; Mallett Supplement; WWAA 1936-1941 (Houston); O'Brien.

Larrinaga, Juan B. (1885-)
B. San Antonio, Mexico. *Who's Who in California.*
Larrinaga lived briefly in Arizona before moving to Los Angeles in 1909. Both he and his brother Mario worked primarily as artist-designers.

Larrinaga, Mario (1895-)
B. Baja California, Mexico. Work: Santa Fe Collection. Museum of New Mexico; Tricia Hurst, "A Statement of Gentleness and Beauty," *Southwest Art,* September 1976,

38–43; "A Master of Scenic Art," *The Western Woman,* vol. 15, #4, 33.

It can be said that Larrinaga began his career as an artist-designer at the age of 11 when his brother Juan so seriously burned his hands while in Globe, Arizona, that he could not complete his assignment with a traveling show. Under Juan's supervision, Mario was launched on a career that took him to California to work in the motion picture industry. There he worked many years as background artist, set designer, art director, and special effects person—earning the title "master of scenic art" in the studios of Hollywood.

Of Basque and Mexican descent, Larrinaga left Mexico for this country at age 10, got most of his formal education in Tucson, Arizona, and studied briefly at Chouinard Art Institute in the 1920s. In 1951 he settled in Taos, New Mexico, where he studied briefly with Emil Bisttram. He has exhibited in Springville, Utah; Santa Fe, New Mexico; Miami, Florida; and at the University of California. He has also worked as a magazine illustrator.

Larsson, Karl (1893–1967)
B. Skovde, Sweden. D. Dobbs Ferry, New York, June 21. Work: Art Institute of Chicago; Museum of International Folk Art, Santa Fe; Mural, Chapel, Lady of Guadalupe, Jemez Springs, New Mexico. Havlice; Mallett Supplement (New York); WWAA 1956–1962 (Santa Fe, New Mexico); Albuquerque Public Library.

Lasky, Bessie (1890–1972)
B. Boston, Massachusetts. D. Los Angeles, California, August 17. Work: Newark Museum. AAA 1925–1933 (New York City); Bénézit; Havlice; Mallett; WWAA 1936–1941 (Beverly Hills, California); *The Art Digest,* June 1929, 14.

Latoix, Gaspard (–)
Kennedy Quarterly, June 1968, 122; *Kennedy Quarterly* October 1964, 50; *Antiques,* October 1967, 414–415; Garnier.

Little is known about this artist who worked in water color

and oil and specialized in painting Indians of the Southwest. According to the Kennedy Gallery, Latoix was active from about 1890 to 1910 and was working in New York in the early 1890s.

Lauderdale, Ursula (1879-)
B. Moberly, Missouri. AAA 1919–1933 (Dallas, Texas); Bénézit; Mallett.

Laudermilk, Jerome Douglas (1893–1956)
B. Rich Hill, Missouri. *Who's Who in California,* 1943.
Laudermilk, whose field was chemistry, worked as an artist from 1922 to 1934 while recovering his health in the Southwest. After returning to his profession he lived in Claremont where he taught geochemistry at Pomona College.

Laurence, Sydney Mortimer (1865–1940)
B. Brooklyn, New York. D. Anchorage, Alaska, September 12. Work: Smithsonian Institution; Joslyn Art Museum; Montgomery Museum of Fine Arts; Shelburne (Vermont) Museum. AAA 1898–1915 (Cornwall, England); AAA 1923–1929 (Anchorage); Bénézit; Mallett; New York *Times,* September 13, 1940, 23/2; "Artists of Alaska," *Connoisseur,* December 1974, 42; H. Wendy Jones, "Sydney Laurence: Alaska's Celebrated Painter," *American Artist,* April 1962, 46–51, 84–85.
During Laurence's years in Alaska, he usually spent winters in Los Angeles where the light was better for painting.

Laurie-Wallace, John (See: Wallace, John Laurie)

Law, Harry V. (-)
Work: Society of California Pioneers. AAA 1917 (Oakland, California); Mallett Supplement (Los Angeles, California).

Lawson, Ernest (1873–1939)**
B. Halifax. Nova Scotia, Canada. D. Miami, Florida, December 18. Work: National Collection of Fine Arts; Dayton Art Institute; Des Moines Art Center; Santa Barbara Museum of Art; Krannert Art Museum, University of Illinois; Toronto Art Gallery. AAA 1900 (Mianus, Connecticut);

AAA 1903-1933 (New York City); Bénézit; Fielding; Havlice; Mallett; WWAA 1936-1940* (New York City); WWWA; Hubbard and Ostiguy; Hagerman; Henry D. Hill, *Ernest Lawson/American Impressionist,* Leigh-on-Sea, England: F. Lewis, Publishers, Limited, 1968; *American Magazine of Art,* February 1940, 118-119.

In an In Memoriam, the *American Magazine of Art* wrote that Lawson, one of the famous Eight, had "produced a type of serene, selfless painting" that was all too rare at that time. Although Lawson was represented in major galleries and museums throughout the country, and in many minor ones, he was barely able to eke out a living during the decade of the thirties. Broken in spirit and in health, he died on a Florida Beach—not a suicide as was commonly thought, but presumably of a heart attack. What placed this once, and now again, highly respected artist in financial jeopardy was not only the depression, but the popularity of social realism then beginning to sweep the country. Impressionism was passé.

Maintaining that "mountains are not paintable," Lawson was never satisfied with his Colorado paintings and found Florida more to his liking. But his Colorado years from 1927 to 1930 were happier and more productive than the years after his health began to fail in the thirties. He enjoyed his associations in Colorado Springs where he taught landscape at Broadmoor Academy, and although his salary was far from impressive, he later accepted much less at an Eastern school.

Lawson made regular visits to New Mexico where his children and his estranged wife lived, but probably did little painting there. "Path of Gold" may be his only New Mexico canvas. He occasionally changed the names of paintings with a view to making them more marketable.

Layham, Julia Sherwood (-)
AAA 1903 (Sharlow, North Dakota).

Layham's listing is found in the Art Annual under "Art Supervisors and Teachers."

Leaming, Susan (-)
Denver Public Library. McClurg.

Leaming studied at the University of Chicago and at the

Art Institute of Chicago. She moved to Colorado Springs, Colorado, with her sister Charlotte early in this century. There she was active in the college art department and at the Leaming Academy which she and her better-known sister founded. The Leamings are mentioned in McClurg's manuscript "Brush and Pencil in Early Colorado Springs," pages 82–85.

Leavitt, Agnes (1859–)
B. Boston, Massachusetts. AAA 1905–1915 (Boston); AAA 1917–1925 (San Jose and San Francisco, California); Mallett.

Leavitt was a landscape painter and teacher. She had studied with Enneking, Hardwick, and Sandham in Boston, and with Spread in Chicago.

Ledgerwood, Ella Ray (–1951)
B. Dublin, Texas. D. March 27. AAA 1913–1933 (Fort Worth, Texas); Havlice; Mallett; WWAA 1936–1947 (Fort Worth); WWAA 1953*.

Lee, Leslie William (1871–1951)
B. Manchester, England, of American parents. Work: New Britain (Connecticut) Museum of American Art; City Art Museum, St. Louis; San Diego Fine Arts Society; San Diego Museum of Man; San Diego Public Library; Smith College. AAA 1913 (New York City); Havlice; Mallett; WWAA 1936–1941 (El Cajon, California); WWAA 1947–1953 (La Jolla, California); *Who's Who on the Pacific Coast*, 1949; "San Diego Artists," *The Art Digest*, July 1929, 12.

Lee began his career as a newspaper artist and cartoonist in New York City in 1892, and turned to teaching in 1903 when he became an instructor for five years at the New York School of Applied Design. The *Art Annual* does not indicate where he was after 1913.

By 1929 Lee was recognized as a San Diego painter who specialized in Indian subjects. According to *The Art Digest*, it was the opportunity to utilize Southern California's brilliant sunlight and to do Indian portraiture that attracted him. His studio was near the Reservations, and his hospitality was such that his

subjects made themselves very much at home there.

The years 1943-1944 were ones of travel and painting in Central America, Honduras, Costa Rica, Guatemala, Panama, Mexico, and LaJolla, California. During the latter years of his career Lee made LaJolla his home.

Lee, Selma V.P. (1879-)

B. New York. AAA 1919-1931 (New York City); AAA 1932-1933 (Scarsdale, New York); Mallett.

Lee, who studied with Henri, Curran, and Mielatz, was a member of Brooklyn Society of Etchers, Chicago Society of Etchers, and Broadmoor Art Academy.

Leland, Clara Walsh (1869-)

B. Lockport, New York. Work: Lincoln Public Schools. AAA 1903 (Lincoln, Nebraska, listed as Walsh); AAA 1917, 1923-1933 (Lincoln); Havlice; Mallett; WWAA 1936 -1941 (Lincoln).

Lemos, Frank B. (1877-)

B. Austin, Nevada. AAA 1919-1925 (Palo Alto, California); Mallett.

Lemos worked at the Museum of Fine Arts, Stanford University. He was a member of California Print Makers.

Lesaar, Charles M. (1884-)

B. Belgium. Work: Chicago Press Club; Sacred Heart College, San Francisco; City Hall, Ghent, Belgium. AAA 1917, 1923-1927 (Chicago, Illinois); Havlice; Mallett Supplement; WWAA 1940-1941 (Oakland, California).

Leslie, Jean Gorman (1888-)

B. Omaha, Nebraska. AAA 1933 (Santa Monica, California); Mallett.

Leslie studied with Albert Rothery and Vaclav Vytlacil.

Lester, Leonard (1876-)

B. Penrith, Cumberland, England. Work: Santa Fe Collection. AAA 1903 (Pasadena, California); AAA 1905-1908 (New York City; Pasadena).

168

Lester studied at the Art Institute of Chicago, National Academy of Design, Art Students' League, and in Munich and Dresden, Germany.

Lester, William Harold (1885–)
B. Valparaiso, Chile. AAA 1917 (New York City; summer: Eatons Ranch, Wolf, Wyoming); AAA 1919–1921 (Los Angeles, California; summer: Wolf); Fielding.
Lester was a member of Chicago Society of Etchers and Brooklyn Society of Etchers. He studied at the Art Institute of Chicago.

Letcher, Blanche (–)
AAA 1913 (Berkeley, California).

Levings, Mark M. (1881–)
B. Canton, Illinois. Work: Society of Liberal Arts, Omaha; Los Angeles Museum. Havlice; Mallett Supplement; WWAA 1936–1939 (Omaha, Nebraska); WWAA 1940–1941 (McCook, Nebraska).

Levy, Nat (1896–)
B. San Francisco, California. Mallett Supplement; California State Library; San Francisco Public Library; "Nat Levy Discusses Wet and Dry Surfaces," *American Artist*, April 1962, 52–53.
A resident of San Francisco for many years, but little known outside Northern California, Levy has chosen as his specialty the Mendocino Coast. He works out of doors exclusively, even to the completion of his paintings. He has received reviews that note his depth of color and the perfection of his drawing.
Levy began his career as a poster designer. In recent years he has painted landscapes in widely separated areas: Europe, the Far East, and New England, as well as California. And he has taught water color painting.
Since the 1930s Levy has exhibited with the Society of Western Artists and the California Society of Etchers. He studied at California School of Fine Arts with Maynard Dixon and Armin Hansen.

Lewis, Alonzo Victor (1891–1950)

B. Chicago, Illinois. D. Seattle, Washington. AAA 1921–1925 (Seattle); Mallett Supplement; *Who's Who in Northwest Art; The Spokesman Review,* Spokane, May 19, 1912, 11; "Jack Dempsey in Oil," *The Literary Digest,* August 18, 1923, 34; Harriet Cone and Jamia Cone Riehl.

Lewis was 15 when he ground colors for Charles Russell in Montana, and it was Russell who encouraged him to study art. Following graduation from the Art Institute of Chicago, Lewis again headed west.

About 1920 Lewis built with his own hands a studio-home in Seattle. A reporter for the *Post-Intelligencer* stumbled upon its unique setting, interviewed the occupant, and dubbed it Seattle's Greenwich Village in his paper for April 17, 1921.

Although better known as a sculptor, Lewis created a furor in art circles when his oil painting of Jack Dempsey was hung amid landscapes in a Kansas City Art Institute exhibit in 1923. Lewis, however, was no stranger to landscape painting. Whenever he was not occupied with bronze or marble, he painted scenic spots around Spokane where he was in 1912, and later in Tacoma and Seattle. He also painted portraits of Indians, including "Wallowa Chief" and "Yellow Tail," both in oil.

Lewis, Han (–)

Groce and Wallace.

Lewis was a Prussian artist who lived briefly in San Francisco in 1860.

Lewis, Harry Emerson (1892–)

B. Hutchinson, Kansas. Work: Internal Revenue Department; Murals, Municipal Collection, City of Grand Rapids; Warner Bros.; Hotel Roosevelt, Hollywood; Grand Rapids Public Schools. AAA 1931–1933 (San Francisco, California); Havlice; Mallett; WWAA 1936–1941 (San Francisco); WWAA 1947–1953 (Corte Madera, California); San Francisco Public Library.

Lindhardt, Dagmar B. 1881–)

B. Racine, Wisconsin. Fisher.

Lindhardt settled at San Juan Pueblo, New Mexico, in 1907.

Lindsay, Ruth Andrews (1888–)
B. Ada, Ohio. AAA 1925 (Pasadena, California); Mallett Supplement; WWAA 1936–1962 (Pasadena).

Lingen/Lingan, Penelope (–)
B. near Mount Mitchell in North Carolina. AAA 1915 (Beaumont, Texas); AAA 1923–1927 (Houston, Texas); Mallett Supplement; O'Brien.

Litchfield, Donald (1897–)
B. London, England. Havlice; Mallett Supplement; WWAA 1936–1941 (Seattle, Washington); *Who's Who in Northwest Art.*

Little, Gertrude L. (–)
B. Minneapolis, Minnesota. Work: Philadelphia Museum of Art. AAA 1917 (New York City); AAA 1921 (Seattle, Washington); AAA 1923–1933 (Los Angeles, California); Fielding; Havlice; Mallett; WWAA 1936–1962 (Hollywood and Los Angeles).

Littlejohn, Hugh Warrick (1892–1938)
B. New York. D. Oakland, California. Havlice; Mallett Supplement; WWAA 1936–1939 (Oakland, California).

Littlejohn, Margaret Martin (1885–)
B. Jefferson, Texas. Work: Murals, Children's Hospital and public schools, Fort Worth. AAA 1913–1924 (Fort Worth, Texas); Havlice; Mallett Supplement; WWAA 1936–1941 (Fort Worth); O'Brien.

Loemans, Alexander F. (–1894)
Work: Minnesota Historical Society. Havlice; Harper 1970; Dwight Miller, professor of art, Stanford University.
Little is known about this Canadian painter whose technique suggests European training, probably Belgian or Dutch. He painted scenes of the Sierra Nevada and Rocky Mountain ranges.

Loft, P. (–)
Work: New York State Historical Society, Cooperstown.

Groce and Wallace; Jeane Lipman, "American Townscapes," *Antiques,* December 1944, 340–341.

Loft, who lived in Rowley, Massachusetts, and briefly in California mining towns, was a miner. About 1865 he did water color paintings of Downieville and Chaparral Hill, Sierra County, California.

Logan, Maurice George (1886–)

B. San Francisco, California. Work: Oakland Museum; Haggin Art Gallery, Stockton; San Diego Fine Arts Gallery; National Academy of Design; Staten Island Institute of Arts & Sciences; Los Angeles Museum of Art; Frye Museum of Art, Seattle. AAA 1917, 1921 (San Francisco); Havlice; Mallett Supplement; WWAA 1940–1941, 1962–1973 (Oakland, California); California State Library; *Who's Who on the Pacific Coast,* 1947.

Loomis, Chester (1852–1924)

B. Syracuse, New York. D. Englewood, New Jersey, November 12. Work: National Collection of Fine Arts; Herron Art Institute; National Academy of Design; Cornell University; Yale University; Englewood (New Jersey) Public Library. AAA 1898–1924 (Englewood, New Jersey); Bénézit; Fielding; Mallett; WWWA; Schriever, 1974; Henry H. Glassie, Washington, D.C.

Loomis studied with Harry Ives Thompson in West Haven, Connecticut, and with Leon Bonnat and Julian Academy in Paris. After 11 years of painting in France and Italy, Loomis returned in 1885 and soon after moved to Texas for a few years to live with his brother on a ranch on the San Saaba River. It is there that he painted "Antelope Hunters," now in the Anschutz Collection. The painting features his brother skinning an antelope after the hunt.

Although Loomis depended primarily on the painting of portraits and murals, and the designing of ecclesiastical stained glass windows for a living, he did many landscapes. An avid fisherman, his landscapes often depict the areas in New Jersey where he liked to fish.

Loomis, William Andrew (1892–)

B. Syracuse, New York. AAA 1925–1933 (Chicago and

Winnetka, Illinois; summer: Williams Bay, Wisconsin);
Havlice; Mallett; WWAA 1936-1939 (Winnetka; summer:
Williams Bay); WWAA 1940-1953 (Pasadena and North
Hollywood, California).

Lorie, Hortense Plaut (1879-)
B. Cincinnati, Ohio. Fisher.
Lorie settled in Santa Fe, New Mexico, in 1942.

Lorraine, Alma Royer (1858-)
B. Randolph, Ohio. Work: West Chester Seminary. AAA
1921-1933 (Seattle, Washington); Bénézit; Havlice;
Mallett; WWAA 1936-1947 (Seattle); *Who's Who in
Northwest Art.*

Lovins, Henry (1883-1960?)
B. New York City. Work: San Diego Museum; Museum of
New Mexico; Southwest Museum. AAA 1929-1933 (Los
Angeles and Hollywood, California; summer: Carmel and
Laguna Beach, California); Havlice; Mallett; WWAA 1936
-1962 (Los Angeles and Hollywood; summer: Carmel and
Laguna Beach), Denver *Republican,* May 29, 1910, 4-3;
Denver *Post,* September 23, 1923, 9; Denver Public Li-
brary; *Who's Who on the Pacific Coast,* 1947.
 Lovins worked closely with Edgar Hewett for a number of
years. Both men were interested in the art of the Southwest, and
among Lovins's paintings are Indian subjects. Prior to settling in
the Los Angeles area he lived in Denver where he headed the art
department of Denver Art Academy.

Lowdon, Elsie Motz (1883-)
B. Waco, Texas. AAA 1917, 1923-1925 (New York City;
Abilene, Texas); AAA 1927-1933 (New York City);
Mallett; O'Brien.

Lukits, Theodore Nicholas (1899-)
Work: Jonathan Club, Los Angeles; Pittsburgh Press As-
sociation; Edgewater Beach Club, Santa Monica. AAA
1923-1933 (Los Angeles); Bénézit; Havlice; Mallett;
WWAA 1938-1962 (Los Angeles).

173

Lundmark, Leon (1875–)

B. Sweden. Work: Krannert Art Museum. University of Illinois; Spies Library, Minominee, Michigan. *Who's Who in California.*

Lundmark was a marine painter who lived in Altadena.

Lussier, Louis O. (–)

Work: Oakland Museum; California Historical Society; Bancroft Library; Chicago Historical Society. California State Library; History of Santa Clara County, 1922, 356.

Lussier was a portrait painter who lived in San Jose, California.

M

McAllister, E. P. (–)

AAA 1917 (San Francisco, California).

McArdle, Henry Arthur (1836–1908)**

B. Belfast, Ireland. D. Texas, February 16. Work: Texas State Library and State Capitol, Austin. Groce and Wallace; Mallett Supplement; O'Brien; Pinckney.

McArdle, who moved to Texas in 1867, is known for his historical portraits and battle scenes. With the aid of extensive research he reconstructed Texas history on canvas, and he also did landscapes of battle fields as they looked in his time.

After McArdle's death his son gave the state a trunk full of his father's research notes, letters, and portraits of historical figures. In exchange, the state purchased McArdle's historical paintings.

McBride, Eva Ackley (1861–)

B. Wisconsin. AAA 1925–1931 (Pasadena, California); California State Library.

174

McBride studied with H. J. Breuer and W. M. Chase. She was a member of the California Art Club, LaJolla Art Club, and Pasadena Society of Artists.

McBurney, James Edwin (1868-1955)
B. Lore City, Ohio. D. Chicago, Illinois, March 2. Work: Southern California Counties' Commission, San Diego; National Bank of Woodlawn, Chicago; Federal Bank and Trust Co., Dubuque, Iowa. AAA 1915-1917 (Los Angeles, California); AAA 1919-1933 (Chicago); Fielding; Havlice; Mallett; WWAA 1936-1953 (Chicago); Art Institute of Chicago, "Scrapbook of Art and Artists of Chicago," 1953, page 12.

McCague, Lydia Scott (1870-)
B. Omaha, Nebraska. Havlice; Mallett Supplement; WWAA 1938-1941 (Omaha).

McCann/McCan, James Ferdinand (1869-1925)
B. Tralee, County Kerry, Ireland. AAA 1915-1924 (Victoria, Texas); AAA 1925 (Boerne, Texas); O'Brien.
This largely self-taught artist spent most of his life in Texas. His love of nature led him to specialize in painting animals and landscapes.

McClellan, Cyranius Bolliva (c.1827-)
California State Library.
McClellan lived in San Francisco from 1850 to 1868, and in Virginia City, Nevada, from 1868 to 1869. He was listed in the Virginia City & Truckee Railroad Directory for 1873-74.

McCormick, Donald (1898-)
B. Wilkes-Barre, Pennsylvania. Havlice; Mallett Supplement; WWAA 1936-1941 (Tulsa, Oklahoma).

McCormick, M. Evelyn (1869-1948)**
B. Placerville, California. D. Monterey, California, May 6. Work: Public buildings in Monterey. AAA 1903-1906 (San Francisco); AAA 1913-1917 (Monterey); Bénézit; Califor-

nia State Library; Irene Alexander, "Last Link With Bohemian Past Broken," Monterey *Peninsula Herald,* May 7, 1948; *Overland Monthly,* January 1908, 31; Monterey Public Library.

McCormick grew up in San Francisco with one career in mind—to be a painter. She studied locally with Emil Carlsen, Virgil Williams, and Raymond Yelland. She also studied in Paris where she exhibited at the Paris Salon.

By 1893 McCormick was a recognized San Francisco painter, and by 1908 *Overland Monthly* noted that her place "among Western artists has long been established."

McCormick was very much a part of the early San Francisco and Monterey art colonies, and just as absorbed in local architecture as her contemporaries in Taos and Santa Fe. She never tired of painting Monterey's historical adobes and was actively engaged in that pursuit until her death.

McCoun, Alice Louise Troxell (1888–)
Havlice; Mallett; WWAA 1936–1941 (Omaha, Nebraska).

McCrea, Samuel Harkness (1867–)
B. Palatine, Illinois. AAA 1903–1933 (Darien, Connecticut); Bénézit; Fielding; Havlice; Mallett; WWAA 1936–1941 (Darien).
McCrea studied art in San Francisco, Chicago, New York, Paris, and Munich. He specialized in landscapes.

McCreery, [Mrs.] Franc Root (1888–1957)
B. Dodge City, Kansas. D. Buffalo, New York, October 31. Work: Buffalo Allied Arts Guild; League of American Penwomen. AAA 1913 (Lincoln, Nebraska); AAA 1921–1933 (Buffalo); Fielding; Havlice; Mallett; WWAA 1936–1956 (Buffalo).

McCrossen, Preston (1894–)
B. Clyde, Michigan. Fisher.
McCrossen settled in Santa Fe, New Mexico, in 1929.

McCulloch/McCullough, Maxie Thomas/Alice M. (1874–)
B. Lee County, Arkansas. Work: Little Rock (Arkansas)

Museum of Fine Arts. AAA 1929-1933 (Eastland, Texas); Havlice; Mallett; WWAA 1936-1941 (Dallas, Texas); WWAA 1947-1953 (Laguna Beach, California).

McDermitt, William Thomas (1884-)
B. Percy, Illinois. AAA 1921, 1925 (State College, Pullman, Washington); Havlice; Mallett; WWAA 1938-1941 (Los Angeles; summer: Pomona, California).
McDermitt specialized in landscape painting.

MacDonald, Katharine Heilner (1882-)
B. Brooklyn, New York. Work: San Diego Fine Arts Gallery; Federal Schools, Inc., Minneapolis. Havlice; Mallett; WWAA 1938-1959 (Coronado and Burlingame, California).

McDuffie, Jane Lee (See: Thurston, Jane McDuffie)

McElroy, Jane (-)
AAA 1913 (San Francisco, California).

McEwen, Katherine (1875-)**
B. Nottingham, England. Work: Detroit Institute of Arts. AAA 1917-1924 (Detroit, Michigan); AAA 1925-1933 (Seven Dash Ranch, Johnson or Dragoon, Arizona); Fielding; Havlice; Mallett; WWAA 1936-1941 (Dragoon); Marion Holden, "Katherine McEwen's Water-colors," *American Magazine of Art*, October 1925, 542-544.

Holden described McEwen's mountain landscapes as having "a fine sense of the bony structure." It was just this kind of landscape that McEwen sought in Arizona, Alaska, and the Rockies.

Though rather frail herself, McEwen chose her sites without regard to comfort or convenience, making little of the rigors involved in living and painting miles from transportation terminals. By boat or train she traveled as far as she could and then hired a guide with horses and camping gear. Upon reaching a destination she stored provisions where chipmunks wouldn't get them, collected and stored firewood where it would remain dry in case of rain, and then set to work. Alone in the midst of bigness

McEwen was able to comprehend her subjects and give them back on paper and canvas, wrote Holden.

What took McEwen to Arizona in the 1920s and kept her there so long was a dude ranch near Dragoon which she and her sister operated.

McGaw, Blanche Evelyn Baldwin (1874–)
B. San Francisco, California. *Who's Who in California*, 1943.

McGaw, who lived in San Francisco, was a member of the San Francisco Art Association.

McGee, Will T. (–)
AAA 1917, 1923–1924 (Fort Worth, Texas).

McGill, Eloise Polk (1872–1939)
B. Independence, Texas, D. San Antonio, Texas. AAA 1907, 1913–1917, 1923–1927 (San Antonio); Mallett Supplement; O'Brien.

McGill was a painter of miniatures, an illustrator, and a teacher who studied at the Art Students' League and the New York School of Art. She was a member of the San Antonio Art League and the Southern States Art League.

McGill, Leona Leti (1892–)
Havlice; Mallett; WWAA 1938–1941 (Dallas and Fort Worth, Texas).

MacGilvary, Norwood Hodge (1874–1949)
B. Bangkok, Siam, of American parents. D. January 6. Work: Detroit Institute of Arts; National Gallery of Art. AAA 1907–1921 (New York City and Brooklyn); AAA 1923–1933 (Pittsburgh, Pennsylvania); Bénézit; Fielding; Havlice; WWAA 1936–1947 (Pittsburgh); WWWA.

MacGilvary studied at the University of California (1896–1897) and the Mark Hopkins Institute of Art (1897–1898). He also studied in France, Holland, and Italy.

Prior to becoming a professor of painting at Carnegie Institute in 1921, MacGilvary worked as an illustrator. He specialized in figure and landscape painting.

McGrath, Lenore K. (-)
AAA 1909-1910 (Seattle, Washington).

McGraw, Hazel Fulton (1897-)
B. Sherman, Texas. Havlice; Mallett; WWAA 1947-1953
(Dallas and Ballinger, Texas).

MacGurrin, Buckley (1896-)
B. Kalamazoo, Michigan. Mallett Supplement; *Who's Who
in California*, 1943.
MacGurrin was a muralist and sculptor who specialized in
the true fresco technique. He lived in Hollywood and El Monte,
California.

Machefert, Adrien Claude (1881-)
B. San Jose, California. Work: Dana High School, San
Pedro, California. Havlice; Mallett; WWAA 1940-1941
(Glendale, California); California State Library.

Mackenzie, Florence Louise Bryant (1890-)
B. Boston, Massachusetts. Havlice; Mallett; WWAA 1940
-1941 (San Francisco, California); *Who's Who on the
Pacific Coast*, 1947.
Mackenzie had studios in San Francisco and Washington,
D.C., where, for a number of years, she was head artist for the
Bureau of Exhibits. She also painted portraits of many prom-
inent persons.

McKinstry, Grace E. (-1936)
B. Fredonia, New York. Work: Minnesota State Capitol;
Carleton College; Beloit College; Pomona College; Cornell
University; Russell Sage College; Lake Erie College. AAA
1903 (New York City); AAA 1905-1917 (St. Paul and Fari-
bault, Minnesota); AAA 1919 (Los Angeles, California);
AAA 1921 (New York City and Faribault); AAA 1923-
1927 (New York City and San Francisco); AAA 1929-1933
(New York City); Bénézit; Fielding; Havlice; Mallett;
WWAA 1936-1937 (New York City); WWWA.

Macknight/MacKnight, Dodge (1860-1950)
B. Providence, Rhode Island. Work: Boston Museum of

Fine Arts; Worcester Museum; Brooklyn Museum; Fogg Museum; Cleveland Museum of Art; Detroit Institute of Arts. AAA 1900–1910 (Spring Hill, Massachusetts); AAA 1913–1933 (East Sandwich, Massachusetts); Bénézit; Fielding; Havlice; Mallett; WWAA 1936–1941 (East Sandwich); WWWA; Ralph Flint, "Dodge MacKnight, Aquarellist," *International Studio,* September 1925, 406–410; *The Art Digest,* February 1, 1929, 17; *Archives of American Art,* Smithsonian Institution, Andrew Oliver collection of Macknight's letters and exhibition brochures.

Macknight began painting in Utah in 1913, and at the Grand Canyon a year later. Of 38 water colors in one Boston exhibition, 20 were Grand Canyon scenes.

In order to work near his subjects, Macknight traveled with camping gear, his sable brushes, a box of water colors, a supply of Whatman paper, and a specially designed case with detachable lid in which wet paintings could be safely stored.

Although Macknight painted in many countries, including France, Spain, Morocco, Canada, and Mexico, he returned most often to the West. In July 1920 he was in Utah at Bryce Canyon which he described as "an extraordinary place, a big hollow a thousand feet deep, filled with thousands of Buddist temples of an orange pink color." Such dramatic aspects of nature lured him to many isolated campsites where he sought to portray "without sentimentality" the scenic wonders of the world.

Macky, Constance L. (1883–)
B. Melbourne, Australia. Work: Oakland Museum. AAA 1915, 1919–1925 (San Francisco, California); Mallett; California State Library; San Francisco Public Library, San Francisco Art and Artists Scrapbook, vol. 1, 61.

Macky, Eric Spencer (1880–1958)
B. Auckland, New Zealand. D. San Francisco, California, May 5. Work: Stanford University Art Gallery; Bohemian Club. AAA 1915–1917, 1923–1925 (San Francisco); Havlice; Mallett Supplement; WWAA 1940–1956 (San Francisco); WWWA; *Who's Who on the Pacific Coast;* California State Library; San Francisco Public Library, San Francisco Art and Artists Scrapbook, vol. 1, 61.

MacLean, Christina (1853–)

B. Glasgow, Scotland. AAA 1913, 1917–1919, 1923–1924 (Fort Worth, Texas); O'Brien.

MacLean taught for many years at Fort Worth University.

McLean, Grace (1885–)

B. Jasper County, Iowa. AAA 1933 (Los Angeles, California); Havlice; Mallett; WWAA 1936–1941 (Pasadena, California).

McLendon, Louise (–)

AAA 1917 (Fort Worth, Texas).

Macleod, Louisa Elizabeth Garden (1857–1944)

B. London, England. D. Los Angeles, California. AAA 1925 (Los Angeles); Mallett; *Who's Who on the Pacific Coast*, 1947; California State Library.

Macleod, who moved to California in 1887, founded and directed the Los Angeles School of Art and Design.

McManus, George (1884–1954)

B. St. Louis, Missouri. D. Hayward, California, October 22. AAA 1921–1931 (New York City); Mallett Supplement (Hollywood, California); WWWA; *Who's Who on the Pacific Coast*, 1949; California State Library.

McMillan, Mary Lane (–)

AAA 1913–1915 (c/o Polytechnic College, Fort Worth, Texas).

McMurdo, James T. (–1955)

D. Albuquerque, New Mexico, March 28. Albuquerque Public Library.

Known as a cowboy artist, this veteran of the First World War was long a resident of New Mexico. Prior to his 23 years in Albuquerque he lived in Colfax County, in Northeastern New Mexico.

Mains, J. R. (c.1833–)

Groce and Wallace.

Mains, who lived in Sacramento, California in 1860, was a resident of Maine.

Maison, Mary Edith (1886-1954)
B. Bethlethem, Pennsylvania. Havlice; Mallett; WWAA 1940-1941 (Manhattan Beach, California); *Who's Who on the Pacific Coast,* 1947.
Maison was also a pianist and a writer of songs. In 1936 she gave a joint concert and art exhibition in Tucson. She was active in clubs in Indio, El Segundo, Banning, and Beverly Hills, and exhibited throughout Southern California.

Mako, B. (1890-)
B. Budapest, Hungary. Mallett (Los Angeles, California).

Manbert, Barton (-)
B. Jamestown, New York. AAA 1915-1919 (Los Angeles, California); AAA 1925-1931 (Glendale, California; summer: Balboa Island, California); Mallett.
Manbert studied with Bridgman, Hitchcock, and Reynolds. He was a member of the California Art Club and the Glendale Art Association.

Mann, Virginia (-)
AAA 1915-1919 (Nampa, Idaho).
Mann was a member of the Cincinnati Woman's Art Club.

Manoir/Manor, Irving K. (1891-)
B. Chicago, Illinois. Work: Joliet (Illinois) Public Library; Milwaukee Art Institute; Speed Memorial Museum, Louisville, Kentucky; Art Institute of Chicago; Brooks Memorial Art Museum, Memphis. AAA 1917-1924 (Chicago); AAA 1925 (LaJolla, California; summer: Chicago); AAA 1927-1933 (Chicago; summer 1933: Spain); Bénézit; Fielding; Havlice; Mallett Supplement; WWAA 1936-1939 (Chicago); WWAA 1940-1962 (Corona Del Mar, California); *American Magazine of Art,* September 1926, 492, referring to Manoir's Taos (New Mexico) paintings.

Many, Alexis B. (1879-1938)
B. Indianapolis, Indiana. Work: George Washington Uni-

versity. AAA 1913 (Glen Echo, Maryland); AAA 1915 (Chevy Chase, Maryland); AAA 1917-1933 (Washington, D.C.); Bénézit; Fielding; Havlice; Mallett; WWAA 1936-1939 (Washington, D.C.).

Many spent several summers in Laguna Beach, California, during the early 1920s.

Maratta, Hardesty Gillmore (1864-1924)

B. Chicago, Illinois. Work: Santa Fe Collection; Delaware Art Museum, Wilmington; Fogg Museum, Harvard University; Hubbell Trading Post Museum, Ganado, Arizona. AAA 1898-1910 (Chicago); AAA 1925*; Bénézit; Young.

Maratta was one of the artists commissioned by Juan Lorenzo Hubbell to copy Navajo rugs, especially of the classic period, in oil or water color. These Hubbell hung on the trading post walls to encourage rug weavers to duplicate the designs of that period. Maratta also painted in California. His "San Juan Capistrano Mission," probably painted before 1907, is in the Santa Fe Collection.

Marble, John Nelson (1855-1918)

B. Woodstock, Vermont. D. Woodstock, April 1. Work: Woodstock Historical Society; Groton School, Groton, Massachusetts; National Academy of Design. AAA 1898-1913 (New York City); AAA 1915 (Santa Barbara, California); AAA 1917 (New York City); AAA 1918*; Fielding; Mallett.

Mari, Valere/Valerie/Valerius de (1886-)

B. New York City. AAA 1913 (Chicago, Illinois); AAA 1915 (Paris, France); California State Library; *The Argonaut*, March 19, 1927, 16.

According to *The Argonaut* Mari was born in Corsica, lived in New York from 1886 to 1905 or 1906, and in Europe from 1914 to 1916. From 1916 to 1927 he lived in the San Francisco Bay area.

Marin, John (1872-1953)

B. Rutherford, New Jersey. D. October 1. Work: Los Angeles Museum; San Francisco Museum of Art; Phillips

Memorial Gallery; Museum of Modern Art; Metropolitan Museum of Art; Brooklyn Museum. AAA 1909-1913 (Paris, France); AAA 1915-1921, 1929-1933 (New York City; Weehawken and Cliffside, New Jersey); Bénézit; Fielding; Havlice; Mallett; WWAA 1936-1953 (Cliffside; summer 1940-1941: Addison, Maine); WWWA; Sheldon Reich, "John Marin and the Piercing Light of Taos," *Art News*, January 1974.

More than a hundred paintings came from Marin's two summers in Taos during 1929 and 1930. Abandoning his geometric formalism, Marin did realistic portrayals. A friend and fellow artist, J. Ward Lockwood, assured Marin that he could lead him to the exact spot where each painting had been made.

From Marin's observation of the San Domingo Indians in 1930 came "Dance of the San Domingo Indians," a dance Marin felt was so beautiful in parts that it was impossible to portray. He wrote his friend Alfred Stieglitz that it was like "rewriting Bach."

Marsh, Charles Howard (1885-1956)
B. Magnolia, Iowa. D. San Diego, California. Work: University of Florida Library. AAA 1921 (Redlands, California; summer: Laguna Beach, California); AAA 1923-1924 (Redlands; summer: La Jolla, California); AAA 1925-1927 (Redlands); AAA 1929-1931 (Fort Wayne, Indiana); AAA 1933 (Orlando, Florida); Bénézit; Fielding; Havlice; Mallett; WWAA 1936-1937 (Brawley, California); WWAA 1938-1941 (San Diego, California).

Marsh, Harold Dickson (1889-)
B. Portland, Oregon. Work: La Grande (Oregon) Public Library; Oregon State Art Museum Association, Salem. AAA 1933 (Portland); Havlice; Mallett; WWAA 1936-1941 (Portland).

Marsh, Mary E. (-)
B. Cincinnati, Ohio. AAA 1919 (Albion, Idaho); AAA 1921 (Los Angeles, California); AAA 1923-1933 (Eagle Rock, California); Fielding, Mallett.
Marsh studied at Cincinnati Art Academy, Chicago

Academy of Fine Arts, and with Birger Sandzen. She was a member of Laguna Beach Art Association and California Art Club. Like her husband Conrad Buff, she was interested in Southwest Indian life.

Marshall, Frank Howard (1866–1934)

B. England. Work: Burlington Northern, Inc., St. Paul, Minnesota. AAA 1913 (Jamestown and New York, New York); AAA 1915–1917 (Worcester, Massachusetts); AAA 1919–1924 (Jamestown); AAA 1925–1931 (Palo Alto, California); AAA 1933 (Carmel, California); Bénézit; Fielding; Havlice; Mallett; WWAA 1936–1941 (Carmel).

Martin, E. Hall (1818–1851)

B. Cincinnati, Ohio. Work: Oakland Museum. Groce and Wallace; California State Library; Oakland Museum; Palo Alto *Times,* January 9, 1974, 18.

Martin was a Cincinnati portrait painter who worked in New York during the late 1840s prior to settling in California in 1849. While living in Sacramento in 1850 he became ill with cholera and died the following year.

In January 1974 the Oakland Museum unveiled Martin's large oil painting entitled "Mountain Jack and a Wandering Miner" which it had purchased for $30,000. The painting had been missing for more than a century, having been taken from the Sacramento City Council Chambers by a man who maintained that Martin owed him $40.

This now famous painting is one of three Martin did on the Mountain Jack theme. The whereabouts of a Mountain Jack hunting scene is unknown. The other Mountain Jack painting is in a private collection.

Martin, J. H. (–)

AAA 1900–1903 (Denver, Colorado); Bromwell Scrapbook, 21, 23, and 28; Denver Public Library.

Martin was known in Denver as a painter of cattle. His "Monarch of the Plains" was described as "fresh and strong—ranks with the best" when it was exhibited in 1899 at the Denver Artists' Club.

185

Martin, John Breckenridge (1857-)**
B. London, Kentucky. Work: Dallas Museum of Fine Arts.
AAA 1933 (Dallas, Texas); Mallett; "Who Found Him,"
The Art Digest, September 1, 1935, 20; O'Brien.

Although Martin had a life-long interest in art, he prob-
ably did not begin his work with pastels until he moved to Dallas
in 1888. Except for help from Robert and Julian Onderdonk when
he was with them on sketching trips, he was entirely self-taught.

Some of Martin's subjects were garnered from his cowboy
days in Texas, which began about 1876, and other remembrances
of the past. In 1934 Joseph Sartor Galleries of Dallas featured
him in a solo exhibition. The following year he gained national
fame when Thomas Hart Benton made enthusiastic remarks
about his work to a Dallas audience. Said Benton, "In Martin's
work can be perceived that original point of view in the treatment
of material which is always to be found in the pictures of the best
artists down the ages." However, according to *The Art Digest,*
Dallas artists thought highly of Martin long before Benton
"found" him.

Martin, Sue Pettey (1896-)
B. Bonham, Texas. Work: Tulsa University; Philbrook Art
Center. Havlice; Mallett Supplement; WWAA 1936-1953
(Tulsa, Oklahoma).

Martinet, Marjorie D'orsi/Dorsey (1886-)
B. Baltimore, Maryland. Work: Association of Jewish
Charities Building, Baltimore. AAA 1923-1933 (Balti-
more); Havlice; Mallett; WWAA 1936-1970 (Baltimore);
The Art Digest, November 15, 1930, 33.

Indians and cowboys were among the Western subjects
Martinet exhibited in 1930.

Martinez, Alfredo Ramos (1872-1946)
B. Monterey, Nuevo Leon, Mexico. D. Los Angeles, Cali-
fornia. Work: California Palace of the Legion of Honor.
Havlice; Mallett; Virginia Stewart, *45 Contemporary Mex-
ican Artists/A 20th Century Renaissance,* Stanford Uni-
versity Press, 1951.

Mattei, Clarence R. (–)
B. California. AAA 1907–1910 (Paris, France); Mallett; California State Library.
Mattei was active in California in the 1920s and 1930s when he lived in Santa Barbara.

Matthew, John Britton (1896–)
B. Berkeley, California. Havlice; WWAA 1947–1962 (Sacramento, California); California State Library.

Mattocks, Muriel (See: Cleaves, Muriel Mattocks)

Matzinger, Philip Frederick (1860–1942)
B. Tiffin, Ohio. D. Pasadena, California, June 18. AAA 1927 (Orosi, California); AAA 1929 (Fresno, California); AAA 1931 (Salada Beach, California); AAA 1933 (Oakland, California); Bénézit; Havlice; Mallett; WWAA 1936–1941 (Pasadena, California).
Matzinger was a member of the Laguna Beach Art Association.

Maybelle, Claude S. (1872–)
B. Portland, Oregon. AAA 1905–1908 (New York City); WWWA.
Maybelle, a cartoonist for the San Francisco *Chronicle* and the San Francisco *Examiner* from 1891 to 1893, studied art at the San Francisco School of Design.

Mayer, Louis (1869–1969)
B. Milwaukee, Wisconsin. D. Carmel, California, January 21. Work: State Historical collections in Des Moines, Iowa, and Madison, Wisconsin; Milwaukee Art Institute; Smithsonian Institution; Burlington (Iowa) Public Library. AAA 1903–1913 (Milwaukee); AAA 1915–1919 (New York City; summer: North Milwaukee); AAA 1921–1933 (New York City and Hopewell Junction, New York); Bénézit; Fielding; Havlice; Mallett Supplement; WWAA 1936–1953 (Hopewell Junction); WWAA 1956 (Fishkill, New York); WWAA 1959–1962 (Carmel, California); California State Library.

Mayhew, Nell Danely Brooker (1876-1940)

B. Astoria, Illinois. D. Highland Park, California. Work: National Collection of Fine Arts. California State Library; Oregon State Museum, Salem; Ambassador Hotels, Los Angeles and Atlantic City. AAA 1915-1924, 1927-1931 (Los Angeles, California); AAA 1925 (Oakland, California); Fielding; Havlice; Mallett; WWAA 1936-1941 (Los Angeles).

Mayhew specialized in landscapes, and is especially well known for her color etchings.

Meadows, Dell (1868-1946)

B. Iowa. D. Los Angeles, California. AAA 1917-1925 (Los Angeles); *Who's Who on the Pacific Coast,* 1947.

Meadows was a member of California Art Club, Laguna Beach Art Association, and Women Painters of the West. She was particularly fond of painting desert scenes.

Means, Mary Maud (1848-)

B. Marietta, Ohio. AAA 1903 (Chicago); AAA 1905-1906 (Santa Barbara, California).

Means studied art in Florence, Italy, and Paris, France.

Meeker, Joseph Rusling (1827-1889)

B. Newark, New Jersey. Work: Brooklyn Museum; Denver Public Library; St. Louis Art Museum. Bénézit; Fielding; Groce and Wallace; Havlice; Mallett; Denver Public Library; *Kennedy Quarterly,* October 1964, 21; *Kennedy Miscellany* #1, August 1965.

This roving landscape painter, who specialized in Southern scenes, lived several years in Buffalo, New York. He was in Louisville, Kentucky, from 1852 to 1859, and thereafter in St. Louis, Missouri. His oil painting entitled "Canon of the Platte River, Colorado Territory" is dated 1870, and his "Green Lake, Colorado" is dated 1871. Undated is "Pikes Peak" which is in the St. Louis Art Museum.

Meeks, Constance A. (-)

AAA 1913 (Oakland, California).

Melvill, Antonia Miether (1875-)

B. Berlin, Germany. Work: South Dakota State Capitol, Pierre; Sacramento (California) Public Library; Harvard Military School, Los Angeles. AAA 1921-1933 (Los Angeles, California); Bénézit; Fielding; Havlice; Mallett; WWAA 1936-1941 (Los Angeles).

Menager, Pierre (1893-)

B. Brittany, France. Fisher.

Menager settled in Santa Fe, New Mexico, in 1927.

Menzler-Peyton, Bertha Sophia (1874-1947)

B. Chicago, Illinois. Work: Union League Club, Chicago; Santa Fe Collection; West End Woman's Club, Chicago; Evanston (Illinois) Woman's Club. AAA 1898-1913 (Chicago); AAA 1915-1921 (New York City); AAA 1923-1929 (New York City; summer: Gloucester, Massachusetts); AAA 1931-1933 (Gloucester); Fielding; Havlice; Mallett; WWAA 1936-1941 (Gloucester); *The Santa Fe Magazine*, November 1973, 11.

Menzler married Edward James Dressler early in her career and was listed as Dressler in the Santa Fe collection, as well as in the Art Annual from 1909 to 1913. By the early 1920s when Menzler was noted in the Art Annual as a landscape painter specializing in Western scenery she was married to Alfred Conway Peyton; this explains the hyphenated name.

Menzler-Peyton has the distinction of being first among several hundred artists to have her work acquired by the Santa Fe Railway. In 1903 the Santa Fe purchased "San Francisco Peaks," an oil depicting the famous Northern Arizona landmark.

Merck, Charles (-)

Work: Society of California Pioneers. Evans; *The Overland*, part 2, August 1868, 119.

The artist was active in San Francisco from 1869 to 1875. He was also known as Herr Merk.

Merrill, Arthur (1885-1973)**

B. St. Louis, Missouri. D. Santa Fe, New Mexico, April 21. Harwood Foundation Library, Taos, New Mexico; personal interview.

Merrill was once a registered pharmacist. Then he studied geology, and finally art. The former inspired an interest in the picturesque rock formations of the West, especially Shiprock which he never tired of painting. Street scenes, mountains, Indians, and Western skies also appear in his work.

Although Merrill did not visit the West until 1930 and did not settle there until 1947, he depicted Western subjects in a manner reminiscent of an earlier period. His work is often seen in Taos where he had a gallery and studio.

Merritt, Ingeborg Johnson (1888-)
B. Norway. Work: Vanderpoel Art Association, Chicago; murals, St. Paul's Church, Helena, Montana. Havlice; Mallett Supplement; WWAA 1940-1941 (Townsend, Montana).

Merritt, Warren Chase (1897-)
B. Randsburg, California. Work: Mamaroneck Public Library, New York; Crown-Zellerbach Building, San Francisco. Havlice; Mallett; WWAA 1938-1939 (Mamaroneck); WWAA 1940-1941 (New Rochelle, New York); San Francisco Public Library; California State Library.

Mersfelder, Lou (-)
B. Chicago, Illinois. AAA 1903 (Chicago); AAA 1905-1906 (San Francisco, California); AAA 1907-1908 (Seattle, Washington); AAA 1909-1910 (San Francisco).

Mersfelder studied at the Art Institute of Chicago and was a member of the Chicago Society of Artists. She married California artist Jules Mersfelder.

Merwin, Antoinette de Forrest Parsons (1861-)
B. Cleveland, Ohio. Work: Boston Art Club; Cuyamaca Club, San Diego. AAA 1905-1917 (Montclair, New Jersey); AAA 1925-1933 (Pasadena, California); Bénézit; Havlice; Mallett; WWAA 1936-1937 (Pasadena); WWAA 1938-1941 (Altadena, California); *American Magazine of Art,* December 1927, 676.

Mesic, [Miss] Julian C. (1889-)
B. Colfax, Washington. Havlice; Mallett Supplement; WWAA 1936-1953 (Oakland, California).

Messenger, Ivan (1895-)
B. Omaha, Nebraska. Mallett; *Who's Who in California, 1943.*

Prior to moving to Southern California where he lived at Julian and San Diego, Messenger taught languages at Stanford University and at the University of Texas. His landscape work is in water color.

Metcalf, Augusta Isabella Corson (1881-1971)
B. Kansas. Work: Oklahoma Art Center, Oklahoma City. Melvin Harrel, "My Life in Indian Territory of Oklahoma: The Story of Augusta Corson Metcalf," *The Chronicles of Oklahoma*, Spring 1955, 49-62; *Oklahoma Today*, Summer 1970, 10-12; Kovinick.

Perhaps no other artist has seen so much of Oklahoma's Indian Country as Augusta Metcalf who moved there with her parents in 1886. Their first house was a 10 x 12 foot shack; the second, in 1892, a picket house on the Washita River near Turkey Creek. Years later Metcalf painted from memory the scenes of her early life.

Metcalf began drawing horses when she was nine. Since she had little in the way of supplies, some of her first efforts appeared on the sides of a white stone house near her first home. Others she sent to an uncle in San Francisco who told her to get the horses' feet out of the grass. (She had put them there because she didn't know how to draw them.) The uncle also cautioned her not to use color until she had mastered drawing.

The practice of drawing and painting continued a number of years until Metcalf considered herself expert enough to send the *Sportsman's Review* an ad illustrated with a bucking horse. The ad announced, "I paint everything but portraits." She also illustrated her mother's writings which were published in educational magazines.

Metcalf has been dubbed the "Sage Brush Artist" by Oklahomans, a title well earned for a half century of depicting Western Oklahoma near Durham where she lived almost all her

life. In 1949 she had a solo exhibition at Oklahoma Art Center; in 1958 her work was shown in New York City at Grand Central Galleries; in 1968 she was elected to Oklahoma's Hall of Fame.

Mettlen, Franke Wyman (1880–)
B. Mazomanie, Wisconsin. Work: Council of Social Agencies, Chicago. Havlice; Mallett Supplement; WWAA 1936 –1937, 1940–1941 (Bloomfield, Nebraska).

Meyer-Kassel/Meyer-Cassel, Hans (1872–1952)
B. Kassel, Germany. D. Genoa, Nevada, August 30. Work: University of Nevada; Genoa Town Hall; California State Capitol; Washoe County (Nevada) Court House. Bénézit; California State Library; Washoe County Library; Basil Woon, "Nevada Might Lose Forever the Collected Paintings of One of Its Greatest Artists," Nevada State *Journal,* February 14, 1954, 9; Sacramento *Bee,* August 30, 1952, 9–17.

Following three years at Amherst College where Meyer-Kassel was guest artist, he made his home in Nevada. The year was 1935.

Although absent from most art directories, Meyer-Kassel had been an art instructor at the Royal Academy in Kassel before moving to New York City in the early 1920s. From all accounts he was proficient in portraiture, landscape, and still life painting, and his work is reputed to be in collections in many parts of the world.

Meyer-Kassel's Indian studies are of particular interest, for they were done in authentic settings. Apparently only one was done from a photographic likeness, for Dat-so-la-lee, the Washoe basket maker, was not living when Meyer-Kassel arrived in Nevada. His portraits of early political figures also were done with the aid of photographs.

After Meyer-Kassel's death his wife sought to preserve for the state 500 to 600 paintings then in her possession. In February 1954 she told Basil Woon she felt her husband's paintings belonged to Nevada "which he loved better than anywhere else in the world."

Meyers, Ralph (1885–1948)**
B. Houghton, Michigan. D. Taos, New Mexico. Work: Har-

wood Foundation, Taos; Hubbell Trading Post Museum, Ganado, Arizona. AAA 1919 (Taos); Rebecca Salsbury James, *Allow Me to Present 18 Ladies and Gentlemen and Taos, N.M. 1885-1939*. Taos, 1953; Interview with Rowena Meyers Martinez.

Meyers grew up in Denver amid traveling celebrities and old timers who frequented a hotel near his home. An avid listener to their talk, he got to know many of them, including Frederic Remington and Frank Sauerwen. Did they or his artist associates of later years influence him to take up painting? His widow Rowena did not think so. More likely it was his love of color and the beauty of the landscape of which Indians and their art were so much a part.

Soon after the turn of the century Meyers began his visits to the Southwest tribes, admiring and collecting some of their finest handicrafts. After he moved to Taos in 1909, he took a job as Forest Service fire guard on Taos Indian land. At his camp on Larkspur Peak he was saved from loneliness by Taos Indians. Enduring friendships were made there and in Taos when he opened a trading post in 1912.

Just when Meyers began to paint is not clear. His first exhibition of record was at the Museum of New Mexico in Santa Fe in 1917 when he showed "Pattern of a Spring Landscape," "Come In," and "The Sentinel." He was not a prolific painter; the trading post was his livelihood. Nevertheless, without training, he did some remarkable work. Leon Gaspard called him one of the finest colorists of that period.

Milam, Annie Nelson (1870-1934)

B. Homer, Louisiana, D. January 9. AAA 1919 (Fort Worth, Texas; summer: El Paso, Texas); AAA 1921-1925 (El Paso); AAA 1927-1929 (Canutillo, Texas); AAA 1931-1933 (Ennis, Texas); Bénézit; Havlice; Mallett; WWAA 1936-1937*.

Milam was a member of El Paso Art Club.

Milburn, Oliver (1883-1934)

B. Toronto, Ontario, Canada. D. Los Angeles, California. AAA 1929-1933 (Los Angeles); Mallett.

Milburn studied at Los Angeles Art Institute and Chou-

inard School of Art. He was a member of California Art Club, Laguna Beach Art Association, San Diego Art Guild, Santa Monica Artists' Society, and California Water Color Society.

Miles, Emily H. (–)
AAA 1915–1917 (Denver, Colorado).
Miles was a member of the Denver Artists' Club.

Miles, Harold Whiting (1887–)
B. Des Moines, Iowa. Work: mural decorations for West Des Moines High School. AAA 1919–1933 (Los Angeles and Hollywood, California); Havlice; Mallett; WWAA 1936–1939 (Hollywood); WWAA 1940–1947 (Roscoe, California); WWAA 1953 (Sunland, California).

Miles, Maud Maple (1871–1944)
B. Chariton, Iowa. Work: Santa Fe Railway Collection. AAA 1907–1908 (Kansas City, Missouri); AAA 1909–1910 (New York City); Kovinick.
Miles studied art at the Art Institute of Chicago, and with Arthur Wesley Dow. She sketched in many states, including Texas, Colorado, Wyoming, Arizona, and California; and she lived at various times in Ohio, Illinois, and Washington, D.C., as well as in New York City and Kansas City.

Miller, Anna Hazzard 1863–)
B. Minnesota. Work: University of Oklahoma; Oklahoma Art League. AAA 1919–1924 (Oklahoma City, Oklahoma; summer 1923–1924: Lyme, Connecticut); AAA 1925–1933 (Oklahoma City; summer 1925–1927: San Diego, California); Havlice; Mallett; WWAA 1936–1941 (Oklahoma City); *Chronicles of Oklahoma*, Autumn 1954, 271–272.

Miller, Delle (–1932)
B. Independence, Kansas. D. Kansas City, Missouri, September 17. Work: Kansas City Art Institute; Kansas City Public Library; Northwest Missouri State Teachers College. AAA 1921 (Kansas City; summer: East Gloucester, Massachusetts); AAA 1923–1924 (Kansas City; summer: Lawrence, Kansas); AAA 1925–1933* (Kansas City); Mallett.

Miller, Edith Maude (–)
AAA 1917 (Galveston, Texas); AAA 1919 (Oklahoma City, Oklahoma).

Miller, Henry (–)
Work: Amon Carter Museum of Western Art. Groce and Wallace; California State Library; Henry Miller, *13 California Towns from the Original Drawings*, with text by Edith M. Coulter and Eleanor Bancroft, San Francisco: The Book Club of California, 1947.
Miller visited California during the mid-1850s.

Miller, Maude Alvera (1883–)
B. Skyland, California. AAA 1929–1933 (Oakland, California; studio: Los Angeles); Mallett.
Miller was a member of San Francisco Society of Women Artists.

Miller, Myra (1882–1961)
B. Montevideo, Minnesota. D. Webster, South Dakota, September 19. Stuart.
This largely self-taught painter and photographer grew up in Milbank, South Dakota. She exhibited at state fairs and won several awards. Her work is in the collection of the South Dakota Memorial Art Center in Brookings.

Miller, Richard Emil (1875–1943)
B. St. Louis, Missouri. D. St. Augustine, Florida, January 23. Work: Luxembourg Gallery, Paris, France; National Collection of Fine Arts; Metropolitan Museum of Art; Corcoran Galley of Art; St. Louis Art Museum; Albright Gallery, Buffalo; Detroit Institute of Art; Chicago Art Institute; Pennsylvania Academy of Fine Arts. AAA 1898–1903 (St. Louis, Missouri); AAA 1905–1921 (Paris, France); AAA 1923–1924 (New York City); AAA 1925–1933 (Provincetown, Massachusetts); Bénézit; Fielding; Havlice; Mallett; WWAA 1936–1941; WWWA.

Millier, Arthur (1893–)
B. Weston Super Mare, Somerset, England. Work: Na-

tional Collection of Fine Arts; Art Institute of Chicago; Los Angeles Museum; Library of Congress; Dallas Museum of Fine Arts. AAA 1923-1931 (Los Angeles, California); Havlice; Mallett; WWAA 1936-1937 (Santa Monica, California); WWAA 1938-1941 (El Monte, California); "Millier, Critic, Shows Etchings at Capitol," *The Art Digest,* October 15, 1922, 21; "Millier as Etcher and Millier as Art Critic," *The Art Digest,* April 1, 1930, 21.

Millier first came to California in 1908. Three years in the Canadian army intervened before he began a series of San Francisco street scenes in 1920 that established him as a capable etcher. In 1922 he moved to Los Angeles where he found much of interest in the Mexican community in Old Town near the Civic Center. His work attracted considerable attention, and in 1926 he became art critic for the Los Angeles *Times.*

After becoming art critic Millier drifted toward landscape subjects as a relief from the town of which he saw enough on the job. He was particularly attracted to "those spots which have been farmed for many years, where there are water and trees and the buildings have been designed out of necessity and without the intervention of an architect."

Milsk, Mark (1899-)
B. St. Paul, Minnesota. Work: San Francisco Art Association; California State Library; Achenbach Foundation. Havlice; Mallett Supplement; WWAA 1940-1962 (San Francisco, California).
Milsk also is known as Mrs. Edmond Imperato.

Miner, Frederick R. (1876-)
B. New London, Connecticut. Work: Union League Club, Los Angeles; Glendale (California) Sanitarium. AAA 1917 -1932 (Los Angeles, California); Bénézit; Fielding; Mallett.
Miner was a landscape painter who studied with William Wendt and John Carlson, and at the Art Students' League in New York City. He was a member of Laguna Beach Art Association, California Art Club, and Society of Independent Artists. He was also a writer.

Mitchell, Arthur Roy (1889-)**
B. near Trinidad, Colorado. Work: Trinidad State Junior

College; Pioneer Museum, Trinidad. Frances Melrose, "Trinidad Painter Helps Preserve History," *Rocky Mountain News*, August 17, 1975, 8, 10.

Background for Mitchell's paintings is largely the Trinidad area. "All my life I've been in love with it," he told Melrose. "To me, home was not a building but the country. These pinon-covered hills, the wide sweep of grama grass were made to order for me."

Mitchell has worked as a cowboy, cartoonist, illustrator, advertising artist, art professor, curator, easel painter, and art department and museum founder. He has lived all over the West and in the East where he spent 19 years as an illustrator. It was upon his return from the East that he founded the art department at Trinidad State Junior College. He taught there for 14 years.

Mitchell, Eleanor B. (1872–)
B. Pittsburgh, Pennsylvania. AAA 1913–1927 (San Anselmo, California); Mallett.

Mitchell studied with Arthur Mathews, and in Paris. She was a member of San Francisco Society of Artists.

Mitchell, Gladys Vinson (1894–)
B. Albuquerque, New Mexico. Work: Museum of New Mexico; Houston (Texas) Art League. AAA 1919 (Minneapolis, Minnesota; summer: Santa Fe, New Mexico); AAA 1921–1924 (Oak Park, Illinois); Mallett; Museum of New Mexico.

By 1919 Mitchell had been doing Indian subjects and landscapes in and around Santa Fe for four years, and had been made a Fellow of the School of American Research. In May of that year her work was shown at the Museum of New Mexico in Santa Fe. The following year her painting "Winter at Bishop's Lodge" was reproduced for the January issue of *Art and Archaeology*. She also worked in Texas where she studied with Boyer Gonzales and E. G. Eisenlohr.

Mocine, Ralph Fullerton (–)
Work: Oakland Museum. AAA 1917–1925 (Los Angeles, California); C. P. Austin in *Out West*, December 1911, 7.

Mocine's painting "Paris" is in the Oakland Museum. Ex-

cept for a brief period of study in Paris in 1906, he was a resident of Los Angeles where he worked as a commercial artist.

Modjeska, Marylka H. (1893-)
B. Chicago, Illinois. Work: National Collection of Fine Arts. AAA 1917 (Chicago; summer: Provincetown, Massachusetts); AAA 1919 (New York City; summer: Provincetown); AAA 1921, 1925-1931 (Tucson, Arizona); Havlice; Mallett Supplement; WWAA 1936-1941 (Tucson; summer: Corona del Mar, California); WWAA 1947-1962 (Tucson); *The Art Digest,* July 1929, 22.
Modjeska is also known as Mrs. Sidney Patterson.

Modra, Theodore B. (1873-1930)
B. Poland. D. Los Angeles, California, October 28. AAA 1915 (New York City); AAA 1919-1925 (Ontario, California); AAA 1927-1931* (Hollywood, California).

Mohling, Fred H. (1894-)
B. Gladstone, Nebraska. Stuart.
The largely self-taught Mohling exhibited at the Corn Palace in Mitchell, South Dakota, in 1963, and at South Dakota state fairs. He lived in Wessington Springs.

Molina Campos, Florencio (1891-)
B. Buenos Aires, Argentina. *Who's Who on the Pacific Coast,* 1949.
Molina came to this country in 1937 and began exhibiting soon afterward. He has had solo shows in several California cities, and in New York. He did some teaching, worked for Walt Disney Studios, and also worked as an illustrator. He lived in Los Angeles.

Monges, Henry B. (1870-)
B. Belville, Texas. AAA 1915 (Berkeley, California).

Monhoff, Frederick (1897-)
B. New York City. Work: Brooklyn Museum; Library of Congress; National Collection of Fine Arts; De Young Memorial Museum; Los Angeles Museum of Art; Museum

of New Mexico. AAA 1925-1927 (Hollywood, California); Havlice; Mallett Supplement; WWAA 1947-1962 (Altadena, California); Robertson and Nestor.

Monhoff also spent some time in Santa Fe, New Mexico, probably in the early 1920s. He specialized in etchings. "Penitente Ceremony, Nambe, N.M." and "Traders, Gallup, N.M." are in the National Collection of Fine Arts.

Monkvold, Oscar E. (1891-1958)
B. Viborg, South Dakota. D. Sioux Falls, South Dakota, November 3. Stuart.

Monkvold studied art and music, the former at the Art Institute of Chicago. He settled in Sioux Falls in 1941 to teach music at Augustana College. His portrait work can be seen in the South Dakota Memorial Art Center in Brookings, and at the State Capitol in Pierre.

Monroe, Laura Potter (-)
AAA 1917 (Muskogee, Oklahoma); AAA 1925 (Chicago, Illinois).

Monserud, Wilma (1899-)
B. Watereville, Iowa. Stuart.

Monserud, who studied at the Minneapolis School of Art and at the University of Minnesota, taught in the public schools of Day, Spink, and Roberts counties in South Dakota. She also was a botanical artist for the University of Minnesota, and a photographer. She lived in Webster, South Dakota.

Montalboddi, Raffaelo (-)
AAA 1915-1919 (Pasadena, California).

Montgomery, Alfred/E. A. (1857-1922)
B. Lawndale, Illinois. D. Los Angeles, California, April 19. Work: Joslyn Art Museum; Philbrook Art Center; Springville (Utah) Museum of Art. AAA 1898-1900 (Lawndale); AAA 1922*; Bénézit; Fielding; Mallett; Topeka Public Library; Topeka *State Journal,* December 30, 1940; "Noted Artist Passes Away," Los Angeles *Times,* April 21, 1922.

Little has been written about this painter of farm scenes

who grew up in Kansas and may have been born there, for he referred to Kansas as his native state. Orphaned in childhood, Montgomery was bound out to farmers until he was 21 and then given $100 for all his years of service.

Somehow Montgomery managed to get an education. He studied art here and abroad, and in Paris his painting "Down on the Farm" won fame.

Montgomery was school principal in Vermillion, Kansas, before becoming Topeka's first teacher of drawing and lecturer on art in the public schools—a position he apparently held in the 1880s and 1890s. Thereafter he became a traveling lecturer whose flamboyant pronouncements on art and other matters did not endear him to his critics any more than did his realistic paintings.

During the last 16 years of Montgomery's life he lived in Los Angeles where he continued to give lectures. Although he probably did little painting there, an oil entitled "Fort Yuma Indian Farm and Reservation" may have been painted as late as 1915.

Montrichard, Raymond Desmus (1887-)
B. Berkeley, California. AAA 1931–1933 (Los Angeles, California); Mallett.
Montrichard was a member of Laguna Beach Art Association.

Moon, Grace (–1947)
B. Indianapolis, Indiana. D. September 6. WWWA; *Who's Who in California*, 1943.
Moon was a writer who sometimes collaborated with her artist husband Carl Moon, and sometimes illustrated her own work. Her paintings of Indian children are in private collections. In 1914 the Moons settled in Pasadena, California, where they specialized in depicting Indians of the Southwest.

Moore, Harry Humphrey (1844–1926)
B. New York. D. Paris, France, January 2. Work: Carnegie Institute Museum of Art; California Historical Society. AAA 1909–1925 (Paris); Bénézit; Fielding; Mallett Supplement; WWWA; California State Library.
Moore was active in San Francisco in 1906 and 1907.

Moore, John Marcellus [Tex] (1865-)

B. Tarrant County, Texas. Mallett Supplement; Denver Public Library; *Frontier Times,* October 1935, 72; O'Brien.

O'Brien, who likely knew Moore personally, said that the first painting Moore sold was to a dude from New York who paid $150 for it and later sold it for $3000. Moore's comment was, "Well, he was the dude and I the dupe."

Moore grew up in Texas range country—a cowboy by day who practiced drawing at night on whatever happened to be handy around the chuck-wagon fire. Remington was impressed with his ability and encouraged him to keep working.

About 1885 Moore established a studio on a dude ranch near Yellowstone. From there he traveled into adjoining states depicting the cowboy life and scenery of the region. Fifty years later he returned to Texas and established a studio in Wichita Falls. About that time the state legislature named him Official Cowboy Artist for Texas. It was also about that time that Vice President Garner acquired three Moore paintings for his Washington office. Moore's work is at the Fort Worth Art Museum and in other public collections.

Moran, Mary Nimmo (1842-1899)

B. Strathaven, Scotland. D. East Hampton, Long Island, New York. Work: National Collection of Fine Arts; East Hampton (New York) Free Library; Newark Museum; Jefferson National Expansion Memorial, St. Louis.

This famous etcher visited the West with her husband Thomas Moran in 1874, when she painted "Yosemite Falls." Apparently she revisited the West, for "Beached Whale Boat, Santa Barbara," was dated June 1891. Both are water colors.

Moran, Paul Nimmo (1864-1907)

B. Pennsylvania. D. Los Angeles, California, May 26. AAA 1898-1903 (New York City); AAA 1907-1908* (Los Angeles); Bénézit; Mallett.

Moran was in the West on sketching trips with his father Thomas Moran prior to settling in Los Angeles about 1898.

Morgan, Charles L. (1890-)

B. Mount Vernon, Illinois. Work: National Collection of

Fine Arts. Havlice; Mallett Supplement; WWAA 1936–1937 (Manhattan, Kansas); WWAA 1938–1941 (Stuart, Florida).

Morgan, Charlotte Elizabeth Bodwell (–)
B. Lakeville, California. Work: Harrison Memorial Library, Carmel, California; California Historical Society. AAA 1931–1933 (Carmel); Havlice; Mallett; WWAA 1938–1953 (Carmel).

Morris, Ada/Adelaide (1881–)
B. Lineville, Iowa. AAA 1919–1925 (Los Angeles, California); AAA 1931–1933 (Honolulu, Hawaii; summer: Los Angeles); Havlice; WWAA 1936–1941 (Los Angeles); Western History Archives, University of Colorado, Boulder.

Personal correspondence of Morris indicates that she was a friend of artist Charles Hudson Cox, and may have helped him organize The Chautauqua Drawing Society. She was one of the 25 artists invited to join the Society which was an outgrowth of the Texas-Colorado Chautauqua held during the summer of 1899.

Personal correspondence also discloses that Morris taught for a short time in Laramie, Wyoming, probably in 1904. If so, this was the year after she received her B.A. at the University of Colorado. She received her M.A. in 1917.

Although Morris had some training in the technique of painting, including landscape painting, her goal was teaching. Ultimately her specialty was renaissance art which she taught at universities in Hawaii and Southern California.

Morris, James Stovall (1898–)
B. Marshall, Missouri. Work: Metropolitan Museum of Art; Santa Barbara Museum of Art; mural, Spanish-American Normal School, El Rito, New Mexico. Havlice; Mallett Supplement; WWAA 1940–1953 (Santa Fe, New Mexico); *The Art Digest,* December 15, 1933, 13.

Morris was known as one of the Rio Grande painters in the early 1930s when he was living in New Mexico.

Morris, Louise (1896–)
B. Alliance, Ohio. Work: Cleveland Municipal Collection.

Havlice; Mallett; WWAA 1938-1941 (East Cleveland, Ohio); School of American Research, Santa Fe, 1940.

Morris illustrated "Los Pastores" in Santa Fe in the early 1930s.

Morrow, Julie Mathilde (-)
B. New York City. Work: Wadleigh Library, New York City; Farnsworth Museum, Wellesley College; American Federation of Womens' Clubs. AAA 1917-1927 (New York City; summer 1917-1919: Provincetown, Massachusetts); AAA 1929-1933 (Cincinnati, Ohio); Bénézit; Fielding; Havlice; Mallett; WWAA 1936-1941 (Cincinnati); *The Art Digest*, February 1, 1935, 29.

The preceding reference discussed Morrow's California landscapes. She was also known as Mrs. Cornelius W. de Forest.

Morse, Vernon Jay (1898-1965)
B. Benton Harbor, Michigan. D. Burbank, California. AAA 1931-1933 (Pasadena, California); Havlice; Mallett; WWAA 1936-1941 (Sierra Madre, California).

Mott-Smith, May (1879-1952)
B. Honolulu, Hawaii. D. June 5. AAA 1915-1924 (Los Angeles, California); AAA 1925-1933 (New York City); Bénézit; Fielding; Havlice; Mallett; WWAA 1947-1953* (New York City).

Mountfort/Moundford, Arnold G. (1873-1942)
B. Eggbaston, England. D. Hollywood, California. AAA 1919-1921 (New York City); Bénézit; Fielding; Mallett.

Mountfort studied at the Birmingham Municipal School of Art in England.

Mowbray, Henry Siddons (1858-1928)
B. Alexandria, Egypt. D. Washington, Connecticut, January 13. Work: National Collection of Fine Arts; Buffalo Fine Arts Academy; mural decorations, Appellate Court and University Club Library, New York City; Morgan Library; Gunn Memorial Library, Washington, D.C. AAA 1898-1928* (New York City; Washington, Connecticut

from 1909; Rome and Italy in 1903); Bénézit; Fielding; Havlice; Mallett Supplement; WWWA.

Mowbray was briefly in California to paint murals for Collis P. Huntington in San Marino.

Mruk, Walter/Wladyslaw E. (1895-1942)

B. Buffalo, New York. Work: Museum of New Mexico. AAA 1919 (Denver, Colorado); AAA 1921 (Buffalo); Mallett Supplement [listed as Murk]; Robertson; Robertson and Nestor; Coke, 1963.

In 1920 Mruk was in Santa Fe doing political cartoons for the Santa Fe *New Mexican* and working as a forest ranger. In 1926 he returned to Buffalo, but was back in Santa Fe briefly a year or two later.

Mruk had the distinction of being one of the first artists to paint Carlsbad Caverns when he went there in 1925 with Will Shuster, another Santa Fe artist.

Mueller, Alexander (1872-1935)

B. Milwaukee, Wisconsin. D. San Marino, California, March 16. AAA 1903-1924 (Milwaukee); AAA 1925-1927 (Munich, Germany); AAA 1929-1933 (San Marino, California); Bénézit; Fielding; Havlice; Mallett; WWAA 1936-1937*.

Mueller was a member of Wisconsin Painters and Sculptors and the Society of Milwaukee Artists. He directed the Milwaukee Art School.

Mueller, Lola Pace (1889-)

B. Atlanta, Georgia. Work: Witte Memorial Museum; Federation of Women's Clubs, Austin, Texas; San Antonio Woman's Club. Havlice; Mallett Supplement; WWAA 1940-1953 (San Antonio, Texas).

Mueller, Michael J. (1893-1931)

B. Durand, Wisconsin. D. Bend, Oregon, in July. AAA 1929 (New York City; Cable, Wisconsin); AAA 1931* (Eugene, Oregon); Mallett; *The Art Digest*, May 1, 1931, 7; *The Art Digest*, August 1, 1931, 16.

Following Mueller's graduation from Yale's School of Fine

Arts, he won the Fellowship of the American Academy in Rome. By 1930 he was teaching at the University of Oregon, and exhibiting. That year he won first prize at the Northwest Annual in Seattle.

Mueller, considered one of the Northwest's most promising artists at the time, was preparing for an exhibition in New York when he died. His landscape work of that period reflects his interest in the fossil country along the John Day River and the scenery near Bend.

Muench, Agnes Lilienberg (1897–)
Havlice; Mallett Supplement; WWAA 1938–1941 (Houston, Texas).
Earlier in her career, Muench lived in Laporte, Texas.

Mukoyama, K. (–)
AAA 1915 (Salt Lake City, Utah).

Muller, Dan (1888–1977)**
B. near Choteau, Montana. D. probably Port Washington, Wisconsin. Mallett Supplement; Federal Writers Project, *Nevada;* Vivian A. Paladin, "Dan Muller: Part Picgan Montana Artist," *Montana Magazine of Western History,* October 1966, 40–57; *Montana Post,* March 1977, 7.

Born to the tough life of bronco breaking and cow punching, Muller had the ability to capture this life in his paintings, and his work has been extremely popular in recent years.

Muller was working for Buffalo Bill Cody when he began selling a few paintings about 1911. When Cody's death in 1917 left him without a job, he tried to make a living as a painter.

Without any formal art training, but with Charlie Russell as his model, Muller returned to the West for subject matter. Back and forth from the Mexican Border to Canada Mueller traveled, finally settling down for a short while in Elko, Nevada. Then he went to Chicago hoping to make a living as an illustrator. By 1933 he had achieved some success. Not long afterward he was listed in Mallett's Supplement as an illustrator for Reilly and Lee, Co., of Chicago, and living in Port Washington.

Muller has done a considerable number of easel paintings in oil, and he has written several books. Like Russell, he found he

could write about frontier life as well as paint it.

Mullgardt, Louis Christian (1866–1942)
B. Washington, Missouri. D. January 12. AAA 1915–1919 (San Francisco, California); WWAA 1947*.
Mullgardt was also an architect. He practiced in Boston before settling in California in 1905. For awhile he was on the staff of the San Francisco *Chronicle.*

Munras, Estaban (–)
California State Library; *Pacific Monthly,* August 1863, 151.
According to *Westways* Magazine, May 1938, 17, Munras decorated Mission San Miguel in 1821.

Munsell, William A. O. (1866–)
B. Cold Water, Ohio. Work: Los Angeles Museum; Scottish Rite Cathedral, Los Angeles; San Marino (California) City Hall. AAA 1919–1927 (Pasadena, California); AAA 1929–1933 (San Marino); Bénézit; Fielding; Havlice; Mallett; WWAA 1936–1941 (San Marino).

Murphy, Harry Daniels (1880–)
B. Eureka, California. Havlice; Mallett Supplement; WWAA 1938–1962 (La Jolla, California).
Murphy also lived in Portland, Oregon, where he worked on the *Oregonian,* and in Denver, Colorado, where he worked on the Rocky Mountain *News.* He is represented in the Huntington Library in San Marino, California.

Murphy, James Edward, Jr. (1891–)
B. Chicago, Illinois. Mallett; *Who's Who in America,* Vol. 8.
Murphy worked as a cartoonist and newspaper artist in Omaha, Nebraska, during 1906 and 1907. He worked as a cartoonist for the Spokane *Inland Herald* in 1910, and for the Oregon *Daily Journal* for a number of years beginning in 1911. By 1934, and perhaps before, he was working and living in New York City.

Murphy, Lawrence M. (-)
AAA 1917-1924 (Los Angeles, California); Fielding.
Murphy was a member of the California Art Club.

Murphy, Minnie B. Hall Perry (1863)
B. Denver, Colorado. AAA 1900, 1915-1929 (Denver, Colorado); Fielding. [Incorrectly listed as Mitchell in *Artists of the American West*, 1974.]
Murphy studied at the Art Students' League, the Art Institute of Chicago, and with Henry Read in Denver. She was a member of National Arts Club in New York City, and Denver Artists' Club.

Myers, Datus E. (1879-1960)
B. Jefferson, Oregon. D. Siskiyou County, California, November 19. Work: National Collection of Fine Arts; U.S. Post Office, Winnsboro, Louisiana; Museum of New Mexico. AAA 1909-1913, 1921 (Chicago, Illinois); AAA 1915 (San Francisco, California); AAA 1917-1919 (Jefferson); AAA 1923-1924 (Santa Fe, New Mexico); AAA 1925 (San Diego, California); AAA 1927-1933 (Santa Fe); Bénézit; Fielding; Havlice; Mallett; WWAA 1940-1941 (Santa Fe); Robertson and Nestor; *El Palacio*, 1927, Part II, page 167.
It was Myers's earnings from running the family farm in Oregon that financed his education at Chouinard School of Art in Los Angeles, and the Art Institute of Chicago.
Myers was first in Santa Fe in 1923. He returned several years later and made it his permanent home. He had a particular interest in Indian painting and played a significant role in coordinating Indian artists under the Public Works of Art Project. He also combined his Egyptian and Oriental art research with that of American Indian painting.
In his own painting, Myers drew from Indian ceremonies for his subjects, reaching "true greatness" with those he exhibited in 1927, according to *El Palacio*. He also painted many New Mexico landscapes. When he left Santa Fe to spend his remaining years in Northern California, he brought to a close nearly three decades of participation in the Santa Fe art movement, including some teaching at the Arsuna School of Fine Arts.

207

Myers, Lloyd Burton (1892-1954?)

B. Sterling, Illinois. AAA 1925-1933 (New York City); Bénézit; Havlice; Mallett; WWAA 1936-1937 (Los Angeles, California); WWAA 1938-1953 (San Francisco, California).

N

Nankivell/Nankivelli, Frank Arthur (1869-)

B. Maldon, Victoria, Australia. Work: Museum of the American Indian; Brooklyn Museum; Metropolitan Museum of Art; University of Virginia, Charlottesville. AAA 1909-1921 (New York City); AAA 1931-1933 (Walton, New York; New York City); Bénézit; Fielding; Havlice; Mallett; WWAA 1936-1941 (New York City; summer: Walton); California State Library.

Nankivell was in San Francisco from 1894 to 1896.

Nau, Carl W. (-)

AAA 1917 (Emporia, Kansas).

Nave, Royston (1876-c.1931)

B. La Grange, Texas. Work: State of Texas. AAA 1915 (Fort Worth, Texas); AAA 1919-1927 (Victoria, Texas; studio: New York City); AAA 1929-1931 (Victoria); Bénézit; Fielding; Mallett; "Memorial for Nave," *The Art Digest,* February 15, 1933, 16; O'Brien.

At the time Mrs. Nave gave the memorial museum to the city of Victoria, she also lent to it for an indefinite period 70 of her son's paintings.

Nave studied in New York with Robert Henri, Lawton Parker, Walt Kuhn, and Irving Wiles. Before returning home he traveled extensively in various other Western states, painting

portraits and landscapes. During his career he exhibited widely in the East and Middle West.

Neilson, Charles P. (See: Nielson, Charles P.)

Neilsen, Kay (1886–)
B. Copenhagen, Denmark. Mallett; *Who's Who in California*, 1943.
Neilsen lived in Santa Barbara, California, during the mid 1930s, and in Altadena, California, in the early 1940s.

Newby, Ruby Warren (1886–)
B. Goff, Kansas. Work: Yale University Art Gallery; Orlando (Florida) Public Library; Rollins College, Winter Park, Florida. AAA 1927 (Orlando); AAA 1929–1931 (Winter Park); AAA 1933 (Sarasota, Florida; summer: Monterey, Massachusetts); Bénézit; Havlice; Mallett; WWAA 1936–1941 (New York City; summer 1936–1937: Monterey); WWAA 1947–1953 (Carlink Ranch, Redington, Arizona, near Benson).

Newton, Helen F. (1878–)
B. Woodbridge, Connecticut. Work: City Hall, Norwich, Connecticut; New Haven Paint and Clay Club. AAA 1931 (New Haven, Connecticut); AAA 1933 (Westville, Connecticut); Havlice; Mallett; WWAA 1936–1939 (Westville; studio: Santa Barbara, California); WWAA 1940–1962 (Norwich, Westville, and New Haven, Connecticut).

Neyland, Watson (1898–)
B. Liberty, Texas. AAA 1931–1933 (Liberty); Mallett; O'Brien.
Neyland studied first to be an architect. While he was at Rice Institute, his studies were interrupted by service in the First World War. Afterward he decided to be an artist, studying first at Rice and then at Pennsylvania Academy of Fine Arts. Two foreign traveling scholarships and two additional years of painting in Europe kept him there until 1925. Thereafter he lived in Liberty.

Nice, Blanch Heim (1892-)
B. Houston, Texas. Havlice; Mallett Supplement; WWAA 1940-1953 (Houston).

Nichols, Audley Dean (1886-1941)
O'Brien; *The Art Digest,* February 15, 1933, 18.
Nichols was an illustrator for *McClure's, Cosmopolitan,* and *Colliers.* He settled in El Paso, Texas, probably in the twenties or early thirties. According to O'Brien his Southwestern desert and cowboy landscapes brought international recognition. He also painted portraits and miniatures. He was a member of Southern National Academy of Design.

Nichols, Pegus [Peggy] Martin (1884-1941)
B. Atchison, Kansas. D. Los Angeles, California, June 27. AAA 1919-1925 (Los Angeles); Bénézit; Fielding; Havlice; Mallett Supplement; WWAA 1936-1941 (Los Angeles).

Nicholson, Isabel Ledcreigh (1890-)
B. St. Louis, Missouri. AAA 1927-1929 (Carmel, California); AAA 1931-1933 (Pebble Beach, California); Bénézit; Havlice; Mallett Supplement; WWAA 1936-1941 (Pebble Beach); *Who's Who on the Pacific Coast,* 1947.
Nicholson was a portrait and landscape painter who also was an inventor and a designer of houses.

Nielson/Neilson, Charles P. (-)
B. Scotland. Work: Oakland Museum; California Historical Society. California State Library.
Nielson was active in Northern California at least as early as 1896, for water color scenes of San Francisco and Monterey are dated that year.

Noble, John (1874-1934)**
B. Wichita, Kansas. D. New York City, January 6. Work: National Collection of Fine Arts; Corcoran Gallery of Art; Wichita (Kansas) Museum; Dallas Museum of Fine Arts; Delgado Museum, New Orleans; Academy of Design, Rhode Island; Brooks Memorial Gallery, Memphis. AAA 1913-1915 (Wichita); AAA 1921-1924 (Paris, France);

AAA 1925-1933 (New York City); Bénézit; Fielding; Havlice; Mallett; WWAA 1936-1937*; WWWA; Merwin Martin, "John Noble, from Kansas," *International Studio,* September 1923, 457-465; "John Noble Dead," *The Art Digest,* January 15, 1934, 11; "John Noble of the Prairie and of the Sea," *The Art Digest,* February 15, 1935, 7; Dale and Wardell.

Among the most famous of the artists who came out of the West to do their work elsewhere is John Noble. Born at the site of present-day Wichita, on uncertain date, Noble received his first painting lessons from Indians, and his first subject matter came from experiences on the family ranch. He participated in cattle drives over the Old Chisholm Trail and in the run into the Cherokee Outlet. As to the latter he secured a claim, but could not hold it because he was too young. Later he did a painting of that momentous event which was hung in the Oklahoma State Capitol.

Noble is generally thought of as a painter of the sea. For many years, both in Europe and on the East Coast, he specialized in fishing scenes, often as they appeared at night by the light of the moon. But throughout his career he retained remnants of Western attire, sporting five-gallon hats and a rattlesnake vest that finally wore out.

Nomura/Nomoura, Kenjiro (1896-1956)
B. Japan. Work: National Collection of Fine Arts; Seattle Art Museum. AAA 1923-1924, 1933 (Seattle, Washington); Havlice; Mallett; WWAA 1936-1941 (Seattle); *Who's Who in Northwest Art;* Kingsbury.

Nomura, who was self-taught, won the Baker Memorial Prize at the Annual Exhibition of Northwest Artists, and in 1933 had a solo exhibition at the Seattle Art Museum. He was a member of Seattle's "Group of 12."

Nordberg, C. Albert (1895-)
B. Chicago, Illinois. Work: Vanderpoel Memorial Collection, Chicago; Cheyenne School, Colorado Springs, Colorado. AAA 1925-1931 (Evanston, Illinois; Colorado Springs, Colorado); Havlice; Mallett; WWAA 1936-1939

(Colorado Springs; Evanston); WWAA 1940–1941 (Evanston).

Norling, Ernest Ralph (1892–)
B. Pasco, Washington. Work: Seattle Art Museum; National Collection of Fine Arts; White House, Washington, D.C.; murals, Bremerton (Washington) Post Office; Bremerton Navy Yard Library. AAA 1929–1933 (Seattle, Washington); Havlice; Mallett; WWAA 1936–1941 (Seattle; studio: Hollywood, California); WWAA 1947–1962 (Seattle); *Who's Who in Northwest Art.*

Noyes, George Loftus (1864–1951?)
B. Bothwell, Canada. Work: Boston Museum of Fine Arts; Des Moines (Iowa) Art Museum; Utah State Museum. AAA 1898 (Malden, Massachusetts); AAA 1900–1933 (Boston); Bénézit; Fielding; Havlice; Mallett; WWAA 1936–1939 (Boston); WWAA 1940–1941 (Pittsford, Vermont); WWWA.

Nugent, Meredith (1860–1937)
B. London, England. D. Long Beach, California. Havlice; Mallett Supplement; WWAA 1936–1939 (Long Beach).

Nuttall, Thomas (1786–1859
B. Long Preston Settle, Yorkshire, England. D. Nutgrove, Lancashire, England, September 10. Groce and Wallace; WWWA; Stuart.
This English painter, printmaker, and naturalist traveled the Missouri River through the Dakotas in 1811, the Arkansas River in 1819, and the Rocky Mountains, California, and Oregon in 1834.

Nye, Elmer Lesly (1888–)
B. St. Paul, Minnesota. AAA 1917–1921 (Grand Forks, North Dakota; summer: Santa Fe, New Mexico); Fielding.

Nye, Myra (1875–1955)
B. Cleveland, Ohio. D. California. AAA 1925 (Los Angeles, California).

O

O'Brien, Smith (–)
 B. Cork, Ireland. AAA 1925-1933 (San Francisco, California); Havlice; Mallett; WWAA 1936-1937 (San Francisco).

O'Donnell, Julian E. (1896–)
 B. Butler, Pennsylvania. California State Library; *Who's Who in Los Angeles County*, 1928, p. 280.
 O'Donnell was an illustrator who worked in New York prior to settling in Los Angeles in 1927.

Oestermann, Mildred Caroline (1899)
 B. San Francisco, California. AAA 1925-1933 (San Francisco); Havlice; Mallett; WWAA 1936-1941 (San Francisco).

O'Hara, Eliot (1890-1969)
 B. Waltham, Massachusetts. D. July 30. Work: Brooklyn Museum; Museum of New Mexico; Springfield (Massachusetts) Museum of Fine Arts; National Gallery of Art; Metropolitan Museum of Art; Museum of Modern Art; Denver Art Museum; Santa Barbara Art Museum. AAA 1925-1931 (Waltham); AAA 1933 (Washington, D.C.; summer: Goose Rocks Beach, Maine); Bénézit; Fielding; Havlice; Mallett; WWAA 1936-1970 (Washington, D.C.; summer: Goose Rocks Beach, through 1966); WWWA; "Eliot O'Hara Holds Ten-Year Retrospective," *The Art Digest*, April 15, 1938, 26.

O'Kane, Regina (–)
 B. Newport, Kentucky. AAA 1900, 1905-1906, 1919 (Los Angeles, California).
 O'Kane, who specialized in painting landscapes and flowers, studied at the Art Students' League.

O'Keeffe, Georgia (1887–)**
 B. Sun Prairie, Wisconsin. Work: Museum of Modern Art; Museum of New Mexico; Whitney Museum of American

Art; Brooklyn Museum; Phillips Memorial Museum; Detroit Institute of Art; Omaha Society of Fine Arts; Butler Art Institute; Montclair (New Jersey) Art Museum. AAA 1915 (Columbia, Georgia); AAA 1917 (Canyon, Texas); AAA 1929–1933 (New York City; summer: Lake George, New York); Bénézit; Fielding; Havlice; Mallett; WWAA 1936–1947 (New York City); WWAA 1953–1976 (Abiquiu, New Mexico); *The Art Digest,* February 1, 1931, 14; Amon Carter Museum 1966 exhibition catalogue quoting Vernon Hunter, 14, 17; O'Brien; Mary Lynn Kotz, "Georgia O'Keeffe at 90," *Art News,* December 1977, 36–46.

For many years O'Keeffe has been as much a part of Northern New Mexico, where she lives near the ancient town of Abiquiu, as of New York City and Lake George. She began painting in New Mexico in 1929, and within a year art critics were taking note of her ability to "depict . . . the spirit of the country," which one critic thought "too overwhelming for most artists."

O'Keeffe's first exposure to the Southwest came in 1912 when she was supervisor of public school art in Amarillo, Texas, for two years. In 1916 she returned to Texas to head for two years the art department of West Texas State Normal College in Canyon.

Artist Vernon Hunter wrote in 1932 that it seemed to him that O'Keeffe's work reflected the topographical structure of that West Texas region with its "lean" beauty, a region "not entirely desert and voluptuous, but spacious, direct, powerful, with great sweeping areas that move uninterrupted into infinity." O'Keeffe's ability to capture the essence of Northern New Mexico has been ably demonstrated, whether or not, as Hunter suggests, she may have carried with her something of her first meeting with the Southwest.

Oliver, Myron Angelo (1891–)
B. Fulton, Kansas. AAA 1921–1933 (Monterey, California); Bénézit; Fielding; Havlice; Mallett; WWAA 1940–1941 (Monterey).

Olson, Callie Williams (–)
B. Wisconsin. Work: South Dakota State University. Stuart.

Olson, who graduated from South Dakota State University in Brookings in 1900, lived at Sioux Falls. Further study was obtained in Los Angeles, California.

Olson, J. Olaf (1894–)

B. Buffalo, Minnesota. Work: Baltimore Museum; Brooklyn Museum; Desmond Fitz-Gerald Art Gallery, Brookline, Massachusetts. AAA 1919 (Buffalo; summer: Provincetown, Massachusetts); AAA 1921 (Brooklyn, New York); AAA 1923–1933 (New York City; summer 1925: Gloucester); Bénézit; Fielding, Havlice; Mallett; WWAA 1940–1947 (New York City); *American Artist*, May 1964, 32–33.

Olson spent his early years on a Minnesota farm and in lumber camps in Western Canada. A meeting with Charlie Russell in 1912 gave impetus to a career in painting. Olson studied in Seattle, Washington, and at the Art Students' League under George Bellows.

O'Malley, Power (1870–1946)

B. County Waterford, Ireland. D. New York City, July 3. Work: Phillips Memorial Gallery; Library of Congress; Fort Worth Museum of Art; Witte Memorial Museum. AAA 1905–1906 (New York City); AAA 1915 (Coytesville, New Jersey; studio: New York City); AAA 1923–1931 (New York City); AAA 1933 (Scarborough, New York); Havlice; Mallett; WWAA 1936–1941 (Scarborough); *The Art Digest*, May 1, 1935, 14.

Commenting upon an exhibition of O'Malley's work, *The Art Digest* mentioned his Taos, New Mexico landscapes and several California subjects.

Onderdonk, Julian (1882–1922)**

B. San Antonio, Texas. D. San Antonio, October 27. Work: Los Angeles Museum of Art; Dallas Museum of Fine Arts; Witte Memorial Museum; Monticello College Foundation, Godfrey, Illinois. AAA 1903–1906 (New York City and Staten Island, New York); AAA 1913–1921 (San Antonio); Bénézit; Fielding; Mallett; O'Brien; L. Tonkin, "Julian Onderdonk/A Tribute by a Fellow Texan," *American Magazine of Art*, October 1923, 556–559.

The premature death of Julian Onderdonk brought to a close the career of one of the best known and most popular painters of Texas.

Onderdonk was fond of painting the landscape just outside of San Antonio—the rolling hills spotted with live oaks, the floating clouds in a deep blue sky. But the sky was not always blue, for he painted in all kinds of weather. He also painted fields full of bluebonnets, though he disliked being called a bluebonnet painter.

William Merritt Chase took a particular interest in Onderdonk, prophesying great things for him, and even painted his portrait.

Onderdonk also studied with Robert Henri, Frank Du-Mond, and his father, Robert Onderdonk. He was one of the first Texas painters to be influenced by impressionism. His work gained prominence in New York where it was exhibited regularly at the National Academy of Design and other New York galleries. He became a member of the Salmagundi Club in 1913, and he belonged to the Allied Artists' Association.

Orchardson, Charles M. Quiller (1873–1917)
B. Scotland. D. April 26, 1917. Bénézit; Mallett; Waters.
Orchardson is supposed to have painted in California prior to service in the First World War. He worked in oil.

Orr, Alfred Everitt (1886–)
B. New York City. AAA 1919–1927 (San Gabriel, California; studio 1919–1921: New York City); Bénézit; Fielding; Mallett; Waters.
Orr studied with Chase and Hawthorne and at the Art Students' League, the Royal Academy, and in Paris. He exhibited in Paris and at the Royal Academy, and he lived for some time in London. He was primarily a portrait painter.

O'Ryan, Lillie V. (See: Klein, Lillie V. O'Ryan)

O'Shea, John (c.1880–1956)
B. Ireland. D. Carmel, California, April 29. Work: Mills College Art Gallery; Bohemian Club. AAA 1919–1924 (Carmel; studio 1923–1924: New York City); Mallett; California State Library; Carmel Public Library.

O'Shea lived several years in Pasadena, California, before moving to Carmel. Ultimately he made his home in Pebble Beach, near Carmel. He was a member of the American Water Color Society, but he is best known for his oils of Arizona and California desert and mountain scenes, including the Coastal Range near Monterey.

O'Sullivan, Elizabeth Curtis (See: Curtis, Elizabeth)

Oswald, Emilie L. (–)
B. Nashville, Tennessee. *Who's Who in Los Angeles.* Oswald settled in Los Angeles in 1904.

Otis, George Demont (1877–1962)**
B. Memphis, Tennessee. D. Kentfield, California, February 25. Work: Chicago Art Institute; Hackley Gallery of Fine Arts, Muskegon, Michigan. AAA 1929–1933 (Burbank, California); Havlice; Mallett; WWAA 1936–1941 (Burbank); WWAA 1947–1962 (Kentfield); *California Historical Courier,* April 1974, 1, published by California Historical Society.

Otis was a great traveler who painted landscapes throughout the country, but lived mostly in the West. Early in his career, in order to regain his health, he lived out of doors in the Colorado Rockies. With back pack and paints he explored vast areas on foot and produced many paintings.

In Arizona and New Mexico, Otis found the Indians of particular interest. He studied their life style and gave considerable attention to authenticity in his work. Before moving to Southern California in 1919, he lived for awhile in Taos.

A decade later, Otis painted in the San Francisco Bay region, capturing the charm and beauty he found there. Muir Woods, Lagunitas Creek, and Mount Tamalpais often were the subjects of his work during the many years he lived at Kentfield.

Otte, William L. (1871–)
B. Sheboygan, Wisconsin. Mallett Supplement (Santa Barbara, California); *American Magazine of Art,* December 1921, 413.

217

Owles, Alfred (1898–)

B. Nottingham, England. Havlice; Mallett Supplement; WWAA 1940-1941 (Fairfax, California; studio: San Francisco).

P

Packard, Alton (1870-1929)

B. Taunton, Massachusetts. D. Oklahoma City, Oklahoma, August 29. AAA 1929* (Oklahoma City); Mallett; WWWA; *The Art Digest*, September 29, 1929, 14.

Packard, Mabel (1873-1938)

B. Parkersburg, Iowa. D. South Pasadena, California. AAA 1903-1906 (Oak Park, Illinois); AAA 1907-1910 (Chicago); AAA 1913 (Oak Park); AAA 1915-1933 (South Pasadena); Fielding; Mallett.

Packard studied at the Colarossi Academy in Paris and at the Art Institute of Chicago. She was a member of Chicago Society of Artists.

Paice/Paige, Philip Stuart (1886–)

B. London, England. AAA 1915-1917 (Denver, Colorado).

Palmer, Jessie A. (1882–)**

B. Lawrence, Texas. Work: Travis School, Dallas, Texas; Dallas Woman's Club. AAA 1929-1933 (Amarillo, Texas); Fielding; Havlice; Mallett; WWAA 1936-1962 (Dallas); O'Brien.

Palmer studied with Frank Reaugh and Martha Simkins of Dallas, at John Carlson's Landscape School in Woodstock, New York, and at the Broadmoor Art Academy in Colorado Springs. She exhibited primarily in New York City and in the South.

Palmer's painting "The Old Bridge" and a story of her life were featured in *La Revue Moderne* in Paris in October 1929.

Palmerton, Don F. (1899-)
B. Chicago, Illinois. Havlice; Mallett Supplement; WWAA 1936-1941 (Hollywood, California).
Palmerton specialized in marine and landscape painting.

Parish, Annabelle Hutchinson (-)
AAA 1905-1906 (Portland, Oregon).

Parker, Cora (-)
B. Kentucky. Work: Kansas City (Missouri) Art Club; Nebraska Art Association; Bruce Museum, Greenwich, Connecticut. AAA 1898-1900 (Lincoln, Nebraska); AAA 1903 (New York City); AAA 1905-1931 (Greenwich, Connecticut); AAA 1933 (Coral Gables, Florida); Fielding; Havlice; Mallett; WWAA 1936-1941 (Coral Gables).

Parker, William Gordon (1875-)
B. Clifton, New Jersey. AAA 1905-1910 (Arkansas City, Kansas); WWWA (Wichita, Kansas.
Parker studied at the Art Students' League. He was on the staff of the Wichita *Eagle* as an illustrator, and he was also a writer.

Parkhurst, Thomas Shrewsbury (1853-1923)
B. Manchester, England. D. Carmel, California. Work: Toledo Museum of Art; Oakland Art Museum; Oklahoma Art League; Des Moines (Iowa) Art Club; Lima (Ohio) Art League. AAA 1913-1917 (Toledo, Ohio); AAA 1919-1921 (Carmel, California); AAA 1923-1924* (Toledo); Fielding; Mallett.
Parkhurst was a self-taught landscape painter and illustrator.

Parkinson, William Jensen (1899-)
B. Hyrum, Utah. Work: Hyrum City High School; State Capitol Building, University Club, and McKinley School, Salt Lake City. Havlice; Mallett; WWAA 1940-1941 (Salt Lake City).

Parslow, Evalyn Ashley (1867–)

B. Westmoreland, New York. *Who's Who on the Pacific Coast,* 1947.

Parslow was an art teacher in New York who retired in 1923 and moved to Los Angeles. She worked in oil, and she also wrote poetry. She was a member of Women Painters of the West.

Parsons, George F. (1844–)

B. Appleton, Ohio. AAA 1898–1900 (Youngstown, Ohio); AAA 1903 (San Francisco, California).

Parsons, who studied in Munich, Germany, exhibited at the Omaha Exposition in 1898.

Partington, Richard Langtry (1868–1929)

B. Stockport, England. D. Philadelphia, Pennsylvania. Work: Oakland Museum; M. H. De Young Memorial Museum. AAA 1917 (San Francisco, California); AAA 1919–1927 (Philadelphia; summer 1925–1927: San Francisco); Bénézit; Fielding; Mallett.

While living in San Francisco, Partington stayed at the Bohemian Club.

Partridge, Imogene (1883–1976)

B. Portland, Oregon. D. San Francisco, California. AAA 1915–1919 (Seattle, Washington).

Better known as Imogene Cunningham, the photographer, Partridge was for many years married to Roi Partridge, the etcher. She studied art in Euope, but turned to photography soon after her return. She was a member of the Seattle Fine Arts Society.

Partridge, Roi/G. Roy (1888–)**

B. Centralia, Washington. Work: M. H. De Young Memorial Museum; San Francisco Museum of Art; Los Angeles Museum; National Collection of Fine Arts; Museum of Modern Art; New York Public Library; Library of Congress; Art Institute of Chicago; Walker Art Gallery; Toledo Museum of Art; Carnegie Institute. AAA 1915–1917 (Seattle, Washington); AAA 1919 (San Francisco); AAA 1921–1931 (Oakland, California); Bénézit;

Fielding; Havlice; Mallett; WWAA 1936–1959 (Oakland); Frederic Whitaker, "The Etchings of Roi Partridge," *American Artist*, November 1973; Jessie A. Selkinghaus, "Etchers of California," *International Studio*, February 1924.

Soon after Partridge moved to San Francisco in 1917, he was invited to teach at Mills College. He resigned in 1946 in order to have more time for landscape work. As a specialist in dry point etching who liked to do the designing, drawing, and incising at the site, Partridge then began traveling extensively in the West in search of fresh material.

Trees, mountains, deserts, and the West Coast are subjects frequently depicted by Partridge. Of trees he is especially fond, and he is well known for the distinctive manner in which he handles them.

Patrick, John Douglas (1863–1937)

B. Hopewell, Pennsylvania. Work: St. Louis Art Museum; Kansas City Art Institute; Johnson County Historical Museum, Shawnee, Kansas. Bénézit; Mallett; "A Veteran Retires," *The Art Digest*, December 15, 1936, 28; Correspondence with the artist's daughter, Grayce Patrick Wray.

Perhaps no other artist has exposed cruelty to animals more effectively than Patrick, who saw a horse brutally beaten on a street in Paris and rushed to the animal's rescue. Afterward he could not get the scene off his mind. In his unheated studio, for he could not afford coal, he painted a 9½ x 11½ foot canvas depicting the incident. Entitled "Brutality," it won an important award at the 1889 Universal Exposition in Paris.

Upon Patrick's return to this country he taught at St. Louis School of Art for three years and then returned to Johnson County where he painted for the next ten years.

In December 1936 a retrospective exhibition of Patrick's work was held at Kansas City Art Institute in conjunction with his retirement from the faculty after 17 years of teaching.

Although Patrick did some landscapes, portraits and still lifes predominate, and most of them are in private collections. Of the more than 200 registered with the Archives of American Art

at the Smithsonian Institution, two are portraits of Jessie James, painted from memory.

Patrick's daughter, Grayce Wray, remembers that her father had only kind words for the outlaw, because it was James who retrieved his father's team of horses from another outlaw who had taken them from Patrick while he was on the way from the family farm to Kansas City. Patrick was 15 years old at that time.

Much of Patrick's life was spent in Johnson County where his family moved about 1867, and he did not leave permanently until 1903 when he moved to Kansas City, Missouri.

Patterson, Ambrose (1877-1967)
B. Daylesford, Victoria, Australia. Work: National Gallery, Adelaide, Australia; National Gallery, Sydney, Australia; Seattle Art Museum; U.S. Post Office, Mt. Vernon, Washington. AAA 1919-1933 (Seattle, Washington); Bénézit; Fielding; Havlice; Mallett; WWAA 1936-1962 (Seattle); *Who's Who in Northwest Art; American Magazine of Art,* April 1922, 138; *The Art Digest,* October 1, 1934, 13.

Patterson, Howard Ashman (1891-)
B. Philadelphia, Pennsylvania. Work: Palace of the Legion of Honor, San Francisco; Pennsylvania Academy of Fine Arts; Carnegie Institute; National Academy of Design; Art Institute of Chicago; Luxembourg Museum, Paris. AAA 1915-1927 (Philadelphia); AAA 1929-1933 (Santa Fe, New Mexico); Bénézit; Fielding; Havlice; Mallett; WWAA 1936-1939 (Ossining, New York); WWAA 1940-1956 (New York City); WWAA 1959-1966 (Princeton and Hopewell, New Jersey); *American Magazine of Art,* January 1925, 42, 50.

Patterson, who exhibited in Santa Fe at least as early as 1924 when his "Christmas, San Felipe" and "Canoncito" were shown, had spent the previous winter there. During the summer he painted in Estes Park. He had been in the West for over a year when his work, on exhibit in Denver, was mentioned in *American Magazine of Art. New Mexico* Magazine featured his work on its

covers for February and June 1934 during his later residence in Santa Fe.

Patterson, Martha (-)
B. Chicago, Illinois. AAA 1898-1900 (San Francisco, California).

Patterson studied with Oscar Kanuth and William Keith in San Francisco, and with William Chase, Irving Wiles, and others in New York City where she attended the Art Students' League. Her work brought prizes at San Francisco Mechanics Institute exhibitions and California state fairs. Patterson was an instructor in freehand drawing and decorative design at Cogswell Polytechnic College. She was also an illustrator.

Paulus, Christoph/Christopher Daniel (1848-)
B. Wurtemburg, Germany. AAA 1905-1908 (Newton, Kansas).
Paulus studied art in Dresden, Germany.

Paval, Philip Kran (1899-)
B. Nykobing, Denmark. Work: Los Angeles Museum of Art; Philbrook Art Center; Metropolitan Museum of Art; Wichita Art Association; Newark Museum; Pasadena Art Institute. Havlice; WWAA 1938-1970 (Hollywood, California); *Who's Who in California*, 1943.

Pawla, Frederick Alexander (1877-1964)
B. England. D. Madera County, California. Work: Burlingame High School, California; Department of Public Markets, New York City. AAA 1931 (New York City; summer: Santa Barbara, California); AAA 1933 (Santa Barbara); Havlice; Mallett; WWAA 1936-1947 (Santa Barbara).

Peabody, Ruth Eaton (1898-1967)
B. Highland Park, Illinois. D. Laguna Beach, California. Work: Laguna Beach Art Association; San Diego Fine Arts Gallery. AAA 1925, 1931-1933 (Laguna Beach); Havlice; Mallett; WWAA 1936-1953 (Laguna Beach).

223

Pearson, (Nils) Anton (1892-)

B. Lund, Sweden. AAA 1919-1925 (Lindsborg, Kansas); Havlice; Mallett Supplement; WWAA 1936-1962 (Lindsborg).

Pearson, Ralph M. (1883-1958)**

B. Angus, Iowa. D. April 27. Work: New York Public Library; Library of Congress; Mechanics Institute, Rochester, New York; Art Institute of Chicago; National Collection of Fine Arts; Newark Public Library; Chicago University Library. AAA 1905-1913 (Chicago); AAA 1915 (Milton, New York); AAA 1917 (New York City; summer: Milton); AAA 1919-1924 (Taos, New Mexico); AAA 1925-1927 (Taos and Milton); AAA 1929-1931 (New York City); Bénézit; Fielding; Havlice; Mallett; WWAA 1936-1941 (New York City; summer: East Gloucester, Massachusetts); WWAA 1947-1956 (Nyack, New York); WWWA; Luna C. Osburn, "Ralph M. Pearson, Painter, Etcher and Modernist," *American Magazine of Art,* September 1925, 467-473.

In search of a new impetus to his etching, Pearson purchased a second-hand Ford and proceeded westward. Cranking, pushing, and lifting much of the way, often on virtually impassable roads, he reached Taos. The year was 1918, and it would mark a significant influence on his work for years to come; for the blend of Pueblo architecture and Pueblo Indian culture was unlike anything he had previously known.

So important did Pearson view this influence that he helped other artists work there, especially students, some of whom he invited to share his home.

Pearson worked briefly in California during the late twenties. Osburn in her article for *American Magazine of Art* commented specifically on such etchings as "El Cerrito," "Cypress Grove," and "House and Rock," a Carmel scene. These prints "for the first time, in this country at least, brought modern thought into etching," Osburn said.

Pearson also was a writer. His major work in that field is *The Modern Renaissance in American Art,* published by Harpers in 1954.

Peers, Marion (-)
AAA 1917, 1923-1924 (Topeka, Kansas).
Peers was a teacher at Topeka High School.

Perkins, Katherine L. (-)
AAA 1917 (Topeka, Kansas). *American Magazine of Art,*
April 1924, 210.
Perkins was among the Kansas artists whose work was
shown at the opening of Mulvane Art Museum in Topeka.

Perl, Margaret Anneke (1887-)
B. Duluth, Minnesota. AAA 1931-1933 (Monterey Park,
California); Havlice; WWAA 1936-1947 (Monterey Park).

Perret, Ferdinand (1888-1960)
B. Illzach, France. D. Los Angeles, California, August 4.
Work: Los Angeles Museum of Art. Havlice; Mallett Sup-
plement; WWAA 1936-1959 (Los Angeles and West Los
Angeles).

Peters, Charles Rollo, III (1892-1967)
B. France. D. January 1. Monterey Public Library, Mon-
terey, California.
The artist, who lived primarily in San Francisco, was the
son of the famous California painter with the same name.

Petetin, Sidonia (-)
B. France. Work: University of California. California State
Library; *Alta* California, July 19, 1861, 1-1; *The Overland
Monthly,* August 1868, 115; Baird, 1967, 44.
Mlle. Petetin arrived in California in July 1861, and re-
mained about six months. She later returned, for Joseph A.
Baird, Jr., in *France and California* says she was active in San
Francisco during the 1870s and 1880s. An artist of considerable
ability, she was considered one of the city's most successful
women artists.

Phister, Jean Jacques (1878-)
B. Berne, Switzerland. AAA 1917 (San Francisco, Cali-
fornia).

Phoenix, Frank (–1924)
 D. Glendale, California. AAA 1900–1913 (Chicago, Illinois); AAA 1925* (Glendale).
 For many years Phoenix taught at the Art Institute of Chicago. He was a member of Chicago Society of Artists.

Pickering, Hal (–)
 AAA 1915 (Salt Lake City, Utah).
 Pickering was an illustrator for Deseret *News*.

Pierce, Lucy Valentine (1890–)
 B. San Francisco, California. AAA 1915, 1919 (Berkeley, California); California State Library.
 Pierce spent considerable time in Monterey, California, where she was considered a Monterey artist.

Pierce, William H. C. (1858–)
 B. Hamilton, New York. AAA 1923–1933 (San Diego, California); Havlice; Mallett; WWAA 1936–1941 (San Diego).

Pinnington, Jane (c.1896–)
 B. Kansas. Fisher.
 Pinnington settled in Santa Fe in 1942.

Piper, Natt (1886–)
 B. Pueblo, Colorado. Work: New York Public Library; Library of Congress; Ashton Collection of Wood Engravings, Springfield, Massachusetts. AAA 1931–1933 (Long Beach, California); Bénézit; Havlice; Mallett, WWAA 1936–1941 (Long Beach).

Pitts, Lendall (1875–1938)
 B. Detroit, Michigan. Work: Washington University Gallery of Art; Detroit Institute of Arts; Yale University. AAA 1907–1908 (Paris, France); AAA 1909–1910 (Detroit); AAA 1915, 1923–1925 (France); Havlice; Mallett; Earle.
 Pitts was in Santa Fe and Taos prior to December 1916. His ability to handle mountain landscapes is mentioned in Earle.

Pizzella, Edmundo/Edmund (1868-1941)

B. Naples, Italy. D. San Francisco, California, November 6. Work: California Historical Society. Bénézit; Mallett; California State Library.

Plotner, Rosa Hooper (See: Hooper, Rosa/Rose)

Plowman, George Taylor (1869-1932)

B. Le Sueur, Minnesota. D. Cambridge, Massachusetts, March 26. Work: Boston Museum of Fine Arts; New York Public Library; Library of Congress; British Museum; National Collection of Fine Arts; Luxembourg Museum, Paris; Sacramento State Museum; Metropolitan Museum of Art; Newark Public Library; AAA 1913 (Berkeley, California); AAA 1915-1917 (Winthrop, Massachusetts); AAA 1919 (Newark, New Jersey); AAA 1921-1932* (Cambridge); Bénézit; Fielding; Mallett; WWWA; *The Art Digest*, March 15, 1931, 20; California State Library; San Francisco Public Library.

Pneuman, Mildred Young (1899-)

B. Oskaloosa, Iowa. AAA 1931-1933 (Gary, Indiana; summer: Boulder, Colorado); Havlice; Mallett; WWAA 1936-1941 (Gary; summer: Boulder); WWAA 1947-1973 (Boulder); WWAA 1976 (Walnut Creek, California); Rocky Mountain *News*, January 13, 1947, 15.

The Rocky Mountain *News* covered an exhibition in Boulder of 70 examples of Pneuman's oil paintings and prints. Singled out for special comment was her painting "Emerald Lake."

Pogany, William Andrew [Willy] (1882-1955)

B. Szeged, Hungary. D. New York City, July 30. Work: Heckscher Foundation and Peoples House, New York City; Park Central Hotel, New York City; Hungarian National Gallery, Budapest. AAA 1919-1925 (New York City); AAA 1927-1933 (Hollywood, California); Bénézit; Fielding; Havlice; Mallett; WWAA 1936-1947 (Hollywood); WWAA 1953 (New York City); WWWA.

Pogson, Annie L. (-)
AAA 1917-1925 (Los Angeles, California).
Pogson was a member of the California Art Club.

Pohl, Hugo David (1878-1960)
B. Detroit, Michigan. D. San Antonio, Texas, July 20.
Work: San Antonio Auditorium; Atelier Art Gallery, San
Antonio; International Harvester Company, Chicago;
Union Pacific Railroad. AAA 1919 (Chicago); AAA 1923-
1924, 1929-1933 (San Antonio); Bénézit; Havlice; Mallett;
WWAA 1936-1959 (San Antonio); O'Brien.

When Pohl traveled west with his mobile studio in 1918, he
stopped in the Colorado Rockies, bought a ranch, built a studio,
and painted. The following year he went to Arizona and New
Mexico where he did many canvases of the Indians. The winter
months he spent in California, painting the old missions.

After making a thorough study of the missions, Pohl ar-
ranged to live in their shadow, so to speak, in order to absorb the
atmosphere and relive their past. For his painting of San Luis
Rey, Pohl camped in the mission yard for 17 weeks. O'Brien con-
sidered Pohl's mission paintings among his best, and, histori-
cally, of "more value to posterity than all of his other work."

Following that winter in California, Pohl established a
studio in Paris. When he returned to this country several years
later, he settled in San Antonio.

Polkinghorn, George (1898-)
B. Leadville, Colorado. AAA 1931-1933 (Los Angeles, Cal-
ifornia); Havlice; Mallett; WWAA 1936-1947 (Los
Angeles); WWAA 1953-1962 (Encino, California).

Pollak/Pollack, Max (1886-1970)
B. Prague, Czechoslovakia. D. probably Sausalito, Cali-
fornia. Work: Metropolitan Museum of Art; New York
Public Library; National Collection of Fine Arts; California
State Library; San Francisco Museum of Art; British Mu-
seum; Prague Art Museum. Bénézit; Havlice; Mallett;
WWAA 1940-1941 (Cincinnati); WWAA 1947-1956 (San
Francisco); WWAA 1959-1962 (Sausalito, California); Cal-
ifornia State Library; San Francisco Public Library.

Pollak began exhibiting in San Francisco in the early 1930s. He painted many Bay area landscapes, and portraits of many prominent residents. He is also known for his dry point etchings and dry point aquatints. He was given a solo exhibition at the Palace of the Legion of Honor in San Francisco in 1940.

Polowetski, Charles Ezekiel (1884-)

B. Russia. Work: State Normal School, Brockport, New York; Patterson (New Jersey) City Hall. AAA 1905-1906 (Paris, France); AAA 1907-1908 (New York City); AAA 1909-1910 (London, England); AAA 1913 (Paris); AAA 1915-1933 (New York City); Havlice; Mallett; WWAA 1936-1941 (New York City); Fisher.

Polowetski was a pupil of Bonnat in Paris and a member of the American Art Association of Paris. He settled in Santa Fe, New Mexico, in 1945.

Pomeroy, Elsie Lower (1882-)

D. New Castle, Pennsylvania. Work: Los Angeles Art Association; Riverside (California) High School; San Francisco Municipal Collection; Butler Art Institute. AAA 1933 (Riverside); Havlice; Mallett; WWAA 1936-1941 (Riverside); WWAA 1947-1962 (Mill Valley, California); California State Library; San Francisco Public Library.

Pommer, Julius (c.1895-1945)

D. San Francisco, California, October 14. Work: California Historical Society, San Francisco. Mallett Supplement; California State Library; San Francisco Public Library; Art Institute of Chicago.

Poock/Pook, Fritz (1877-1944?)

Havlice; Mallett Supplement; WWAA 1936-1941 (Los Angeles, California.

Poole, Eugene Alonzo (1841-1912)

B. Poolesville, Maryland. D. September 27. Work: Butler Institute of American Art. AAA 1905-1906 (Pittsburgh, Pennsylvania); AAA 1907-1908 (New York City); AAA 1913 (Pittsburgh); WWWA; California State Library.

Poole had a studio in Washington, D.C., for many years.

Poray, Stan Pociecha (1888-1948)
B. Krakow, Poland. D. New York City, October 18. Work:
Los Angeles Museum; Los Angeles Commercial Club;
Gardena (California) High School; Radcliffe College. AAA
1931-1933 (Hollywood, California); Havlice; Mallett;
WWAA 1936-1947 (Hollywood and Los Angeles); California State Library.

Potter, Louis McClellan (1873-1912)
B. Troy, New York. D. Seattle, Washington, August 29.
AAA 1903-1910 (New York City); AAA 1913*; Bénézit;
Fielding; Havlice; Mallett; WWWA.
Better known as a sculptor than as an etcher, Potter made
a specialty of American and Alaskan Indian groups.

Potter, Zenas L. (1886-1958)
B. Minneapolis, Minnesota. D. Carmel, California, July 6.
Who's Who in California, 1943; California State Library.
Potter, who was a business executive, painted landscapes
at Carmel, California.

Powell, Arthur James Emory (1864-1956)
B. Vanwert, Ohio. D. Poughkeepsie, New York, July 15.
Work: Milwaukee Art Institute; Boise (Idaho) Library; National Arts Club, New York. AAA 1907-1929 (New York
City); AAA 1931-1933 (Dover Plains, New York); Bénézit;
Fielding; Havlice; Mallett; WWAA 1936-1956 (Dover
Plains); WWWA; Garnier.

Powell, J. S. (-)
AAA 1915 (Logan, Utah).
Powell was associated with the Utah Agricultural College
in Logan.

Powell, Jennette M. (c.1871-1944)
B. Kingston, Nova Scotia, Canada. D. New York City,
March 6. AAA 1915 (Tacoma, Washington); AAA 1925-
1927 (Kingston); AAA 1929-1933 (Camp Hill, Pennsyl-

vania; Norton and West Norton, Massachusetts); Mallett; WWAA 1947*.

Powell studied with Chase, Henri, Parsons, Hawthorne, and Sandzen, and in Paris. During her career she taught at the University of Washington and was art department head at Iowa State College.

Price, William Henry (1864-1940)
B. Pennsylvania. D. Pasadena, California, October 8. Work: Laguna Beach Museum of Art. Havlice; Mallett; WWAA 1936-1940 (Pasadena).
Price was active in Laguna Beach at least as early as 1910.

Pries, Lionel H. (1897-)
B. San Francisco, California. Havlice; Mallett Supplement; WWAA 1947-1962 (Seattle, Washington); *Who's Who in Northwest Art.*

Probst, Thorwald A. (1886-1948)
B. Warrensburg, Missouri. D. Los Angeles, California, December 24. Work: Laguna Beach Museum of Art. AAA 1917, 1925 (Los Angeles; summer: Santa Barbara, California); AAA 1927-1933 (Los Angeles); Mallett.
Probst was a member of California Art Club and Laguna Beach Art Association.

Proper, Ida Sedgwick (1873-1957)
B. near Des Moines, Iowa. Work: Iowa Historical Gallery; William A. Farnsworth Library and Art Museum (Maine); New Jersey State House. AAA 1900 (Denver, Colorado); AAA 1909-1913 (Paris, France); AAA 1915-1917 (New York City).
Proper studied at the Art Students' League and in Paris and Munich. She exhibited in Denver at least as early as 1898, and she was a member of the Denver Artists' Club.

Pushman, Hovsep/Horsep T. (1877-1966)
B. Diarbaker, Armenia. D. New York City, February 11. Work: Smith College Museum of Art; Milwaukee Art Institute; Layton Art Gallery, Milwaukee; Museum of Mod-

ern Art; Minneapolis Art Museum; Rockford (Illinois) Art Guild; University of Illinois, Springfield; Metropolitan Museum of Art. AAA 1913–1915 (Paris, France); AAA 1919–1921 (Chicago; studio: Paris); AAA 1923–1927 (Paris and New York City); AAA 1929–1933 (New York City); Bénézit; Fielding; Havlice; Mallett; WWAA 1936–1941 (New York City); WWWA.

Pushman also lived briefly in Riverside, California.

Pyle, Clifford Colton (1894–)
B. Missouri. Work: Metropolitan Museum of Art. AAA 1927–1929 (New York City); AAA 1931–1933 (Oakland, California); Havlice; Mallett; WWAA 1936–1941 (Oakland).

Q

Quinan, Henry Brewerton (1876–)
B. Sitka, Alaska. AAA 1905–1908 (Paris, France); AAA 1925 (Tuckahoe, New York); AAA 1927–1931 (New York City); Bénézit; Mallett Supplement; California State Library.

R

Rabino, Saul (1892–)
B. Odessa, Russia. Work: Los Angeles Public Library.

Havlice; Mallett Supplement; WWAA 1940-1941 (Los Angeles, California).

Rahtjen, Fitzhugh (-)
AAA 1917 (San Francisco, California).

Randall, D. Ernest (1877-)
B. Rush County, Indiana. AAA 1909-1913 (St. Paul, Minnesota); AAA 1915-1924 (San Francisco, California); Bénézit; Fielding; Mallett.
 Randall studied under Vanderpoel and Hubble at the Art Institute of Chicago.

Randall, George Archibald (1887-1941)
B. Oakland, California. D. October 6. Havlice; WWAA 1940-1941 (Ranger Ranch, Ventura, California); WWWA.
 Randall, who moved to Ventura in 1923, illustrated Western ranch and Indian life for *Desert* Magazine, *Westways*, and other publications.

Raschen, Henry (1856-1937)**
B. Oldenburg, Germany. D. Oakland, California, August 24. Work: Oakland Museum; California Historical Society; Edward Doheny Memorial Library, Camarillo, California. Bénézit; Garnier; Alan David, Philadelphia; Henry Flayderman, privately printed book about Raschen, 1958; Hartley; *The Morning Call*, San Francisco, January 21, 1894; *Antiques*, July 1969, 21.
 Raschen moved with his parents to Fort Ross, California, in 1868, and to San Francisco the following year. He studied in Europe from 1875 to 1883, and returned to Europe in 1890 for four years of painting and further study.
 When Raschen returned to California in 1883, he settled on the family ranch in Sonoma County near Cazadero. His models were Indians of Mendocino County, where he had grown up, and the Indians of Sonoma County. His landscapes indicate that he also worked in Colorado and Arizona among the Arapahos and the Apaches at some time during his career.
 When Raschen returned from his second trip to Europe, he opened a studio in San Francisco. Questioned by the *Call* about

his famous sitter Salomon, who maintained that he remembered Fort Ross when the Russians were there, Raschen told of Salomon's system for keeping track of the days he sat for his portrait for which he was to receive a dollar a day. Each day Salomon cut a notch around a stick he carried. If the sitting required a half day, Salomon cut the notch halfway around.

Regarding the success of Raschen's Indian paintings in Europe, the *Call* reported that the artist had difficulty meeting the demand, and that he got about five times as much there as in San Francisco.

The 1906 earthquake and fire destroyed the entire building on Montgomery Street where Raschen had his studio. He opened another across the Bay in Alameda where he remained until 1920. Thereafter his studio was in Oakland.

Raulston, Marion Churchill (1883-1955)
B. Great Falls, Montana. Work: University of Southern California; Los Angeles Art Association. AAA 1933 (Los Angeles, California); Havlice; Mallett; WWAA 1936-1953 (Los Angeles; summer 1938-1941: La Jolla, California).

Rauschnabel, W. F. (-)
AAA 1917 (San Francisco, California); Mallett Supplement (San Anselmo, California).

Ravagli, Angelino (1891-)
B. Italy. Fisher.
Ravagli settled in El Prado, New Mexico, in 1931.

Ravlin, Grace (1885-1956)
B. Kaneville, Illinois. D. September 25. Work: National Collection of Fine Arts; Santa Fe Collection; Art Institute of Chicago; Luxembourg Art Gallery, Paris, France; City of Chicago Collection; Newark Museum; Los Angeles Museum; Vanderpoel Art Association Collection. AAA 1907-1908 (Kaneville); AAA 1909-1917 (Chicago); AAA 1919 (Chicago and New York City); AAA 1921-1933 (New York City); Bénézit; Fielding; Havlice; Mallett; WWAA 1936-1941 (Kaneville); WWWA; Paul A. F. Walter, "The Santa Fe-Taos Art Movement," *Art and Archaeology*, December 1916, 333.

Ravlin was one of the first women artists to paint in New Mexico. There she was attracted to the Indian ceremonies of the Pueblos which she painted during the summers of 1916 and 1917 when she lived in Santa Fe and Taos.

Fresh from having established an international reputation with her interpretations of the Moorish dances of Northern Africa, Ravlin produced Indian dance paintings that attracted considerable attention. At the opening in 1917 of the newly built Museum of New Mexico in Santa Fe, Ravlin was represented by "Corn Dance, San Domingo," "Annual Fiesta, Laguna," and "Entering Kiva After the Dance."

Raymond, Grace Russell (1876–)
B. Mt. Vernon, Ohio. Work: Winfield (Kansas) High School Art Gallery; Douglas (Kansas) Public Library. AAA 1913–1917 (Washington, D.C.); AAA 1921–1933 (Winfield; summer 1923–1925: Paris, France; summer 1927–1933: Rome, Italy); Bénézit; Fielding; Havlice; Mallett; WWAA 1936–1962 (Winfield).

Reckless, Stanley Lawrence (1892–)
B. Philadelphia, Pennsylvania. Work. Wood Art Gallery, Montpelier, Vermont. AAA 1921–1924 (Lumberville, Pennsylvania); AAA 1925–1933 (New Hope, Pennsylvania); Bénézit; Fielding; Havlice; Mallett; WWAA 1936–1941 (Los Angeles, California).

Rederer, Franz (1899–1965)
B. Switzerland. D. Zurich, Switzerland. Work: De Young Memorial Museum; San Francisco Museum of Art; Santa Barbara Museum of Art; Seattle Art Museum; Caracas Museum of Art. Havlice; WWAA 1947–1953 (Berkeley, California); *American Artist,* November 1966, 42–47, 73–75; San Francisco Public Library.

Reed, Earl Meusel (1894–)
B. Milford, Nebraska. Work: University of Nebraska; Philadelphia Art Alliance; Rawlings (Wyoming) Public Library; Queens College, New York; Pennsylvania Academy of Fine Arts; University of Wyoming. Havlice; WWAA

1940-1941 (Philadelphia; summer: Jenny Lake, Wyoming); WWAA 1947-1956 (Casper, Wyoming).

Reeser, Lillian (1876-)
B. Denver, Colorado. AAA 1900 (Denver).

Although the Annual's entry for 1900, page 58, is the only listing for Reeser, it is quite informative. She studied art in Boston, exhibited at the Omaha Exposition in 1898, and was active in several organizations, including Denver Artists' Club. In Denver she taught painting and applied arts.

Reeves, Joseph Mason, Jr. (1898-1973)
B. Washington, D.C. Work: University of California; Ebell Club; Bohemian Club; U.S. Navy Department. Havlice; Mallett; WWAA 1936-1973 (Los Angeles and Glendale, California); California State Library.

Regalado, Manuel Rivera (1886-)
Mallett Supplement (San Francisco); California State Library.

Reid, Aurelia Wheeler (1876-1969)
B. Beekman, Dutchess County, New York. D. Los Angeles, California. Work: Philadelphia Museum of Art; Los Angeles State Building. AAA 1905-1906 (New York City; Augusta, Georgia); AAA 1923-1933 (San Pedro, California); Havlice; Mallett; WWAA 1936-1962 (San Pedro and Los Angeles).

Reitzel, Marques E. (1896-1963)
B. Fulton, Indiana. D. December 26. Work: Chicago Public School Collection; Rockford (Illinois) Public School Collection; Belvidere Woman's Club, Colorado State College, Greeley. AAA 1923-1924 (Lafayette, Indiana; summer: Kilbourne, Wisconsin); AAA 1925-1929 (Chicago; summer 1927-1929: Oregon, Illinois); AAA 1931-1933 (Rockford and Cleveland; summer 1931: Greeley, Colorado); Bénézit; Havlice; Mallett; WWAA 1936-1939 (Rockford); WWAA 1940-1953 (San Jose, California); WWAA 1956-1962 (Pescadero, California); WWWA; *The Art Digest,* May 1,

1935, 9; "Marques E. Reitzel Describes his Wet-in-Wet Method," *American Artist*, March 1964, 36–37, 59.

Renner, Otto Hermann (1881–)
B. San Francisco, California. AAA 1933 (Paso Robles, California); Mallett.

Renshawe, John H. (1852–1934)
Work: Yellowstone National Park. AAA 1913 (Washington, D.C.); National Collection of Fine Arts, *National Parks and the American Landscape*, Washington, D.C.: Smithsonian Institution Press, 1972.

Renshawe, an employee of the U.S. Geological Survey, was in Yellowstone National Park in 1883. Examples of his work are on pages 98 and 99; text is on page 86. He worked in water color.

Reynolds, Alice M. (–)
B. Olcott, New York. AAA 1903 (Denver, Colorado); AAA 1907–1908 (New York City).

Reynolds studied at the Art Students' League, and in Paris, France.

Reynolds, George (–)
AAA 1917–1925 (Los Angeles, California).

Reynolds was a member of California Art Club.

Rezac, Henry (1872–1951)
B. Czechoslovakia. D. Sioux Falls, South Dakota, December 11. Stuart.

Rezac had a studio in Sioux Falls from about 1917 to 1946. His murals and architectural paintings are in the Sioux Falls Egyptian Theatre and Pettigrew Museum.

Rice, Lucy Wilson (1874–)
B. Troy, Alabama. Work: University of Texas; University Men's Club, Austin; Texas state collection; Baylor University; San Antonio Public Library. AAA 1931–1933 (Austin); Havlice; Mallett; WWAA 1936–1941 (Austin); O'Brien.

Rice, William Seltzer (1873-)

B. Manheim, Pennsylvania. Work: California State Library; California School of Arts and Crafts. AAA 1917–1933 (Oakland, California); Bénézit; Fielding; Havlice; Mallett; WWAA 1936–1962 (Oakland); California State Library.

Richardson, Theodore J. (1855–1914)

B. Readfield, Maine. D. Minneapolis, Minnesota, November 19. Work: Fogg Museum; Burlington Northern, Inc. AAA 1915 and 1915* (Minneapolis and Netley Corners, Minnesota); Bénézit; Fielding; Mallett; Michael S. Kennedy, "Alaska's Artists: Theodore J. Richardson," *The Alaska Journal*, Winter, 1973; Minneapolis Public Library.

Once a widely known artist, Richardson is regaining prominence through the research of the Minneapolis Public Library staff and the writing of Michael Kennedy, director of Anchorage Historical and Fine Arts Museum.

Richardson's first trip to California preceded his first trip to Alaska in 1884. Two years later he married a Monterey artist, and thereafter was often in California. He painted many of the missions and old buildings of Southern California when he and his wife were there during the winter of 1890–1891. Following a six-year residence in Europe the Richardsons were again in California for the winter months. Summers were spent in Alaska. He usually traveled there by way of the West Coast, painting landscapes and Indian subjects in the areas through which he passed.

Richardson grew up in Red Wing, Minnesota. Later he lived in Minneapolis where he was supervisor of drawing in the public schools from 1880 to 1893.

Richardson, Volney Allan (1880-)

B. Attica, New York. AAA 1933 (Buffalo, New York); Havlice; Mallett; WWAA 1936–1937 (Buffalo); WWAA 1938–1941 (Houston, Texas).

Richmond, Evelyn K. (1872-)

B. Boston, Massachusetts. AAA 1931–1933 (Santa Barbara, California); Havlice; Mallett; WWAA 1936–1959 (Santa Barbara).

Rickard, Marjorie Rey (1893-1968)

B. Belvedere Island, California. Louise Teather, *Island of Six Names*, Belvedere-Tiburon: Landmarks Society, 1969.

Prior to marriage and the life of a rancher's wife in Mendocino County, California, Rickard was active in the Belvedere-Tiburon area as artist, conservationist, and local history buff.

Riddell, William Wallace (1877-1948)

B. Chicago, Illinois. Work: Laguna Beach Museum of Art. AAA 1921-1925 (Chicago); AAA 1927-1933 (Laguna Beach, California); Bénézit; Fielding; Havlice; Mallett; WWAA 1938-1941 (Laguna Beach).

Rider, Arthur Grover (1886-)

B. Chicago, Illinois. AAA 1931 (Laguna Beach, California); Havlice; Mallett; WWAA 1940-1941 (Los Angeles, California).

Rider, Charles Joseph (1880-)

B. Trenton, New Jersey. AAA 1909-1910 (Wilmington, Delaware); AAA 1919-1921 (Pasadena, California; summer 1921: Supai, Grand Canyon, Arizona); AAA 1929-1933 (San Pedro, California); Mallett.

Rider studied with William Merritt Chase.

Riess, William J./Wilhelm (1850-1919)

B. Berlin, Germany. D. Chicago, Illinois, March 30. Work: Indianapolis Museum of Art. AAA 1909-1910 (Indianapolis, Indiana); AAA 1919* (Chicago).

Riess was a painter of Indian life and Western scenes.

Rife, Dwight W. (1896-)

B. Chicago, Illinois. Fisher.

Rife settled in Santa Fe, New Mexico, in 1931.

Righter, Alice L. (-)

B. Monroe, Wisconsin. AAA 1898-1900 (Lincoln, Nebraska).

Righter studied at the Art Institute of Chicago, the Art Students' League, and in Paris, France.

Righter, Mary (-)
AAA 1900 (Lincoln, Nebraska).

Rindisbacher, Peter (1806–1834)
B. Eggiwil, Switzerland. D. St. Louis, Missouri, August
13. Work: Gilcrease Institute of American History and
Art; Amon Carter Museum of Western Art; Peabody Mu-
seum, Harvard University. Bénézit; Groce and Wallace;
WWWA; Honour; Stuart; *American Art Review,* March-
April 1965, 72–73; Alvin M. Josephy, Jr., *The Artist Was
a Young Man/The Life Story of Peter Rindisbacher,* Fort
Worth: Amon Carter Museum, 1970.

In recent years the work of Rindisbacher has been dis-
cussed in various articles and books, along with newly discovered
information about the places where he painted. It now appears
likely that he preceded Catlin in living among the Plains Indians.
His much publicized "Blackfeet Hunting on Snowshoes" may
have been used by Catlin in constructing a similar scene. One
hundred twenty-four of Rindisbacher's drawings and water col-
ors have been recorded.

Rindisbacher's Western paintings appear to have been
done after he moved to St. Louis in 1829. There he began selling
his work to *The American Turf Register* and *Sporting Magazine.*
In 1831 he advertised for patrons desiring landscapes and minia-
tures. His painting of the Blackfeet is dated 1833.

Rindlaud, [Mrs.] M. Bruce Douglas (-)
AAA 1917–1919 (Fargo, North Dakota).
Rindlaub was a painter of miniatures.

Ring, Alice Blair (1869–1947)
B. Knightville, Massachusetts. D. California. AAA 1905–
1917 (Paris, France); AAA 1919–1933 (Pomona,
California); Bénézit; Havlice; Mallett; WWAA 1936–1941
(Pomona).

Ripley, Thomas Emerson (1865–)
B. Rutland, Vermont. AAA 1931–1933 (Santa Barbara,
California); Havlice; Mallett; WWAA 1936–1947 (Santa
Barbara); WWAA 1953 (Tacoma, Washington); WWWA;

Who's Who in California, 1943; California State Library.

Ripley was in the logging and manufacturing business in Tacoma before moving to Santa Barbara in 1927 to write and paint.

Risher, Anna Priscilla (1875-)
B. Dravosburgh, Pennsylvania. AAA 1931-1933 (Laguna Beach, California); Havlice; Mallett; WWAA 1936-1939 (Hollywood, California); WWAA 1940-1941 (La Crescenta, California).

Rivera, Diego (1886-1957)
B. Guanajuato, Mexico. Bénézit; Havlice; Mallett; WWWA; San Francisco Art Commission.
Rivera was active in San Francisco during the early 1930s.

Roberts, Hermine Matilda (1892-)
B. Cleveland, Ohio. Havlice; Mallett Supplement; WWAA 1938-1941 (Billings, Montana); *Who's Who in Northwest Art.*

Roberts, Maurine Hiatt (See: Hiatt, Maurine)

Robertson, Jane Porter (-)
AAA 1915-1919 (Denver, Colorado).
Robertson was a member of the Denver Artists' Club.

Robinson, Charles Hoxey (1862-1945)
B. Edwardsville, Indiana. D. Morro Bay, California, May 19. AAA 1933 (Morro Bay); Mallett; *Who's Who in California,* 1943; California State Library.

Robinson, Irene Bowen (1891-)
B. South Bend, Washington. Work: Pasadena (California) Art Institute. AAA 1923-1933 (Los Angeles); Havlice; Mallett; WWAA 1936-1962 (Los Angeles).

Robinson, (Virginia) Isabel (1894-)
B. Eagle Ranch, Adair County, Missouri. Work: Columbia University Library; Amarillo (Texas) Public Library; Pan-

handle Plains Historical Society Museum. Havlice; Mallett Supplement; WWAA 1936-1962 (Canyon, Texas; summer: Cook, Minnesota; South Gifford, Missouri); O'Brien.

Few outside Texas know the contribution Robinson made to Texas art, not only as an artist and a teacher, but as a lecturer on the early and contemporary art and artists of the state.

Not long after Georgia O'Keefe left West Texas Teachers College in Canyon, Robinson was hired to teach and to head its art department, a position she held from 1927 to 1958. During those years she exhibited regularly with the Southern States Art League and at principal Texas art museums. She was given several solo exhibitions, including one at Michigan State College.

Robinson was fond of outdoor sketching, which she often combined with riding and hiking in West Texas, the Vermillion Lake country of Minnesota, and the South Gifford area of Missouri.

Rochard, Pierre (1869–)
B. Lyon, France. Work: murals, Metropolitan Opera House and Waldorf Astoria Hotel in New York City. AAA 1915-1919 (Salt Lake City).

Rockwell, Bertha (1874–)
B. Junction City, Kansas. AAA 1903 (Junction City); AAA 1909-1910 (New York City).

Rocle, Margaret K. (1897–)
B. Watkins, New York. Work: Baltimore Museum of Art; San Diego Fine Arts Gallery. AAA 1929-1933 (Chula Vista, California; summer 1929-1931: Paris, France); Bénézit; Havlice; Mallett; WWAA 1936-1941 (Chula Vista).

Rocle, Marius Romain (1897–)
B. Brussels, Belgium. Work: Baltimore Museum of Art; San Diego Fine Arts Gallery. AAA 1929-1933 (Chula Vista, California; summer 1929-1931: Paris, France); Bénézit; Havlice; Mallett; WWAA 1936-1941 (Chula Vista).

Roerich, Nicholas/Konstantin (1874–1947)

B. St. Petersburg, Russia. D. Naggan, India, December 12. Work: Philadelphia Museum of Art. Bénézit; Fielding; Mallett; WWWA; School of American Research, 1940.

Roerich came to this country about 1920. He lived primarily in New York City and briefly in Santa Fe, New Mexico. Although best known for ballet and religious subjects, he painted landscapes in the West and in Maine. Ultimately he settled in India.

Rogers, Eleanor Gale (–)

AAA 1917–1925 (Los Angeles, California).

Rogers was a member of the California Art Club.

Romero de Romero, Esquipula (1889–1975)

B. Cabezon, New Mexico. D. Albuquerque, New Mexico, April 21. Albuquerque *Journal,* January 13, 1963, and April 25, 1975; Albuquerque Public Library.

Romero de Romero was an early New Mexico artist who settled in Albuquerque in 1904, established a successful outdoor advertising company, and turned to serious painting in 1926. By the 1930s he was well known locally for his portrait, landscape, and Penitente paintings.

In 1936 Romero sold his combined home, studio, and art gallery, built in 1924, and left Albuquerque to live and paint in Latin American countries. He exhibited widely and was still preparing for solo exhibitions at age 73. That year, 1962, he returned to Albuquerque, assisted in the building of a new home, and on occasion was seen riding a motorcycle. Prior to that time he had also painted in Mexico, Canada, and in other Western states, especially along the West Coast. He specialized in landscapes.

Roney, Harold Arthur (1899–)

B. Sullivan, Illinois. Work: South Bend (Indiana) Public Schools; Austin (Texas) Art League; Witte Memorial Museum; Southwest Texas State University; Sullivan Public Library. AAA 1931–1933 (San Antonio, Texas); Bénézit; Havlice; Mallett; WWAA 1936–1976 (San Antonio); O'Brien.

Roney was an art teacher in a South Bend, Illinois, school

prior to moving to Houston in 1925. After three years of commercial art work and night-school teaching, he moved to Boerne in the hill country 30 miles west of San Antonio. There he specialized in landscape painting.

In 1958 Roney began teaching oil landscape painting at Froman School of Art where he was still active in the mid 1970s. He has had several solo exhibitions and has exhibited widely in group shows.

Ronnebeck Arnold (1885-1947)
B. Nassau, Germany. D. Denver, Colorado, November 14. Work: Denver Public Library Western History Collection; National Collection of Fine Arts; Denver National Bank; La Fonda Hotel, Santa Fe, New Mexico. AAA 1929-1933 (Denver); Bénézit; Havlice; WWAA 1936-1947 (Denver); WWWA; Rocky Mountain *News,* November 15, 1947, 5.

Ronnebeck was a sculptor who also did lithographs. His work at La Fonda Hotel consists of friezes depicting Indian ceremonial dances. He was director of the Denver Art Museum from 1926 to 1931, and a professor of sculpture in Denver from 1929 to 1935.

Ropp, Roy M. (1888-)
Havlice; Mallett Supplement; WWAA 1936-1953 (Laguna Beach, California).

Rose, Ethel Boardman (1871-1946)
B. Rochester, New York. D. Pasadena, California. AAA 1923-1925 (Pasadena); Havlice; WWAA 1938-1939 (Santa Barbara, California); WWAA 1940-1953 (Pasadena); *Who's Who in California,* 1943; California State Library.

Rose lived in Southern California during most of her life, for she married the California painter Guy Rose in 1895.

Rosenberg, Louis Conrad (1890-)
B. Portland, Oregon. Work: Cleveland Museum of Art; National Collection of Fine Arts; University of Nebraska; New York Public Library; Smithsonian Institution; Library of Congress; Victoria and Albert Museum, London; British Museum. AAA 1923-1931 (New York City and

Fairfield, Connecticut); Bénézit; Fielding; Havlice; Mallett; WWAA 1936-1941 (Fairfield); WWAA 1947 (Portland, Oregon); WWAA 1953-1962 (Green Farms, Connecticut); WWAA 1966-1976 (Lake Oswego, Oregon); "Old World Bits by an Itinerant Architect," *Arts and Decoration*, January 1924, 22.

Rosenthal, Mildred (1890-)
B. Panama, Central America. AAA 1929-1933 (San Francisco, California); Havlice; Mallett; WWAA 1938-1953 (San Francisco).

Ross, Mary Herrick (-)
AAA 1917 (Oakland, California).

Rothstein, Theresa (1893-)
B. Richmond, Minnesota. Havlice; Mallett Supplement; WWAA 1938-1941 (Vancouver, Washington).

Rozaire, Arthur D. (1879-1922)
B. Montreal, Canada. D. Los Angeles, California. Work: Laguna Beach Museum of Art. Bénézit; Mallett (Los Angeles).

Rudersdorf, Lillian C. (1882-)
B. Clarkson, Nebraska. AAA 1917-1919 (Omaha, Nebraska); AAA 1921-1927 (Chicago, Illinois); Fielding; Mallett Supplement; WWAA 1940-1941 (Chicago).

Rudhyar, Dane (1895-)
B. Paris, France. School of American Research, 1940.
Rudhyar was a musician who studied painting in Santa Fe, New Mexico.

Rudy, James F. (-)
AAA 1917 (Los Angeles, California).
Rudy was a member of California Art Club.

Runquist, Albert Clarece (1894-1971)
B. Aberdeen, Washington. Work: National Collection of

Fine Arts; University of Oregon Library; mural, U.S. Post Office, Sedro Wooley, Washington. Havlice; WWAA 1947 -1953 (Portland, Oregon); *Who's Who in Northwest Art.*

Runquist, Arthur (1891–)
B. South Bend, Washington. Work: mural, University of Oregon Library; Portland Art Museum. Havlice; Mallett Supplement; WWAA 1940-1947 (Manzanita, Oregon); WWAA 1953-1962 (Nehalem, Oregon); *Who's Who in Northwest Art.*

Russell, Morgan (1886-1953)
B. New York City. D. Broomall, Pennsylvania, May 29. Work: National Collection of Fine Arts; Whitney Museum of American Art; Los Angeles County Museum of Art; San Diego Fine Arts Gallery; Cornell University; Albright-Knox Art Gallery. AAA 1915 (New York City); Havlice; Mallett (Los Angeles, California).

Ruthrauff, Frederick G. (1878-1932)
B. Findlay, Ohio. D. Ogden, Utah, February 15. AAA 1929-1932* (Ogden); Mallett.

Rutledge, Ann (1890–)
B. Kansas. Havlice; Mallett Supplement; WWAA 1940-1941 (Long Beach, California).

Rutledge, Bertha V. (1890–)
B. Topeka, Kansas. AAA 1933 (Topeka); Havlice; Mallett; WWAA 1938-1939 (Topeka).

Rutt, Anna Hong (1895–)
B. Monona County, Iowa. AAA 1923-1924 (Seattle, Washington); AAA 1927-1933 (Evanston, Illinois; summer: Altadena, California); Bénézit; Havlice; Mallett; WWAA 1936-1937 (Evanston; summer: Altadena); WWAA 1938-1962 (Baton Rouge, Louisiana).
During the early years of her career, Rutt was listed in art directories as Hong.

Ryan, William Redmond (-)

B. England. Groce and Wallace; Ryan, *Personal Adventures in Upper and Lower California, in 1848-49,* London: 1850; Jackson, 1949.

While Ryan was living in New York City, he volunteered for service in the Mexican War in California. Afterward he did some gold mining, and upon his return to England wrote and illustrated his personal recollections.

S

Saalburg, Allen Russell (1899-)

B. Rochelle, Illinois. Work: Whitney Museum of American Art; Philadelphia Museum of Art. Havlice; Mallett Supplement; WWAA 1940-1941, 1956 (New York City); WWAA 1959 1962 (Fronchtown, New Jersey); The American Federation of Arts/National Exhibition Service, No. 3, 1938-1939, 29; *New Yorker,* January 31, 1977, page 8, announcing exhibition of "19th century trade cards hand-silk-screened into Lucite."

Saisett, Ernest Pierre de (See: De Saisset, Ernest Pierre)

Salazar, Maria (1893-)

B. Cleveland, Ohio. Fisher.
Salazar moved to Cerrillos, New Mexico, in 1928.

Salz, Helen Arnstein (1883-)

B. San Francisco, California. AAA 1919 (San Francisco); Havlice; Mallett Supplement; WWAA 1940-1941 (San Francisco); San Francisco Public Library.

Salzbrenner, Albert (-)
AAA 1915 (Salt Lake City, Utah); Mallett (New York City).

Sammann/Sammaren, Detlef (-)
B. Germany. Work: Edward Doheny Memorial Library. AAA 1915–1917 (Pebble Beach, California); Austin.

Sammann is mentioned in artist Charles Percy Austin's article for *Out West,* published in 1912, at which time he was fairly well established in California.

Samuels, W. G. M. (1815–1902)
Work: Witte Memorial Museum. Groce and Wallace.

Samuels was an early sheriff in San Antonio, Texas, who painted views of the main plaza of that city in 1849.

Sandefur, John Courtney (1893–)
B. Indiana. Work: National Collection of Fine Arts. AAA 1929–1931 (Chicago, Illinois); Havlice; Mallett Supplement; WWAA 1936–1937 (Los Angeles, California).

Sands, Gertrude Louis (1899–)
B. Cawker City, Kansas. Havlice; Mallett Supplement; WWAA 1940–1941 (Berkeley, California).

Sandzen, Sven Birger (1871–1954)**
B. Blidsberg, Sweden. D. June 19. Work: Art Institute of Chicago; National Collection of Fine Arts; Museum of New Mexico; Library of Congress; William Rockhill Nelson Gallery of Art; National Museum, Stockholm; Brooklyn Museum; Wichita Art Museum; Luxembourg Museum, Paris. AAA 1913–1933 (Lindsborg, Kansas); Bénézit; Fielding; Havlice; Mallett; WWAA 1936–1953 (Lindsborg); WWWA; Elisabeth Jane Merrill, "The Art of Birger Sandzen," *American Magazine of Art,* January 1927.

Before coming to this country at age 23 to teach art at Bethany College in Lindsborg, Sandzen studied with Anders Zorn and others in Sweden, continuing with additional study in France. His painting technique, derived as it was from modern European training, was not well understood by his American au-

dience, whether radical or conservative. Sandzen was "different." It was many years before his work was fully appreciated.

During those trying years Sandzen became a much sought-after teacher while his own work developed to a point where his lithographs reached near perfection. His painting and wood engraving lagged not far behind.

Kansas is not generally considered landscape territory, but Sandzen was able to make it so. Without his individual style for depicting rolling plains and gentle streams, there would have been little inspiration for his students. Sandzen, of course, went far beyond the confines of Kansas for much of his material. The Rocky Mountains, the Southwestern Deserts, and the coastal areas of the Western Hemisphere also have received his distinctive touch.

Sargent, Paul Turner (1880–)
B. Hutton, Illinois. Work: University of Indiana, Bloomington. AAA 1913–1915 (Chicago, Illinois); AAA 1925–1933 (Charleston, Illinois); Havlice; Mallett; WWAA 1938–1941 (Charleston).

Sawyer, Edmund Joseph (1880–)
B. Detroit, Michigan. Work: New York State Museum; Albright Art Gallery; Detroit Institute of Arts; Old Faithful Museum, Yellowstone National Park; Cornell University, Department of Ornithology; U.S. Post Office, Dennison, Ohio. Havlice; Mallett Supplement; WWAA 1940–1941 (Billings, Montana); WWAA 1947 (Bellingham, Washington); WWAA 1953–1962 (Kirkland, Washington).
Sawyer specialized in bird representation.

Sayer, Edmund Sears (1878–)
B. Meadville, Pennsylvania. Work: Library of Congress; New York Public Library; New York Historical Library. AAA 1933 (Washington, D.C.); Havlice; Mallett; WWAA 1936–1939 (Washington, D.C.); WWAA 1940–1941 (San Diego, California).

Scammon, Laurence Norris (–)
AAA 1898, page 93; AAA 1923–1927 (Fruitvale, California); San Francisco Public Library.

In 1898 Scammon was an assistant in the Department of Decorative and Industrial Arts at the University of California in Berkeley. Ultimately he made a name for himself in the San Francisco area as an etcher.

Schaffer, L. Dorr (-)
AAA 1900, 1905–1906 (Redlands, California); AAA 1917 (Santa Barbara, California).
Schaffer was a member of the Art Club of Philadelphia.

Schevill, William Valentine (1864–1951)
B. Cincinnati, Ohio. Work: Cincinnati Museum; Herron Art Institute; Chicago Historical Society; Washington University, St. Louis; St. Louis Art Museum. AAA 1907–1921 (New York City); AAA 1923–1931 (St. Louis, Missouri); AAA 1933 (New York City; summer: Charlevoix, Michigan); Bénézit; Fielding; Havlice; Mallett; WWAA 1936–1937 (New York City; summer: Charlevoix); WWAA 1938–1941 (Los Angeles, California; studio: New York City); WWWA.

Schiwetz, Edward M. [Buck] (1898–)**
B. Cuero, Texas. Work: Dallas Museum of Fine Arts; Houston Museum of Fine Arts; Fort Worth Art Association. Havlice; Mallett; WWAA 1940–1941, 1953–1962 (Houston, Texas); Norman Kent, "A Portfolio of Drawings of Texas by Edward M. (Buck) Schiwetz," *American Artist*, December 1961; "Edward M. Schiwetz Discusses Mixed Techniques," *American Artist*, December 1961, 41, 79; O'Brien.
Schiwetz began his career as an architectural designer in Dallas and Houston in the early 1920s. Ten years later he turned to water color, experimenting until he found himself at home in that medium. He described for *American Artist* the technique and pallet he evolved while capturing the busy life of Galveston Harbor, the subject of his experiments.
A writer as well as an artist, Schiwetz put both talents to work to tell how he felt about the passing glories of Texas, especially those old homes that all too often were "torn down to make way for parking lots, hamburger dispensaries, and other symbols

250

of 'progress.' " *Buck Schiwetz' Texas*, published in 1960 by the University of Texas Press, was his attempt to save them from further destruction.

Schlaikjer, Jes Wilhelm/William (1897–)
B. Brooklyn, New York. Work: National Academy of Design; Nelson Art Gallery, Kansas City; Department of State. AAA 1925–1929 (Riverdale, New York); AAA 1931–1933 (New York City); Bénézit; Fielding; Havlice; Mallett; WWAA 1936–1941 (New York City); WWAA 1947–1976 (Washington, D.C.); *The Art Digest*, December 1, 1928, 5.

Schmidt, Albert H. (1883–1957)
B. Chicago, Illinois. D. New Mexico. Work: Museum of New Mexico; Field Museum, Chicago; Chicago Municipal Art Commission. AAA 1903–1919 (Chicago); Havlice; Mallett; WWAA 1940–1941 (Santa Fe, New Mexico); Denver Public Library; Albuquerque Public Library.
From 1922, when Schmidt moved to Santa Fe, he specialized in scenes of the surrounding area. He also painted portraits.

Schmidt, Karl (1890–1962)
B. Worcester, Massachusetts. D. Santa Clara County, California. AAA 1913 (Boston, Massachusetts); AAA 1915 (Worcester); AAA 1917–1919 (Santa Barbara, California); AAA 1921–1931 (Worcester and New York City); AAA 1933 (Silvermine, Connecticut); Bénézit; Havlice; Mallett; WWAA 1936–1941 (Ardmore, Pennsylvania).

Schmidt, Otto (–1940)
B. Philadelphia, Pennsylvania. D. May 20. Work: Vanderpoel Art Association; Fellowship, Pennsylvania Academy of Fine Arts; mural, Northeast High School, Philadelphia. AAA 1921–1933 (Philadelphia; Lindenwold, New Jersey); Havlice; Mallett; WWAA 1936–1941 (Philadelphia; Lindenwold); Boise Public Library.

Schmitt, Paul A. (1893–)
B. Philadelphia, Pennsylvania. Havlice; Mallett Supple-

ment; WWAA 1936-1941 (Oakland, California); California
State Library; San Francisco Public Library.

Schneider, Isobel (1880-1962)
B. New York state. AAA 1917 (Buffalo, New York);
Havlice; Mallett Supplement; WWAA 1938-1941 (Ocean
Beach, California).

Schneider, Otto H. (1865-1950)
B. Iowa. D. San Diego, California. AAA 1913-1917 (Buf-
falo, New York); Havlice; Mallett; WWAA 1938-1941
(Ocean Beach, California); *The Art Digest,* July 1929, 1.
Schneider and his wife Isobel probably were living in
Southern California much earlier than WWAA indicates, for he
was teaching landscape at San Diego Academy of Fine Arts in
1929.

Schoonover, Frank Earle (1877-1972)
B. Oxford, New Jersey. D. September 1. Work: Cornell
University; Delaware Art Museum; Fletcher Brown Voca-
tional School, Wilmington, Delaware. AAA 1905-1913
(Wilmington); AAA 1915-1933 (Wilmington; summer:
Bushkill, Pennsylvania); Fielding; Havlice; Mallett;
WWAA 1936-1941 (Wilmington; summer: Bushkill);
WWWA; Courtland Schoonover, *Frank Schoonover,*
Watson-Guptill, 1976; Courtland Schoonover, "Frank
Schoonover's Frontier," *The American West,* March-April
1977; Reed.

Schouler, Willard C./William (1852-)
B. Arlington, Massachusetts. Work: Boston Museum of
Fine Arts. AAA 1905-1919 (Arlington); AAA 1921 (Ar-
lington; Canaan, New Hampshire); AAA 1923-1929 (Ar-
lington); Bénézit; Fielding; Mallett; *Kennedy Quarterly,*
October 1961, 185.
Schouler specialized in Western and Arabian scenes.
Wyoming probably is the setting for "Goodwin Ranch PO,
1888," an oil.

Schroder, Arnold (-)
AAA 1917 (San Francisco, California).

Schroeder, George Eugene (1865-1934)

B. Chicago, Illinois. D. April 11. *Who's Who in Northwest Art* (Burley, Idaho); Hiram T. French, *History of Idaho,* Vol. III, 977-978; Boise Public Library; *American Magazine of Art,* May 1927, 270.

Through clippings on file at the Boise Public Library one can obtain additional information about Schroeder, the energetic businessman and artist who settled in Idaho in 1906. His early experience was in sign painting, a field he developed into a chain of businesses reaching from Chicago to Lincoln, Nebraska.

During Schroeder's years in Idaho where he lived in Twin Falls, Rupert, Heyburn, and Burley, he did much to encourage development of art throughout the state. And through his paintings he advertised the beauties of the Sawtooth Mountains and the Jackson Lake country. Schroeder also painted in California, Utah, and in Europe. He worked in oil, and his specialty was landscape painting.

Schroff, Alfred Hermann (1863-1939)

B. Springfield, Massachusetts. D. Eugene, Oregon, April 16. AAA 1900-1906 (Boston, Massachusetts); AAA 1907-1908 (Newtonville, Massachusetts); AAA 1909-1913 (Greenwood, Massachusetts); AAA 1915 (Portland, Maine; summer: Wellesley Farms, Massachusetts); AAA 1917-1921 (Eugene); AAA 1923-1933 (Eugene; Carmel, California); Fielding; Havlice; Mallett, WWAA 1936-1939 (Eugene; Carmel); *Who's Who in Northwest Art.*

Schulman, Abraham Gustav (1881-1935)

B. Konigsberg, Germany. D. Phoenix, Arizona, June 2. AAA 1907-1908 (New York City); AAA 1909-1910 (East Haddam, Connecticut); AAA 1913-1927 (New York City); Fielding; Havlice; Mallett; WWAA 1936-1937*.

Schultz, George F. (1869-)

B. Chicago, Illinois. Work: Union League Club and Cliff Dwellers, Chicago; Chicago Municipal Collection; Muscatine (Iowa) Art Association; Muskogee (Oklahoma) Public Library; Minneapolis Art Institute. AAA 1898-1933 (Chicago); Bénézit; Fielding; Mallett; WWWA.

Schultz specialized in landscapes and marines.

Schumann, Paul Richard (1876-)
B. Reichersdorf, Germany. Work: Vanderpoel Art Association; Dallas Woman's Forum; Fort Worth School of Painting; Rosenberg Library, Galveston. AAA 1923-1924, 1931-1933 (Galveston, Texas); Havlice; Mallett; WWAA 1936-1941 (Galveston); O'Brien.
Schumann was a marine painter who has produced some prize-winning landscapes such as "A Bit of New Mexico."

Schupbach, Mae Allyn (See: Christie, Mae Allyn)

Schuster, Donna Norine (-)
Work: Laguna Beach Art Museum. AAA 1913 (Boston, Massachusetts); AAA 1915-1933 (Los Angeles, California); Bénézit; Fielding; Havlice; Mallett; WWAA 1936-1956 (Los Angeles).

Schuyler, Remington (1887-1955)
B. Buffalo, New York. D. St. Louis, Missouri, October 19. Work: Bacone College; Darien (Connecticut) High School; Washington School, New Rochelle, New York; New Rochelle High School. AAA 1925-1927 (Pelham Manor, New York); AAA 1929-1933 (Westport, Connecticut); Havlice; Mallett; WWAA 1936-1941 (Westport); WWAA 1947-1953 (Buckingham, Pennsylvania); Henry W. and Jean Tyree Hamilton, *Missouri Historical Society Bulletin,* January 1969, 118-122; Mahony, Latimer, and Folmsbee, 1947.
Schuyler, whose mother was related to Frederic Remington, grew up in Michigan, Missouri, and the West. The years 1903 and 1904 were particularly eventful ones. Among hundreds of Sioux Indians and a few white men, Schuyler worked at a trading post on the Rosebud Reservation, and as a cowhand at Bob Emery's E. Bar Ranch. He recounted in later years the exciting times he had at O Kreek playing with Sioux boys. On one occasion he sold his long red hair for a pony. The Sioux wanted the hair to trim his scalp shirt.
In 1910 Schuyler returned to Rosebud where he painted

the Bruel Sioux re-enacting the Sun Dance. About 1926 he returned to the Reservation for more material.

Although Schuyler lived mainly in the East, he found an outlet for his interest in Indian life in his illustrations for periodicals and books for young people. He also painted a number of oil portraits of his Indian friends.

In 1921, in company with Marshal Foch, Schuyler painted Indian ceremonies at Mandan, North Dakota, and on the Crow Reservation in Montana.

Schwankovsky, Frederic John, Jr. (1885-)
B. Detroit, Michigan. AAA 1917-1924 (Los Angeles, California); AAA 1925 (Laguna Beach, California; studio: Los Angeles); Fielding; Havlice; Mallett; WWAA 1936-1953 (Laguna Beach); WWAA 1956-1962 (Laguna Beach; summer: Meadow Lakes, via Auberry, California); *Who's Who on the Pacific Coast,* 1947.

Schwarz, Frank Henry (1894-1951)
B. New York City. D. September 5. Work: Brooklyn Museum; University of Nebraska; Oregon State Capitol. AAA 1925-1933 (New York City and Norwalk, Connecticut; summer 1927: Provincetown, Massachusetts); Bénézit; Havlice; WWAA 1936-1937 (Scarsdale, New York); WWAA 1938-1947 (Croton-on-Hudson, New York); WWWA.

Schwentker, Hazel F. (1894-)
B. Panama, Nebraska. Stuart.

Schwentker painted and studied art in Peru, Nebraska; Scottsdale, Arizona; Jackson, Wyoming; and Orlando, Florida. Although primarily an educator, she has taught privately in Rapid City, South Dakota, beginning about 1952. She has exhibited at Black Hills State College in Spearfish, Rapid City Civic Art Gallery, the Surbeck Center at South Dakota School of Mines and Technology, and at South Dakota state fairs in Huron.

Scofield, Edna M. (-)
AAA 1917-1925 (San Diego, California).

Scofield, who also was listed as Edna Halseth, is better

known as a sculptor. She was a member of the California Art Club.

Scott, Anna Page (-1925)
B. Dubuque, Iowa. D. Dubuque, October 13. Work: Carnegie Stout Public Library, Dubuque. AAA 1905-1910 (Rochester, New York); AAA 1917-1925* (Dubuque); Fielding; Mallett.

Scott studied with Dow and Anshutz, and in Paris, France. She was an alumna of the Art Institute of Chicago, and had a fellowship in Pennsylvania Academy of Fine Arts.

Scott, Carlotta Buttoraz (1886-1972)
Scott studied in New York City and in Europe. She did not work professionally, but painted a number of California desert scenes, old missions, and portraits. She lived in Calexico, California, and later in Paradise Park on the San Lorenzo River near Santa Cruz. Information about this artist comes from Marian Collins of Los Altos, California.

Scott, Nellie Burrell (-1913)
D. San Francisco, California, November 17. California State Library.

Scott specialized in painting fish.

Scott, Quincy (1882-)
B. Columbus, Ohio. Work: Columbus Gallery of Fine Arts; Huntington Library. Havlice; Mallett Supplement; WWAA 1938-1941 (Portland, Oregon; summer: Bainbridge Island, Washington); *Who's Who in Northwest Art;* Dorothy Ballard, *Horseback Honeymoon,* New York: Two Continents Publishing Group and Morgan Press, 1975.

Scruggs/Scruggs-Carruth, Margaret Ann (1892-)
B. Dallas, Texas. Work: Elisabet Ney Museum; American Embassy, Bucharest, Rumania; bookplates, Corcoran Gallery of Art; National Society of the Daughters of the American Revolution, Washington, D.C. Havlice; Mallett Supplement; WWAA 1936-1962 (Dallas, Texas); O'Brien.

For more than two decades, Scruggs was the foremost

etcher of historical spots in Texas and the South. Landmarks such as "Dallas Hall of S.M.U.," "Trinity River Viaduct," and "Cynthia Anne Parker's Pioneer Cabin" are among her subjects. A particularly distinctive aspect of her etchings is her handling of trees.

Scruggs did not restrict her art to etching. On one occasion Joseph Sartor Galleries of Dallas featured her work in three media. She also lectured and wrote, illustrating her own work.

Scudder, (Alice) Raymond (-)
B. New Orleans, Louisiana. AAA 1915-1921 (New Orleans); AAA 1923-1933 (Pasadena, California); Bénézit; Fielding; Mallett.

Scudder studied with Chase and Mora and at Newcomb School of Art. She was a member of New Orleans Art Association.

Scutt, Winifred (1890-)
B. Long Island, New York. Work: Ernest Thompson Seton Memorial, Santa Fe, New Mexico; Pioneers' Museum, Colorado Springs, Colorado. Havlice; Mallett; WWAA 1947-1953 (Colorado Springs; studio: Santa Fe); WWAA 1962 (Santa Barbara, California); Fisher.

Scutt began working in Santa Fe at least as early as 1942.

Sears, Benjamin Willard (1846-1905)
B. Guilford, Connecticut (probably). D. Pacific Grove, California, November 18. Work: Oakland Museum; California Historical Society; Society of California Pioneers; Tuolumne County (California) Historical Society. California State Library; Society of California Pioneers; Tuolumne *Independent,* November 30, 1878, and June 21, 1879.

Sears studied photography in San Francisco in the early 1870s, but soon abandoned what he called "the black art" in favor of sketching and painting. Self-taught though he was, he managed to eke out a living in San Francisco before settling in Sonora, California, in 1878. Six months of sketching for the U.S. Coast Survey followed in 1879.

With a wife and five children, Sears was compelled to paint

257

whatever jobs came his way. His creative work often was done on wooden panels, pie tins, and material salvaged from buggy tops in place of canvas.

Inland marine scenes and mountain landscapes predominate in Sears's work. His major painting is a panorama of principal California scenes that Sears thought ended up somewhere in Eastern United States.

Seavey, Julian Ruggles (1857–1940)

B. Boston, Massachusetts. D. Hamilton, Ontario, Canada. AAA 1898–1900 (Hamilton); Havlice; Mallett Supplement; Harper, 1966; *Kennedy Quarterly,* June 1969, 46–47.

According to the *Kennedy Quarterly,* Seavey's "Bridger Pass, Colo.," probably was painted in 1878 or 1879. Seavey studied in Paris, France; Rome, Italy; and in Germany. He taught in Hamilton, and in London, England. In Canada he is a well-known painter and illustrator.

Seavey, Lilla B. (–)

AAA 1898 (Denver, Colorado).

Seavey, who studied at the National Academy of Design, exhibited at the Omaha Exposition in 1898.

Seawell, Henry Washington/Harry W. (–)

B. San Francisco, California. AAA 1915–1933 (San Francisco); Bénézit; Fielding; Mallett.

Seawell studied in Paris where he was a member of the Paris Association of American Artists. He also was a member of the Bohemian Club.

See, Imogene (1848–1940)

B. Ossining, New York. D. Ocean Grove, New Jersey, March 8. *Kennedy Quarterly,* November 1963, 48–49; Kovinick.

See lived in Nebraska for about a year in 1885. Her oil-on-board paintings are entitled "Dinnertime, Nebraska," "Sodbuster's Cabin, Nebraska," and "Sod House, Nebraska," and all three are reproduced in *Kennedy Quarterly.* Her home was in Port Chester, New York. According to Kovinick, an obituary refers to her as a Western artist.

Seeberger, Pauline Bridge (1897–)
B. Chicago, Illinois. Havlice; Mallett Supplement; WWAA 1936–1941 (San Francisco, California).
Seeberger also is known as Mrs. Roy Vernon Sowers.

Seely, Walter Frederick (1886–)
B. Monkton, Canada. AAA 1931–1933 (Los Angeles, California); Havlice; Mallett; WWAA 1956–1959 (Los Angeles).

Seewald, Margaret (1899–)
B. Amarillo, Texas. Havlice; Mallett Supplement; WWAA 1936–1941 (Amarillo); O'Brien.

Seideneck, George Joseph (1885–1972)
B. Chicago, Illinois. D. Carmel, California, March 9. AAA 1915–1921 (Chicago); Fielding; Carmel Public Library.
Seideneck was active in Carmel from 1918.

Sekido, Yoshida (1894–)
B. Tokyo, Japan. Work: California Palace of the Legion of Honor; San Francisco Museum of Art; University of Oregon Museum of Art; Toronto Art Museum. Havlice; Mallett Supplement; WWAA 1938–1941 (San Francisco, California); California State Library.

Senat, Prosper Louis (1852–1925)
B. Germantown/Philadelphia, Pennsylvania. D. Germantown. Work: Joslyn Art Museum; Delaware Art Museum. AAA 1898–1900 (Philadelphia); AAA 1903 (Philadelphia; Kennebunkport, Maine); AAA 1905–1910 (Pasadena, California); AAA 1919–1921 (Annisquam, Massachusetts); AAA 1925*; Bénézit; Fielding; Mallett.

Sepeshy, Zoltan L./Zelton (1898–)
B. Kassa, Hungary. Work: Toledo Museum of Art; Albright Art Gallery; National Collection of Fine Arts; Wichita Art Museum; San Diego Fine Arts Society; Butler Art Institute; University of Arizona. AAA 1923–1924 (Highland Park, Michigan); AAA 1925–1931 (Detroit,

Michigan); AAA 1933 (Bloomfield Hills, Michigan); Bénézit; Fielding; Havlice; Mallett; WWAA 1936-1947 (Bloomfield Hills); WWAA 1953-1966 (Bloomfield Hills; summer: Bridgewater, Connecticut); *The Art Digest,* July 1, 1935, 15; *The Art Digest,* December 1, 1938, 7.

Serbaroli, Hector (1886-)
B. Rome, Italy. Havlice; Mallett Supplement; WWAA 1940-1941 (Los Angeles, California).

Sewall, Blanche Harding (1889-)
B. Fort Worth, Texas. AAA 1923-1933 (Houston, Texas); Fielding; Mallett.
Sewall was a member of Southern States Art League.

Sewall, Howard Stoyell (1899-)
B. Minneapolis, Minnesota. Work: murals, Timberline Lodge, Mt. Hood; Oregon City Senior High School. Havlice; Mallett Supplement; WWAA 1940-1941 (Portland, Oregon); *Who's Who in Northwest Art.*

Sexton, Frederick Lester (1889-)
B. Cheshire, Connecticut. Work: Hopkins School, New Haven; New Haven City Hall; Connecticut University. AAA 1923-1933 (New Haven, Connecticut); Bénézit; Havlice; Mallett; WWAA 1936-1962 (New Haven).

Seymour, Ralph Fletcher (1876-1966)
B. Milan, Illinois. Work: Newberry Library, Ayer Collection; Art Institute of Chicago; National Gallery of Art; Bibliothèque Nationale, Paris; Los Angeles Museum; Milwaukee Art Institute. AAA 1903 (Chicago, Illinois); AAA 1905-1908, 1917-1931 (Ravinia, Illinois); Bénézit; Fielding; Havlice; Mallett; WWAA 1936-1962 (Chicago); WWWA; Denver Public Library; Seymour, "Indian Visit," *The Midwest,* September 1934, 3, 8.
Seymour made frequent trips to the Southwest where he studied Indian life in considerable detail and wrote about his observations. He is best known for his etchings. A woodcut entitled "Snake Dancers" illustrates Seymour's article in *The Midwest.*

Shannon, Aileen Phillips (1888-)

B. Gillsburg, Mississippi. Work: Rock Springs (Wyoming) Art Association; New Mexico State College; Mississippi Art Association. Havlice; Mallett Supplement; WWAA 1940-1962 (Las Cruces, New Mexico); Fisher; Albuquerque Public Library.

Prior to moving to Las Cruces in 1924, Shannon lived in Santa Fe and Clayton, New Mexico.

Sharp, Louis Hovey (1875-1946)

B. Glencoe, Illinois. Work: Santa Fe Collection. AAA 1905-1908 (Oak Park, Illinois); California State Library; Santa Fe Industries, Inc., catalog.

According to data supplied the Smithsonian Institution for its Inventory of American Paintings, Sharp's "Panorama of Grand Canyon" and "Colorado River, Grand Canyon" probably were painted before 1910; "Buffalo Dance at Mishongnovi" and "Hopi Pueblo of Walpi" before 1913; "In the Village of Mishongnovi" before 1915; and "Isis Temple, Grand Canyon" before 1917.

Sharp also worked in Southern California where he lived in Pasadena for a number of years. He had been a student at the Art Institute of Chicago and a pupil of Chase, Duveneck, and Charles E. Boutwood.

Sharp, William (1800-1900)

B. Ramsey, England. Work: Boston Museum of Fine Arts; National Collection of Fine Arts. Groce and Wallace; WWWA; California State Library; National Collection of Fine Arts; Archives of American Art, Smithsonian Institution.

Because there are several artists named William Sharp, this artist cannot be identified with certainty. Year of birth varies from 1800 to c.1802; years of activity are given as 1819-1862, but at least one painting is dated 1870. Bénézit lists a William Sharp whose exhibitions correspond to this artist's years of activity. *Alta California*, July 28, 1869, 1-3, refers to a Boston veteran artist's being in the San Francisco area on a visit. Groce and Wallace confirm Sharp's residence in Boston where he was active as a drawing teacher, color lithographer, and painter of

portraits and landscapes. He was a pioneer in color lithography.

Sharp, William A. (1864-1944)
Work: Stetson University, De Land, Florida. AAA 1905-1910 (Washington, D.C.); AAA 1917-1921 (Los Angeles, California).
Sharp was a member of Washington Water Color Club, Society of Washington Artists, and California Art Club.

Shaw, Lois Hogue (1897-)
B. Merkel, Texas. Work: Sweetwater High School. Havlice; WWAA 1959-1962 (Sweetwater, Texas).

Shead, Ralph (-)
AAA 1917 (Jenks, Oklahoma).

Shear, Fera Webber (1893-)
B. Eustace, Florida. Havlice; Mallett Supplement; WWAA 1936-1962 (Berkeley, California); *Who's Who in California,* 1943.

Sheckell, T. O. (-)
AAA 1915 (Salt Lake City, Utah).

Sheeler, Charles (1883-1965)
B. Philadelphia, Pennsylvania. D. May 7. Work: Boston Museum of Fine Arts; Columbus Gallery of Fine Arts; National Collection of Fine Arts; Art Institute of Chicago; Pennsylvania Academy of Fine Arts; Museum of Modern Art; California Palace of the Legion of Honor; University of Nebraska. AAA 1905-1919 (Philadelphia; summer 1915-1919: Doylestown, Pennsylvania); AAA 1921 (New York City; summer: Doylestown); Bénézit; Fielding; Havlice; Mallett; WWAA 1936-1937 (New York City); WWAA 1938-1941 (Ridgefield, Connecticut); WWAA 1947-1962 (Irvington, New York); WWWA; *American Artist,* January 1976, 102.
Sheeler painted landscapes in the National Parks and along the West Coast in 1957, and perhaps earlier.

Sheffers, Peter Winthrop (1893-1949)

B. San Antonio, Texas. D. April 3. Work: Belle Keith Art Gallery, Rockford, Illinois; Peoria (Illinois) Public Library. Havlice; Mallett Supplement; WWAA 1940-1941 (Peoria); WWAA 1947 (Portland, Oregon); WWAA 1953*.

In 1947 Sheffers exhibited Pacific Coast landscapes at Crocker Art Gallery, Sacramento, California.

Shepard, Clare (See: Shisler, Clare Shepard)

Shepherd, Nellie (1877-1920)

B. Kansas. Work: Santa Fe Collection. AAA 1917 (Oklahoma City, Oklahoma); AAA 1919 (Chickasha, Oklahoma); Jacobson and d'Ucel, 268-269; Dale and Wardell, 524; Nan Sheets, "Miss Shepherd's Work Admired," *Daily Oklahoman,* October 17, 1943.

Shepherd, who moved with her family to Oklahoma in 1889, studied one year at the Cincinnati Art Academy; she then went to Paris for four more years of study. Among her teachers there was Henri Martin. She returned an impressionist at a time when impressionism was not yet in vogue here, and achieved little recognition during her short lifetime.

Although an accomplished landscape painter, Shepherd preferred portraiture. A painting of her sister Lottie won the Grand Salon award in Paris in 1910. When precarious health caused her to live in Arizona for several years, she did a number of paintings of Pima and Papago Indians. An oil, "Papago Indian Hut, Arizona," is in the Santa Fe Collection.

Sheridan, Joseph Marsh (1897-)

B. Quincy, Illinois. Work: University of Minnesota; Beloit College; Mills College; University of California; San Francisco Museum of Art; Berkeley Public Library. Bénézit; Havlice; Mallett Supplement; WWAA 1938-1941 (Oakland, California); WWAA 1947-1962 (New Wilmington, Pennsylvania); California State Library.

Sherman, Elizabeth Evelyn (1896-)

B. Chicago, Illinois. Mallett (Coronado, California).

Sherrer, Sabrina Doney (1857–1930)

B. Kewaskum, Wisconsin. D. Huron, South Dakota, August 18. Stuart.

This largely self-taught artist settled in Huron in 1883. Her work is in the South Dakota State Fair Pioneer Museum in Huron.

Shields, Emma Barbee/Barber (1863–1912)

D. New York City, January 16. Work: Swarthmore College. AAA 1913*; Bénézit; Mallett.

Shields was a portrait painter who had lived many years in Texas before moving to New York in 1893.

Shiras,George E. (–)

AAA 1917–1921 (Los Gatos, California).

Shiras was a member of Pittsburgh Art Association.

Shisler, Clare Shepard (–)

AAA 1915 (Seattle, Washington, listed as Shepard); AAA 1919–1929 (Seattle, Washington; studio in Pasadena, California, from 1923); Mallett Supplement (San Anselmo, California).

Shisler was a member of the Pennsylvania Society of Miniature Painters. She began receiving prizes in 1913 and won a water color award at the Panama-Pacific Exposition in 1915.

Shiva, Ramon N. (1893–1963)

B. Santander, Spain. D. Santa Fe, New Mexico, April 27. Work: Museum of New Mexico. AAA 1919–1933 (Chicago, Illinois); Havlice; Mallett; WWAA 1936–1939 (Chicago); WWAA 1940–1941 (Chicago; Santa Fe); Albuquerque Public Library.

Shiva is famous for the casein paints he developed. During the early years of his career he specialized in commercial art. After seeing the Armory Show he turned to fine art. After 1937, he had a home in Santa Fe.

Shively, Douglas (1896–)

B. Santa Paula, California. Havlice; Mallett; WWAA 1938–1956 (Santa Paula).

Shively specialized in landscape painting.

Shockley, May Bradford (1879-)

B. Moberly, Missouri. California State Library; Palo Alto (California) Community Book, 1952, 295-296; Palo Alto Public Library; Personal interview, November 1975.

In 1902 Shockley graduated from Stanford University with an art major and a mathematics minor, intent upon a teaching career. She took a position in Seattle, but within a few years joined her father in Tonopah, Nevada, as a partner in his mining engineering firm. In 1906 she was appointed United States Deputy Mineral Surveyor for Nevada. While living there she did a number of Nevada landscapes.

Following marriage, Shockley lived in Palo Alto, California, where she became well known as a painter. Her career, however, was short lived, for her husband died in 1925. She turned to more lucrative employment to support herself and her son. Whenever possible, she took short painting trips. Her work indicates a particular interest in California wild flowers and Oriental art objects.

Shorb, Mrs. D. L. (-)

Denver Public Library.

Shorb was a landscape painter who opened a studio in Denver, Colorado. Between October 1881 and May 1882 she was mentioned several times in the Rocky Mountain *News*.

Shore, Henrietta M. (-)

B. Toronto, Ontario, Canada. Work: San Diego Fine Arts Gallery; National Collection of Fine Arts; Dallas Museum of Fine Arts; University of Washington; National Gallery, Ottawa. AAA 1915-1919 (Los Angeles and Hollywood, California); AAA 1921-1929 (New York City; summer: Hollywood); AAA 1931 (Hollywood); AAA 1933 (Carmel, California); Bénézit; Fielding; Mallett; WWAA 1936-1953 (Carmel).

Shoven, Hazel Brayton (1884-)

B. Jackson, Michigan. AAA 1931-1933 (San Diego, California); Havlice; Mallett; WWAA 1936-1941 (San Diego).

Shupp, Alice Connel (1896-)
B. Las Vegas, New Mexico. Fisher.
Shupp was still living in Las Vegas as of 1947.

Shurtliff, Wilford Haskill (1886-)
B. Ogden, Utah. Havlice; Mallett Supplement; WWAA
1940-1941 (Salt Lake City, Utah).

Siboni, Emma Benedikta (1877-)
B. Soro, Denmark. Work: Huntington Art Gallery. AAA
1903 (Buffalo, New York); AAA 1905-1908 (Fort Wayne,
Indiana); AAA 1909-1910 (Fort Wayne; Europe); AAA
1913-1919 (Hubbard Woods, Illinois); AAA 1925 (Pasa-
dena, California); AAA 1931-1933 (Washington, D.C.);
Bénézit; Fielding; Havlice; Mallett; WWAA 1940-1941
(Washington, D.C.).

Sichel, Harold M. (1881-)
B. Benicia, California. AAA 1921 (New York City);
Havlice; Mallett; WWAA 1938-1939 (New York; summer:
Gilmanton, New Hampshire); WWAA 1940-1941 (Oak-
land, California).

Silsby, Clifford F. (1896-)
B. New Haven, Connecticut. Work: Los Angeles Museum;
Victoria and Albert Museum, London; Evansville (In-
diana) Museum of Art. AAA 1929 (Los Angeles, Califor-
nia); AAA 1933 (France; Los Angeles); Havlice; Mallett;
WWAA 1936-1941 (Los Angeles; Nice, France); WWAA
1947 (Los Angeles); WWAA 1953-1959 (Sherman Oaks,
California); WWAA 1962 (Los Angeles).

Silsby, Wilson (1883-1952)
B. Chicago, Illinois. D. January 17. Work: Metropolitan
Museum of Art; Library of Congress; Art Institute of
Chicago; Pennsylvania Academy of Fine Arts; Crocker Art
Gallery; Museum of New Mexico; Seattle Art Museum;
Denver Art Museum. Havlice; Mallett; WWAA 1936-
1939 (Los Angeles, California; Nice, France); WWAA
1940-1953 (Los Angeles); WWWA (Sherman Oaks, Cali-
fornia).

Silvius, Paul T. (1899–)

B. Hampton, Iowa. AAA 1931–1933 (Los Angeles, California); Mallett.

Silvius was a member of Laguna Beach (California) Art Association.

Simkins/Simpkins, Martha (–)

B. Texas. AAA 1915 (Oak Cliff, Texas); AAA 1919–1924 (Woodstock, New York); AAA 1925–1929 (New York City; summer: Woodstock); AAA 1931 (Woodstock).

Simkins studied at the Art Students' League and with Chase. She was a member of National Association of Women Painters and Sculptors, and known as a teacher as well as a painter in Texas and New York.

Simmang/Simmange, Charles (1874–)

B. Serbin, Texas. Work: Witte Memorial Museum, San Antonio. AAA 1923–1931 (San Antonio, Texas); Bénézit; Havlice; Mallett Supplement; WWAA 1936–1941 (San Antonio); O.Brien.

Simmang specialized in steel relief engravings.

Simpson, E. V. (–)

AAA 1915 (Salt lake City, Utah).

Simpson, Marian/Marion (1899–)

B. Kansas City, Missouri. Work: Ward Fund, Cleveland; Mills College Gallery; YWCA, San Francisco; Alameda County (California) Court House. AAA 1925–1933 (Berkeley, California); Havlice; Mallett; WWAA 1936–1941 (Berkeley); California State Library.

Singerman, Gertrude Sterne (–)

AAA 1917, 1923–1924 (Seattle, Washington); AAA 1925–1927 (New York City).

Skeats, Miall (1858–1928)

B. England. D. California. Albuquerque Public Library.

Skeats, who conducted geological studies in Southeastern New Mexico, did authentic paintings of New Mexico flora during

the 1890s. They were exhibited at the University of New Mexico Art Museum in July 1967. Skeats also worked in California and perhaps elsewhere in the West.

Skelly, Alta L. (1896–)
B. Pinckneyville, Illinois. Fisher.
Skelly settled in Silver City, New Mexico, in 1926.

Skelton, Phillis Hepler (1898–)
B. Pittsburgh, Pennsylvania. Work: Pasadena Art Museum; Bowdoin College; Victoria (B.C.) Art Gallery. WWAA 1956 (Pasadena, California); WWAA 1959–1973 (Claremont, California).

Skene, Harold Vincent (1883–)
B. Pittsfield, Massachusetts. Work: Denver Public Library Western History Collection.
In a manuscript prepared for the Denver Public Library, Skene gave an account of his career. He graduated from Harvard School of Architecture in 1906. Although he painted chiefly in Colorado and neighboring states and on the West Coast, he also painted on the East Coast, in rural New England, and in England, France, and Switzerland. His home was in Denver where, in 1964, he was still painting the Western scene. He had exhibited at the Broadmoor Art Academy where earlier he had been a student, and at the Denver Art Museum. "Taos at Night" is among the eight items in the Library's Western History Collection painted by Skene.

Sleeth, L. MacD/Macdonald (1864–1951)
B. Croton, Iowa. Work: Museum of New Mexico. AAA 1917–1933 (Washington, D.C.); Bénézit; Fielding; Mallett; California State Library.
Although best known as a sculptor and a teacher, Sleeth studied painting with Whistler and Emil Carlsen and was active in Washington water color clubs. She was also a member of San Francisco Art Association, Laguna Beach Art Association, and Washington Art Club.

Sloan, Edna (–)
AAA 1900 (Salt Lake City, Utah).

Sloan was a member of Utah Society of Artists. By 1903 she was primarily active as secretary of the Utah Art Institute which had been created by the state in 1899. She is referred to in this capacity on page 4 of the 1903 Art Annual.

Sloan (James) Blanding (1886-)
B. Corsicana, Texas. Work: Brooklyn Museum; Museum of New Mexico; California Palace of the Legion of Honor. AAA 1917 (Chicago, Illinois; Corsicana); AAA 1919-1921 (New York City; Corsicana); AAA 1923-1933 (Corsicana); Fielding; Havlice; Mallett; WWAA 1936-1939 (West Hollywood, California); WWAA 1940-1941 (Cos Cob, Connecticut); Merwin Martin article, *International Studio*, April 1923, 385-390; *The Art Digest*, January 1, 1929, 23.

Sloan, John (1871-1951)**
B. Lock Haven, Pennsylvania. D. Hanover, New Hampshire, September 8. Work: Cincinnati Museum of Art; Carnegie Institute; Metropolitan Museum of Art; National Collection of Fine Arts; Brooklyn Museum; Museum of New Mexico; Phillips Memorial Gallery; Detroit Institute of Art; Los Angeles Museum; New York Public Library; Newark Public Library. AAA 1905-1933 (New York City; summer: Santa Fe, New Mexico, from 1919); Bénézit; Fielding; Havlice; Mallett; WWAA 1936-1947 (New York City; summer: Santa Fe); WWWA; Brooks (Sloan quotation reprinted by permission of the publishers, E. P. Dutton).
Sloan visited Santa Fe in 1919, and bought a summer home there in 1921. Years later he recalled his impressions of the first Corn Dance he saw at nearby Santo Domingo: "I felt the same strong emotion for the rhythm of the drums and primitive intensity of that age-old dance ritual that I experienced when I saw Isadora Duncan fill the stage . . . with her great personality." Though Sloan did not usually make sketches at the site, here he climbed to the roof of an adobe dwelling and made the sketch through clouds of dust from a sudden storm which gave the scene an unforgetable atmospheric quality, wrote Van Wyck Brooks.
Early in his career Sloan developed the ability to retain in his mind the painting or etching he wished to create. However,

"Chama Running Red" and many other of his New Mexico land-
scapes were done at the site. This is also true of his Gloucester
paintings of earlier years when he spent summers there.

Slutz, Helen Beatrice (1886–)
B. Cleveland, Ohio. AAA 1915–1921 (Chicago, Illinois);
AAA 1923–1933 (Chicago and Evanston, Illinois; Holly-
wood, California); Bénézit; Fielding; Havlice; Mallett;
WWAA 1940–1941 (Evanston; Dallas, Texas).

Small, Hazel (–)
AAA 1915–1921 (Denver, Colorado).
Small was a member of the Denver Artists' Club.

Smart, Edmund Hodgson (1873–1942)
B. Alnwick, Northumberland, England. D. November 16.
Work: National Collection of Fine Arts. Mallett; WWWA;
Waters.
Smart was a painter of portraits and allegorical subjects
who exhibited widely in this country and at the Royal Academy
and the Paris Salon. During his career he lived in Alnwick; Los
Angeles and Beverly Hills, California; and Bermuda Island.

Smellie, Robert (–c.1908)
B. Scotland. Work: Historical Society of Colorado. Denver
Art Museum, *Colorado Collects;* Denver Public Library;
Rocky Mountain *News,* May 16, 1888, 4–4.
Smellie, who exhibited at the Royal Academy in Scotland
from 1858 to 1887, arrived in Denver in May 1888. His oil paint-
ing "Torchlight Procession" was inspired by the Benjamin Har-
rison Presidential parade in Denver, November 12, 1888. Mostly
he painted landscapes of a romantic nature.

Smith, Annie (–)
AAA 1917 (Chickasha, Oklahoma).

Smith, Camille (1892–)
B. Corsicana, Texas. Fisher.
Smith was a resident of Carlsbad, New Mexico, from 1906.

Smith, Charles L. A. (1871–1937)

B. New York. D. Los Angeles, California. Work: Laguna Beach Museum of Art; University of Maine Art Gallery; Lawrence (Massachusetts) Art Museum. AAA 1903–1910 (Chicago, Illinoia); AAA 1913–1919 (West Somerville, Massachusetts; Chicago); AAA 1923–1933 (Los Angeles; summer 1923–1924: Berkeley, California); Fielding; Mallett.

Smith was a member of Boston Art Club; California Art Club; California Water Color Club; Chicago Society of Artists, and Society of Western Artists. He was self-taught.

Smith. E. Bert (–)

AAA 1905–1906 (Denver, Colorado).

Smith was a cartoonist for Rocky Mountain *News* and a member of Denver Artists' Club. He exhibited six works at the Club's annual exhibition in 1900, according to a clipping in the Bromwell scrapbook, page 28.

Smith, Edwin James (1899–)

B. Omaha, Nebraska. AAA 1933 (Omaha); Havlice; Mallett; WWAA 1936–1941 (Omaha).

Smith, Elmer Boyd (1860–1943)

B. St. John, New Brunswick, Canada. D. Wilton, Connecticut. Work: William A. Farnsworth Library and Art Museum, Maine. AAA 1898–1900 (Boston, Massachusetts); AAA 1903–1908 (Cos Cob and Greenwich, Connecticut); AAA 1909–1933 (Wilton); Fielding; Mallett; WWWA; California State Library; Denver Public Library.

Smith, Ernest Browning (1866–1951)

B. Brimfield, Massachusetts. Work: Los Angeles Museum; San Francisco Museum of Art. AAA 1917–1933 (Los Angeles); Havlice; Mallett; WWAA 1936–1953 (Los Angeles).

Smith was a self-taught painter who specialized in landscapes.

Smith, George Washington (1879-1930)

B. East Liberty, Pennsylvania. AAA 1915-1929 (Santa Barbara, California); Fielding.

Smith studied at Harvard University School of Architecture, and in Rome and Paris. He was a member of the California Art Club and the Paris Association of American Artists.

Smith, Howard (Everett) (1885-1970)

B. West Windham, New Hampshire. D. Carmel, California, October 9. Work: Pennsylvania Academy of Fine Arts; Brown University; University of Nebraska; Crocker Art Gallery; North Adams (Massachusetts) Public Library. AAA 1917-1933 (Boston, Massachusetts; summer 1921-1933: Rockport, Massachusetts); Bénézit; Fielding; Havlice; Mallett; WWAA 1936-1937 (Boston; summer: Rockport); WWAA 1938-1941 (Rockport); WWAA 1947-1953 (Carmel); WWAA 1959-1962 (West Chester, Pennsylvania); California State Library.

Smith, Irwin Elwood (1893-)

B. Labette County, Kansas. Work: Kansas Federation of Women's Clubs; Boswell and Crane junior high schools, Topeka, Kansas; Stephenson School, Winfield, Kansas; National Headquarters Gallery, National Association of Retired Civil Employees, Washington D.C. AAA 1933 (Topeka); Havlice; Mallett; WWAA 1936-1956 (Topeka); WWAA 1959-1962 (Leesburg, Florida); Margaret E. Whittmore, "Some Topeka Artists," *Community Arts & Crafts,* December 1929, 19.

Smith, John Francis (-)

B. Chicago, Illinois. AAA 1900-1906 (Chicago); AAA 1919-1924 (Los Angeles, California); AAA 1925-1931 (Los Angeles; summer: El Cajon/Spring Valley, California); AAA 1933 (San Diego, California); Bénézit; Havlice; Mallett; WWAA 1936-1939 (St. Helen's Ranch, Spring Valley, near San Diego); WWAA 1940-1941 (West Los Angeles).

Smith, Katharine English (1899-)

B. Wichita, Kansas. AAA 1923-1929 (Wichita).

Smith studied with Sandzen, Charles Hawthorne, Robert Reid, and Emma M. Church. She was a member of Wichita Art Association and Smoky Hill Art Club.

Smith, Lillian B. (-)
AAA 1900 (Denver, Colorado); Bromwell, page 46.
Smith exhibited at the Eighth Annual Exhibition of the Denver Artists' Club.

Smith, Lillian Wilhelm (1882-1971)
B. New York City. Mallett Supplement (Phoenix, Arizona); H. M. Norton, "Lillian Wilhelm Smith, Southwestern Artist," *Progressive Arizona,* December 1932; Denver Public Library; Museum of Northern Arizona.

Smith is a niece of the novelist Zane Grey. She got her introduction to the West in 1913 when she illustrated his book *The Rainbow Trail.* Later she illustrated another book for him, *The Border Legion.*

Following marriage to Jesse Smith, a cowboy, Smith settled down to a lifetime of painting Indians and scenery in Arizona, and occasionally in bordering states. Much of her work comes from the Tuba City area where the Smiths operated a trading post and guest ranch. Later they established their business in the redrock country of Sedona.

Though well trained as an artist in New York and New Jersey schools, Smith did not pursue a career beyond the borders of Arizona. There she is well known as a landscape painter and designer of china. She was one of the first women to descend into Havasupai Canyon. Her paintings of the Havasupai Indians were used by the Heard Museum in Phoenix to illustrate a lecture on these Indians during the mid 1930s.

Smith, Linus Burr (1899-)
B. Minneapolis, Kansas. AAA 1933 (Manhattan, Kansas); Havlice; Mallett; WWAA 1936-1941 (Lincoln, Nebraska).

Smith, Margery Hoffman (1888-)
B. Portland, Oregon. AAA 1923-1933 (Portland); Havlice; Mallett; WWAA 1936-1941 (Portland); WWAA 1947-1953 (San Francisco, California); *Who's Who in Northwest Art.*

Smith, Marietta Riggs (-)
 Denver Public Library; McClurg.
 Smith lived in Colorado Springs, Colorado.

Smith, Paul Kauvar (1893-)
 B. Cape Girardeau, Missouri. Work: National Collection of
 Fine Arts. Havlice; Mallett Supplement; WWAA 1940-
 1973 (Denver, Colorado); Denver *Post Roundup,* February
 16, 1958, 16, interview with Anne Arneill; Denver Public
 Library.
 Smith, who settled in Denver in 1921, trained to be a cab-
 inet maker. Later he turned to full-time painting, mostly of Col-
 orado subjects, and since has become one of the state's best-
 known artists. By 1958 he had exhibited nationally and had had
 two solo exhibitions at the Denver Art Museum, one a showing of
 Colorado mining towns.
 Although Smith's preference is Colorado scenery and relics
 of the past, he also does still life and genre paintings. Still life and
 Mexican genre subjects were among the paintings shown at
 Chappell House in Denver in January 1948.

Snow, E. E. (-)
 AAA 1915 (Salt Lake City, Utah).

Somervell, W. Marbury (-)
 AAA 1917 (Seattle, Washington).
 Somervell was a Seattle architect who later established a
 firm in Los Angeles, California.

Sooy, Louise Pinkney (1889-1965)
 B. Blairstown, Iowa. D. California. Work: Oakland Mu-
 seum. AAA 1929 (Sawtelle, California; studio: Los
 Angeles); AAA 1931-1933 (Los Angeles); Havlice; Mallett;
 WWAA 1936-1941 (West Los Angeles).

Sorkner, E. (-)
 AAA 1915 (Seattle, Washington).
 Sorkner was a member of Seattle Fine Arts Society.

274

Souder, Mary Rinard (1879–)

B. Winchester, Indiana. AAA 1915 (San Francisco, California).

Southworth, Frederick W. (1860–1946)

B. Ontario, Canada. Work: Joselyn Memorial Museum; University of Iowa Memorial Union; Ferry Museum, Tacoma, Washington; Tacoma Public Schools. AAA 1923–1931 (Tacoma); AAA 1933 (Seattle, Washington); Bénézit; Havlice; Mallett; WWAA 1936–1941 (Tacoma); *Who's Who in Northwest Art.*

Spafard/Spaford, Myra B. (–)

B. Manchester, Michigan. AAA 1898–1906 (New York City); AAA 1907–1913 (Manchester); AAA 1915–1917 (Denver, Colorado; Manchester); AAA 1919–1931 (Detroit, Michigan; Manchester); Mallett.

Spafard studied at the Art Students' League and Teachers College in New York City. She was a member of New York Woman's Art Club.

Spalding, Elisabeth (c.1869–1954)

B. Erie, Pennsylvania. D. Denver, Colorado, May 20. Work: Denver Art Museum; Erie (Pennsylvania) Art Club; Morey Junior High School and Girls' Industrial School, Denver. AAA 1903–1910 (Denver); AAA 1913–1917 (Denver; summer: Monoach, Baileys Post Office, Colorado); AAA 1919–1933 (Denver); Bénézit; Fielding; Havlice; Mallett Supplement; WWAA 1936–1941 (Denver); Denver Public Library; Rocky Mountain *News,* May 20, 1954, obituary; *Episcopalian,* July 1954.

A Denver resident from age five, Spalding later became Colorado's best-known woman artist. She was one of the founders of the Denver Artists' Club and exhibited there regularly. During her long career she was given several solo exhibitions, including one in Stockholm comprised of water colors. She also worked in oil, and it was a Colorado landscape in that medium that was hung in 1928 at Societé Nationale de Beaux Arts in Paris.

Spalding studied with Arthur Wesley Dow in New York City where she became a member of a water color club. Her spe-

cialty was landscapes, and those she exhibited usually were in water color.

Spaulding, Grace (See: John, Grace Spaulding)

Spencer, Guy Raymond (1878–1945)
B. Jasper County, Missouri. AAA 1913–1917 (Florence, Nebraska); AAA 1919–1921 (Omaha, Nebraska); Bénézit; Mallett; WWWA.

Spencer was a cartoonist on the Omaha *World-Herald* from 1899 to 1902, and the Lincoln *Commoner* from 1902 to 1910. Further information is given in *Who's Who in America*, 1924–1925.

Spencer, Margaret Fulton (1882–)
B. Philadelphia, Pennsylvania. AAA 1915–1933 (New Hope, Pennsylvania); Bénézit; Fielding; Havlice; Mallett; WWAA 1936–1937 (New Hope); WWAA 1938–1947 (Tucson, Arizona; summer 1941: New Hope); WWAA 1953 (Tucson; Sweetwater Ranch, Santa Barbara); WWAA 1956–1962 (Tucson).

Spohn, Clay (Edgar) (1898–)
B. San Francisco, California. Work: San Francisco Museum of Art; Castro Valley (California) Community Center; murals, U.S. Post Offices in Montebello and Los Gatos, California. Havlice; Mallett Supplement; WWAA 1940–1947 (San Francisco); WWAA 1953–1959 (Taos, New Mexico); WWAA 1962 (New York City); San Francisco Public Library.

The San Francisco Museum of Art has three paintings and 52 drawings by Spohn.

Sprague, Elizabeth (–)
AAA 1915 (Fairmont College, Wichita, Kansas).

Spratt, Alberti/Alberte (1893–1950)
B. near Gilroy, California. D. Monterey, California, September 12. Work: murals, Orinda Country Club. Havlice; Mallett Supplement; WWAA 1940–1941 (Monterey, California; studio: Carmel, California); Monterey Public Library.

Spratt also was known as A. S. Lamb and Alberta Wilson Lamb.

Sprenkle, Arthur George (1881-)
B. Hanover, Pennsylvania. AAA 1921 (Pittsburgh, Pennsylvania); Havlice; WWAA 1938-1941 (Los Angeles, California).

Stacey, Anna Lee (-1943)
B. Glasgow, Missouri. D. Pasadena, California, March 4. Work: Santa Fe Collection; Chicago Woman's Club; Kenwood Club, Chicago; Union League Club, Chicago; Chicago Art Commission. AAA 1898-1933 (Chicago, Illinois); Fielding; Havlice; Mallett; WWAA 1936-1939 (Chicago); WWAA 1940-1941 (Pasadena); WWWA.
Stacey painted at the Grand Canyon about 1915.

Stacey, John Franklin (1859-1941)
B. Biddleford, Maine. D. February 3. Work: Union League Club, Chicago; Chicago Art Commission; Herron Art Institute; Museum of Fine Arts, Santiago, Chile. AAA 1898-1933 (Chicago, Illinois); Bénézit; Fielding; Havlice; Mallett; WWAA 1936-1939 (Chicago); WWAA 1940-1941 (Pasadena, California); WWWA.

Stair, Ida M. (1857-1908)
B. Logansport, Indiana. D. Denver, Colorado, March 27. AAA 1903-1910* (Denver); Bénézit; Mallett; Denver Public Library.
Stair was art instructor for the Denver Woman's Club art students' class. She had studied with William Merritt Chase and others, and is best known for her sculpture. She was a member of Denver Artists' Club.

Staley, Willie Anna (c.1865-)
B. Sedalia, Missouri. Boise Public Library.
Staley was a resident of Idaho from childhood. She taught painting in Pocatello. During her later years she lived in Boise and Blackfoot, Idaho.

Stanley, George (-)

AAA 1900 (Denver, Colorado). Work: Museum of New Mexico; Eisenhower Museum, Abilene, Kansas. AAA 1900 (Denver, Colorado); Robertson and Nestor; Denver Public Library; Bromwell Scrapbook, pages 19, 21.

The mysterious Stanley established a studio in Santa Fe, New Mexico, in 1897, and painted New Mexico subjects. His painting "Tesuque" is in the Eisenhower Museum. It may be the same painting Stanley exhibited in 1900 at the Denver Artists' Club exhibition when he was living in Denver.

The previous year Stanley exhibited paintings from a trip made earlier into the region of the Utes. They were entitled "Going Into Camp" and "In the Ute Country," and were described as carefully executed. It was anticipated by the reviewer that they would "no doubt become favorites with the Denver public, as they [dealt] exclusively with the Ute Indians."

Whether Stanley and Charles St. George Stanley (*Artists of the American West*, Swallow Press, 1974) are the same person has yet to be determined with certainty. The prevailing view that he is, is supported by research now in progress.

Stanton, Lucy May/Mary (1875-1931)

B. Atlanta, Georgia. D. May 19. Work: Concord (Massachusetts) Art Association; Lincoln Memorial Museum, Milton, Massachusetts; Emory University Library; National Capitol, Washington, D.C. AAA 1903 (New York City); AAA 1905-1906 (Los Angeles, California); AAA 1907-1917 (Athens, Georgia); AAA 1919 (Athens; Baltimore, Maryland); AAA 1921-1925 (Boston, Massachusetts; summer: Ogunquit, Maine); AAA 1927-1929 (Boston; Athens); Bénézit; Fielding; Havlice; Mallett; WWWA.

Starkey, Jo-Anita (1895-)

B. Gresham, Nebraska. Havlice; WWAA 1953-1962 (Los Angeles, California).

Starr, Katharine Payne (1869-)

B. Kansas City, Missouri. Havlice; Mallett Supplement; WWAA 1938-1941 (Hollywood, California); *Who's Who on the Pacific Coast*, 1947.

Stedman, Wilfred Henry (1892-1950)

B. Liverpool, England. D. probably Santa Fe, New Mexico, November 17. AAA 1933 (Houston, Texas); Havlice; Mallett; WWAA 1936-1953* (Santa Fe); Ina Sizer Cassidy, "Art and Artists of New Mexico," *New Mexico Magazine*, February 1936, 24, 46-47.

Stedman's 30 years in the West began in Colorado Springs where he studied landscape and figure painting with John Carlson and Robert Reid at Broadmoor Art School. He then became its director of industrial art. He also taught two years at the School of Art for Disabled Soldiers.

From Colorado Springs, Stedman moved to Houston for ten years, and then to Santa Fe. He was on the Staff of *New Mexico Magazine*, first as an illustrator and then as its art editor. During his stay in Houston and in Santa Fe he did many easel paintings and exhibited regularly. He had a particular interest in adobe dwellings for their architecture as well as for their picturesque and paintable qualities. Himself an architect, Stedman designed a number of small adobe homes for Santa Feans.

Steele, Albert Wilbur (1862-1925)

B. Malden, Illinois. D. March 12. Work: Denver Public Library. AAA 1905-1913 (Denver, Colorado); WWWA; Denver Public Library.

Steele was on the staff of the Denver *Post* as a cartoonist from 1897. Previously he had been seven years with the Rocky Mountain *News*. He studied art in Denver with J. Harrison Mills.

Stensen, Matthew Christopher (1870-)

B. Norway. Work: East Bay Art Association, Oakland, California. Havlice; Mallett Supplement; WWAA 1936-1941 (Richmond, California).

Stephens, Clara Jane (-)

AAA 1913-1933 (Portland, Oregon); Bénézit; Havlice; Mallett; WWAA 1936-1941 (Portland); *American Magazine of Art*, June 1927, 331.

Stephens was one of several women artists selected to serve on the Panama-Pacific International Exposition's Advisory Committee for the West.

Sterba, Antonin (1875–)

B. Hermanec, Czechoslovakia. Work: State Museum, Springfield, Illinois; Northwestern University; De Pauw University; National Collection of Fine Arts; Baylor University. AAA 1900–1933 (Chicago and Evanston, Illinois); Fielding; Havlice; Mallett; WWAA 1936–1962 (Chicago).

Sterchi, Eda Elisabeth (1885–)

B. Olney, Illinois. AAA 1917–1921 (Olney); AAA 1923–1925 (Olney; summer: Paris, France); AAA 1927–1933 (Olney; summer: Tunis, Tunisia); Havlice; Mallett; WWAA 1938–1939 (Phoenix, Arizona; summer: Tunis); WWAA 1940–1962 (Phoenix; Olney).

Sternfeld/Sternfield, Edith A. (1898–)

B. Chicago, Illinois. AAA 1931–1933 (Grinnell, Iowa); Bénézit; Havlice; Mallett; WWAA 1936–1962 (Grinnell).

Stetson, Katherine Beecher (1885–)

B. Providence, Rhode Island. AAA 1913 (Rome, Italy); AAA 1915–1919 (New York City); AAA 1921–1933 (Pasadena, California); Fielding; Havlice; Mallett; WWAA 1936–1962 (Pasadena).

Stetson also is known as Mrs. F. Tolles Chamberlin.

Stevens, Esther (1885–)

B. Indianapolis, Indiana. AAA 1917 (Berkeley, California); AAA 1919 (Monterey, California); AAA 1921–1924 (San Diego, California); Fielding.

Stevens was a pupil of Robert Henri and a member of San Diego Art Guild. She was known also as Mrs. Walter T. Barney.

Stevens, Helen B. (1878–)

B. Chicago, Illinois. Work: National Collection of Fine Arts. AAA 1907, 1913 (Chicago); AAA 1915–1924 (Pittsburgh, Pennsylvania); AAA 1925–1933 (Chicago); Fielding; Havlice; Mallett; WWAA 1936–1941 (Santa Fe, New Mexico); Santa Fe Public Library.

Stevens was etching instructor and assistant curator of prints at the Art Institute of Chicago from 1909 to 1912.

Stevens, Kelly Haygood (1896–)

B. Maria, Texas. AAA 1931–1933 (Mexia); Havlice; Mallett Supplement; WWAA 1936–1947 (Mexia); WWAA 1953–1962 (Austin, Texas); O'Brien.

A favorite theme of Stevens' work is the Indian ceremonial and dance. His long interest in these events inspired some of his best canvases, according to O'Brien.

Stevens exhibited widely in this country and abroad, and has had many solo exhibitions. Before turning exclusively to painting, he taught art for eight years at New Jersey School for the Deaf. His own art study began at Texas School for the Deaf, followed by Gallaudet College in Washington, D.C. where he received his B.A. His M.A. is from Louisiana State University.

Stevens, Lawrence Tenney (1896–1972)

B. Brighton, Massachusetts. Work: Brooklyn Museum; University of Pennsylvania; Scripps College; Central High School and Chamber of Commerce, Tulsa, Oklahoma. AAA 1925 (Brighton, Massachusetts); AAA 1927 (Mt. Kisco, New York); AAA 1929 (New York City; summer: Bedford Village, New York); AAA 1931–1933 (Bedford Hills, New York); Bénézit; Havlice; Mallett; WWAA 1936–1939 (Bedford Hills); WWAA 1940–1941 (Horse Head Ranch, Ishawoca, Wyoming); WWAA 1947–1956 (Tulsa, Oklahoma); WWAA 1959–1962 (Tempe, Arizona); Denver Public Library; M. Barr.

Stevens, Ruth Tunander (1897–)

B. Calumet, Michigan. Havlice; Mallett Supplement; WWAA 1938–1947 (Seattle, Washington); *Who's Who on the Pacific Coast*, 1947; *Who's Who in Northwest Art*.

Stevens, Stanford (1897–)

B. St. Albans, Vermont. Work: Wood Gallery of Art, Montpelier, Vermont; Rockland (Maine) Art Gallery; IBM. Havlice; Mallett Supplement; WWAA 1936–1939 (Nantucket, Massachusetts); WWAA 1940–1941 (Carmel, California; studio: Nantucket); WWAA 1947 (Tucson, Arizona); WWAA 1953 (Sasabe, Arizona; summer: Guanajato, Mexico); WWAA 1956–1962 (Mexico).

Stevens, Will Henry (1881–)

B. Vevay, Indiana. Work: Oklahoma University; J. B. Speed Memorial Museum; Delgado Museum; Richmond (Indiana) Art Gallery; IBM. AAA 1905–1906 (Cincinnati, Ohio); AAA 1907–1910 (Vevay and New Albany, Indiana); AAA 1915 (Vevay; Louisville, Kentucky); AAA 1917 (New York City and Vevay); AAA 1919 (Chicago and Vevay); AAA 1921–1933 (New Orleans, Louisiana; summer 1933: San Angelo, Texas); Fielding; Havlice; Mallett; WWAA 1936–1941 (New Orleans; summer: Gatlinberg, Tennessee); WWAA 1947–1953 (New Orleans); *The Art Digest,* July 1928, 17.

Stevens was in Texas earlier than indicated by the Art Annual, for during the summer of 1928 he was teaching at the Texas Artists' Camp in Cristoval.

Stewart, Dorothy N. (1891–)

B. Philadelphia, Pennsylvania. Work: Museum of New Mexico. Fisher; Elizabeth Willis DeHuff, " 'D.N.S.' Sketch of a Kindly Satirist," *New Mexico* Magazine, November 1934, 24, 52.

Stewart, who signed her work "DNS," was described by DeHuff as a quiet, though colorful, figure. With her tiny Austin, converted by a blacksmith and carpenter into a covered "wagon," Stewart found her subjects in New Mexico and in Mexico where she occasionally spent winter months. She settled in Santa Fe in 1925.

Stewart, Worth (–)

AAA 1913 (Butte, Montana).

Stimson, John Ward (1850–1930)

B. Paterson, New Jersey. D. Corona, California, June 11. AAA 1905–1910 (New York City); AAA 1913–1917 (Redding, Connecticut); AAA 1919–1930* (Corona, California); Bénézit; Fielding; Mallett; WWWA; *The Art Digest,* June 1930, 16.

Stimson also lived in Riverside, California. He was a writer, lecturer, and instructor as well as a landscape painter. By 1918 he had written three books on art education.

Stinchfield, Estelle (1878-1945)

B. Brownville, Colorado. D. Boulder, Colorado, October 30. Work: Denver Public Library Western History Collection; Guggenheim Hall, Colorado State College of Education, Greeley. Havlice; Mallett; WWAA 1936-1941 (Greeley); Denver Public Library.

A mural entitled "The Coming of Water to the Uplands" at the State College in Greeley stands as a monument to Stinchfield's artistic ability. For this major undertaking she studied documents and books relating to Greeley's pioneer history, including the development of irrigated agriculture.

Described as "a fine sensitive colorist," Stinchfield passed on her technique to hundreds of students, many of them teachers. She began teaching in Denver schools after returning from Minnesota where she had spent her girlhood. She moved to Greeley in the mid-1930s, and later to Boulder. Many of her easel paintings are of the Colorado Rockies.

Stinson, Lucile S. (1898-)

B. Nebraska. Mallett Supplement; Fisher; Denver Public Library; *Western Artist,* June 1934, 6.

Prior to moving to Alamogordo, New Mexico, in 1945, Stinson lived in Denver, Colorado, where she became a charter member of Denver Artists' Guild, founded in 1928. She painted at Yellowstone National Park for at least two summers during vacations in the early 1930s.

Stockton, Pansy (c.1894-1972)

B. Eldorado Springs, Missouri? D. Colorado Springs, Colorado. Work: Museum of New Mexico. Mallett Supplement; Fisher; *New Mexico* Magazine, March 1951, 27; *Desert* Magazine, April 1947, 13; *Western Artist;* December 1934, 7; "Pansy Stockton—The Sun Painter," *The Santa Fe Scene,* June 7, 1958, 4-8; Santa Fe Public Library.

Stockton created her first sun paintings in 1916. At that time she was living in Durango, Colorado, where she had been working in water color and oil. Experimentation with the palette knife technique led to the now famous and highly prized sun paintings.

Using bark, moss, leaves and other flora, Stockton created

landscapes that brought national recognition in the early 1950s when she appeared on the Ralph Edwards "This Is Your Life" show. At that time she was a well-established Santa Fe artist with a significant local reputation. She had moved from Denver to Santa Fe about 1940.

Stockton, who had been adopted into the Sioux nation and given the name Wanashta Wastaywin, was especially interested in Indians and their culture and had acquired a remarkable collection of their arts and artifacts. She may even have been Indian or partly Indian, for some Santa Feans maintain she was born on an Indian Reservation in Oklahoma, not in Missouri.

Stojana, Gjura (1885–) (See: Stanson, George C.)
Artists of the American West, Swallow Press, 1974.

Stone, George Melville (1858–1931)
B. Topeka, Kansas. D. Topeka, November 2. Work: Topeka Public Library; Kansas State Historical Society. AAA 1907–1910, 1915 (Topeka); Mallett; C. A. Seward, "George Melville Stone, the Millet of the Prairies," *Kansas* Magazine, August 1909, 1–5; Margaret E. Whittmore, "Some Topeka Artists," *Community Arts & Crafts,* December 1927, 19; Kansas City *Times,* November 3, 1931, crediting the Kansas City *Star's* Topeka Bureau for an article captioned "George M. Stone Dead."

Although more widely known for his portraits of prominent persons, Stone is to Kansans "the Millet of the Prairies" for his paintings immortalizing the Western farmer. He was also a muralist whose work is in Grace Cathedral and the State House in Topeka, and in Mission Inn, Riverside, California.

Stone, who studied primarily in France, was an impressionist. One of the distinguishing features of his work is his use of light. He depicted all manner of atmospheric conditions, "from the fierce heat of a noon-day sun" in the cities of Mexico, "to the cooling breezes in the shadows of the forests of Fontainebleau," wrote Seward, another Kansas artist.

Stone, Viola Pratt (1872–1958)
B. Omaha, Nebraska. D. Long Beach, California. AAA

1929-1933 (Long Beach); Havlice; Mallett; WWAA 1936-1953 (Long Beach).

Stover, Allan James (1887-)
B. West Point, Mississippi. AAA 1919-1933 (Corvallis, Oregon; studio 1927-1929: Point Loma, California); Fielding; Havlice; Mallett; WWAA 1936-1941 (Corvallis).

Stowitts, Hubert J. (1892-)
B. Rushville, Nebraska. Havlice; Mallett; WWAA 1936-1941 (Hollywood and Los Angeles, California).

Strahalm/Strahaln, Frank/Franz S. (1879-1935)
B. Vienna, Austria. D. Dallas, Texas, March 3. Work: Memorial Library, Shreveport, Louisiana. AAA 1923-1933 (Dallas); Havlice; Mallett; WWAA 1936-1937*; O'Brien.
Strahalm was active in Texas from 1911, living first in San Antonio, then in Houston. He moved to Dallas in the early 1920s.

Strater, Henry (1896-)**
B. Louisville, Kentucky. Work: Portland Museum of Art; Kentucky Museum, Louisville; J. B. Speed Art Museum; Bowdoin College Museum; Ogunquit Museum; IBM. AAA 1929-1931 (New York City; summer: Ogunquit, Maine); AAA 1933 (Ogunquit); Havlice; Mallett; WWAA 1936-1941, 1953-1976 (New York; Ogunquit, Maine); Howard Devree, "Seeing the Exhibition," *American Magazine of Art*, December 1936, 830; "From a Portfolio of Nudes by Henry Strater," *American Artist*, March 1962, 34-39, 59-61; *American Artist*, May 1972, 42.
When Strater set out to paint the West's regional qualities in the mid 1930s, he sought to depict them without sentimentality. "He has looked on the great open spaces and called them good," wrote Devree, "and he has made his vision appeal to all who can understand."
The success of Strater's Western work did not fade with time, for he is now credited with having done for the Far Western states what Burchfield, Hopper, and Sheeler have for the Eastern and Central states. Strater attributes the success of his landscapes to his liking for the outdoors, a condition he deems essential to all good landscape painting.

285

Streator, Harold Arthur (1861-1926)

B. Cleveland, Ohio. D. Pasadena, California. AAA 1898-1903 (Cleveland); AAA 1905-1908 (Morristown, New Jersey); AAA 1909-1915 (Cleveland); AAA 1917-1921 (Morristown); AAA 1923-1927 (Pasadena, California; studio: Morristown); Fielding; Mallett.

Streator studied at Art Students' League and Boston Museum School. He was a member of the Salmagundi Club from 1906.

Streight, Howard A. (1836-1912)

D. San Jose, California. Work: Denver Public Library Western History Collection. AAA 1913*; Bénézit; Mallett; Maturano; Denver Public Library.

Best known for his painting "Cross on the Mountain," Streight painted landscapes for Kansas Pacific Railroad. He had been in California prior to making his home in Denver where he had gone for his health in 1870. Thereafter much of his time was spent holding seances in his darkened studio while supposedly painting under spiritual guidance. While the lights were off, he substituted a wet painting for the blank canvas he had displayed to his audience. He left Denver in 1890.

Stringfield, Vivian F. (c.1882-1933)

B. California. AAA 1919-1933 (Los Angeles, California); Fielding; Mallett.

Stringfield was a member of Southern California Art Teachers' Association.

Stuber, Dedrick Brandes (1878-)

B. New York. Work: National Collection of Fine Arts; Pasadena Art Museum. AAA 1913 (Woodside, Long Island); AAA 1923-1933 (Los Angeles, California); Fielding; Havlice; WWAA 1936-1941 (Los Angeles).

A painting in a private collection entitled "Silver Mining in Southern California" is thought to have been done about 1915. If so, this places Stuber in Southern California earlier than indicated in the Art Annual.

Sutter, Samuel (1888-)

B. San Francisco, California. California State Library; *The Argonaut,* April 16, 1927, 13.

Sutter was a sign painter who lived in San Francisco and the San Joaquin Valley. With encouragement from Maynard Dixon, he painted landscapes, primarily in Marin and Monterey counties.

Svoboda/Swoboda, Josef Cestmir (1889-)

B. Smichov-Prague, Czechoslovakia. Work: John Toman Public Library, Chicago. AAA 1927-1929 (Berwyn, Illinois; summer: Taos, New Mexico); AAA 1931-1933 (New York City); Bénézit; Havlice; Mallett; WWAA 1938-1941 (New York City; summer: Taos); WWAA 1947-1953 (Dallas, Texas).

Swartz, Harold C. (1887-)

B. Marcial, New Mexico. Work: Los Angeles County Art Museum. AAA 1923-1933 (Los Angeles, California); Havlice; Mallett; WWAA 1936-1941 (Los Angeles).

Swift, Florence Alston Williams (1890-)

B. San Francisco, California. Work: University of California; Mills College; San Francisco Museum of Art. AAA 1919-1924, as Williams (San Francisco; summer: Monterey, California); Havlice; Mallett Supplement; WWAA 1938-1962 (Berkeley, California); San Francisco Public Library.

T

Tadama, Fokko (1871-1937)

B. Bandar, India. D. Seattle, Washington, May 23. Work:

San Francisco Art Museum; New Royal Theatre, Victoria, B.C.; Press Club and Industrial Exhibition Building, Seattle. AAA 1915–1924 (Seattle); Bénézit; Fielding; Mallett; *Who's Who in Northwest Art.*

Tait, Agnes Gabrielle (1894–)
B. New York City. Work: National Collection of Fine Arts; New York Public Library; Metropolitan Museum of Art; Museum of New Mexico; Library of Congress. AAA 1915–1919, 1931 (New York City); Havlice; Mallett; WWAA 1936–1937 (New York City; summer: Bedford Village, New York); WWAA 1938–1941 (Providence, Rhode Island); WWAA 1947–1962 (Santa Fe, New Mexico); Santa Fe Public Library; *New Mexico* Magazine, April 1952, cover illustration.

Tait has lived in Santa Fe much of the time since 1941. In private life she is Mrs. William McNulty.

Talberg, Carl H. (1882–1973)
B. Romsdal, Norway. D. Ogden, Utah, April 21. Stuart.

Talberg lived in this country from 1889. He was in Waubay, South Dakota, by 1910 and in Ogden by 1942. He studied at Minneapolis Institute of Arts and specialized in wildlife painting.

Talbot, Catherine (–)
AAA 1900 (Portland, Oregon).

Tamotzu, Chuzo (1891–1975)
B. Kagoshima, Japan. Work: Metropolitan Museum of Art; National Collection of Fine Arts; Hirshhorn Gallery; Museum of New Mexico. AAA 1933 (New York City); Havlice; Mallett; WWAA 1936–1941 (New York City); Denver Public Library; Elena Montes, "Art and Artists of New Mexico," *New Mexico* Magazine, January 1967, 33, 36.

Tamotzu settled in Santa Fe, New Mexico, in 1948.

Tanaka, Yasushi (1886–)
B. Tokyo, Japan. AAA 1915–1924 (Seattle, Washington); Bénézit; Mallett; *Who's Who in Northwest Art.*

Tanaka was active in France until 1927. On the occasion of his departure for Paris in 1920, he was given a solo exhibition in Seattle where he was a member of Seattle Fine Arts Society.

Tanberg, Ella Hotelling (1862–1928)
B. Janesville, Wisconsin. D. Hollywood, California, April 6. Work: Janesville Art League. AAA (Chicago; summer: Lake Geneva, Wisconsin); AAA 1919 (Los Angeles; summer: Lake Geneva); AAA 1921–1929* (Hollywood and Laguna Beach, California). Fielding; Mallett.
Tanberg was a member of Janesville Art League, California Art Club, and Laguna Beach Art Association.

Tapp, Marjorie Dodge (–)
AAA 1917–1927 (Shawnee, Oklahoma).
Tapp was a member of Oklahoma Art Association.

Tatum, Edward H. (1879–)
B. Cleveland, Ohio. Fisher.
Tatum settled in Santa Fe, New Mexico, in 1939.

Tauszky, David Anthony (1878–)
B. Cincinnati, Ohio. Work: Denver Art Museum; Wingate School, New York City. AAA 1905–1910 (New York City); AAA 1913–1917 (New York; summer: Budd Lake, New Jersey); AAA 1919–1924 (Hollywood, California; summer: Budd Lake); 1925–1933 (Pasadena, California; studio 1931–1933: New York City; summer 1925–1927: Budd Lake); Bénézit; Havlice; Mallett; WWAA 1936–1937 (New York City); WWAA 1938–1941 (Pasadena and Altadena, California; studio: New York City).

Taylor, Edward De Witt (1871–)
B. Sacramento, California. Work: San Francisco Museum of Art. Havlice; Mallett Supplement; WWAA 1938–1941 (San Francisco, California); *Who's Who on the Pacific Coast*, 1947; California State Library.
Taylor has painted such rural California landmarks as "In the Carmel Valley—Old Martin Barn."

Taylor, Minnie C. (1865–)

B. Bangor, Maine. AAA 1915 (San Francisco, California).

Taylor, who exhibited two paintings at the Panama-Pacific International Exposition, studied in New York, Boston, Chicago, San Francisco, London, Munich, and Paris.

Taylor, Rolla S. (1874–)

B. Galveston, Texas. AAA 1923–1924 (San Antonio, Texas; summer: Chicago, Illinois); AAA 1925–1933 (San Antonio); Bénézit; Mallett; WWAA 1936–1941 (San Antonio); O'Brien.

Taylor, whose academic education was in law, established himself as a landscape painter in the early 1920s. He sketched in France and Holland. While living in San Antonio he painted the old missions and other remnants of the past, and he also painted in Mexico.

Taylor, Will/William Ladd (1854–1926)

B. Grafton, Massachusetts. D. December 26. AAA 1905–1927* (Wellesley, Massachusetts); Bénézit; Fielding; Mallett; WWWA; Earle; California State Library.

Taylor traveled extensively during his long career as a painter and an illustrator. He spent one year in Colorado where he painted several Rocky Mountain scenes while recuperating from an illness.

Teesdale, Christopher Hugh (1886–)

B. Eltham, Kent, England. Work: Cleburne Public Schools; Fort Worth Public Schools; Masonic Temple, Cleburne. AAA 1923–1933 (Cleburne, Texas); Bénézit; Havlice; Mallett; WWAA 1936–1941 (Cleburne); O'Brien.

By profession a civil engineer, Teesdale began in the early 1920s to establish himself as an artist. His training had begun at an early age when he studied with an uncle by the same name. In 1920 he returned briefly to England for further study.

Much of Teesdale's work has been done in the southwestern section of Johnson County, Texas. He was also a portrait painter. He exhibited with Southern States Art League, Texas Fine Arts Association, and Cleburne Art Association of which he was a founder.

Before moving to Texas, Teesdale lived in Eastern Washington and California. Information about him does not indicate that he did any painting in those states.

Teichert, Minerva Kohlhepp (1889-)

B. Ogden, Utah. Work: State Capitol, Cheyenne, Wyoming; State Capitol, Boise, Idaho; South High School and Hotel Utah, Salt Lake City; Havlice; Mallett Supplement; WWAA 1936-1941 (Cokeville, Wyoming); *Who's Who in Northwest Art*; M. Barr; Boise Public Library.

Before moving to Cokeville, Teichert lived in Idaho. She studied at the Art Institute of Chicago and at the Art Students' League. Among her teachers at ASL was Robert Henri, who became a lifetime friend.

Despite the remoteness of Cokeville and the busy life of a rancher's wife, Teichert had a successful career. The remoteness of that region is reflected in her Western subjects, giving them an authenticity that comes with long familiarity.

Teichert had the honor of being one of five Wyoming artists whose work was selected for the First National Exhibit of American Art at Rockofeller Center in 1936.

Temple, C. M. (-)

AAA 1915 (Salt Lake City, Utah).

Temple's address is listed as "The Salt Lake Route, Judge Building, Salt Lake City."

Terry, Eliphalet (1826-1896)

B. Hartford, Connecticut. Work: Wadsworth Atheneum, Hartford. Fielding Addendum, 1974; Groce and Wallace; Stuart; *Kennedy Quarterly*, October 1962, 102.

Terry and William Jacob Hays were together on a sketching trip along the Missouri River in 1860. Both were animal and landscape painters. Terry had a studio in Hartford until 1851, and thereafter in New York City. He exhibited at American Art Union and National Academy of Design. His "Indian Encampment Near the Upper Yellowstone," an oil, is shown in the *Kennedy Quarterly*.

Terry, John Coleman (1880-1934)

B. San Francisco, California. D. Coral Gables, Florida,

February 27. Havlice; Mallett Supplement; WWAA
1936–1937*.

In 1900 Terry began working for the San Francisco *Call* as
an illustrator.

Theiss, John William (1863–)
 B. Zelionople, Pennsylvania. AAA 1917–1927 (Los
 Angeles, California; summer: Mt. Wilson, California);
 AAA 1929–1933 (Springfield, Ohio); Fielding; Mallett;
 WWWA (Portland, Oregon, 1889–1893; Santa Rosa, Cali-
 fornia, 1894–1904, and then Los Angeles).
 Theiss studied with Lorenzo Latimer and Anthony Ander-
son. He was a member of Springfield Art League.

Theobald, R. C. (–)
 AAA 1917–1919 (Los Angeles, California.
 Theobald was a member of the California Art Club.

Thoma, Eva (–)
 AAA 1917 (Norman, Oklahoma).

Thomas, Alice Blair (–)
 B. Collingwood, Ontario, Canada. AAA 1917–1924 (Holly-
 wood and Los Angeles, California); Havlice; California
 State Library.
 Prior to moving to California, Thomas was active from
1897 to 1916 in Canada. She specialized in water colors for about
20 years, then turned to oils.

Thomas, D. F. (–1924)
 B. Aix-la-Chappelle/Aachen, Germany. AAA 1898–1900
 (New York City); AAA 1925–1926* (Baldwin Park, Cali-
 fornia); Mallett.
 Thomas studied with his father at Dusseldorf Academy.
He also studied in Brussels and Rome. He was a member of Cali-
fornia Society of Miniature Painters, and he had won awards in
California in 1915 and 1916 when he exhibited at the San Diego
Exposition.

Thomas, Helen Haskell (–)
 B. Marysville, California. *Who's Who in California,* 1943.

Prior to marrying Stephen Seymour Thomas in 1892, the artist lived in San Francisco. Thereafter they lived mainly in Paris, New York City, and La Crescenta, California. Thomas does not appear to have been active after 1897 when she exhibited in Paris.

Thomas, Marian (1899–)

B. Sulphur Spring, Texas. Mallett Supplement; Fisher; O'Brien.

According to O'Brien, Thomas was the first art major of Southern Methodist University. Later she studied with Bert Phillips in Taos where she lived for a number of years beginning in 1928 She also studied at Broadmoor Art Academy in Colorado Springs. Her work is in public buildings in Wichita Falls, Texas, where she lived for some time after reaching age 11. She is also known as Mrs. W. E. Sanford.

Thomas, Marjorie Helen (1885–1978)

B. Newton Center, Massachusetts. D. Mesa, Arizona, April 1. Work: Santa Fe Collection; Scottsdale (Arizona) City Hall; Governor's office, Phoenix, Arizona. AAA 1925 (Scottsdale); Fielding; Havlice, Mallett Supplement; WWAA 1936–1941 (Scottsdale); Richard E. Lynch, Scottsdale City Historian; Maggie Wilson, "Scottsdale 'Character' Paints Tales of Old-time Phoenix," Arizona *Republic*, September 12, 1975; Mary Leonhard, "Artist Painted Her Memories," Arizona *Republic*, October 17, 1976; Joseph Stacey, "Make Room for Western Art!" *Arizona Highways*, October 1976, 11.

Thomas had just graduated from the Boston Museum of Fine Arts School when she moved to Scottsdale in 1909 with her mother and very ill brother. After nearby Paradise Valley was opened to homesteads, she and her brother each developed 160 acres. He lived six more years than the two months he was given, and she lived there or in Scottsdale the rest of her life, except for part of the fifties and sixties when she was in Fitchburg, Massachusetts.

Wherever Thomas lived, she painted. In later years much of her painting was done from memory and early photographs.

But taken altogether, her output over the years represents much that is no longer here to see.

When Thomas moved to Scottsdale it was no more than a stagecoach stop. When she died it was a bulging metropolis adjoining a somewhat less congested Paradise Valley. "Old Maud," the mule that belonged to Chaplain Winfield Scott, the city's founder, hangs behind the Mayor's desk in City Hall. Elsewhere, the Riggs Ranch in South Dakota, which Thomas painted, is under the lake at Oahe Dam, but preserved on canvas and on paper. And so are innumerable ranch scenes in Paradise Valley, and street scenes in Boston.

During September 1975, when Thomas was 90, the Scottsdale Historical Society presented 99 oils, water colors, and drawings in the Mezzanine Gallery of the Scottsdale Public Library.

Thomas, Stephen Seymour (1868–1956)**

B. San Augustine, Texas. D. La Crescenta, California, February 29. Work: National Collection of Fine Arts; Metropolitan Museum of Art; Albright Gallery of Art; Los Angeles County Art Museum. AAA 1898 (San Antonio, Texas); AAA 1900 (Paris, France); AAA 1905–1921 (New York City and Paris); Bénézit; Fielding; Havlice; Mallett; WWAA 1936–1941 (Los Angeles and La Crescenta); WWWA; O'Brien; Pinckney.

Thomas was a portrait and genre painter. He did some landscape work and considerable outdoor sketching in Texas, California, New York, France, and Holland. After moving to Southern California he continued to work long after he ceased to be in *Who's Who in American Art.*

A painting entitled "Old Mission San Jose," exhibited in New Orleans when Thomas was sixteen, first brought his work to public attention.

Thompson, Hannah (1888–)

B. Philadelphia, Pennsylvania. AAA 1919–1927 (Pasadena, California); Fielding.

Thompson, who studied with William Merritt Chase, was a member of California Art Club and California Society of Etchers.

Thompson, Thomas Hiram (1876–)

B. San Francisco, California. AAA 1905–1906 (Spokane, Washington); AAA 1907–1908 (Mullan, Idaho).

This self-taught artist won gold medals for oil, water color, and pastel at the Interstate Art Exposition in Spokane in 1902 and 1903. Thompson was a member of Spokane Art League. His address at Mullan was listed "c/o Snowstorm Mine."

Thomson, Adele Underwood (1887–)

B. Grosbeck, Texas. Havlice; WWAA 1947–1959 (Corpus Christie, Texas); Collins.

Thorndike, Willis Hale (1872–1940)

B. Stockton, California. D. Los Angeles, California, March 18. AAA 1913 (Stockton); Mallett Supplement; WWWA.

Thorndike, who studied in San Francisco, New York City, and Paris, began his career in 1890 as an artist for the San Francisco *Chronicle*. He is better known as a cartoonist.

Thurston, Jane McDuffie (1887–1967)

B. Ripon, Wisconsin. D. Pasadena, California. Work: Pasadena Art Institute. AAA 1923–1924, listed McDuffie (Pasadena; summer: Paris, France); AAA 1925–1933 (Pasadena); Havlice; Mallett; WWAA 1936–1962 (Pasadena; summer 1940–1941: Skyforest, California); *Who's Who in California*, 1943.

Tietjens, Marjorie Hilda Richardson (1895–)

B. New Rochelle, New York. Fisher; Theron Marcos Trumbo, "Her Canvases are Windows," *Desert* Magazine, March 1950, 21–23; *New Mexico* Magazine, December 1962, 17.

Tietjens, who grew up in England, showed talent in drawing at age five, and at age 12 entered the Royal Drawing Society. Later she studied at the British Academy in Rome. Following marriage she returned to New York where she did portraiture.

After the death of her husband she visited cousins in New Mexico and liked the area so well she made Las Cruces her home in 1943. Since then she has specialized in Western subjects. She usually sketches in pencil, but sometimes in oil, and she com-

pletes her paintings at her studio. She told Trumbo that she probably spent more time studying Western skies in preparation of her paintings than any other aspect of the New Mexican scene. At the time of the interview she was planning a series of ranch life paintings depicting different stages of the roundup.

Tillotson, Alexander (1897–)
B. Waupun, Wisconsin. Work: Milwaukee Art Institute; Mulvane Art Center, Topeka. AAA 1923–1924 (Milwaukee, Wisconsin); AAA 1925 (Waupun); AAA 1927 (Wauwatosa, Wisconsin); AAA 1929–1933 (Milwaukee); Havlice; Mallett; WWAA 1936–1941 (Milwaukee); WWAA 1947–1959, 1966 (Topeka, Kansas).

Timmerman, Walter (–)
AAA 1917 (Kansas City, Kansas).

Timmons, Edward J. Finley (1882–1960)
B. Janesville, Wisconsin. D. January 31. Work: University of Chicago; University of Arkansas; University of Illinois; Beloit College; Janesville Art League; San Diego Museum of Fine Arts; State Capitol, Cheyenne, Wyoming. AAA 1909–1933 (Chicago); Bénézit; Fielding; Havlice; Mallett; WWAA 1936–1941 (Chicago); WWWA (Evanston, Illinois; studio: Carmel, California); *Who's Who on the Pacific Coast.*

Tingley, Blanche (–)
AAA 1915 (San Francisco, California).

Tirrell, John (c.1826–)
B. Massachusetts. Groce and Wallace; California State Library; San Francisco Public Library.
Tirrell worked as an artist, designer, and illustrator in California in 1860. The census for that year shows him living in Sacramento.

Titus, (Mr.) Aime Baxter (1883–1941)
B. Cincinnati, Ohio. D. San Diego, California. AAA 1917 (Los Angeles, California); AAA 1919–1933 (San Diego); Mallett.

Titus studied at the Art Students' League and the San Francisco Art Institute.

Tobriner, Haidee (–)
AAA 1913 (San Francisco, California); California State Library.

Toeplitz, Charlotte V. (1892–)
B. Germany. Fisher; Ina Sizer Cassidy, "Art and Artists of New Mexico," *New Mexico* Magazine, February 1951, 28, 54.

Toeplitz, who studied in Germany, left in 1938 and settled in Wilmington, Delaware. She exhibited regularly with Wilmington Society of Fine Arts, but soon moved on to Topeka, Kansas. There she began exhibiting in the Middle Western states, and on two occasions she had solo exhibitions in Topeka.

After moving to Hobbs in 1945, Toeplitz exhibited primarily in New Mexico, and in Texas where she was a member of El Paso Art Association.

Toeplitz told Cassidy that at first the landscape of the Hobbs area was difficult because it was "so strange, so different." She had to learn "to see it" before she could paint it.

Tokita, Kamekichi (1897–1948)
B. Japan. Work: Seattle Art Museum. Havlice; Mallett; WWAA 1940–1941 (Seattle, Washington); *Who's Who in Northwest Art.*

Tokita was active in Seattle at least as early as 1931, for he was winning prizes at that time. He was mainly self-taught, and sufficiently accomplished to merit a solo exhibition at the Seattle Art Museum.

Tolman, Ruel Pardee (1878–1954)
B. Brookfield, Vermont. Work: National Collection of Fine Arts. AAA 1913–1931 (Washington, D.C.); Bénézit; Fielding; Havlice; Mallett; WWAA 1936–1956 (Washington, D.C.); California State Library.

Towner, (Miss) Xaripa (–)
AAA 1917 (Los Angeles, California).

Towner was a member of California Art Club.

Townsley, Channel Pickering (1867-1921)
B. Sedalia, Missouri. D. London, England. Work: Los Angeles County Art Museum; Santa Fe Collection. AAA 1913 (New York City); AAA 1915-1919 (Pasadena and Los Angeles, California); AAA 1921 (London and Los Angeles); Bénézit; Fielding; Mallett; Porter, *et al,* 1916.

Tranquillitsky, Vasily Georgievich (1888-)
B. Russia. Work: murals, Chamber of Commerce, Seattle, Washington. Havlice; Mallett Supplement; WWAA 1940-1941 (San Francisco, California).

Traver, (Charles) Warde (1880-)
B. Ann Arbor, Michigan. AAA 1915-1927 (New York City; summer 1917-1919: Waunita Hot Springs, Colorado); Bénézit; Fielding; Mallett.
 Traver studied at the Royal Academy in Munich, Germany, and also with Millet and Snell.

Travis, Diane (1892-)
B. New York City. AAA 1933 (Tulsa, Oklahoma); Havlice; Mallett; WWAA 1936-1939 (Dallas,Texas); WWAA 1940-1941 (Houston, Texas).

Travis, Kathryne Hail (1894-1972)
B. Ozark, Arkansas. Work: Dallas Public Art Gallery; National Collection of Fine Arts; Bonham (Texas) High School. AAA 1923-1933 (Dallas, Texas; summer: Ozark); Bénézit; Havlice; Mallett; WWAA 1936-1941 (Beverly Hills, California); WWAA 1956-1962 (Dallas; summer: Ruidoso, New Mexico); WWAA 1970 (Ruidoso); O'Brien; *New Mexico* Magazine, November-December 1962, 37.
 In Dallas, where Kathryne and Olin Travis moved in 1923, they founded the Dallas Art Institute. In Ruidoso, where Kathryne began spending summers in the 1950s, she founded the Gallery of Art and Summer School of Painting. Her specialty, besides teaching, was painting wild flowers.
 Travis spent considerable time in Colorado during the

1930s, and on one occasion exhibited 18 canvases of flowers and landscapes at the Denver Art Museum. She also had solo exhibitions in Los Angeles, Seattle, and various Arkansas and Oklahoma cities.

Travis, Olin Herman (1888-)**
B. Dallas, Texas. Work: Dallas Museum of Fine Arts; Elisabet Ney Museum. AAA 1921 (Chicago, Illinois); AAA 1923-1933 (Dallas; summer: Ozark, Arkansas); Bénézit; Fielding; Havlice; Mallett; WWAA 1936-1976 (Dallas); O'Brien.

After graduating from business college, Travis worked his way through Chicago Art Institute. Following marriage to Kathryne Hail, he taught commercial art for a short while and then returned to Dallas to do landscape, figure, and portrait work. In 1926 he and Kathryne founded Dallas Art Institute.

Trease, Sherman (1889-1941)
B. Galena, Kansas. D. San Diego, California. Work: San Diego Fine Arts Society; Joplin Art League. AAA 1923-1924 (Joplin, Missouri); AAA 1927-1933 (San Diego, California); Havlice; Mallett; WWAA 1938-1941 (San Diego).

Treidler/Triedler, Adolph/Adolf (-)
B. Colorado. AAA 1913-1921, 1925-1929 (New York City); Bénézit; Havlice; Mallett Supplement; WWAA 1947-1953 (New York City); "Footnotes," *American Artist*, October 1969; "Adolph Treidler," *American Artist*, March 1974.

Treidler was 12 when his family moved to San Francisco. About 1909, at age 19, he went to Chicago where he worked in an art studio for $5 a week, and later for the Chicago *Sunday Tribune* at $15 a week. His failure to obtain an increase in salary hastened his move to New York City.

In the March 1974 issue of *American Artist* Treidler told about his studio, opposite Madison Square, which he shared with another artist. Although it had neither heat nor hot water, it had a skylight, and even more important, it had a landlord who never accepted the rent until he was assured his artist tenants had something left for food.

It is now over 25 years since Treidler turned to landscape painting because, as an illustrator, he was not comfortable with the style limitations imposed by editorial policy.

Triebel, Frederic Ernst (1865-)
B. Peoria, Illinois. AAA 1905-1910 (New York City); AAA 1913 (New York City; Rome, Italy); AAA 1921-1933 (Long Island, New York); Bénézit; Fielding; Havlice; Mallett; WWAA 1936-1941 (College Point, Long Island); WWWA; Boise Public Library.

Trousset/Trouset, Leon (-)
Work: Santa Cruz City Museum; Carmel Mission, Carmel, California; Academy of Natural Sciences, Philadelphia; Museum of New Mexico. California State Library; Monterey Public Library; Monterey Peninsula *Herald,* October 29, 1960; Archives of American Art, Smithsonian Institution.
Trousset has been described by the Monterey Peninsula *Herald* as one of the "hungry bohemians" who were active in Monterey during the late 1870s and early 1880s. Among five paintings registered in the Archives of American Art are "City of Monterey, California," a water color painted in 1875, and "Founding of the Carmel Mission (Ceremony at Monterey)," an oil painted in 1877. Also there is an oil entitled "Mission Santa Cruz."
Near Monterey is Castroville where Trousset did a painting of Moss Landing. He also worked in New Mexico, for an oil entitled "Socorro Court House 1885" is in the collection of the Museum of New Mexico.

Trucksess, (Frederick) Clement (1895-)
B. Brownsburg, Indiana. Work: University of Colorado; Jefferson School, Lafayette, Indiana. AAA 1923-1931 (Brownsburg); AAA 1933 (Boulder, Colorado); Havlice; Mallett; WWAA 1936-1941 (Boulder); Denver Public Library.
Although Chinese art and calligraphy have been the prin-

cipal influences in Trucksess's art, Colorado and New Mexico have provided inspiration for many paintings.

Trucksess, Frances Hoar (See: Hoar, Frances)

Truesdell, Edith Park (1888–)
B. Derby, Connecticut. Work: Denver Art Museum. AAA 1925–1933 (Los Angeles, California); Havlice; Mallett; WWAA 1936–1939 (Los Angeles; summer: Brookvale, Colorado); WWAA 1940–1941 (Brookvale); Denver Public Library; Rena Andrews, "The Fine Arts," Denver *Post*, September 12, 1971, 27; Rocky Mountain *News*, September 9, 1971, 54.

Edith Park was an art teacher in the East when she married John Truesdell of Colorado. From then on she lived in Colorado and California, traveling with her husband and painting daily in all manner of places between Denver and Los Angeles. During that period of the 1920s and 1930s she exhibited regularly in major American cities.

Then came 14 years of no painting, for Truesdell's husband had become ill, and his care had left time for little else. Following his death, Truesdell returned to California where she began working with acryllics instead of oils. She again exhibited regularly, including several solo exhibitions. She lives in Carmel Valley where she is quite the talk of Monterey Peninsula, for despite her age, she is remarkably productive and the reviews of her work are most favorable.

Truesworthy, Jessie/Jay (1891–)
B. Lowell, Massachusetts. Havlice; Mallett; WWAA 1936–1959 (Pasadena, California); WWAA 1962 (Newport Beach, California).

T'Scharner, Theodore (1826–1906)
B. Belgium. D. Furnes, Belgium. Bénézit; California State Library; Jan Albert Goris (Intro. and Trans.), "A Belgian in the Gold Rush: California Indians/A Memoir by Dr. J. J. F. Haine," *California Historical Society Quarterly*, June 1959, 141–155.

T'Scharner visited California between 1850 and 1853. He

took back to Belgium about 40 drawings of miners, Indians, buildings, and city views, including many of San Francisco.

Tschudy, Herbert Bolivar (1874-1946)
B. Plattsburg, Ohio. D. New York City, April 5. Work: Brooklyn Museum; Museum of New Mexico; Yellow Springs Public Library; National Museum, Warsaw; National Museum, Sofia. AAA 1919-1933 (Brooklyn and New York City; summer 1919: Yellow Springs, Ohio); Bénézit; Fielding; Havlice; Mallett; WWAA 1936-1947* (Brooklyn and New York City); WWWA; Brooklyn Museum; *The Art Digest,* March 1, 1934, 15; "Herbert Tschudy and the Southwest," *The Art Digest,* January 15, 1935, 16.

About 1914 Tschudy was on a Western sketching expedition which included Arizona, California, and Glacier National Park. His sketches were to be used in making installations at Brooklyn Museum.

A regular visitor to the West thereafter, Tschudy in time achieved recognition as an artist, and by the 1930s was receiving favorable reviews in New York City. About half of his paintings for a 1934 exhibition at "Fifteen Gallery" were of New Mexico, painted during the previous summer. By 1935 Tschudy was identified in New York reviews as a painter of the Southwest.

During the early years of Tschudy's career he sometimes simplified the spelling of his name. An oil called "Hubbell Hill," at Hubbell Trading Post Museum in Ganado, Arizona, is signed "Judy." The first volume of Brooklyn Museum *Quarterly,* page 113, also used that spelling.

Turnbull, (Daniel) Gale (1889-)
B. Long Island City, New York. Work: Brooklyn Museum; Luxembourg Museum, Paris. AAA 1923-1933 (Paris and Finistere, France); Bénézit; Havlice; WWAA 1936-1939 (Paris and Finistere); WWAA 1940-1941 (Los Angeles, California); *Who's Who in California,* 1943.

Turney/Turvey, Ester/Esther (-)
AAA 1917-1919 (Norman, Oklahoma).

U

Ueyama, Tokio (1890-)

B. Wakayama, Japan. Work: State College, Pennsylvania. AAA 1923-1931 (Los Angeles, California); Mallett Supplement.

Ueyama studied at Pennsylvania Academy of Fine Arts where he had a fellowship.

Uhler,Ruth Pershing (1898-1969?)

B. Gordon, Pennsylvania. Work: Houston Museum of Fine Arts; Houston Public Library. AAA 1925, 1933 (Houston, Texas); Havlice; Mallett; WWAA 1936-1941 (Houston; summer: Santa Fe, New Mexico); WWAA 1947-1966 (Houston); O'Brien.

Ulber, Althea (1898-)

B. Los Angeles, California. Work: Los Angeles Museum of Art. AAA 1925-1933 (Los Angeles); Havlice; Mallett, WWAA 1936-1941 (Los Angeles); WWAA 1947-1956 (La Crescenta, California).

Underwood, Addie (-)

AAA 1917 (Lawrence, Kansas).

Underwood, J. A. (-)

Groce and Wallace; Rasmussen, 1942.

Lt. Underwood did some illustrations while with the United States Exploring Expedition of 1844.

Unsworth, Edna Ganzhorn (1890-)

B. Baltimore, Maryland. AAA 1923-1924 (Atascadero, California); AAA 1931-1933 (Long Beach, California); Mallett.

V

Valentien, Albert R. (1862–1925)

B. Cincinnati, Ohio. D. August 5. Work: Bowers Museum Foundation, Santa Ana, California. AAA 1898–1910 (Cincinnati); AAA 1913–1925* (San Diego, California); Bénézit; Fielding; Mallett; California State Library; San Francisco Public Library.

Valentien, Anna M. (1862–1947)

B. Cincinnati, Ohio. AAA 1903, 1907–1910 (Cincinnati); AAA 1913–1933 (San Diego, California); Fielding; Havlice; Mallett; WWAA 1936–1947 (San Diego); WWWA.

Valle, Maude Richmond Fiorentino/Florentino (1868–1969)

B. near St. Paul, Minnesota. D. Mill Valley, California, June 14. AAA 1921–1933 (Denver, Colorado; summer: Mt. Morrison, Colorado); Havlice; Mallett; WWAA 1936–1941 (Denver; summer 1936–1939: Mt. Morrison); Denver Public Library; *Independent Journal* (California), December 3, 1968, 15.

Vallombrosa, Medora Hoffman (c.1858–c.1921)

Vallombrosa was an amateur artist who spent summers at Medora, North Dakota, from 1883 to 1886. The house in which she lived in is now a museum. A number of her paintings are there and in Bismarck, North Dakota. She is supposed to have exhibited in France, and in 1952 the American Artists' Professional League is supposed to have awarded her posthumously a merit certificate.

Vanderhoff,Charles A. (–1918)

D. Locust Point, New Jersey, April 8. Work: National Collection of Fine Arts. AAA 1907–1910 (New York City); AAA 1918*; Franz R. and Mrs. F. R. Stenzel, *An Art Perspective of the Historic Pacific Northwest,* a catalog privately published in 1963.

Vanderhoff was a painter, etcher, and illustrator who

taught for some years at Cooper Union. He did much of his painting and exhibiting in Europe.

Vanderhule, Lavina Matilda Bramble (1839-1906)
B. Harland, Vermont. D. Yankton, South Dakota, June 6. Stuart.

Vanderhule studied at Harland Academy in Vermont, and in New York. She lived in Yankton from 1875, but was first there in 1866. Her work is in the Yankton County Territorial Museum.

Vann, Esse Ball (1878-)
B. Lafayette, Indiana. Havlice; Mallett Supplement; WWAA 1938-1941 (Richmond Beach, Washington); *Who's Who in Northwest Art.*

Vann also lived in Woodinville, Washington.

Van Pelt, Ellen Warren (-)
AAA 1900 (University Park, Colorado).

Van Sweringen, Norma (1888-)
B. San Marcial, New Mexico. Work: Museum of New Mexico. Fisher.

Van Sweringen settled in Santa Fe, New Mexico in 1910.

Van Westrum, Anni (See: Baldaugh, Anni)

Van Zandt, Hilda (1892-1965)
B. Henry, Illinois. D. Long Beach, California. AAA 1927-1933 (San Pedro, California); Havlice; Mallett; WWAA 1936-1941 (San Pedro).

Vik, Della Blanche (1889-)
B. River Sioux, Iowa. Mallett Supplement (Rapid City, South Dakota); Stuart.

Vik, who maintains a studio in Rapid City, studied at the Colorado Springs Fine Arts Center, and with Gutzon Borglum. She has exhibited at Rockefeller Center, Surbeck Center (South Dakota School of Mines and Technology), and at South Dakota State Fairs. Her work is at Mount Rushmore National Monument, South Dakota Memorial Art Center in Brookings, and

South Dakota School of Mines and Technology. She is also a photographer.

Vinatieri, Frank Villiet (1891-1965)
 B. Yankton, South Dakota. D. Yankton, July 11. Stuart.
 Vinatieri was a carpenter and cabinet maker who taught himself to paint. His work is in Yankton County Territorial Musuem. Besides Yankton, Vinatieri lived in Lead, South Dakota, and Santa Monica, California.

Vincent, Andrew McDuffie (1898-)
 B. Hutchinson, Kansas. Work: Seattle Art Museum; murals, U.S. Post Office, Toppenish, Washington; U.S. Post Office, Salem, Oregon; Eugene (Oregon) City Hall. Havlice; Mallett Supplement; WWAA 1940-1966 (Eugene, Oregon); *Who's Who in Northwest Art; The Art Digest,* April 15, 1934, 8.

Vivian, Calthea Campbell (1857-1943)
 B. Fayette, Missouri. Work: California Historical Society; California Palace of the Legion of Honor; Society of California Pioneers; Bancroft Library, University of California; Massachusetts Historical Society. AAA 1915-1919 (Pacific Grove, California); AAA 1921-1933 (Berkeley, California); Fielding; Mallett; San Francisco Public Library; Baird, 1968.
 Vivian studied at Crocker Art Institute, Hopkins Art Institute, where she was a pupil of Arthur Mathews, and in Paris. She lived in various other California cities besides Berkeley and Pacific Grove. They are Sacramento, Woodland, San Francisco, Los Angeles, and San Jose, where she was in 1911. Among the organizations to which she belonged are San Francisco Art Association; Laguna Beach Art Association, and California Art Club.

Vogel, Elmer Henry (1898-)
 B. Chicago, Illinois. Fisher.
 Vogel settled in Silver City, New Mexico, in 1943.

Volck, Fannie (-)
 AAA 1913 (Houston, Texas).

Von der Lancken/Lacken, Frank/Francis (1872-1950)

B. Brooklyn, New York. Work: Tulsa (Oklahoma) Public Library; National Collection of Fine Arts; Pennsylvania Academy of Fine Arts; University of Rochester; Mechanics Institute, Rochester. AAA 1898-1900 (New York City); AAA 1907-1925 (Rochester, New York; summer 1915-1925: New Milford, Connecticut); AAA 1927-1933 (Tulsa; summer: Chatauqua, New York); Havlice; Mallett; WWAA 1936-1947 (Tulsa; summer 1936-1937: Chatauqua; summer 1938-1941: New Milford).

Von Hassler, Carl (1887-1969)

B. Bremen, Germany. D. Albuquerque, New Mexico, November 30. Albuquerque Public Library.

Von Hassler was born in Germany of French and Dutch parents. He came to this country about 1920, and settled in Albuquerque in 1922. Except for some work done on the West Coast, the Southwest has been the scene of his portraits and landscapes.

A number of Van Hassler's early Navajo portraits were done at Manuelito, an old trading post near the Arizona-New Mexico border. Many of his landscapes are familiar scenes in and around Albuquerque. He also painted murals. In 1924 he did a series for Albuquerque's Franciscan hotel, a building no longer standing. But most of these murals have been preserved by the wrecker who was in charge of demolition.

Von Schneidau, Christian C. (1893-)

B. Smaland, Sweden. Work: John Morton Memorial Museum, Philadelphia. AAA 1917 (Chicago, Illinois); AAA 1919-1933 (Los Angeles, California); Fielding; Havlice; Mallett; WWAA 1936-1956 (Los Angeles); WWAA 1959-1976 (Los Angeles and Laguna Beach, California); *Who's Who in California,* 1943; *Who's Who on the Pacific Coast,* 1949.

Voss, Nellie Cleveland (1871-1963)

B. Northfield, Minnesota. D. Milbank, South Dakota, December 22. Stuart (Milbank).

Voss lived in Milbank from 1880. Her work is in South Dakota Memorial Art Center in Brookings.

Vreeland, Francis William (1879-1954)

B. Seward, Nebraska. D. Los Angeles, California. AAA 1925-1933 (Hollywood, California); Havlice; Mallett; WWAA 1936-1941 (Hollywood).

Vysekal, Edouard Antonin (1890-1939)

B. Kutna Hora, Czechoslovakia. D. December 2. Work: Barbara Worth Hotel, El Centro, California; Mission Inn, Riverside, California; Thomas Starr King and John Marshall high schools, Riverside. AAA 1917-1933 (Los Angeles, California); Bénézit; Fielding; Mallett; WWAA 1936-1940*.

Vysekal, (Ella) Luvena Buchanan (-1954)

B. Lemars, Iowa. D. Los Angeles, California. Work: State Historical Building, Topeka, Kansas; Kansas State Agricultural College; Kansas State Capitol; Los Angeles Art Institute; Barbara Worth Hotel, El Centro, California. AAA 1919, 1925-1933 (Los Angeles, California); Bénézit; Fielding; Havlice; Mallett; WWAA 1936-1953 (Los Angeles); *Who's Who on the Pacific Coast*, 1947.

Following marriage to Edouard Vysekal in 1917, Vysekal worked with him on the murals for Barbara Worth Hotel in El Centro.

W

Wagenhals, Katherine H. (1883-)

B. Ebensburg, Pennsylvania. Work: Herron Art Institute. AAA 1915-1919 (Fort Wayne, Indiana); AAA 1921-1927 (San Diego, California); Bénézit; Fielding; Mallett.

Wagenhals studied at the Art Students' League, and in Paris, France. She was an associate member of Society of Western Artists.

Waggoner, Elizabeth (–)
 AAA 1925 (Hollywood, California).
 Waggoner was a member of California Art Club.

Wagner, Blanche Collet (1873-1958?)
 B. Grenoble, France. AAA 1921-1924 (New York City);
 AAA 1925-1927 (Berkeley, California); AAA 1929-1931
 (San Marino, California); Havlice; Mallett; WWAA
 1936-1956 (San Marino); *Who's Who in California*, 1943;
 California State Library.

Wagoner, Harry B. (1889-1950)
 B. Rochester, Indiana. D. Phoenix, Arizona, April 9. AAA
 1931-1933 (Palm Springs, California; summer: Chicago, Il-
 linois); Mallett (Altadena, California).
 Wagoner was a member of International Society of Sculp
 tors, Painters, and Gravers; Hoosier Salon; Pasadena (California)
 Sculptors and Painters. By the latter 1920s he was well known in
 Southern California as a painter of Arizona and California desert
 scenes.

Walker, John Law (1899–)
 B. Glasgow, Scotland. Work: Murals, U.S. Post Offices in
 South Pasadena, California, and Lockhart, Texas. AAA
 1933 (Burbank, California); Havlice; Mallett; WWAA
 1936-1953 (Burbank); "Artist Attacks Demon Rum and
 Wins Prize," *The Art Digest*, January 15, 1933, 13.

Wall, Bernhardt/Bernardt (1872-1954?)
 B. Buffalo, New York. D. Sierra Madre, California. Work:
 Morgan Library; Frick Library; New York Historical
 Society; Huntington Library; British Museum. AAA
 1917-1924 (New York City); AAA 1925 (Warren, Connecti-
 cut); AAA 1927 (Lime Rock, Connecticut); Havlice;
 Mallett; WWAA 1936-1941 (Lime Rock); WWAA 1947-
 1953 (Sierra Madre); O'Brien; *Who's Who on the Pacific
 Coast*, 1949.
 Few outside Texas know why Wall was so fond of that
 state. His love for it began the winter of 1893 when he got off a
 freight train in San Antonio, and soon afterward found a niche for

himself in the city's art life. He had a class of paying pupils; he was part owner of the San Antonio Engraving Company; and he was president of the San Antonio Art League which he had organized.

Two years after Wall's arrival in San Antonio he married a Texan and moved to Houston where they lived briefly until moving to New York City. The kind of work this avid pictorial biographer specialized in required his presence in the East. But some of his subject matter was in the West, to which he returned frequently.

Missions of the Southwest contains 24 etchings of various features of Missions Concepcion and San Jose in San Antonio. *Under Western Skies* came from other parts of the West and includes etchings of Cheyenne and Pocatello Indians. *Following General Sam Houston,* with sixty sheets of etchings to tell the story, was the work of his later years and required considerable time in Texas. It was at that time he told friends and colleagues there how much the state meant to him.

Wall, Gertrude Rupel (1886–)
B. Greenville, Ohio. Havlice; Mallett Supplement; WWAA 1936–1953 (Berkeley, Oakland, and San Francisco, California).

Wallace, John Laurie (1864–1953)
B. Garvagh, Ireland. Work: University of Nebraska; Omaha Public Library; Joslyn Art Museum; Press Club, Chicago; New York City Athletic Club. AAA 1917–1933, listed as Laurie-Wallace (Omaha, Nebraska); Havlice; Mallett; WWAA 1936–1941 (Omaha).
Wallace, who was director of the Omaha School of Art, was living in that city by 1900.

Walter, Solly H. (1846–1900)
B. Vienna, Austria. D. Honolulu, Hawaii, February 16. AAA 1900*; Bénézit; Mallett; California State Library.
Walter came to this country in 1878 and settled in San Francisco in 1883. He founded a School of Drawing there, and joined the Bohemian Club and the San Francisco Art Association.

Walter, Valyne G. (1898–)

B. Rockdale, Texas. Albuquerque Public Library.

Walter is well-known in Santa Fe and Albuquerque, New Mexico, where she has been painting since the late 1920s. Among her teachers were Gerald Cassidy, Sam Smith, and Frederick Taubes. She exhibits in Albuquerque where she is active in the New Mexico Art League and the National League of American Pen Women.

Walters, Carl Albert (1883–1955)

B. Fort Madison, Iowa. D. November 12. Work: Metropolitan Museum of Art; Whitney Museum of American Art; Art Institute of Chicago; Worcester Art Museum; Davenport (Iowa) Municipal Art Gallery; Portland (Oregon) Museum of Art; Cincinnati Museum; Detroit Institute of Arts. AAA 1915-1919 (Portland, Oregon); Havlice; Mallett; WWAA 1936-1937 (New York City); WWAA 1938-1953 (Woodstock, New York); WWWA.

During the latter part of his career Walters specialized in ceramics and sculpture.

Ward, Harold Morse (1889–1973)

B. Brooklyn, New York. D. Sacramento, California, January 20. Mallett Supplement; California State Library; Crocker Art Gallery.

Ward lived in Sacramento where he was particularly active during the 1940s.

Ward, J. Stephen (1876–)

B. St. Joseph, Missouri. Work: Fairfax High School, Hollywood, California; Clubb Collection, Kaw City, Oklahoma. AAA 1929 (Glendale, California; summer: June Lake, California); AAA 1931-1933 (Jacksonville, Oregon); Mallett; *The Art Digest*, November 15, 1930, 9.

Ward studied in California with Brewer and Braun. By 1930 he was active in Oregon where he was one of the prizewinners in the state's annual exhibition.

Ward, Jean S. (1868–)

B. Wisconsin. AAA 1923-1925 (Los Angeles, California); Mallett Supplement (San Francisco, California).

Wardin, Frances Mitchell (1888–)
 B. Topeka, Kansas. AAA 1915 (Topeka).
 Wardin was a pupil of Robert Henri.

Warhanik/Warhanic, Elizabeth C. (1880–)
 B. Philadelphia, Pennsylvania. AAA 1921–1933 (Seattle,
 Washington); Havlice; Mallett; WWAA 1936–1941 (Seattle); *Who's Who in Northwest Art.*

Warner, William R. (c.1885–1947)
 B. Ontario, Canada. Albuquerque Public Library.
 Warner had lived in New Mexico since his youth. While he
was a forest ranger at Gila Forest, he began landscape painting.

Warshawsky, Alexander/Xander (1887–)
 B. Cleveland, Ohio. D. Los Angeles, California. Work:
 Cleveland Museum of Art; Los Angeles Museum of Art.
 AAA 1923–1933 (Paris, France); Bénézit; Fielding; Havlice;
 Mallett; WWAA 1936–1941 (Paris); *Who's Who in California*, 1943.
 Although the art directories mention only his Paris resi-
dence, Warshawsky also lived in Los Angeles. He exhibited wide-
ly in the West.

Washburn, Max Murray (1888–)
 B. Las Animas, Colorado. Fisher.
 Washburn settled in Santa Fe, New Mexico, in 1937.

Waterbury/Waterbory, Laura Prather (–)
 B. Louisville, Kentucky. AAA 1915, 1923–1924 (Corona,
 California).

Waterman, Myron A. (1855–1937?)
 B. Westville, New York. D. Kansas City, Kansas. Havlice;
 Mallett Supplement; WWAA 1936–1939 (Kansas City).

Watkins, Catherine/Cathrine W. (–)
 B. Hamilton, Ontario, Canada. AAA 1905–1906 (Paris,
 France; Montclair, New Jersey); AAA 1913–1915 (Paris);
 AAA 1917–1921 (Woodstock, New York); AAA 1923–

1927 (Los Angeles, California); AAA 1929 (San Francisco, California); AAA 1931-1933 (Los Angeles); Havlice; Mallett; WWAA 1936-1941 (Los Angeles).

Watkins specialized in landscape painting.

Watkins, Susan (1875-1913)

B. California. D. June 18. Work: California Historical Society. AAA 1903-1910 (Paris, France); AAA 1913-1915, listed Serpell (Norfolk, Virginia); AAA 1917*; Bénézit; Fielding; Mallett; California State Library.

Watrous, Mary E. (-)

AAA 1917-1925 (Laguna Beach, California; studio: Pacific Grove, California, in 1925).

Watrous was a member of California Art Club.

Watson, Adele (1873-1947)

B. Toledo, Ohio. D. Pasadena, California, March 23. AAA 1917-1933 (New York City; summer: Pasadena); Bénézit; Havlice; Mallett; WWAA 1938-1947* (New York City); *The Art Digest*, May 1, 1933, 12.

The *Art Digest* compared Watson's work to that of Blake and A. B. Davies, and noted that she had just left New York for California.

Watson, Jesse/Jessie Nelson (1870-)

B. Pontiac, Illinois. AAA 1909-1927 (St. Louis, Missouri); Fielding; Havlice; Mallett Supplement; WWAA 1938-1953 (Glendale, California).

Watts, Eva A. (1862-)

B. Chillicothe, Missouri. Boise Public Library.

Watts was an amateur artist who began painting when she was 20. When she settled in Boise, Idaho, in 1900, she was known as Mrs. John Mossberger.

Watts, William Clothier (1867-1961)

B. Philadelphia, Pennsylvania. D. Carmel, California. Work: Oakland Museum; California Palace of the Legion of Honor; M. H. De Young Memorial Museum; Monterey Art

Museum. AAA 1909-1919 (Philadelphia); AAA 1921-1933 (Carmel); Fielding; Havlice; Mallett; WWAA 1936-1941 (Carmel Highlands).

Webb, Edith Buckland (1877-)
B. Bountiful, Utah. California State Library; *Who's Who in California*, 1943.

Webb was a writer and researcher who did considerable painting, a pursuit she called recreation. She wrote and illustrated *Indian Life at the Old Missions*, published by Warren F. Lewis in 1952. Webb was educated in Utah, but spent much of her adult life in Los Angeles, California.

Webb, Margaret Ely (1877-1965)
B. Urbana, Illinois. Work: Santa Barbara Museum of Natural History; Library of Congress; British Museum; Huntington Library; American Antiquarian Society. AAA 1909-1917 (Glen Ridge, New Jersey); AAA 1919-1931 (Santa Barbara, California; studio: Boston, Massachusetts, 1919-1921); Fielding; Havlice; Mallett Supplement; WWAA 1936-1962 (Santa Barbara); *Who's Who on the Pacific Coast*, 1947.

Weedell, Hazel Elizabeth (1892-)
B. Tacoma, Washington. AAA 1917-1919 (Roy, Montana; Minneapolis and Austin, Minnesota); AAA 1921-1931 (Glendale, Missouri); Fielding.

Weedell graduated from Minneapolis School of Art. She is also known as Mrs. Gustav F. Goetsch.

Weeks, Isabelle May Little (1851-1907)
B. Kalamazoo, Michigan. D. Yankton, South Dakota, March 12. Stuart.

Weeks spent her adult life in Yankton. Her work is in the South Dakota Memorial Art Center in Brookings.

Weinberg, Emilie Sievert (-1958)
B. Chicago, Illinois. D. Piedmont, California, January 15. Work: Vanderpoel Art Association; Mills College; Oakland Museum; University Elementary School, Berkeley. AAA

1915 (Chicago); AAA 1917–1933 (Oakland and San Francisco, California); Havlice; Mallett; WWAA 1936–1941 (Berkeley, California); California State Library; *El Palacio*, November 16, 1918, 235.

Weinberg did landscape and portrait work in New Mexico during the summer of 1918, and perhaps in subsequent years.

Wentz, Henry Frederick (1876–)
B. The Dalles, Oregon. Work: Washington State University; Portland Art Museum. AAA 1913–1915 (Portland, Oregon); AAA 1917–1933 (Portland; summer: Nehalem, Oregon); Fielding; Havlice; Mallett; WWAA 1936–1941 (Portland; summer: Nehalem); *Who's Who in Northwest Art.*

Werner, Fritz (1898–)
B. Vienna, Austria. Havlice; Mallett; WWAA 1936–1941 (New York City; winter: Chandler, Arizona); *Who's Who on the Pacific Coast.*

Wesselhoeft, Mary Fraser (1873–)
B. Boston, Massachusetts. Work: Fogg Art Museum; National Collection of Fine Arts. AAA 1900–1919 (Cambridge, Massachusetts); AAA 1921–1925 (New York City), AAA 1927–1931 (Santa Barbara, California); Bénézit; Fielding; Havlice; Mallett; WWAA 1936–1941 (Santa Barbara).

Wessels, Glenn Anthony (1895–)
B. Capetown, South Africa. Work: San Francisco Museum of Art; University of California; Seattle Art Museum; Washington State College; Oakland Art Museum. Havlice; Mallett; WWAA 1936–1970 (Berkeley, California); WWAA 1973–1976 (Placerville, California); California State Library; San Francisco Public Library, San Francisco Art & Artists Scrapbook, vol. 1, 91; *The Art Digest*, February 1, 1934, 22.

West, Benjamin Franklin (1818–1854)
B. Salem, Massachusetts. D. Salem, April 6. Groce and

315

Wallace; Mallett; California State Library.

West was a marine and ship painter who was listed in the San Francisco Directory for 1854.

Westfall, Tulita/Gertrude Bennett (1894–1962)
B. Monterey, California. D. Pacific Grove, California, December 9. Work: Monterey Public Library; Oak Grove Grammar School, Monterey. Havlice; Mallett Supplement; WWAA 1936–1937 (Oakland, California; summer: Monterey); WWAA 1938–1941 (Monterey); *Who's Who in California,* 1943.

Although Havlice lists Tulita and Gertrude separately, they appear to be the same person. WWAA 1936–1939 lists her as Gertrude; WWAA 1940–1941 lists her as Tulita. All other data are identical.

Weston, (Mrs.) Otheto (1895–)
B. Monterey, California. *Who's Who on the Pacific Coast;* California State Library; Crocker Art Gallery.

This self-taught painter, who lived in Columbia, California, did a number of paintings of the Mother Lode country. She exhibited at Haggin Gallery in Stockton, California, and at Crocker Art Gallery in Sacramento.

Westrum, Anni von (See: Baldaugh, Anni)

Wheelan, Albertine Randall (1863–)
B. San Francisco, California. AAA 1927 (New York City); AAA 1929 (Los Angeles, California); California State Library.

Wheeler, Janet D. (–1945)
B. Detroit, Michigan. D. October 25. AAA 1898–1931 (Philadelphia, Pennsylvania); AAA 1933 (Long Beach, California); Bénézit; Fielding; Havlice; Mallett; WWAA 1936–1941 (Long Beach); WWWA.

Wheelock Warren Frank (1880–1960)
B. Sutton, Massachusetts. D. Albuquerque, New Mexico. Work: Los Angeles Museum of Art; Whitney Museum of

American Art; Museum of New Mexico; Brooklyn Museum; Portland Museum of Art. AAA 1921-1924 (New York City); AAA 1929-1933 (New York City; summer: Linville Falls, North Carolina); Bénézit; Fielding; Havlice; Mallett; WWAA 1936-1953 (New York City); WWAA 1956-1959 (Santa Fe, New Mexico); Albuquerque Public Library.

Wheelock was one of the founders with John Sloan of the Society of Independent Artists. As an associate of Sloan, Wheelock probably was working in Santa Fe at a much earlier time than indicated in art directories, and at least as early as 1949 when he began teaching at Hill & Canyon School of Art.

Wheete, Glenn (1884–)
B. Carthage, Missouri. Havlice; Mallett Supplement; WWAA 1936-1941 (Tulsa, Oklahoma).

Wheete, Treeva (1890–)
B. Colorado Springs, Colorado. Havlice; WWAA 1936-1941 (Tulsa, Oklahoma).

Whetsel, Gertrude P. (1886–)
B. McCune, Kansas. AAA 1923-1931 (Portland, Oregon); AAA 1933 (Los Angeles, California); Bénézit; Fielding; Mallett.

Whitaker, Frederic (1891–)
B. Providence, Rhode Island. Work: Metropolitan Museum of Art; Boston Museum of Fine Arts; Neilson Museum, Pocatello, Idaho; Lawrence Gallery, Atchison, Kansas; IBM Collection. AAA 1931-1933 (Cranston, Rhode Island); Havlice; Mallett; WWAA 1936-1947 (Cranston); WWAA 1953-1962 (Norwalk, Connecticut); WWAA 1966-1976 (La Jolla, California); Jay Jennings, "Frederic Whitaker: Mister Watercolor," *American Artist*, August 1977, 66-73, 91-95; *Southwestern Art*, July-August 1975, 50-55.

Whitcraft, Dorothea Fricke (1899–)
B. Fairmont, Nebraska. Fisher.

Whitcraft settled in Albuquerque, New Mexico, in 1925.

White, Edith (1855-1946)
B. Decorah, Iowa. D. Berkeley, California. Work: Santa Fe Collection; California Historical Society; Mount Holyoke College. Denver Public Library; Bromwell Scrapbook, page 12; California State Library; Kovinick.

According to Kovinick, White lived in California from 1859. She painted portraits, landscapes, and flowers. In 1898 she sent a flower painting to the Denver Artists' Club for the Fifth Annual Exhibition.

White, Inez Mary Platfoot (1889-)
B. Ogden, Utah. Work: Windsor and Fields schools, Omaha. AAA 1933 (Omaha, Nebraska); Havlice; Mallett; WWAA 1936-1953 (Omaha).

White, Jessie Aline (1889-)
B. Wessington, South Dakota. AAA 1931-1933 (Dallas, Texas); Havlice; WWAA 1936-1939 (Dallas); WWAA 1940-1941 (Fort Worth, Texas); O'Brien.

According to O'Brien, White moved to Dallas in 1919. In the early 1930s she did a series of water colors, depicting the American industrial scene, which were exhibited at Joseph Sartor Art Galleries in January 1933. White is also known as Mrs. George R. Angell.

Whitehan/Whiteham, (Edna) May (1887-)
B. Scribner, Nebraska. AAA 1917 (University Place, Nebraska); AAA 1919-1921 (Clarendon, Virginia); AAA 1923-1925 (Takoma Park, Maryland); Fielding.

Whitehan studied at the University of Nebraska and the Art Institute of Chicago. She was a member of Lincoln Art Club in Lincoln, Nebraska.

Whiteley, Rose (-)
AAA 1915 (Salt Lake City, Utah).

Whitlock, Frances Jeannette (1870-)
B. Warren, Illinois. AAA 1917 (New York City); AAA

1919-1921 (Los Angeles, California); AAA 1923-1925 (Fresno, California; Los Angeles).

Whitlock, who studied with Arthur Wesley Dow and Charles Martin, was a member of California Art Club. She taught art at the State Normal School in Fresno.

Whitlock (Mary) Ursula (1860-1944)

B. Great Barrington, Massachusetts. D. Riverside, California, December 7. Work: National Collection of Fine Arts; Los Angeles Museum of History, Science, and Art. AAA 1898-1921 (New York City and Brooklyn; summer: Gloucester, Massachusetts, from 1913); Fielding; Havlice; Mallett; WWAA 1938-1947* (Riverside).

Whitman, Paul (1897-1950)

B. Denver, Colorado. D. Carmel, California, December 11. Work: Stanford University; Del Monte (California) Hotel; California State Library. AAA 1929-1931 (Carmel); Havlice; Mallett Supplement; WWAA 1936-1941 (Carmel); WWAA 1947-1953 (Pebble Beach, California); California State Library; "California Etcher in Smithsonian Show," *The Art Digest,* November 1929, 22.

Whittemore, Frances Davis (1857-1951)

B. Decatur, Illinois. D. Topeka, Kansas, December 22. AAA 1923-1933 (Topeka); Fielding; Havlice; Mallett; WWAA 1936-1941; Topeka Public Library; Correspondence with the artist's daughter, Margaret Whittemore.

Prior to marriage in 1891 to Dr. L. D. Whittemore of Topeka, Frances Davis accompanied John Wesley Powell, her uncle, to Arizona. The purpose of her presence on the trip was to sketch artifacts of ethnological importance, and the Navajo Indians. Her daughter related that on one occasion "Uncle Wes" arranged for Frances "to draw the entrance of a cliff dwelling from a bo's'n's chair which was suspended for that purpose at just the right height and proper angle."

Whittemore's real mission in life was "to instill in others an appreciation of the works of great masters," her daughter said. To this end Whittmore not only taught, but from 1912 to 1929 directed the art department at Washburn College. She also

was the director and principal founder of Mulvane Art Museum. Other accomplishments are her paintings, and a book, *George Washington in Sculpture,* published in 1933.

Whittemore, Margaret Evelyn (1897-)
 B. Topeka, Kansas. Work: Thayer Art Museum, University of Kansas; Kansas State Historical Society; Clay Center, Wichita, and Topeka Public Libraries. AAA 1923-1925 (Topeka); Havlice; Mallett Supplement; WWAA 1936-1953 (Topeka); WWAA 1956-1962 (Short Hills, New Jersey; Sarasota, Florida); Topeka Public Library; Correspondence with Margaret Whittemore.
 Although Whittemore worked mainly in Kansas, the latter years of her career have been spent in New Jersey and Florida. During early years, when she was a student at the Art Institute of Chicago, she was the only girl among the chosen three to spend a summer in Taos with the Taos Art Colony. Some years later she spent a summer in Colorado.
 Whittemore's particular interest is birds, and her preferred medium is block printing. During the 1940s she illustrated *Birds of Kansas* for the State Department of Agriculture, and *Bird Notes* for Harry Rhodes. The latter was published by Hall Lithographic Company of Topeka.
 During the 1950s Whittemore wrote and illustrated *One-Way Ticket to Kansas,* and *Historic Kansas: A Centenary Sketchbook.* Both books were published by the University of Kansas Press. Whittemore also illustrated articles for a number of magazines and newspapers, and she wrote articles for *Audubon, Scholastic, American Magazine of Art,* and others.
 In Florida where Whittemore now lives she has resumed her interest in birds, and she has completed another book which is ready for publication.

Wiberg, Fritjof (-)
 B. Norway. Kate B. Carter. (comp.), *Heart Throbs of the West,* published by Daughters of Utah Pioneers in Salt Lake City.
 Little is known about Wiberg who studied in Norway, and lived briefly in Salt Lake City where he did murals and easel paintings for the Temple.

Wiboltt, (Jack) Aage Christian (1894-)
 B. Middelfart, Denmark. Work: Los Angeles Junior College. Havlice; WWAA 1936-1941 (Los Angeles, California); *Who's Who in California*, 1943.
 By 1943 Wiboltt was living in San Francisco. He had previously lived in New York City and Los Angeles.

Wideman, Florence/Florice P. (1893-)
 B. Scranton, Pennsylvania. Havlice; Mallett Supplement; WWAA 1936-1939 (Los Altos, California); WWAA 1940-1947 (Palo Alto, California).

Wilcocks, Edna Marrett (1887-)
 B. Portland, Maine. Work: Bowdoin College; Court House, Wilkes-Barre, Pennsylvania. AAA 1931-1933 (Altadena, California); Havlice; Mallett; WWAA 1936-1962 (Altadena).

Wilcox, Frank Nelson (1887-1964)
 B. Cleveland, Ohio. Work: Cleveland Museum of Art; Brooklyn Museum; Toledo Museum of Art; Western Reserve Historical Society. AAA 1923-1933 (Cleveland and East Cleveland); Bénézit; Fielding; Havlice; Mallett; WWAA 1936-1941, 1953-1962 (East Cleveland); Norman Kent, "Frank N. Wilcox, Watercolorist," *American Artist*, February 1963, 31-33, 68-70.
 Wilcox has worked in the Southwest and in the mountain regions of western Montana and Idaho.

Wildhack, Robert J. (1881-1940)
 B. Pekin, Illinois. D. Montrose, California. AAA 1909-1919 (New York City; Indianapolis, Indiana; Greenlawn, Long Island, New York); AAA 1921-1931 (La Crescenta, California); Fielding; Mallett.
 Wildhack studied with Robert Henri. He was a member of the Society of Illustrators and the Salmagundi Club. His specialty was posters.

Wilford, Loran Frederick (1892-1972)
 B. Wamego, Kansas. D. December 5. Work: Toledo Mu-

seum of Art; Atlanta Art Association; New York Public Library; Holmes Public School, Darien, Connecticut. AAA 1917, 1921 (Kansas City, Missouri); AAA 1923-1925 (Stamford, Connecticut); AAA 1927-1933 (Springdale, Connecticut); Fielding; Havlice; Mallett; WWAA 1936-1953 (Springdale; Stamford); WWAA 1956-1970 (Sarasota, Florida); WWWA; *The Art Digest*, April 15, 1931, 15.

Wilford's depiction of Indian life in the Santa Fe-Taos area won New York critics' approval in 1931. See also, "Loren F. Wilford Exhibit," *El Palacio*, May 20, 1931, 249-250.

Wilkin, Mildred Pierce (1896-)
B. Kansas. AAA 1931-1933 (Chino, California); Havlice; Mallett; WWAA 1938-1941 (Chino); WWAA 1947-1953 (Corona, California).

Wilkinson, Edward (1889-)
B. Manchester, England. Work: Dioramas at Houston Public Library, and Houston and Huntsville museums in Texas. AAA 1923-1933 (Houston); Havlice; Mallett; WWAA 1940-1941 (Houston).

Willard, Frank Henry (1893-1958)
B. Anna, Illinois. D. January 11. Bénézit; Havlice; Mallett; WWAA 1936-1941 (Tampa, Florida); WWAA 1959*; WWWA (Los Angeles, California); *Who's Who on the Pacific Coast*, 1949.

Willard, Howard W. (1894-1960)
B. Danville, Illinois. AAA 1925 (London, England); AAA 1927-1931 (New York City); Havlice; Mallett; WWAA 1936-1941 (New York City); Reed.
Willard lived in Los Angeles prior to 1920.

Willard, (Miss) L. L. (1839-)
B. New York. AAA 1915-1917 (Salt Lake City, Utah).

Willey, Edith Maring [E. Willey] (1891-)
B. Seattle, Washington. Work: Law Library, Olympia (Washington); King County Court House and John Hay

School, Seattle. Havlice; Mallett Supplement; WWAA 1940-1953 (Seattle; summer 1947-1953: Union, Washington); WWAA 1956-1962 (Bremerton, Washington); *Who's Who in Northwest Art.*

Williams, Clifton (1885–)
B. Richmond, Indiana. California State Library; *Who's Who on the Pacific Coast,* 1949.

Williams practiced law in Wisconsin before becoming an orange and lemon grower in San Diego County. About 1939 he began devoting considerable time to oil painting. He studied art for seven years, and specialized in desert, snow, and animal scenes. He lived at Carlsbad, California.

Williams, Florence Alston (See: Swift, Florence Alston)

Williams, John Caner (c.1841–)
B. Pennsylvania. Groce and Wallace; California State Library.

Williams was a portrait painter. The San Francisco City Directory shows him living there from 1873-1876, 1880-1881, and 1860-1866.

Williams, John L. Scott (1877-1975)
B. Liverpool, England. D. November 4. Work: Art Institute of Chicago; Indiana State Library and Historical Building; Johns Hopkins University. AAA 1909-1910 (Rutherford, New Jersey); AAA 1913-1915 (Leonia, New Jersey); AAA 1917-1919 (Englewood, New Jersey); AAA 1921-1933 (New York City); Bénézit; Fielding; Havlice; Mallett; WWAA 1936-1953 (New York City); WWWA (Gettysburg, Pennsylvania); *Who's Who on the Pacific Coast,* 1949.

Williams also lived in Laramie, Wyoming, where he taught at the University from 1946 to 1949.

Williams, Lawrence Pickett (1899-1930)
B. Prague, Czechoslovakia. O. B. Jacobson and Jeanne d'Ucel, "Art in Oklahoma," *Chronicles of Oklahoma,* Autumn 1954, 267-268; "Exhibit Shows Oklahoma Art Has

Come of Age," *The Art Digest*, Mid-December, 1928, 7.

In 1928, Larry Williams received national coverage when his painting "Socorro Mountains" was featured in *The Art Digest* with an article on Oklahoma art. Oklahoma, the youngest of the 48 states, was then in its 21st year. The accomplishments of her artists had been largely ignored, for, as H. W. Bentley wrote in the *Digest*, there had been a "tendency towards a slavish subservience to eastern schools on the one hand or to the Santa Fe and Taos tradition on the other." He found this 13th annual exhibition of the Association of Oklahoma Artists aiming toward an indigenous art.

Years later Jacobson and d'Ucel collaborated in an article about these Oklahoma artists. Larry Williams had been a student at the University of Oklahoma from 1918 to 1922. Following further study at Yale he joined its faculty.

Jacobson and d'Ucel felt his untimely death had terminated a most promising career. His work was different from any other, and he belonged to no particular school of painting. They wrote that in his interpretations of the states of the Southwestern high plains—he had painted in all of them—he depicted the "bitterness of nude earth, drifting sands, and muddy water," and in the mountains of New Mexico he depicted the "sternness"of the Rocky Mountain range.

Williams, Louise Houston (1883–)
B. Garnett, Kansas. AAA 1931–1933 (Anacortes, Washington); Havlice; Mallett; WWAA 1936–1941 (Anacortes); *Who's Who in Northwest Art; Who's Who on the Pacific Coast,* 1947.
Williams also worked in Guthrie, Oklahoma.

Williamson, Clara McDonald (1875–)
B. Iredell, Texas. Donald and Margaret Vogel, *Aunt Clara: The Paintings of Clara McDonald Williamson,* Austin and London: University of Texas Press, 1966.
Williams began painting when she was nearing 70. She studied at Southern Methodist University and the Dallas Museum School; although she had lived in Dallas since 1920, she did not take up painting until after her husband's death in 1943. From then until 1966 she sold and/or exhibited more than 150

paintings. Many of them were from memory such as "Chicken for Dinner," painted in 1945, and identified as her first memory painting.

Williamson, Shirley (-)
B. New York City. AAA 1905-1913 (New York City); AAA 1915-1917 (Carmel, California); AAA 1919-1925 (Berkeley, California; Carmel); AAA 1927-1933 (Palo Alto, California); Fielding; Havlice; Mallett; WWAA 1936-1941 (Palo Alto).

Willis, J. R. (1876-)
B. Sylvania, Georgia. Fisher; Denver Public Library; Santa Fe Public Library; Ina Sizer Cassidy, "Art and Artists of New Mexico," *New Mexico Magazine*, June 1936, 23, 51.
Willis began as a reporter on the Atlanta *Constitution*. In 1902 he turned to the study of art under Robert Henri and William Merritt Chase.
Following a stint of motion picture and newspaper work in California, Willis moved to New Mexico where he established a photo studio in Gallup. Summers were largely devoted to painting Indians on the Reservations of Arizona and New Mexico.
During the early 1930s Willis moved to Albuquerque. He exhibited regularly in Santa Fe, and did a historical mural for Gallup High School under the WPA program. Winters he spent in New Orleans or Atlanta.

Willis, Katherine (-)
AAA 1898-1900 (Omaha, Nebraska).
Willis studied with John Laurie Wallace. She exhibited in 1898 at the Omaha Exposition.

Willis, Ralph Troth (1876-)
B. Leesylvania, Virginia. Work: Library of Congress. AAA 1909-1917 (New York City); AAA 1925-1929 (Encinitas, California; Westport, Connecticut; studio: Hollywood, California); AAA 1933 (Encinitas; studio: Los Angeles); Havlice; Mallett; WWAA 1936-1941 (Encinitas); *Who's Who on the Pacific Coast*, 1947.

Willits, Alice (1885-)

B. Illinois. AAA 1907-1910 (Friendswood, Texas).

Willits was a pupil of Cincinnati Art Academy and a member of the Woman's Art Club of Cincinnati.

Willmarth, William A. (1898-)

B. Chicago, Illinois. Havlice; Mallett Supplement; WWAA 1936-1941 (Omaha, Nebraska).

Wilson, Charles Theller (1855-1920)

D. New York City, January 3. AAA 1920*; Bénézit; Mallett; California State Library.

Wilson, who had devoted his life to painting redwoods, was in New York City to exhibit his paintings when he died. Clarke Memorial Museum in Eureka, California, has one or more of his paintings.

Wilson, Donna A. (-)

AAA 1898-1900 (Lorton, Nebraska).

Wilson studied at the Art Institute of Chicago.

Wilson, Floyd (1887-)

B. St. Peter, Minnesota. AAA 1915 (Portland, Oregon).

Mallett Supplement lists an artist by the same name who was born and lived in Woodstock, New York.

Wilson, Hazel Marie (1899-)

B. Chicago, Illinois. Fisher; O'Brien.

Wilson obtained her first instruction at the Art Institute of Chicago through a scholarship given to talented children. Presumably she was living in Chicago at that time, for by 1915 she was in Union, New Mexico.

Thereafter she studied with Xavier Gonzales of San Antonio, Texas; Cyril Kay-Scott in El Paso, Texas; and a California marine painter named Dey de Ribcowsky. She exhibited in El Paso, Denver, Las Cruces, and Santa Fe.

Wilson, Helen (1884-)

B. Lincoln, Nebraska. AAA 1917-1925, 1933 (Lincoln, Nebraska); Havlice; Mallett; WWAA 1938-1941 (Lincoln).

Wilson, Jeremy (1824-1899)

B. Illinois. Work: Oakland Museum; Blair County (Pennsylvania) Historical Society. Groce and Wallace; Oakland Museum; Young.

Wilson was a portrait and landscape painter who exhibited at Pennsylvania Academy of Fine Arts from 1853 to 1863. In 1849 he was briefly in California. "The High Sierra," painted in 1863, is at the Oakland Museum.

Wilson, William J. (1884-)

B. Toledo, Ohio. Work: Bilge Club, San Pedro, California. AAA 1931-1933 (Long Beach, California); Havlice; Mallett; WWAA 1936-1941 (Long Beach).

Winchell, Ward (-)

AAA 1917-1925 (Los Angeles, California).

Winchell was a member of California Art Club.

Winebrenner, Harry Fielding (1885-1969)

B. Summersville, West Virginia. D. Los Angeles, California. Work: Oklahoma State Historical Society; Municipal Art Gallery, Oklahoma City; Oklahoma Art Museum; mural, North Oklahoma Junior College. AAA 1915 (Chicago, Illinois); AAA 1919-1921 (Venice, California); AAA 1923-1933 (Santa Monica, California); Fielding; Havlice; Mallett; WWAA 1936-1941 (Santa Monica); WWAA 1947-1962 (Chatsworth, California).

Winterburn, George T. (-)

AAA 1898, page 93.

Winterburn was an instructor in the Department of Decorative and Industrial Art, University of California, Berkeley.

Winterburn, Phyllis (1898-)

B. San Francisco, California. Work: San Francisco Museum of Art; California Palace of the Legion of Honor; Marin (California) Art Association. Havlice; Mallett Supplement; WWAA 1936-1941 (Sausalito, California); *Who's Who on the Pacific Coast*, 1947.

Wintermote, Mamie W. (1885–)

B. Liberty, Missouri. Havlice; Mallett Supplement; WWAA 1936–1941 (Hollywood, California).

Wirth, Anna Marie Barbara (1868–1939?)

B. Johnstown, Pennsylvania. AAA 1917 (Philadelphia); AAA 1919–1929 (Johnstown; studio: Pasadena, California); AAA 1931 (Johnstown; studio: Altadena, California); Fielding; Havlice; Mallett; WWAA 1936–1939 (Altadena).

Wiser, Guy Brown (1895–)

B. Marion, Indiana. Work: Muskingum College; University Hospital and Law College, Ohio State University. AAA 1929–1933 (Columbus, Ohio); Havlice; Mallett; WWAA 1936–1941 (West Los Angeles, California).

Wolf, Hamilton Achille (1883–1967)

B. New York City. Work: Huntington Library and Art Gallery; Oakland Museum; Washington County Museum, Hagerstown, Maryland; Georgia Museum of Art, Athens; University of Washington. AAA 1917 (New York City); AAA 1929–1933 (Berkeley, California); Havlice; Mallett; WWAA 1936–1953 (Oakland, California); WWAA 1956–1962 (San Francisco); WWAA 1966 (Oakland); *Who's Who on the Pacific Coast,* 1949; *The Art Digest,* December 1, 1929, 8; *The Art Digest,* June 1928, 20.

Wood, Annie A. [Nan] (1874–)

B. Dayton, Ohio. Work: Dayton Art Institute. AAA 1929–1933 (Ipswich, Massachusetts; winter: Tucson, Arizona); Havlice; Mallett Supplement; WWAA 1940–1953 (Tucson).

Wood, Charles Erskine Scott (1852–1944)

B. Erie, Pennsylvania. D. January 21. AAA 1903–1913 (Portland, Oregon); WWWA (Los Gatos, California).

Wood, who was involved in the Nez Perce Campaign of 1877, has written many books about Indians and other subjects, and is much better known as a writer than as an artist.

Wood, E. Shotwell (See: Goeller, E. Shotwell)

Wood, Katheryn Leon (1885–)
B. Kalamazoo, Michigan. Work: U.S. District Court, Cincinnati; Continental Memorial Hall, Washington, D.C. AAA 1915–1919 (Los Angeles and Pasadena, California; Kalamazoo); AAA 1921 (New York City); AAA 1923–1931 (Kalamazoo); AAA 1933 (Los Angeles); Bénézit; Fielding; Havlice; Mallett; WWAA 1936–1937 (Los Angeles).

Wood, Madge McAllister (–)
AAA 1903, 167.
Wood, who is listed under "Art Supervisors and Teachers," was on the staff of Los Angeles College of Fine Arts, Los Angeles, California.

Woodson, Marie L. (1875–)
B. Selma, Alabama. Work: Denver Public Library. AAA 1915–1933 (Denver, Colorado); Bénézit; Havlice; Mallett; WWAA 1936–1941 (Denver); Denver Public Library.

Woollett, William Lee (–)
AAA 1909–1910, listed under Architects (San Francisco, California); California State Library, *News Notes of California Libraries*, July 1935, 88; The American Federation of Arts, Handbook No. 3, 1938–1939, 19.
Woollett was an architect who did a number of prints of Boulder Dam, the San Francisco Bay bridges, the All-American Canal, and other subjects.

Woolley, Virginia (1884–1971)
B. Selma, Alabama. Work: High Museum of Art, Atlanta, Georgia. AAA 1913 (Paris, France); AAA 1923–1924 (Atlanta; summer: Laguna Beach, California); AAA 1925–1933 (Laguna Beach); Havlice; Mallett; WWAA 1936–1941, 1959–1962 (Laguna Beach).

Woolsey, Wood W. (1899–)
B. Danville, Illinois. Work: Danville High School; Art Association, Kokomo, Indiana; Museum of Fine Arts, Evansville, Indiana; Lafayette (Indiana) Art Institute. AAA 1929–1933 (Taos, New Mexico); Havlice; Mallett;

WWAA 1936–1939 (Martinsville, Indiana); WWAA 1940–1953 (Tunkhannock and Stroudsburg, Pennsylvania); *The Art Digest*, September 1930, 8.

Woolsey, a self-taught artist, did portrait and figure paintings of Pueblo Indians while living in Taos.

Works, Katherine S. (1888–)
Work: U.S. Post Office, Woodland, California. Havlice; Mallett Supplement (Dallas, Texas); WWAA 1940–1941 (San Anselmo, California).

Worthington, Mary E. (–)
B. Holyoke, Massachusetts. AAA 1915–1931 (Denver, Colorado); Denver Public Library.

Worthington studied with F. V. DuMond and Henry Read, and in Paris. She was a member of Denver Artists' Club in which she served as an officer at least as early as 1914. She exhibited with the Club from the mid-1890s.

Woy, Leota (1868–)
B. New Castle, Indiana. AAA 1903–1910, 1915 (Denver, Colorado); AAA 1923–1925 (Laguna Beach, California); Denver Public Library.

This self-taught artist was a member of Denver Artists' Club. She specialized in bookplates.

Wragg, Eleanor T. (–)
Work: Carolina Art Association, Charleston, South Carolina. AAA 1907–1913 (Waco, Texas); AAA 1917–1925 (Stony Creek, Connecticut); O'Brien.

Wragg was a painter of miniatures who specialized in portraits and landscapes. She taught for a number of years at Baylor.

Wright, James Garfield (1881–)
B. Bradford, Pennsylvania. Fisher.
Wright settled in Raton, New Mexico, in 1914.

Wright, Jennie E. (–)
AAA 1905–1906 (Portland, Oregon).

Wulff, Timothy Milton (1890–)

B. San Francisco, California. AAA 1917–1933 (San Francisco); Mallett.

Wyatt, A. C. (–1933)

B. England. D. Montecito, California, February 8. AAA 1933* (Montecito); Bénézit; Mallett; Waters; *The Art Digest*, March 1, 1933, 8.

Wyatt was a landscape painter who worked in California, South Carolina, Hawaii, and the New England states. He exhibited at leading London galleries from 1883, and in this country.

Wyttenbach/Wytterbach, Emanuel (–1903)

Work: Society of California Pioneers. California State Library; Denver Art Museum, *Building the West*, October 1955.

Wyttenbach's oil painting "An Evening in California," borrowed from a private collector, was shown at the Denver Art Museum in 1955.

Y

Yardley, Ralph O. (1878–)

B. Stockton, California. Work: Huntington Library. Havlice; Mallett Supplement; WWAA 1938–1953 (Stockton); WWAA 1956–1962 (Carmel, California).

Young, Frank Herman (1888–1964)

B. Nebraska City, Nebraska. D. Albuquerque, New Mexico, September 15. Havlice; WWAA 1947–1962 (Chicago, Illinois); WWWA; Albuquerque Public Library; "Sketching in the Colorado Wonderland," *Colorado Wonderland*, April 1954, 19–21; Denver Public Library.

Young was staff artist for the Los Angeles *Times* in 1911, and the Washington *Post* in 1913. Two years later he was on the move again, working as newspaper and advertising artist in many other parts of the country.

In his later years, Young turned to pencil sketching. His preference was outdoor and adobe subjects, and they have appeared in *Arizona Highways, Colorado Wonderland, New Mexico Magazine*, and *American Artist*. In August 1958 a group of his sketches was exhibited in Albuquerque at the Public Library.

Among Young's Colorado sketches are scenes from Garden of the Gods, Glenwood Springs, and Big Thompson River Canyon.

Young, Myrtle M./Mattie (1876-)
B. Hillier, Canada. AAA 1917-1924 (San Francisco, California); Bénézit.

Younkin, William LeFevre (1885-)
B. Iowa City, Iowa. Havlice; WWAA 1936-1941 (Lincoln, Nebraska).

Yphantis, George (1899-)
B. Kotyora, Turkey. Work: Seattle Art Museum; Montana State University. Havlice; Mallett Supplement; WWAA 1940-1941 (Pasadena, California; Missoula, Montana); WWAA 1947-1953 (Berkeley, California); WWAA 1962 (Boston, Massachusetts); *Who's Who in Northwest Art*.

Z

Zakheim, Bernard Baruch (1898-)
B. Warsaw, Poland. Work: San Francisco Museum of Art; frescoes, Coit Memorial Tower and Jewish Community

Center, San Francisco. Havlice; Mallett Supplement; WWAA 1938-1941 (San Francisco, California); WWAA 1947-1962 (Sebastopol, California); *Who's Who on the Pacific Coast,* 1947; San Francisco Public Library; California State Library.

Zetterlund, John (-)
AAA 1917 (Berkeley, California).

Ziegler, Samuel P. (1882-1967)
B. Lancaster, Pennsylvania. D. Fort Worth, Texas. Work: Fort Worth Museum of Art; University Club, Texas Christian University; Carnegie Library, Fort Worth. AAA 1923-1933 (Fort Worth); Bénézit; Havlice; Mallett; WWAA 1936-1962 (Fort Worth); O'Brien.

O'Brien wrote that Ziegler's aim was to portray "nature in all her moods." This meant working on cold, drizzly winter days which Ziegler seemed not to mind, but to others made him seem all the more remarkable.

When Ziegler, the artist, accepted a position at Texas Christian University, it was to teach cello, not art. However, he soon moved into his chosen profession and ultimately headed the art department. In 1953 he retired, but continued as emeritus professor and advisor.

Ziegler's many canvases, etchings, and lithographs are primarily of Texas, for only in summer did he have time to work in other states.

Zilverberg, Jake (1886-)
B. The Netherlands. Work: South Dakota Memorial Art Center, Brookings; Hyde County Library, Highmore. Stuart.

Zilverberg, who studied in Amsterdam, and elsewhere in the Netherlands, came to this country in 1909. For many years he worked as an itinerant sign painter in Wyoming, Colorado, and South Dakota. In 1945 he opened a studio and sign shop in Highmore, South Dakota.

Zim, Marco (1880-)
B. Moscow, Russia. Work: New York Public Library; Li-

brary of Congress; Art Institute of Chicago. AAA 1921–1925 (New York City); AAA 1927 (Los Angeles, California); AAA 1931–1933 (New York City); Bénézit; Havlice; Mallett; WWAA 1936–1947 (New York City; summer: New Boston, Massachusetts).

Zimmerman, Frederick Almond (1886–1974)
B. Canton, Ohio. D. California. Work: John Muir Public School, Seattle, Washington; Pasadena and Monrovia (California) Public Schools. AAA 1925–1933 (Pasadena); Bénézit; Havlice; Mallett; WWAA 1936–1962 (Pasadena); *American Magazine of Art,* December 1927, 650, 676.

Zorach, Marguerite Thompson (1887–1968)
B. Santa Rosa, California. D. Brooklyn, New York. Work: Metropolitan Museum of Art; Whitney Museum of American Art; National Collection of Fine Arts; Museum of Modern Art; Newark Museum; Brooklyn Museum. AAA 1915–1933 (New York City; summer 1927–1933: Robinhood, Maine); Bénézit; Havlice; Mallett; WWAA 1936–1966 (New York and Brooklyn); *American Art Review,* March-April 1974, 43–57.

Bibliography

ART AND OTHER DICTIONARIES AND DIRECTORIES

American Art Annual. Washington, D.C.: The American Federation of Arts, 1898-1933.

Appelton, Marion Brymner (ed.). *Who's Who in Northwest Art.* Seattle: Frank McCaffrey, 1941.

Bénézit, E. *Dictionnaire—Critique et Documentaire des Peintres, Dessinateurs, Graveurs et Sculpteurs.* Paris: Ernest Grund Editeur, 1907-1950; Librairie Grund, 1976.

Binheim, Max (comp. and ed.). *Women of the West.* Los Angeles: Publishers' Press, 1928.

Bryan, M. B. (G. C. Williamson, supervisor). *Bryan's Dictionary of Painters and Engravers.* London: George Bell and Sons; New York: The MacMillan Company, 1903-1905.

Cederholm, Theresa Dickason. *Afro-American Artists/A Bio-bibliographical Directory.* Boston: Boston Public Library, 1973.

Clement, Clara Erskine and Laurence Hutton. *Artists of the Nineteenth Century and Their Works.* Boston: Houghton Mifflin, 1899.

College Art Association. *Index of 20th Century Artists 1933-1937.* New York: Arno Press, 1970.

Collins, J. L. *Women Artists in America.* J. L. Collins, 1973.

Cummings, Paul. *A Dictionary of Contemporary American Artists.* New York: St. Martin's Press, 1966; second edition, 1971.

Current Biography Year Book. New York: H. W. Wilson Company, 1939-1975.

Dawdy, Doris Ostrander. *Artists of the American West.* Chicago: The Swallow Press, Inc., 1974.

Dictionary of American Biography. New York: Charles Scribner's Sons, 1927-1964.

Earle, Helen L. (comp.). *Biographical Sketches of American Artists.* Charleston: Garnier & Co., 1972 (unabridged replication of 1924 edition, Michigan State Library, Lansing).

Encyclopedia of Painting (Bernard S. Myers, ed.). New York: Crown Publishers, Inc., 1955.

Fielding, Mantle (James F. Carr, comp.). *Mantle Fielding's Dictionary of American Painters, Sculptors and Engravers.* New York: James F. Carr, 1965; Green Farms, Connecticut: Modern Books and Crafts, Inc., 1974.

Fisher, Reginald (comp. and ed.). *Art Directory of New Mexico.* School of American Research. Santa Fe: Museum of New Mexico, 1947.

Graves, Algernon. *Dictionary of Artists Who Have Exhibited Works in the Principal London Exhibitions from 1760 to 1893.* Third edition. New York: Burt Franklin, 1970.

Groce, George C. and David H. Wallace. *New York Historical Society's Dictionary of Artists in America 1564-1860.* New Haven: Yale University Press, 1957; second printing, 1964.

Hamilton, Sinclair. *Early American Book Illustrators and Wood Engravers 1670-1870.* Princeton: Princeton University Library, 1958; Vol. II Supplement, 1968.

Harper, J. Russell. *Early Painters and Engravers in Canada.* Toronto: University of Toronto Press, 1970.

Havlice, Patricia Pate. *Index to Artistic Biography.* Metuchen, New Jersey: The Scarecrow Press, Inc., 1973.

Johnson, J. and A. Greutzner, (comps.). *The Dictionary of British Artists 1880-1940.* England: Baron Publishing, 1976.

McCoy, Garnett. *Archives of American Art.* Smithsonian Institution. New York and London: R. R. Bowker Company, 1972.

Macdonald, Colin S. (comp.). *A Dictionary of Canadian Artists.* Ottawa: Canadian Paperbacks, 1968.

Mahony, Bertha E., Louise Payson Latimer, and Beulah Folmsbee (comps.). *Illustrators of Children's Books 1744-1945.* Boston: The Horn Book, Inc., 1947.

Mallett, Daniel Trowbridge. *Mallett's Index of Artists.* New York: R. R. Bowker Company, 1935, supplement, 1940; New York: Peter Smith, 1948, supplement, 1948.

Mason, Lauris, and Joan Ludman. *Print Reference Sources: A Select Bibliography, 18th-20th Centuries.* Millwood, New York: Kraus-Thompson Organization, 1975.

Moure, Nancy Dustin Wall. *Dictionary of Art and Artists in*

Southern California Before 1930. Los Angeles: Privately
printed, 1975.

National Cyclopaedia of American Biography. New York: James
T. White & Company, 1893–1969.

Samuels, Peggy and Harold. *The Illustrated Biographical En-
cyclopedia of Artists of the American West.* Garden City:
Doubleday & Company, 1976.

Smith, Ralph Clifton. *A Biographical Index of American Artists.*
Charleston: Garnier & Company, 1967. (Unabridged and
unaltered reproduction of the work originally published by
Williams and Welkins in 1930.)

Stuart, Joseph, (ed.). *Index of South Dakota Artists.* Brookings:
South Dakota State University, 1974.

Waters, Grant M. *Dictionary of British Artists Working 1900–
1950.* Eastbourne, England: Eastbourne Fine Art, 1975.

Who's Who in America. Chicago: A. N. Marquis Co.

Who's Who in American Art. American Federation of Arts. New
York: R. R. Bowker Company.

Who Was Who in America. Chicago: A. N. Marquis Co.

Who's Who in California. Russell Holmes Fletcher (ed.). Los
Angeles: Who's Who Publications Co., 1943.

Who's Who in the Pacific Southwest. Los Angeles: Times Mirror
Printing and Binding House, 1913.

Who's Who on the Pacific Coast. Chicago: Larkin, Roosevelt &
Larkin, Ltd., 1947; Chicago: A. N. Marquis Co., 1949.

Who's Who in the West. Chicago: A. N. Marquis Co.

Young, William (comp. and ed.). *A Dictionary of American Art-
ists, Sculptors and Engravers.* Cambridge: William Young
and Co., 1968.

BOOKS AND ARTICLES

Anonymous. "Bright Pessimism." *The Art Digest,* Mid-Febru-
ary, 1930, 6, quoting Oakland *Tribune* art critic Florence
Wieben Lehre on the plight of the Northern California art
market and the reasons therefor.

Anonymous. "Exhibit Shows Oklahoma Art Has Come of Age."
The Art Digest, Mid-December, 1928, 7.

Anonymous. "Fifty-Thousand View Art Display in Utah." *The*

Art Digest, June 1, 1937, 23, describing the Springville Annual in its 6th year.

Anonymous. "Growth of Western Regionalism Theme of Colorado Springs Exhibit." *The Art Digest,* September 1, 1937, 5, 13.

Anonymous. "In the Northwest." *The Art Digest,* April 1, 1937, 25.

Anonymous. "Indians and the American West." *The Santa Fe Magazine,* November 1973, 8–11, describing the origin of the Santa Fe Railway Art Collection.

Anonymous. "San Diego Artists." *The Art Digest,* July 1929, 12, describing organization and early membership of Associated Artists of San Diego.

Anonymous. "The Desert Will Remain." *The Art Digest,* February 15, 1938, 16. Two viewpoints at that time on the future of desert painters.

Anonymous. "West vs. East." *The Art Digest,* Mid-December, 1929, 8, quoting artist Jennie Vennerstrom Cannon's observations on the art of Eastern and Western United States, and certain discriminatory practices that favored Eastern artists.

Austin, Charles Percy. "Some Artistic Aspects of California," *Out West,* January 1912, 51–56.

Avery, Benjamin Parke. "Art Beginnings on the Pacific." *The Overland Monthly,* Vol. I, #1 (July 1868), 28–34; Vol. I, #2 (August 1868), 113–119.

Barsness, Larry. *The Bison in Art.* Flagstaff: Northland Press in cooperation with The Amon Carter Museum of Western Art, 1977.

Blodgett, Richard. "Riding High with Cowboys, Indians and Bucking Broncos." *Art News,* December 1976, 63–66. Current views of the contemporary scene; the imitators and the imitated.

Brooks, Van Wyck. *John Sloan/A Painter's Life.* New York: E. P. Dutton, 1955; Copyright (c) by Van Wyck Brooks, 1955.

Carter, Kate B. (comp.). *Heart Throbs of the West.* Salt Lake City: Daughters of Utah Pioneers, n.d.

Coke, Van Deren. "Why Artists Came to New Mexico/'Nature Presents a New Face Each Moment.' " *Art News,* January 1974, 22.

Coke, Van Deren. *Taos and Santa Fe.* Albuquerque: University of New Mexico Press, 1963.

Cravens, Thomas. *Modern Art/The Men/The Movements/The Meaning.* New York: Simon and Schuster, 1940.

Dale, Edward Everett, and Morris L. Wardell. *History of Oklahoma.* New York: Prentice-Hall, Inc., 1948.

Douthit, Mary Osborn (ed.). *The Souvenir of Western Women.* Portland: Anderson & Duniway Company (printer), 1905.

Dykes, Jeff. *Fifty Great Western Illustrators.* Flagstaff, Arizona: Northland Press, 1975.

Ewers, John, Frederick Dockstader, and William Truettner. *Frontier America/The Far West.* (Jonathan Fairbanks, ed.) Boston: Museum of Fine Arts, 1975.

Forrest, James Taylor. "How Early Frontier Artists Captured the Western Scene." *El Palacio,* Autumn 1961, 168–179.

Harper, J. Russell. *Painting in Canada/A History.* Toronto: University of Toronto Press, 1966.

Hassrick, Peter. "The American West Goes East." *American Art Review,* March-April 1975, 63–78.

Heller, Mary, and Julia Williams. "Portrait of America: The American Land and Its People as Celebrated by Eight American Painters. (Homer, Sloan, Curry, Bierstadt, Sheeler, Eastman Johnson, Hopper, O'Keefe) *American Artist,* January 1976, 34–76.

Hewett, Edgar L. "On the Opening of the Art Galleries." *Art and Archaeology,* January-February 1918, 50–52.

Hewett, Edgar L. "Recent Southwestern Art." *Art and Archaeology,* January 1920, 31–48.

Honour, Hugh. *The European Vision of America.* Cleveland: The Cleveland Museum of Art, 1975.

Hubbard, Robert H. (ed.). *An Anthology of Canadian Art.* Toronto: Oxford University Press, 1960.

Jackson, Joseph Henry. *Gold Rush Album.* New York: Charles Scribner's Sons, 1949.

Jacobson, O. B., and Jeanne d'Ucel, "Art in Oklahoma," *Chronicles of Oklahoma,* Autumn 1954, 263–277.

Luhan, Mable Dodge. *Taos and Its Artists.* New York: Duell, Sloan and Pearce, 1947.

O'Brien, Esse Forrester-. *Art and Artists in Texas.* Dallas; Tardy Publishing Co., 1935. Also indexed under Forrester-O'Brien.

Olds, Frederick A. "Historians and Art." *Chronicles of Oklahoma.* Summer 1974.

Ormes, Manly Dayton and Eleanor R. Ormes. *The Book of Colorado Springs.* Colorado Springs: The Denton Printing Co., 1933.

Patterson, Jerry E. "The Western Art Rush." *Art News,* December 1974, 26–30.

Peters, Harry Twyford. *California on Stone.* New York: Doubleday, 1935.

Pinckney, Pauline A. *Painting in Texas: The Nineteenth Century.* Austin: University of Texas Press, 1967.

Pollock, Duncan. "The Philip Anschutz Collection of Western Painting," *American Art Review,* November-December 1975, 104–115.

Porter, Bruce, *et al. Art in California.* San Francisco: R. L. Bernier, 1916.

Rasmussen, Louise. "Artists of the Explorations Overland, 1840–1860." *Oregon Historical Quarterly,* March 1942, 56–62.

Rasmussen, Louise. "Artists with Explorations on the Northwest Coast." *Oregon Historical Quarterly,* 1941, 311–316.

Reed, Walt. *The Illustrator in America 1900–1960s.* New York: Reinhold Publishing, 1966.

Reich, Sheldon. "A Genuine Longing for an Older, Simpler Time." *Art News,* December 1974, 32.

Robertson, Edna, and Sarah Nestor. *Artists of the Canyons and Caminos: Santa Fe, the Early Years.* Layton, Utah: Peregrine Smith, 1976.

Robertson, Edna. *Los Cinco Pintores.* Santa Fe: Museum of New Mexico, 1975.

Schwartz, Sanford. "When New York Went to New Mexico," *Art in America,* July-August 1976, 92–97.

Taft, Robert. *Artists and Illustrators of the Old West.* New York: Charles Scribner's Sons, 1953.

Turnbull, George S. *History of Oregon Newspapers.* Portland, 1939. See essay on "Literature, Drama, Music and Art."

Van Nostrand, Jeanne. *A Pictorial and Narrative History of Monterey.* San Francisco: California Historical Society, 1968.

Van Nostrand, Jeanne, and Edith Coulter. *California Pictorial: A History in Contemporary Pictures, 1786-1859.* Berkeley: University of California Press, 1948.

Van Stone, Mary R. "The Fiesta Art Exhibition." *Art and Archaeology,* December 1924, 225-240.

Walker, Franklin. *The Seacoast of Bohemia.* Santa Barbara and Salt Lake City: Peregrine Smith, 1972.

Walter, Paul A. F. "The Santa Fe-Taos Art Movement." *Art and Archaeology,* December 1916, 330-338.

Whitaker, Frederic. "Watercolor in California." *American Artist,* May 1968, 34-45, 70.

Wilkinson, Augusta. "Art in Idaho." *American Magazine of Art,* May 1927, 270-271.

Wilson, L. W. "Santa Barbara's Art Colony." *American Magazine of Art,* December 1921, 411-414.

CATALOGS

American Federation of Arts, The. *National Exhibition Service,* Handbook No. 1 (1936-37), Handbook No. 2 (1937-38), Handbook No. 3 (1938-39). Washington, D.C.

Arkelian, Marjorie. *The Kahn Collection of Nineteenth Century Painting in California.* Oakland Museum Art Department. Oakland: Oakland Museum, 1975.

Baird, Joseph A., Jr. (comp.). *The West Remembered/Artists and Images 1837-1973.* San Francisco and San Marino: California Historical Society, 1973.

Barr, Maurice Grant. *One Hundred Years of Artist Activity in Wyoming 1837-1937.* (Preface by James T. Forrest) University of Wyoming Art Museum. n.d.

Denver Art Museum. *Colorado Collects Historic Western Art/ The Nostalgia of the Vanishing West,* 1973.

Denver Art Museum. *Picturesque Images from Taos and Santa Fe,* 1974.

Evans, Elliot A. P. (comp.). *A Catalog of the Picture Collections of Society of California Pioneers.* San Francisco, 1955.

Garnier, John H. (comp.). *Auction Prices of American Antique Paintings (1968-1972).* Charleston: Garnier & Company Fine Arts, 1973.

Guidon Books. *Artists and Illustrators of the West.* (Introduction by Dean Krakel) Scottsdale, Arizona: Guidon Books, 1974.

Hubbard, R. H., and J. R. Ostiguy. *Three Hundred Years of Canadian Art.* Ottawa: The National Gallery of Canada, 1967.

Hubbard, Robert H. (ed.). *Catalog of Paintings and Sculptures.* Toronto: University of Toronto Press, 1959.

Kingsbury, Martha. *Art of the Thirties; The Pacific Northwest.* Seattle: University of Washington Press, 1972.

Kovinick, Phil. *The Woman Artist in the American West 1860–1960.* Fullerton, California: Muckenthaler Cultural Center, 1976.

Panama-Pacific International Exposition Department of Fine Arts. *Illustrated Official Catalog.* San Francisco: The Wahlgreen Company, 1915.

Robertson, Edna C. (comp.). *Handbook of the Collections 1917–1974.* Museum of Fine Arts. Santa Fe: Museum of New Mexico, 1974.

San Francisco Art Commission. *A Survey of Art Work in the City and County of San Francisco,* 1975.

Santa Fe Industries, Inc. *Paintings from the Collection of the Santa Fe Industries, Inc.* Chicago. n.d.

School of American Research. *Representative Art and Artists of New Mexico.* Santa Fe: Museum of New Mexico, 1940.

Schriever, George (ed.). *American Masters of the West.* (Selections from the Anschutz Collection) Denver, Colorado.

Seattle Art Museum. *Eugene Fuller Memorial Collection.* n.d.

Shalkop, Robert L. *A Show of Color.* Colorado Springs: Colorado Springs Fine Arts Center. n.d.

Truettner, William H., and Robin Bolton-Smith. *National Parks and the American Landscape.* National Collection of Fine Arts. Washington, D.C.: Smithsonian Institution Press, 1972.

REFERENCES IN MIMEOGRAPH AND MANUSCRIPT FORM

Baird, Joseph Armstrong, Jr. *Catalogue of Original Paintings, Drawings and Watercolors in the Robert B. Honeyman, Jr.*

Collection. Berkeley: The Friends of the Bancroft Library, University of California, 1968. Mimeo.

Baird, Joseph Armstrong, Jr. (ed.). *France and California/The Impact of French Art and Culture on California.* Davis: U.C. Davis Art Department, 1967. Mimeo.

Baird, Joseph A., Jr. (ed.). *Fifteen and Fifty/California Paintings at the 1915 Exposition, San Francisco.* Davis: University of California Art Department, 1965. Mimeo.

Baird, Joseph Armstrong, Jr. *Northern California Art/An Interpretive Bibliography to 1915* (With Additions and Bibliographical Research by Ellen Schwartz). Davis: Library Associates, University Library, University of California, 1977. Mimeo.

California Art Research. Federal WPA Project, 1937. Mimeo.

Grove, R. "Notes on Art in Colorado Springs 1820-1936." (With partial directory of Colorado Springs artists active during this period). Colorado Springs Fine Arts Center Library. Typescript, 1958.

Hagerman, Percy. "Notes on the History of the Broadmoor Art Academy and the Colorado Springs Art Center, 1919-1945." Colorado Springs Fine Arts Center Library. Typescript. n.d.

Hartley, Russell. "California Artists' Research Bureau." Bulletins 1 through 9 (June 1972-February 1973). Privately published. Mimeo.

McClurg, Gilbert. "Brush and Pencil in Early Colorado Springs." Typescript. n.d.

Maturano, Mary Lou. "Artists and Art Organizations in Colorado." Thesis, University of Denver. (Also available at Denver Public Library.) Mimeo.

Rasmussen, Louise. "Arts and Artists of Oregon, 1500-1900." Oregon State Library. Typescript.

United States Historical Records Survey. *Early American Portrait Artists 1663-1860.* Compiled by The New Jersey Historical Records Survey Project. Newark: The Historical Records Survey, 1940. Mimeo.

Women's History Research Center. *Female Artists Past and Present.* Berkeley, California: Women's History Research Center, Inc., 1974. Mimeo.

OTHER REFERENCES

Bromwell, Henrietta. Bromwell Scrapbook. Denver Public Library Western History Collection.

California State Library. *News Notes of California Libraries.* Sacramento, 1906–.

Carmel Art Association. *The Western Woman.* Carmel, California. n.d.

San Francisco Public Library. San Francisco Art & Artists Scrapbook, vols. I–V.

Acknowledgments

Librarians make books like this possible, and they also make them a pleasure to write. Especially do I wish to thank staff members of the following libraries: National Portrait Gallery, Washington, D.C.; Stanford and Princeton University libraries; California State Library; South Dakota State University Library and South Dakota Memorial Art Center; M. H. De Young Museum and San Francisco Museum of Modern Art libraries; Museum of New Mexico Library; Albuquerque, Boise, Denver, Menlo Park, Minneapolis, Palo Alto, Redwood City, Santa Fe, San Francisco, Taos, Topeka, Umatilla County, and Waukegan public libraries.

Friends and acquaintances lent me pertinent articles and books; staff members of historical societies and commercial galleries let me peruse their files; and relatives of various artists supplied unpublished information.

I hope publication of this book gives all of you who helped me the feeling that without you it would not have materialized in its present form.

D.O.D.